TRANSNATIONAL CO...

"This is a major and highly readable contribution to the analysis and interpretation of the global circumstance, astutely combining an anthropological with other social-scientific perspectives on various aspects of contemporary globality. I have nothing but admiration for Hannerz's accomplishment."
Roland Robertson, Professor of Sociology, *University of Pittsburgh*

"This collection of essays by one of anthropology's pioneers in 'transnational' studies constitutes a sustained argument of considerable power. It is both lucid and engaging but it is also an argument everywhere attendant to the complexities of local reaction to the emergent world system."
James Fernandez, Professor of Anthropology, *University of Chicago*

What connects the headquarters of the World Bank with a meeting of clan elders in an African village? What happens when people and cultures move and mix?

Transnational Connections provides a lucid account of culture in an age of globalization. Ulf Hannerz argues that, in an evermore interconnected world, national understandings of culture have become insufficient. He explores the implications of boundary-crossings and long-distance cultural flows for established notions of "the local," "community," "nation," and "modernity."

Hannerz not only engages with theoretical debates about culture and globalization but raises issues of how we think and live today. His account of the experience of global culture encompasses a shouting match in a New York street about Salman Rushdie; a papal visit to the Maya Indians; Kung Fu dancers in Nigeria and Rastafarians in Amsterdam; the nostalgia of foreign correspondents and the surprising experiences of tourists in a world city or on a Borneo photo safari.

Ulf Hannerz is Professor of Social Anthropology at Stockholm University. He is the author of several books, including *Exploring the City: Inquiries toward an Urban Anthropology* (1980) and *Cultural Complexity: Studies in the Social Organization of Meaning* (1992).

COMEDIA

Series editor: David Morley

TRANSNATIONAL CONNECTIONS

Culture, people, places

Ulf Hannerz

London and New York

First published 1996
by Routledge
11 New Fetter Lane, London EC4P 4EE

Simultaneously published in the USA and Canada
by Routledge
29 West 35th Street, New York, NY 10001

Routledge is an International Thomson Publishing company I T P

© 1996 Ulf Hannerz

Typeset in Times by
Poole Typesetting (Wessex) Limited, Bournemouth, Dorset
Printed and bound in Great Britain by
Clays Ltd, St Ives PLC

British Library Cataloguing in Publication Data
A catalogue record for this book is available from the British Library

Library of Congress Cataloguing in Publication Data
A catalogue record for this book has been requested

ISBN 0–415–14308–x (hbk)
ISBN 0–415–14309–8 (pbk)

CONTENTS

CONTENTS

Part III Places

ACKNOWLEDGMENTS

Most chapters in this book were written within the framework of the project "National and Transnational Cultural Processes," based at the Department of Social Anthropology, Stockholm University, and the Department of Ethnology, University of Lund, directed by Orvar Löfgren and myself, and supported by the Swedish Research Council for the Humanities and Social Sciences. They also draw on my time as a director of the Swedish Collegium for Advanced Study in the Social Sciences, Uppsala, where I was responsible for the Globalization Program.

Chapter 1 was written for the present volume.

Chapter 2 was first presented at the University of Chicago/Transcultura Centennial Conference on "The Conditions of Reciprocal Understanding," Chicago, 12–17 September 1992. It has appeared in *The Conditions of Reciprocal Understanding*, edited by James W. Fernandez and Milton B. Singer and published by the Center for International Studies, University of Chicago, 1995. I have also presented it in the Henry R. Luce lecture series on Cultural Identity and Global Processes at Clark University, Worcester, Massachusetts, and at Concordia University, Montreal.

Chapter 3 was presented as a keynote lecture at an annual conference of the Swedish Anthropological Association (SANT), on the theme "Culture: Shared and Distributed," at Kungälv, 26–28 March 1993. It was first published in *Ethnos*, vol. 58, pp. 95–111, 1993.

Chapter 4 was presented at the conference on "Modernity Reconsidered," arranged by the Swedish Collegium for Advanced Study in the Social Sciences and Daedalus at Friibergh Mansion, Sweden, 26–29 May 1994.

The first version of Chapter 5 was presented at a conference on "The Economics of Transnational Commons," co-hosted by the University of Siena, the World Institute for Development Economics Research (WIDER), and the International Economic Association at Certosa di Pontignano, 25–27 April 1991. It has subsequently been presented at a conference on "Multiculturality – Threat or Asset?" at the University of Gothenburg, 5–6 March 1992, and in lectures at the Central European University in Budapest, at Tel Aviv University, at the Ben Gurion University of the Negev, Beersheva, and at the Netherlands School for Public Administration, The Hague. A Swedish translation appeared in the bilingual

conference volume *Multiculturality: Warfare or Welfare?* edited by Dora Kós-Dienes and Åke Sander (KIM Reports, University of Gothenburg, 1992).

Chapter 6 was presented in an earlier version at the Intercollegiate Seminar on "Culture, History and Identity: Creolization as a Cultural Process," University College London, in March 1992, and later at the Hebrew University of Jerusalem, the University of Haifa, and the Amsterdam School for Social Science Research. Parts of it were presented at the annual meeting of the American Anthropological Association, Chicago, 20–24 November 1991, in a session on "Sociocultural Creolization" organized by Christine Jourdan.

Chapter 7 was presented at the conference on "Defining the National," organized by the Project on National and Transnational Cultural Processes at Bjärsjölagård, Sweden, 26–28 April 1992, and was first published in *Ethnos*, vol. 58, pp. 377–391, 1993.

Chapter 8 was presented in a seminar series on "Global Communities – Global Families" at the School of Oriental and African Studies, London, in October 1993.

The first version of Chapter 9 was presented at the First International Conference on the Olympics and East/West and South/North Cultural Exchanges in the World System, in Seoul in August 1987. It was previously published in *Theory, Culture and Society*, vol. 7, pp. 237–251, 1990, and in *Global Culture*, edited by Mike Featherstone (London: Sage, 1990).

Chapter 10 was presented at the Society for Cultural Anthropology conference on "Cultural Production under Late Capitalism," Chicago, 13–15 May 1994.

Chapter 11 was presented at an international symposium on "The Age of the City: Human Life in the 21st Century" in Osaka, Japan, in March 1990, and published in *Humanising the City?* edited by Anthony Cohen and Katsuyoshi Fukui (Edinburgh University Press, 1993).

Chapter 12 was presented in a slightly different form as a public lecture at the Centrum voor Grootstedelijk Onderzoek, University of Amsterdam, where I was a visiting professor in a program sponsored by the city of Amsterdam, on 12 November 1991. It was published by CGO with another lecture of mine in booklet form as *Culture, Cities and the World* (1992) and later included in *Understanding Amsterdam*, edited by Léon Deben, Willem Heinemeijer and Dick van der Vaart (Amsterdam: Het Spinhuis, 1993).

Chapter 13 was presented at a conference on "The Organization of Diversity: Botkyrka, Sweden, as a Multi-Cultural Setting," 13–16 June 1990, and appeared in *To Make the World Safe for Diversity*, edited by Åke Daun, Billy Ehn and Barbro Klein (Botkyrka: Swedish Immigration Institute and Museum, 1992).

Chapter 14 was written for the conference on "Symbols of Change: Transregional Culture and Local Practice in Southern Africa" held in Berlin, 7–10 January 1993, and was published in the *Journal of Southern African Studies*, vol. 20, pp. 181–193, 1994 (published by the Carfax Publishing Company, Abingdon, Oxfordshire). It has also been presented as a lecture at the University of Lancaster.

I am grateful for comments and suggestions offered in the contexts of these earlier presentations, and to publishers of earlier versions for allowing me to bring them together here.

ACKNOWLEDGMENTS

The chapters which have been published previously have been somewhat revised to be integrated into the book; references have been updated to take note of some relevant later publications, and here and there in the notes I have taken the opportunity to respond to published comments on earlier versions.

Once more, I am pleased to thank my wife and colleague, Helena Wulff, for her continued multifaceted support.

Ulf Hannerz

1

INTRODUCTION
Nigerian Kung Fu, Manhattan *fatwa*

The chapters in this book have grown in a certain biographical terrain. This will become apparent off and on, but let me sketch a few landmarks immediately: a modest hotel in one continent, a street scene in another, and a small village in a third.

Rosy Guest Inn, when I stayed there during several periods in the 1970s and 1980s, was a simple one-storey building, with bright yellow walls and blue shutters (and iron bars rather than glass in the windows), under a corrugated zinc roof. In the inside courtyard toward which rooms opened, there was a central water tap. The kitchen staff would slaughter a chicken or two under it in the morning, while otherwise it was available to the guests. Probably never more than half a dozen at any one time, these included ginger traders, itinerant magicians, and soldiers on a weekend spending spree.

I was in Kafanchan, the central Nigerian town where Rosy Guest Inn was located, to do anthropological field research, and became the only long-term guest in the establishment when I was confronted with a housing shortage in the town after a unit of the Nigerian army had based itself there, and the officers had spread themselves over much of whatever accommodation was available.[1] By staying at Rosy Guest Inn, I avoided the distractions of establishing a household of my own. (After a tiring day, I could come into the dining room and ask for a pot of tea, and the young woman in charge would bend over the table and ask, for clarification, "coffee or Tetley's?" As I had the only typewriter in the house, I could also help out retyping the menu.) But staying there also helped me gain a sense of both the physical and the mental mobility of contemporary Nigerian urban life, of the horizons of townspeople who came there for meals and boisterous arguments, and of the standards by which visitors judged Kafanchan. A trader from a bigger city found no local taxis plying Kafanchan's alternately muddy or dusty streets, and asked me what I would propose for local transportation. In jest I suggested he might check if one of the truck-pushers resting under the big tree in Danhaya Street would be willing to push him around. He looked at me in horror before he broke into laughter.

The proprietor of Rosy Guest Inn, a migrant from the south, did not live in Kafanchan, but he visited every week, coming in on his puffing motorcycle from the bigger city some distance away. There was another Rosy Guest Inn there, and

a third in the university town a little further north; he also ran two book and stationery shops, one of them in Kafanchan, where I would go for newspapers. He preferred to staff his businesses with his relatives, although in Kafanchan an exception was made in the kitchen, where he preferred to have a man from Calabar, on the southeast coast of Nigeria. Since early colonial times, Calabar cooks have had a reputation as the best professional cooks in Nigeria (although perhaps the one in Kafanchan did not do much to uphold it).

I still have the studio photograph which Rosy Guest Inn's proprietor had taken of him and me on the eve of one of my departures, as well as his elegant name-card, in a sort of wooden finish, with his several business addresses, and the home address which he shared with wife and twelve children. At Rosy Guest Inn in Kafanchan I also first encountered Ben, a young electrician who was working there at the time when electricity was being introduced, in a period of Nigerian petroleum-based affluence, in Kafanchan as well as many other small towns.

Ben (whose father had been the first in his village to more or less give up tilling the soil and become a petty trader) turned out to be a person of many talents and interests, and so when the work of electrification was in large part done, he started working with me instead, in the varied roles of a field anthropologist's assistant – guide, advisor, interpreter, go-between. He would enjoy conversing and dancing the Kung Fu in Kafanchan's beer bars, would complain about having to kneel on the coarse cement floor in one of the small breakaway churches we visited, would sometimes ask leading local businessmen rather more pointed questions than I had dared do myself, and would also have endless questions for me about other cities, other countries. I was not surprised when he asked me if he could have my newspapers after I had read them, although perhaps a little disappointed when it turned out he would take them straight to the market place to sell them to traders who used them to wrap dried fish.

Again, this was in the 1970s. One of Ben's older brothers who was an army officer had named his first-born son Gagarin, after the Soviet cosmonaut. When Ben had his first son, he wanted to go one better, and named him Lenin. Some time later, when I was there, Ben discovered that the students at a teachers' college on the outskirts of Kafanchan (where he also did occasional electrical work) lacked a convenient shopping facility for soap, snacks, matches and other small items. So he thought of establishing a small shop there, which as a proud father he would operate in his young son's name – "Lenin's Supermarket." More than a decade before the demise of state socialism in the Soviet Union, this now seems remarkably foresightful.

A decade or so later, another urban scene: it is a winter morning in New York, and I stand in line on a lower Broadway sidewalk, hoping like a great many others to get into a public meeting where a number of leading American writers are to appear, to show their support for Salman Rushdie. *The Satanic Verses* has just appeared, and Ayatollah Khomeini has issued his *fatwa*.

Far too many people were out there under the umbrellas, so most of us (myself included) did not get into the small hall. Instead we witnessed, or took part in, the

goings-on outside. On one side of Broadway, then, were the people who had wanted to get into the meeting, members of a well-educated American middle class, shouting "Free Speech! Free Speech!" or even "Hey hey, ho ho, Hizbollah has got to go." (One woman passed by and commented that this was like in '68.) On the sidewalk across the street was a gathering of Muslim immigrants, with their own speech choirs, and their own posters. One of the latter argued that "Islam promotes dialogue." And so there they were, east and west, or north and south if one so prefers, on opposing sides of lower Broadway, shouting at each other.

The third place is a village in southern Sweden, where I spend most summers. My great-grandfather bought a small house there after he realized that none of his sons was about to take over the family farm, a few miles away. My grandfather became a sea captain, and two of his brothers emigrated to America. Their two unmarried sisters remained in the house after the elderly parents had died, reporting in letters to their city relatives about seasonal changes in the garden, the habits of hedgehogs, and the arrivals and departures of birds of passage.

Over the years, the village has changed. Most of the villagers used to be artisans and farm people. Now many of them (or rather their successors) commute to nearby towns. The house next door belonged for a while to a famous former bank-robber who had started a new life; not so entirely easy, as people would still tend to remember the time when he was internationally televised, holding a frightened group of bank employees to ransom. Since he left, a retired farming couple live in that house. The wife, speaking the local dialect with an almost undetectable accent, grew up between the world wars as the daughter of a prosperous landowner in East Prussia, and entered adulthood in a new country just as the old way of life had been destroyed forever.

A few houses further away, a star ice hockey player resided fairly briefly, brought there by a wealthy local entrepreneur (not a village resident, however) who wanted to advance the fortunes of a team in a nearby town. But the hockey player was soon bought by a major Canadian team, in the National Hockey League in North America, and has not been seen since. Villagers still speak of his hot temper. The old village grocery has been turned into an art gallery, and the woman who runs it also teaches courses in intercultural communication at an adult education center in the town. Apart from the lady from East Prussia, only a few people originating in other countries have yet made their way, somehow, to this village. (In the nearest town, a fair number of Vietnamese appear to lead quiet lives.) Yet as elections are coming up, they and their neighbors find in their mailboxes a leaflet from a right-wing group in the city some twenty miles to the south, proclaiming that Sweden has been turning, in a few decades, from a welfare state and a *folkhem*, "home of the people," into a "multicultural inferno."

A GLOBAL ECUMENE

Distances, and boundaries, are not what they used to be. The local magnate who brought the ice hockey celebrity to our village also took some special interest in

long-distance travel – he erected a small monument in the forest at the place where he had once on a summer evening encountered a spaceship and its crew, from another planet. Unfortunately, as one crew member had become ill and they all had to return to where they came from, nobody else saw them.

Mostly, we are not yet into interplanetary connections. But this is a time when transnational connections are becoming increasingly varied and pervasive, with large or small implications for human life and culture. People move about across national boundary lines, for different reasons: in the Swedish village, because for someone an earlier way of life elsewhere has been destroyed, in a part of Germany no longer German, or because for someone else the pay in Canada is better. The technologies of mobility have changed, and a growing range of media reach across borders to make claims on our senses. Our imagination has no difficulty with what happens to be far away. On the contrary, it can often feed on distances, and on the many ways in which the distant can suddenly be close.

Anthropologists, it has been said, are "merchants of astonishment," dealing in the wonders of strange cultures (Geertz 1984: 275). No doubt there is a great deal to that description, although one might worry that the market for this kind of merchandise will shrink when some of the more remarkable customs in the global cultural inventory fade away, and when in any case more people have seen too much to be easily astonishable. At present, it seems that some of the goods consist of the astonishment of displacement and juxtaposition: Kafanchan Kung Fu, Manhattan *fatwa*. Yet the sheer surprise value of such goods may soon enough also decline, as we accumulate more and more anecdotal evidence of this type.

At least for as long as I have been in it, anthropology has been in the process of being "rethought," "reinvented," "recaptured". Some say this is because it is in a crisis, although it could just be a sign of vitality, and ongoing adaptation to changing circumstances (as well as of generational struggles, and the pressures of the academic marketplace). Anyhow, the desire to cultivate new understandings of how the world hangs together, of transnational connections, in the organization of meanings and actions – and move beyond mere astonishment over new mixtures and combinations – is clearly one increasingly important strand in changing anthropology now, as an intellectual enterprise and as a craft.

When I turned to anthropology in the early 1960s, this was the subject in the university which would allow you (or, perhaps more precisely, force you) to engage with exotic continents like Africa, and where the assumption indeed was that if you stayed on your course long enough, you would end up in a distant village in another continent, trying to make sense of a slice of local life. The world, to anthropologists at least, seemed to be made up of a myriad of such more or less local, bounded entities; a sort of global mosaic.

Then anthropology went through a period of critical scrutiny, from inside and outside, as colonialism's child. The idea of having a separate discipline for a study of "other cultures," for the West looking at the rest, appeared increasingly dubious, on moral and intellectual grounds. (Consequently there is no particular emphasis on "the rest" in this book, apart from the fact that I may show some predilection for

things African.) More researchers began doing "anthropology at home," a rather stretchable notion. Yet even then, the assumption of the mosaic of small-scale, territorially anchored social and cultural units mostly remained in place.

By the time I came to Kafanchan, I expected to do a local study, an experiment in urban anthropology, a study of an internally complex and heterogeneous town as a whole. Surely this was already a step away from the traditions of anthropology. The people of the town, migrants from all over Nigeria, belonged to ethnic groups about which some of the discipline's classic monographs were once written – Ibo, Hausa, Yoruba, Tiv, Nupe. And ethnicity, "tribalism," was certainly one of the everyday principles of social organization in the life of the town. Yet it was not wholly uncontroversial. In the ledger at Rosy Guest Inn, where guests were requested to register their names, occupations, and addresses, and also their tribes, one guest wrote in an irritated paragraph of protest against the tribal column. This, he said, had no place in a united Nigeria. The practice was retrograde and should be abolished immediately. I suspect that the proprietor had really only copied the design from the guest ledger at the more prestigious state-run hotel on the outskirts of Kafanchan.

The tiff between the management and the enlightened guest at Rosy Guest Inn is a reminder that Nigeria is one of the many places where the national is understood to be threatened mostly from below, by sectional loyalties which are more local. All the same, the idea of the national was there, in a country which had not existed, either as an independent or as a dependent but coherent entity, at the last turn of a century. It was a conception imported from the outside, making Nigeria itself in significant part an organizational artifact of the integrative processes in the world.

As I was doing my urban study, I became increasingly preoccupied with the nature of contemporary Nigerian culture on this rather wider scale. How do you understand, and portray, a culture shaped by an intense, continuous, comprehensive interplay between the indigenous and the imported? What tools do we need to grasp the character of what may even be thought of as a new civilization? Beyond such questions, moreover, there was a larger one: in what kind of global interconnectedness does Kafanchan, a town built around a colonial-era railway junction, with inhabitants like Ben and his son Lenin, now have a place?

What follows is a series of partial attempts to approach an answer to that question; even as we will often seem far away from Kafanchan, for much the same question can accompany us to lower Broadway in Manhattan, or to the south Swedish village, or to any number of other settings.

In these introductory notes, I want to make some general points, and also say something about the organization of the chapters. First, a few comments on vocabulary may be in order. After a fashion, this is obviously a book on "globalization" – a key word of the present, and as such, a contested term. One almost expects any mention of globalization now to be accompanied by either booing or cheering. To business consultants and journalists, this is apparently often a word with a pleasant ring – newsworthy, promising of opportunities. In the sense of

5

"cultural imperialism," on the other hand, it is understood to be bad, and listening to stories of "the global" versus "the local," we are expected to know where our sympathies should lie.

It would seem to me that contemporary interconnectedness in the world is really too complicated and diverse to be either condemned or applauded as a whole. Different aspects of it may quite justifiably draw different responses – detached analysis sometimes, a sense of wonder over its intricacies at other times, not always a rush to moral judgment. This book is not intended as a paean to globalization, nor as its opposite.

I am also somewhat uncomfortable with the rather prodigious use of the term globalization to describe just about any process or relationship that somehow crosses state boundaries. In themselves, many such processes and relationships obviously do not at all extend across the world. The term "transnational" is in a way more humble, and often a more adequate label for phenomena which can be of quite variable scale and distribution, even when they do share the characteristic of not being contained within a state.[2] It also makes the point that many of the linkages in question are not "international," in the strict sense of involving nations – actually, states – as corporate actors. In the transnational arena, the actors may now be individuals, groups, movements, business enterprises, and in no small part it is this diversity of organization that we need to consider.[3] (At the same time, there is a certain irony in the tendency of the term "transnational" to draw attention to what it negates – that is, to the continued significance of the national.)

Some things may be more truly global in themselves, however, and in their crisscrossing aggregate, transnational connections contribute to overall interconnectedness. By what term can we capture this quality of the entity as a whole? While the notion of the world as a mosaic now looks questionable – too much boundedness and stability – other metaphors may come to mind. In the mid-1960s, Marshall McLuhan (e.g. 1964: 93), provocatively rewriting world cultural history (past, present, future) in terms of communication media properties, suggested that there was now a "global village." The term has stuck in public consciousness, much more than most of McLuhan's far-reaching claims. (The Queen of England, for example, recently used it in a Christmas address to the British people. One can hardly imagine it coming from the mouth of one of her royal predecessors, during that period when the sun never set in the Empire, and much of the world map was colored pink.) Yet the "global village" is in some ways a misleading notion. It suggests not only interconnectedness but, probably to many of us, a sense of greater togetherness, of immediacy and reciprocity in relationships, a very large-scale idyll. The world is not much like that.

I prefer another term, drawn from anthropology's past. (Sometimes it is perhaps not so much "reinventing" that is needed, but – to begin with, at least – some mere "remembering," or "retrieving," in so far as previous generations have left certain unfinished, yet worthwhile business behind.) Around the mid-twentieth century, a handful of leading anthropologists, such as Alfred Kroeber and Robert Redfield, were engaged in different ways in shaping a sort of macroanthropology, dealing

6

especially with conceptions of civilization. At a yet more encompassing level, in his 1945 Huxley Memorial Lecture to the Royal Anthropological Institute in London, Kroeber discussed the "ecumene" (*oikoumene*) of the ancient Greeks. That ecumene, the entire inhabited world as the Greeks then understood it, stretched from Gibraltar toward India and a China rather uncertainly perceived. In our time, the corresponding unit is both larger, in the sense of encompassing more, and smaller, in the more metaphorical senses of connectedness and reachability. Yet as Kroeber (1945: 9) had it, the ecumene "remains a convenient designation for an interwoven set of happenings and products which are significant equally for the culture historian and the theoretical anthropologist," and thus the global ecumene is the term I – and some others with me – choose to allude to the interconnectedness of the world, by way of interactions, exchanges and related developments, affecting not least the organization of culture.[4] It is in the global ecumene, then, that Ben in Kafanchan does the Kung Fu, that a *fatwa* pronounced in Teheran becomes a matter of a street shouting-match in Manhattan, and that someone in a south Swedish village turns out to be a teacher of intercultural communication.

CULTURE, PEOPLE, PLACES

The chapters of this book were written in different contexts, as papers for one conference or other (and in some cases thereafter published, in scattered places), and each is therefore a relatively independent piece. Yet they draw on a single, although evolving, perspective toward cultural processes in the contemporary world, and no doubt show some continuing preoccupations.[5] Quite literally, I believe, they are essays aiming at contributing to a conversation, partly public and partly perhaps taking place within the circles of the anthropological community, about the wider cultural interconnectedness and the ways we try to grasp it.[6] What are the recurrent motifs in the stories we tell each other about it, what scenarios do we have for its continued development? How well do our hidden assumptions, entrenched figures of thought, most favored metaphors, serve us as we try to orient ourselves in the emergent cultural order? And what are the strategic sites for observing it? Again, the continuous emphasis is on elaborating and exemplifying a point of view, a conceptualization, not on presenting new or more deeply researched facts. The ethnographic evidence will often be anecdotal (as it often is in arguments about globalization), a bit parachutist: Kafanchan now, lower Broadway next. And yet I hope it will contribute to a sense of the overall organization of diversity. Let me add that "organization," and the second word of the title, "connections," carry some weight here. In the tradition of social anthropology, I try to look at the coherence of the world in terms of interactions, relationships, and networks.

I have organized the chapters under three headings: culture, people, places. It is plain that these are not easily separable themes, and actually they tend to mingle throughout the book. Yet the differences in emphasis may be discernible.

7

Culture is really a continuous, overarching concern in the pages which follow. There are obviously many concepts of culture, and even that of anthropology is not entirely of one piece. I see at least three main emphases which it has tended to combine, and which have usually been assumed to coexist harmoniously.

One is that culture is learned, acquired in social life; in computer parlance, the software needed for programming the biologically given hardware. The second is that it is somehow integrated, neatly fitting together. The third is that it is something which comes in varying packages, distinctive to different human collectivities, and that as a rule these collectivities belong in territories.

The second of these assumptions, that a culture is highly integrated, and to be grasped as "a whole," has been deeply entrenched in anthropology for many years. It reached its high point with Ruth Benedict's *Patterns of Culture* (1934), probably still the discipline's all-time classic. In the 1960s and 1970s, however, some of the preeminent anthropological thinkers of the times – Fredrik Barth (1966: 12 ff.), Clifford Geertz (1973: 404 ff.), Victor Turner (1977) – began to express their doubts about it, along different lines. "Well, it is a matter of degree ..."; "Too much integration may not be such a good thing ..."; "In any case, it should be a matter for investigation." And the idea has hardly been quite the same since; surely not in times of postmodernism.[7] No doubt it has something to it, but as we look at lives including a quite noticeable share of contradictions, ambiguities, misunderstandings, and conflicts, we sense that making things go together is something that we at least have to work on.

The third characteristic, of cultures, in the plural, as packages of meanings and meaningful forms, distinctive to collectivities and territories, is the one most obviously affected by increasing interconnectedness in space. As people move with their meanings, and as meanings find ways of traveling even when people stay put, territories cannot really contain cultures. And even as one accepts that culture is socially acquired and organized, the assumption that it is homogeneously distributed within collectivities becomes problematic, when we see how their members' experiences and biographies differ.

Fundamentally, we seem to be left with the first of the three emphases, on culture as meanings and meaningful forms which we shape and acquire in social life. This seems to define the range of cultural analysis.[8] With regard to the other two, I would suggest, the strategy now should be to reformulate them as core problematics in our thinking comparatively about culture, its variations and its historical shifts. How, and to what degree, do people arrange culture into coherent patterns as they go about their lives? How, as they involve themselves with the interconnectedness of the world, does culture sometimes, in some ways, become organized into the more or less tidy packages we have called "cultures," and under other circumstances take on other kinds of distribution?

In his 1945 address on the ecumene, Kroeber went on to argue that

> while any national or tribal culture may and must for certain purposes be viewed and analyzed by itself ... any such culture is necessarily in some

8

degree an artificial unit segregated off for expediency and that the ultimate
natural unit for ethnologists is "the culture of all humanity at all periods and
in all places".

<div align="right">(Kroeber 1945: 9)</div>

While this is a book focusing on the present, thus not dealing with "all periods"
(but not, I think, denying or ignoring the fact that there is a past), it does, after a
fashion, occupy itself with a notion of "the culture of all humanity." Local and
national frameworks for thinking about the social organization of meanings and
meaningful forms have been strongly entrenched both in the anthropological
tradition and elsewhere in social and cultural thought. The first set of five chapters
deals with various questions which confront us when we distance ourselves from
such frameworks. A recurrent theme is also the variously bewildering and illu-
minating interplay between different culture concepts, and between academic
uses and the increasing popularity of vocabularies of culture in numerous other
contexts: "culture shock," "multicultural inferno," "intercultural communica-
tion." You might say that on that winter morning on lower Broadway, two culture
concepts confronted one another. Those who shouted "Free speech" from one
sidewalk represented that variety which we identify with a critical interest in art
and literature, and with a consciously cultivated esthetic and intellectual aware-
ness. They were there to defend an individual artist's rights of expression, and
their own rights, as consumers, to choose their cultural consumer goods. Those on
the other sidewalk were not there as literary critics, to argue that *The Satanic
Verses* was an inferior novel. Rather, they were agitated and hurt by what seemed
like an attack on ideas which had shaped them as living beings, and which
remained fundamental to their identities and daily lives. Culture, that is to say, is
not only in books; it also makes human beings.

In this set of chapters, then, Chapter 2, "The local and the global: continuity and
change," hints at the internal diversity of globalization, for one thing, and for
another, tries to clarify some of the assumptions about "the local" as a source of
cultural continuity, and "the global" as a source of change. Chapter 3, "When
culture is everywhere," deals with recent debates over the culture concept itself.
Is it only a word for differences, and if that is so, what are its implications for
humanity living together? What is the relationship between singular and plural
forms of the concept? And a theme which turns out to be recurrent makes its
appearance here as well: when the culture concept comes into increasingly wide-
spread use as humanity talks about itself, what is the relationship between acad-
emic and other uses?

Clearly, once we start trying to look at matters in more global terms, there are
a number of other key concepts beside culture which will tend not to be left in
their accustomed places, undisturbed: modernity, community, nation. Chapter 4,
"The global ecumene as a landscape of modernity," takes its point of departure in
one current theoretical view of modernity, as a type of civilization spreading
through the world. It illustrates the unevenness of that diffusion process, yet

suggests that to trace it, one needs to relativize the boundedness of social and cultural entities. In addition, the chapter considers the relationship between the concept of modernity and assumptions of similarity, and that between the concept of culture and assumptions of difference.

In Chapter 5, "Seven arguments for diversity," the question is what cultural differences are good for. In the global ecumene where far-reaching cultural homogenization is at least imagined as a possible scenario for the future, should we happily see that "multicultural inferno" go away, or are there any more or less tangible advantages involved in maintaining variety – and advantages for whom?

This is a time in the world when "the pure products go crazy," James Clifford, intellectual historian and meta-anthropologist, suggested in *The Predicament of Culture* (1988), and for some time now, anthropologists as well as other commentators on the present have been somewhat preoccupied with "impurity," with blending: the cultural equivalents of hybridity, pastiche, or mélange. While the theme is more or less visible through most chapters, it is particularly the focus of Chapter 6, "Kokoschka's return." The chapter begins by enumerating some of the metaphors we now use in portraying cultures and cultural processes: from art, from biology, from language. Yet mostly, it deals with the sort of questions which insistently drew my attention in Kafanchan: how can we best grasp the character of those contemporary cultures which have been thoroughly shaped by the coming together of historically separate cultures, under circumstances of inequality in center–periphery structures? I argue that understandings of creolization inspired by sociolinguistics take us further than most competing metaphors, but also that we need to scrutinize the interplay between state, market, and forms of life to understand how an internally diverse cultural continuum comes into being.

The second set of chapters, "People," shifts the balance somewhat toward a social dimension. These chapters are concerned with collectivities and categories. Chapter 7, "The withering away of the nation?," considers the relationship between national identification and life experience, and suggests that to a growing number of people, of quite varied kinds – some business people, some street people – the nation is not quite what it used to be as a container of significant activities and relationships. Chapter 8, "A Polish Pope among the Maya," examines concepts of community, and draws on a newer view of the varieties of social relationships to argue for a wider range of ethnographic approaches to both large-scale and small-scale management of meaning in transnational contexts. In Chapter 9, "Cosmopolitans and locals in world culture," I attempt to shift a classic contrast to the global setting, concentrating on a portrait of a cosmopolitan who sees the experience of cultural diversity as a value in itself. Chapter 10, "Trouble in the global village," the last chapter in this section, is an exploration of the occupational culture of foreign correspondents (comparing it to that of anthropologists) and the part they play in depicting and interpreting the world to the general public.

Anthropologists find people and places good to think with. In his *Rethinking Anthropology* (1961: 1), one of the leading figures of post-World War II anthropology, the late Sir Edmund Leach, commented about some prominent British

colleagues, and some ethnographic classics, that "for Firth, Primitive Man is a Tikopian, for Fortes, he is a citizen of Ghana." The formulation perhaps jars our sensitivities now, in more ways than one, but as I suggested at the very beginning of this chapter, the point is that certain specific experiences and encounters may lead us on to rather more general perspectives and orientations.

It is obviously characteristic of the contemporary global ecumene that there is no really distant Other, no "Primitive Man," among the people whom I have found it good to think with, but rather a mixture and a continuum of kinds of direct and mediated engagements. The people of Kafanchan, for instance, have thus had an influence, individually and collectively although mostly unwittingly, in making me think in certain ways about the world, and about creolization. There are also some particular individuals who make repeated entries in the pages which follow whom I never met in person, but who personify kinds of insight or intellectual predilection. Alfred Kroeber, then, and Robert Redfield, seem to me to stand for earlier ambitions in anthropology to "think big" about culture, and will thus appear now and then as chosen ancestral figures (of the kind that are sometimes honored, occasionally bickered with, and at other times just ignored). Marshall McLuhan, whatever else may be said about him, has earned an enduring niche in the twentieth-century history of ideas, both for drawing attention to growing global interconnectedness and for insisting that we think about the specific cultural implications of different media.

One might think that among those just mentioned, the Nigerian townspeople are, in the old way, the people out of ethnography, my Tikopians, while the others are the representatives of a world of theory. But then, representing the ways the divide is being bridged, there is Salman Rushdie, both a commentator on the global ecumene in his own right and, through the "Rushdie affair," a key person in an exemplary global ethnographic drama, drawing its own interpretive commentary; which can for one thing be a commentary on the way places are now.

So there we were on lower Broadway, shouting (or listening to people shouting), and building up a sense, not least through the intensity of media coverage, that this was a New York affair. In some ways it was. There was a controversy over the responsibility of booksellers as guardians of the freedom of speech – worrying over the risk of violent reprisals, the expansionist chain-stores had stopped selling the book. And one inside commentator drew attention to the pecking-order among local literary lions who were (or were not) invited to take part in solidarity events, or interviewed on television.

But then "the Rushdie affair" also seemed, for half a year or so, to be taking place everywhere, and nowhere in particular. *The Satanic Verses* was originally published in Britain, was first banned in India, and provoked riots in Pakistan; the *fatwa* was proclaimed in Iran. In Nigeria there were death threats against the Nobel laureate Wole Soyinka, who had expressed his solidarity with Rushdie, and in Sweden the local news was an open conflict within the Swedish Academy, whose members disagreed on how to handle the entire matter, as fellow writers and as public officials. In Italy, it appears that guards were stationed at the grave

of Dante, who was reputed to have made anti-Islamic statements in his time. In the eye of the storm, at the center of the affair, on the other hand, there was a void, as Rushdie himself had gone underground.

This first global literary event is one indication then, in Roland Robertson's (1992: 6) words, of "the compression of the world into a single place." The Third World is in the First World, and the First World in the Third; the North is in the South, and the South is in the North; the center is in the periphery, and the periphery is in the center.

With regard to more ordinary, territorially circumscribed places, the related point is that people and culture now rather more than before refuse to stay put in them, and that long-distance relationships often have an important part in producing them. This is true to some degree of that south Swedish village, and the coming and going is yet more noticeable in the Nigerian town. Rosy Guest Inn is of course not precisely "typical," since any hotel must be a site of some particular transiency. Yet it was because of the coming of the railway that Kafanchan sprang up, and it is still a place where few people have deep roots.

The places which get special attention in the third section of this book, however, are of a kind where the interplay between the local, on the one hand, and the interconnectedness of the global ecumene, on the other, is especially conspicuous. All these four chapters deal with cities.

Over the years, to turn autobiographical once more, I have shifted somewhat from being an anthropologist of urbanism to being an anthropologist of transnational life.[9] Yet the change is perhaps more one of focus than of locus, since cities have a major part in ordering transnational connections, and must therefore be major observation posts for a study of that "culture of all humanity," and of how it comes together.

Chapter 11, "The cultural role of world cities," thus attempts to sketch how a handful of cities become centers of the global ecumene through the convergence there of some different categories of people who share the common characteristic of transnational linkages. And the cultural role of these cities is seen as resulting from the combination of local and long-distance processes. Chapter 12, "Amsterdam: windows on the world", is a brief, impressionistic sketch, a sort of visiting ethnographer's postcard, from a city which for one thing insistently draws attention to the historical continuities of interconnectedness. What Amsterdam is now, and who lives there and how, depend on what it has been: a center of trade and empire, a haven of tolerance.

In Chapter 13, "Stockholm: doubly creolizing," I turn to the city where I live, to describe how it engages on the one hand with impulses from the centers of the world, on the other hand with the local presence of immigrants from other countries and continents; and I argue that these engagements interpenetrate, by way of imported models for the interpretation and management of diversity. Finally in Chapter 14, "Sophiatown: the view from afar," there is an appreciation of a legendary black South African suburb, living and dying under *apartheid*, yet

pointing toward the emergence of a new and vital mixed culture with its own impact on the world.

Cities, then, are good to think with, as we try to grasp the networks of relationships which organize the global ecumene of today. They are places with especially intricate internal goings-on, and at the same time reach out widely into the world, and toward one another. Even so, transnational connections are not facts of city life alone; and thus we find ourselves next, briefly, in another village.

Part I

CULTURE

2

THE LOCAL AND THE GLOBAL
Continuity and change

My wife and I were on vacation in Ireland, and stayed for a night in Carna, a fishing village in Connemara. Noticeably many young people were milling about on the village roads, but mostly, we found out, they were not locals. Carna is in one of those remote areas of western Ireland where Irish children come during the summer to live with Gaelic-speaking families, and thus improve their usually very limited knowledge of Gaelic. But the Gaelic language would probably soon be gone in Carna as well, the hostess of our bed-and-breakfast place told us. Hardly anybody now grew up to speak it fluently. As for herself, that morning she was on her way to Galway town, where her family would hold a reunion. She hoped, but was not sure, that a brother of hers, who had had a career of singing in music pubs in New York, would come flying home for the event. Her own adult life had mostly been in London, it turned out, and there were times when she missed the bright lights. Returning to rural Ireland, she said, "was a real culture shock, you know."

A very ordinary little tale, but it draws together a number of themes of contemporary life. It suggests that the greater time depth of cultures tends to be tied to particular places and regions, as Gaelic language and folk tradition are to villages like Carna, and it shows that people just about anywhere can turn out to have personal experiences and relationships linking them to places in other countries and on other continents. Moreover, it shows that this is something people are aware of and perhaps increasingly preoccupied with, and that the vocabulary for dealing with such matters is growing and spreading, so that a term like "culture shock," invented by an American anthropologist some half century ago, now comes readily to the lips of a boarding-house landlady in Connemara.

In the most general sense, globalization is a matter of increasing long-distance interconnectedness, at least across national boundaries, preferably between continents as well. That interconnectedness has a great many aspects. We have ways of meddling with other people's environments, from the destruction of rain forests and the intercontinental dumping of toxic wastes to global warming; and with their bodies, as in a growing transnational trade in human organs for transplants. The goods we buy may come from far away. This is a fact we sometimes ignore, but at other times the distant provenance has an aura of its own.[1] People whose ancestors lived thousands of miles from one another, and hardly knew of each

17

other's kind, are now in each other's immediate presence, rubbing shoulders; but even when they are not, the proliferation of media technologies allows their ideas, and the tangible shapes which they give them, to circulate without much regard for distance.

These varied kinds of linkage, on the other hand, do not combine in the same way everywhere. Thus in the last half-century or so, the Second World, that of state socialism, for as long as it lasted mostly had its own globalization; the media could to some degree slip in from the outside, but mostly not the material goods, and people could seldom get either in or out.[2] This was also a world that hardly needed to import any environmental destruction. It has been the First World, industrial and capitalist, that has been most intensely involved, within itself, in all kinds of interconnectedness, and sharing some of it with the Third World on those unequal terms which have made globalization seem in large part synonymous with westernization. Meanwhile it has been the tragedy of the Fourth World of aboriginal peoples, during the same period, that it was mostly forced into retreating before that expansion of the First, Second and Third Worlds which again and again destroyed its environments.

As one of the key words of our times, "globalization" stands for a central challenge to intellectual traditions in the human sciences, and draws a variety of commentators of other kinds as well. But in that cacophony of what one commentator (J. Abu-Lughod 1991) has aptly called globalbabble, there is also some tendency to resort to hyperbole and excessive generalizations, to tell a story of dramatic shifts between "before" and "after." In fact, of course, interconnectedness across great distances is not altogether new – Kroeber's discussion of the ancient ecumene of the Greeks, referred to in Chapter 1, showed as much. That image of a cultural mosaic, where each culture would have been a territorial entity with clear, sharp, enduring edges, never really corresponded with realities. There were always interactions, and a diffusion of ideas, habits, and things, even if at times we have been habituated to theories of culture and society which have not emphasized such truths.

Moreover, if "globalization" literally refers to an increase in interconnectedness, we must realize that locally and regionally at least, there can be histories of deglobalization as well. The process is not irreversible. Countries – Myanmar (a.k.a. Burma), Hoxha's Albania – may pursue policies of cutting themselves off, delinking; a kind of active anti-globalization which is in a dialectical relationship with globalization itself. Or they, or parts of them, may deglobalize because they can no longer afford to keep interconnectedness going, and the world does not need them any more. We may see something like this happening in some places in Africa. This might seem like parts of the Third World marching back into the Fourth, if it were not for the fact that so many traces of earlier globalization are still around.

Globalization, all this goes to say, is not brand new, it can move back and forth, it comes in many kinds, it is segmented, and it is notoriously uneven; different worlds, different globalizations. For an anthropologist, it is surely often tempting

18

to take on the old responsibility of the slave, whispering in the ear of the grand theorist that "things are different in the south." To put it differently again, once in a while at least, globalization has to be brought down to earth.

In this chapter I will try to contribute a little to that with respect to some questions of culture. But these are fairly big questions, and so I think the best thing might be to move up and down, between grassroots view and overview, to try to catch what is going on. One is whether globalization leads to less culture, or more. Before we get to that, I would like us to have a look at the packaging of culture, the way we conceptualize units of meanings and meaningful forms in social space. Finally, I want to consider the nature of the local under conditions of globalization. We have now acquired the habit of contrasting the local and the global, and tend to take for granted that the local is to the global more or less as continuity is to change. The outside interferes with the reproductive processes of local culture, but meets with resistance of one kind or other. No doubt there is something to such assumptions, but there is apparently a certain risk of mystification here, and we might try to clarify what is going on in this encounter.

PACKAGING CULTURE

Two aspects of this encounter in particular seem to make the rules of the game for cultural organization rather different in the late twentieth century than they have been before: the mobility of human beings themselves, and the mobility of meanings and meaningful forms through the media.

Throughout human history, there have been people on the move; but usually not very far, or taking a long time to get anywhere. Large-scale air transportation, of jet-set business executives, academics, tourists, pilgrims, or labor migrants as well as refugees from political terror or ecological disasters, shifts people from one place to another more quickly over greater distances than ever before; for one thing, perhaps it did take that Irish–American bar performer from New York on an *Aer Lingus* flight to his family reunion in Galway. The media (in which I include all those communicative technologies, ranging from handwriting to television and electronic mail, that allow people to get messages across to one another without face-to-face co-presence) have not only become more effective in reaching across space. In their growing variety, they have also increased their capacity for handling different symbolic modes, one by one or in combination.

It is in large part due to these media and transport technologies that the world, or at least much of the world, is now self-consciously one single field of persistent interaction and exchange. Obviously, these technologies have not come into being in a vacuum, but in particular social matrices where major uses for them can be identified, and where resources for their development can be amassed. Let us beware of the simplest forms of technological determinism.[3] Yet the reason why I especially want to emphasize the importance of these tools for moving people and meanings is not only that they are so directly involved in globalization. It is also because once they have come into existence, their uses may multiply, their

19

further development takes new turns, and their consequences for the organization of social life and culture in the world have hardly been altogether foreseeable.

People, meanings, and meaningful forms which travel fit badly with what have been conventional units of social and cultural thought. Social theorists now criticize again and again the established tendency to treat "societies" as autonomous universes, often only implicitly identified with the modern form of states – I will come back to the issue especially in Chapter 4. "Cultures," in the plural, have of course been almost the mirror image of "societies" here, perhaps a bit more emphatically suggesting the coexistence and diversity of the entities, but at the same time setting forth the idea of boundedness and distinctiveness even more explicitly. And one strong reason for this has been the historical affinity between mainstream cultural thought, in anthropology and elsewhere, and those ideas about nationhood which emerged in Europe mostly in the nineteenth century.[4]

The idea of an organic relationship between a population, a territory, a form as well as a unit of political organization, and one of those organized packages of meanings and meaningful forms which we refer to as cultures has for a long time been an enormously successful one, spreading throughout the world even to fairly unlikely places, at least as a guiding principle. Perhaps anthropologists, studying human lives even in places where states have not existed, should have been a bit more wary of the construct. But with the personal experience of citizenship surrounding them in their own lives, facing the classical conditions of local fieldwork, and under the influence of a natural history tradition in which cultures are seen more or less as taxonomically analogous with biological species, they have hardly been more inclined than anyone else to scrutinize the assumptions linking at least people, place, and culture.

Neither places nor nation-states may now be quite what they have been, however, and some indeed say that the noticeable increase in sophisticated interpretations of nationhood and nationalism recently is a sign of the decline of the nation-state; that is, with some distance, we see things more clearly now. More about that later (in Chapter 7). Anyway, one of the most influential books in cultural history recently has undoubtedly been Benedict Anderson's *Imagined Communities* (1983), and a very important part of its message is right there in the title. "Imagined communities" suddenly seem to appear all over the place among the theorists.[5] For Benedict Anderson, of course, the imagined communities are nations, and what I find especially interesting for my purposes here is the way his argument exemplifies one variety of interplay between technology, social organization, and particular meaningful forms.

Anderson argues that it was in large part the commoditization of the printed word that made it possible for rapidly growing numbers of people to recognize that there were people much like themselves beyond the face-to-face community. That is, the leap out of the local was made by way of one media technology; or at least that technology in combination with the market. And because that technology was what it was, it was a leap of one human symbolic mode, language, transformed from something heard into something seen. Now certainly, with its unique

20

flexibility and richness, language may in any case be foremost among the symbolic capacities which humanity has at its disposal. Yet what I find worth speculating about here is to what extent this media technology helped give language a head start over other symbolic modes in defining cultural boundaries, and even the very nature of such boundaries. For what resulted, in that case, could be a rather biased view.

Writing and print, in the era of early European nationalism, may have marked the most inclusive social space within which people could engage in a common intelligibility, and thus develop the sense of "we-ness." But simultaneously, it would have underlined a sense of cultural discontinuity which was very congruent with the political ideal of the nation-state. As you are a citizen of one country and not another, and as territory belongs to one state but not the other, you identify with either one language or the other. Writing imposes such discontinuity even where spoken language shows a more gradual shift. And we have become used to certain expectations about language discontinuity. At first encounter, we understand a foreign language with great difficulty, or more probably not at all. Moreover, if we are to learn it, it is likely to be a slow and probably laborious process.

For quite some time, language has probably dominated our thinking about cultural boundaries, since it has coincided with notions of nation, and the active involvement in other symbolic modes – music, gesture, and others, and their combinations – has tended to be mainly confined to local, face-to-face settings. Now that media technology is increasingly able to deal with other symbolic modes, however, we may wonder whether imagined communities are increasingly moving beyond words. To Marshall McLuhan (1964), the global village was the ultimate imagined community: for the cultural implications of Gutenberg's invention have to be relativized, and other media may create other social and symbolic constellations.

The global ecumene is, for one thing, a place of music video and of simultaneous news images everywhere. Leaving aside the important fact of bilingualism and multilingualism (many people now switch, situationally and routinely, between a national and one or more world languages, and this could also have some implications for the communities they imagine) the various symbolic modes which are now medialized probably entail their own literacies, and perhaps we belong to differently distributed communities of intelligibility with regard to different kinds of meaningful form.[6]

I am reminded of Dan Sperber's (1985) suggestion of an "epidemiology of representations." Depending on the nature of our cognitive capacities, and on the interplay between mental representations and the public representations available to the senses, Sperber argues, some representations are more contagious than others, spreading efficiently and often swiftly through human populations. These are the ones which become "more cultural," in the sense of establishing themselves more widely and more enduringly in society. As I read Sperber, he is more interested in human cognitive capacities "in the raw," as it were, and their variously effective handling of different representations. But we could also consider

how differentially cultivated competences for symbolic modes relate to the flow of cultural forms through the world. Could there be affinities which allow us, for example, to appreciate what Nigerians or Indonesians do as they sing or dance, even as what they say when they speak sounds to us as only gibberish? Perhaps we have to draw different boundaries of intelligibility for each symbolic mode; if that is the case, the notion of the boundaries of "a culture," as a self-evident package deal, with a definite spatial location, becomes suspect.

HABITATS OF MEANING

It should not, however, be only the shifting relationship between culture and territory that bothers us. No less at issue is the assumption that the carrier of "a culture" is "a people" – that strongly sociocentric, collectivist understanding of culture, rooted at least in the anthropological tradition. The current parallels in social theory are obvious. There has been a resurgence of interest in agency, no doubt partly as a pendulum swing away from a previous strong emphasis on structure, system and social determinism; partly, I think, also because these ideas have been so firmly, if not always entirely visibly, set in the framework of the nation-state.[7] In anthropology, for some time now, the absence of any explicit notion of agency has been one of the points of criticism in arguments about the trouble with "culturalism," and in and out of that particular debate, there have now for some time been calls to bring human beings back in.[8]

In so doing, however, we must not lose sight of the diversity of actors and organizational contexts involved in managing contemporary complex culture. We cannot occupy ourselves only with the small-scale handling of meanings and symbols by individuals, or small groups, and assume that wider cultural entities come about simply through an aggregation of their activities. To grasp the nature of the culture we live with now, we must also take an interest in the management of meaning by corporate and institutional actors, not least by the state and in the market-place. (I develop this view in Chapter 6.) As far as the state is concerned, this means that it is treated rather as one player among others, with its own interests and logic, rather than as the universe of analysis.

One of the recent writers on concepts of agency has been the Polish–English sociologist Zygmunt Bauman (1992: 190–191), generally one of the most insightful and interesting commentators on the relationship between theory and the emergent realities of contemporary life. Bauman suggests that a notion of agency should be combined, not with system, but with a flexible sense of habitat; a habitat in which agency operates and which it also produces, one where it finds its resources and goals as well as its limitations.

Adapting Bauman's point of view, I think a notion of "habitats of meaning" may serve us well in cultural analysis.[9] The relativist streak in cultural analysis has frequently led us to such turns of phrase as "worlds of meaning," but this again suggests too much autonomy and boundedness. Habitats can expand and contract. As they can overlap entirely, partially or just possibly not at all, they can

be identified with either individuals or collectivities. But in the latter case, it is the analysis of cultural process in social relationships, rather than an axiomatic assertion, that has to convince us that a habitat of meaning is really shared. Much of the time, cultural process will be shaped rather by the way that fairly different habitats of meaning are made to intersect.

In the global ecumene, some people may indeed share much the same habitats of meaning, but these can also become quite idiosyncratic. The places we have been to and the people we have met in them, the books and newspapers we read, the television channels we can zap to, all these make a difference. My own daily habitat of meaning changed the day our apartment building installed cable TV, and I suddenly had access to British, French, German, Turkish, American, and Russian programming apart from the Swedish channels. Yet our habitats of meaning will of course depend not only on what in some physical sense we are exposed to, but also on the capabilities we have built up for coping with it knowledgeably: the languages we understand, write, or speak, our levels of literacy with respect to other symbolic forms, and so on.

What I have been saying so far is that the distribution of meanings and meaningful forms over people and social relationships in the world is now so complicated that any social units we work with in cultural studies must be more or less arbitrary, artifacts of particular analytical objectives. The idea of cultures in the plural is problematic; no doubt difficult to do away with for historical and ideological as well as scholarly reasons, but often little more than a tentative and limited intellectual organizing device. Yet at the same time, the idea of culture in the singular, encompassing the entire more or less organized diversity of ideas and expressions, may become more important than it has been, as we explore the way humanity inhabits the global ecumene.

LESS CULTURE, OR MORE?

This idea of culture as one single large inventory is what I will turn to now, from one particular angle. Listen again to Zygmunt Bauman (1992: xx); we live at present in a "habitat of diffuse offers and free choices," he argues, and thus "public attention is the scarcest of all commodities." In a way, that is, there are too many communities to imagine, too much meaning to be faced and managed.

Is there more culture now, or is there actually less? Since there is no widely agreed-upon, direct, and universally suitable way of measuring culture quantitatively, any answer to the question may have to rest on its general plausibility, but I want to sketch some lines of argument.[10] Not all of them have to do immediately with globalization, but the consequences of that greater interconnectedness may well be seen against the wider background.

Indeed the claim that the cultural inventory is growing in absolute terms seems to have much going for it. There is the fact that science is engaged in systematic, relentless creation of new knowledge, at least in part for its own sake. With regard to my comments about the importance of large-scale agency, it is obvious that

23

major parts of our habitats of meaning are now deliberately shaped by institutional and corporate actors. In the era of the nation-state the cultural aspect of statecraft has been very important, as states gain a large part of their legitimacy through the promotion of distinctive culture and through the cultural construction of citizens. In the market, a growing proportion of commodities are in themselves nothing but meanings, and forms carrying meanings. "What is increasingly produced" in contemporary economies, write the sociologists Scott Lash and John Urry (1994: 4), "are not material objects, but *signs*." At the same time, the advertising industry is also working hard to attach more meaning, especially as fairly arbitrary associations, to assorted things and activities.[11] Watching some commercials, you can hardly tell whether it is soft drinks or beaches that are on offer. In the cultural market, too, competition depends in no small part on continuous innovation. As commodities, meanings and meaningful forms often have to be made into "news."

If there is now more culture, however, it does not depend only on the production of new culture. There may also be less of the old-style, natural, haphazard forgetting of old culture. Media technologies do not only allow us to reach out through space. They also bind time by allowing us to record things, and thus preserve ever more kinds of ideas and cultural forms, in great detail, from that past which is continuously evolving as today becomes tomorrow's yesterday. The cultural heritage just grows and grows and grows, and is now turning into a storage problem.[12] Again, of course, it is not only a matter of technology, but of organization as well. But here the state tends to take on a great deal of responsibility (through schools, archives, museums, and other institutions). If it is in large part in the workings of the market to push new culture, then the state makes sure that at least some selection of old culture is kept available as well. Without the Irish state, Gaelic would disappear even faster, in Connemara as well as in Dublin.

Here, however, we get to the influence of globalization on the combined cultural inventory of humankind. As the uneven battle between English and Gaelic in Ireland implies, there is at least one powerful argument for a decrease in culture as well. To a great many people, the term "globalization" means above all this: a global homogenization in which particular ideas and practices spread throughout the world, mostly from the centers of the West, pushing other alternatives out of existence. In the eyes of some, this is the triumphant march of modernity. Others lament it as a takeover by giant cultural commodity merchants, who make sure that Coca Cola can be sipped, *Dallas* watched, and Barbie dolls played with everywhere, in the ex-Second World and the Third as well as in the First where they originated.

Now there is certainly something to the global homogenization scenario, and the sense of cultural loss. A great many ideas and ways of doing things may pass away, out of practice if not out of the record, where at least ethnographers will by now surely have placed them. While along the range of human cultural diversity some stretches will be more crowded, with more detail and more continuously generated new microvariations on some themes, the range as a whole seems to get shorter.

But this is hardly the final solution to the problem of cultural difference, and can only be one part of the cultural accounting of globalization.[13] The redistribution of culture in space and between habitats of meaning is not only a zero-sum game, a battle of survival between existing entities. It will be a theme of later chapters that in the mingling of old, formerly more separate currents of meaning and symbolic form, new culture also comes into existence.

All this, however, is in the manner of arguing whether there is less culture, or more, in terms of some putative overall measure of quantitative changes in the global inventory. What I think is more certainly an implication of greater interconnectedness is that most of us have the experience of personally running into a larger share of it, in our own habitats of meaning. If it used to be the case that we could live in ignorance of most of the combined cultural inventory of the world, in the global ecumene each one of us now, somehow, has access to more of it – or, conversely, more of it has access to us, making claims on our senses and minds. In large part, change is made up of other people's continuities, quite suddenly coming up close to us as well, without necessarily being fully understood, or fully accepted. "Culture shock," wherever it occurs, is mostly about this, and so are debates about multiculturalism, in the United States and in Europe.

SENSES OF PLACE

In the meeting of the alien and the familiar, however, it seems that the familiar often wins out in the end. Having begun the chapter by drawing on a vacation experience in Ireland, let me turn to some other chance anecdotal evidence from a summer holiday.

The newspaper in the town next to that southern Swedish village where I spend summers is sometimes referred to facetiously as "the pig paper," since it is the newspaper of record for area farmers, for example when it comes to current pig prices. It is, like many small-town papers, quite intensely local, carrying foreign news from the major agencies in a rather routine, offhand way. But then at times, the outside world can itself be locally newsworthy, and so some years ago in mid-July there was a half-page spread under the headline "Adventures in the jungles of Borneo" (Siverson 1992).

A local man had won first prize in a photo contest, a three-week trip for two to Borneo. He and his wife went, and they had now returned, full of impressions: the heat, the hotel in Kuching which changed the towels three times a day, the upriver trip to the Iban tribe (ex-cannibals by reputation), the comfortable guest-house on high poles, the crocodile farm, the strange food and drink; indeed, a pig feast as well. They had seen just a few beggars and no drunkards in the entire trip. And not everything was unfamiliar. Danish beer was common, and taxis were cheap, although you had to settle the price with the driver before going. And in Kuching many people had wanted to talk about the ongoing European soccer championship, and had their particular favorite player on the Swedish team. Anyway, it had been nice to come home, and the first thing these two travelers did was to have

a large glass of cold milk each. Now as photo enthusiasts they also brought back a collection of 700 slides, and looked forward to showing these to people at home, to community groups or wherever.

This, clearly, is a story about that encounter between "the global and the local"; the way one couple's habitat of meaning is dramatically enlarged, but also the way that among a multitude of first-time experiences, they after all find some particular pleasure in reporting on what is familiar – the availability of Danish beer, the reputation of a Swedish soccer player. Moreover, what is not the same as at home can after all often be described in well-known categories – a frequent change of towels, how to take a taxi, drunkards or no drunkards, beggars or no beggars. And as a happy ending, two glasses of cold milk (nothing could be more Swedish).

For those who have some doubts that contemporary globalization changes everything, this is a beautiful story. It is of course a recurrent assertion on the part of various theorists that the local itself is not what it used to be. "In conditions of modernity," writes Anthony Giddens (1990: 18–19), for example, "place becomes increasingly *phantasmagoric*: that is to say, locales are thoroughly penetrated by and shaped in terms of social influences quite distant from them ... the 'visible form' of the locale conceals the distanciated relations which determine its nature." And Mark Poster asks:

> If I can speak directly or by electronic mail to a friend in Paris while sitting in California, if I can witness political and cultural events as they occur across the globe without leaving my home, if a database at a remote location contains my profile and informs government agencies which make decisions that affect my life without any knowledge on my part of these events, if I can shop in my home by using my TV or computer, then where am I and who am I?
>
> (Poster 1990: 74)

I have one sort of answer to that question in a moment. To get there, however, it may be useful to try and be clear about what it is that makes the local a likely source of continuity, and that safeguards the continuous importance of place.

A number of things tend to come together here.[14] One is that much of what goes on locally is what we describe as "everyday life." And if again we must try to be more specific about what this is, we might say that it tends to be very repetitive, redundant, an almost endless round of activities in enduring settings. Furthermore, everyday life is in large part practical. People participate actively, training their personal dexterities without necessarily reflecting much on the fact. There develops a trained capacity for handling things in one way, and – in Veblenesque terms – perhaps a trained incapacity for doing anything else.[15]

What is local also tends to be face-to-face, in large part in focused encounters and broadly inclusive long-term relationships. People can have each other under fairly close surveillance. Shared understandings can be worked out in detail in the back-and-forth flow of words and deeds. Deviations can be punished informally but effectively, changes may need to be negotiated. At the same time, obviously,

these relationships can have a strong emotional content; they are often relationships to "significant others." This affects the meanings built up in them, and the commitment to these meanings.

Moreover, it is in the face-to-face, and what will turn out to be everyday, contexts that human beings usually have their first experiences. If we accept that they undergo a sort of continuous cultural construction work, whatever materials are put in place early will presumably have some influence on what can be assimilated later on. This may not be an argument that we want to push to the extreme, but most would probably agree that there is something to it.

To these fairly familiar points I would add that the local tends to be a special kind of sensual experience. People often make a distinction between a "real" experience and what they have only read about, or seen on television. So what is "unreal" about these latter kinds of experience? Of course, we can consider this only a figure of speech, but another way of looking at it is that people are in the local setting bodily, with all their senses, ready not only to look and listen but to touch, smell, and taste, without having their fields of attention restricted, prestructured for them. There is a feeling of immediacy, even of immersion, of being surrounded. What is experienced is also extensively contextualized. This is surely at least part of what the "real" is about. If there is now a growing celebration in social and cultural theory of the body as a symbolic site of self and continuity, and of the senses, a greater concern with the body and the senses in their contexts might help us understand some of what "place" is about.[16] When Mark Poster, in the lines quoted above, asks rhetorically where he is, it seems he has already offered one not wholly trivial answer – at "home." Home is where that glass of cold milk is.

Taking these items together – the everyday, the face-to-face, the early and formative, the sensual and bodily experience – it would appear that a fairly strong case exists for the continued importance of the local. And this could be true as far as experienced reality is concerned even when much of what is in a place is shaped from the outside. We are just giving up the idea that the local is autonomous, that it has an integrity of its own. It would have its significance, rather, as the arena in which a variety of influences come together, acted out perhaps in a unique combination, under those special conditions. If I remember correctly one of the immortal sayings of J.R. Ewing of *Dallas*: "Once you throw integrity out of the window, the rest is a piece of cake."

Yet perhaps not quite. As an intellectual category, "the local" seems more protean than primordial. In identifying the typical components of localness, we may also come to realize more clearly that they are not all intrinsically local, linked to territoriality in general or only some one place in particular. That connection is really made rather by recurrent practicalities of life, and by habits of thought. And if somehow these characteristic features of local life become differently distributed in the social organization of space, so that for example everyday life is less confined, or those "real" experiences with a full range of senses are spread out more equally over some number of places which thus approach the

qualities of "home," then the one and only local would appear to be a rather less privileged site of cultural process. I am not suggesting that it is really disappearing, losing all distinctiveness; only that by unpacking the category, we may entertain a more precise idea of the place of "place" in cultural organization.

Take the example of media. "Most students of contemporary culture agree on the unique role of the media as the principal vehicle of culture production and distribution," writes Zygmunt Bauman (1992: 31). In a way this seems to me an unfortunate formulation. The principal vehicles, I think, so far remain those which we largely take for granted as parts of local life, and which I have just tried to sketch. (The everyday and face-to-face may be small-scale; in the aggregate, it is massive.) But the cultural capacity of the media has not been constant, and perhaps in the terms I have suggested they can gradually acquire more of the qualities we have been used to thinking of as local. Mastering a wider range of symbolic modes, they can speak more broadly to the senses, make their contents seem more "real," than they could when only the printed word was at their command. Those media which are more interactive can begin to achieve some of the efficiency which face-to-face interaction has through rapid feedback. The local seems to be losing some of its superiority here.[17]

GUARDIANS OF CONTINUITY, AGENTS OF CHANGE

For all its real qualities, "the local" in cultural thought sometimes becomes a thing of romance and mystique. It reminds me a little of a certain animal in Viking mythology, the succulent boar *Särimner*, which the warrior heroes could eat every evening, only in order to find it alive and well, ready to be slaughtered again, the next day. In some comment on the global and the local, that is, local tradition seems to be just forever there, in limitless supply. The global is shallow, the local deep.

In a way, then, if as I said before, the global sometimes has to be brought down to earth, the local has to be brought up to the surface, to be demystified. The thing about cultural continuity is that there is no way for socially organized meanings to stay down there in the depths all the time, they must also come up and present themselves to the senses. And whenever they do so, they are also at risk: ready to be reinterpreted, reorganized, even rejected.[18]

No doubt the local is, for at least the reasons I suggested before, something special. In the end, however, it is an arena where various people's habitats of meaning intersect, and where the global, or what has been local somewhere else, also has some chance of making itself at home. At this intersection, things are forever working themselves out, so that this year's change is next year's continuity. We may wonder, then, both what the place does to people, and what people do to the place.

With regard to the former, let me just insert that one noteworthy thing may be that in the global ecumene, habitats of meaning seem to become increasingly malleable. In Zygmunt Bauman's terms again, there are more "diffuse offers and free choices" (yet again, more in the First World than in the others). The decision to migrate, or to stay, is less fateful than it has been when certain life styles are

replicated in many places, together with the special markets to serve them, and when both media and jet flights allow you to shuttle between places.[19]

When it comes to people making places, we come back to the fact of uneven globalization, yet this time at the grassroots level. Locally, we may ask, who are the globalizers? To understand contemporary culture, this may be a key issue, but the answer is likely to be complicated.

In the past, in a great many places, it may have been common that transnational connections, or even any ties at all outside the local face-to-face community, were more or less an elite affair, a task in a community division of labour as well as an instrument of domination. Today it remains true that the high and mighty of politics, administration, and business are both frequent fliers and frequent faxers, and that the facilities of travel as well as media technology may be organized to serve their requirements especially. But that is not the entire story. In the First World, the working class is now in no small part from the Third World, and may increasingly become ex-Second World.

We should no doubt consider the matter in gender terms; in places where women are more sedentary, and less visible in public life, they may have a greater part in carrying local tradition into the present.[20] But this is hardly the case everywhere. In age terms, it would appear that some young people are now among those most at home in the global ecumene itself, footloose and uncommitted enough to spread their period of liminality over two or three continents, quickly cultivating the desirable literacies when media technologies change and new symbolic forms become available.[21] What happens to them as they get older? In a two-steps-forward, one-step-back fashion, they may become adults, too, but perhaps not quite the same kind of adults as their parents were.

And then there are old people. Certainly we will expect them to be the real guardians of continuity, as migrants from the past. Yet even this may need a closer look. Left to themselves, some of them turn out to become intensely involved with the media, rather than with the people next door. If they have not only time but other resources as well at their disposal, as many of them have recently had in more affluent parts of the world, they may choose to travel: go on trips, retire in a different climate. Squeezed between young ones and elders at leisure with wider horizons, working adults in their middle years may be the real locals.

Perhaps the main point in all this is that the arrangements of personal inter-connectedness between the local and the global are getting increasingly opaque. So many kinds of kinship, friendship, collegiality, business, pursuits of pleasure, or struggles for security now engage people in transnational contacts that we can never be sure in which habitats of meaning these can turn up, and have a peripheral or a central part. I will return to this theme in later chapters.[22] Nor may it be either entirely predictable or entirely unpredictable who will turn out to set meanings acquired from afar in local circulation. The bed-and-breakfast landlady in Connemara may be an ex-Londoner and the sister of a New Yorker, and still keep a fairly low profile; I suspect that those Swedish amateur photographers with their 700 slides from Borneo most likely will not.

3

WHEN CULTURE IS EVERYWHERE
Reflections on a favorite concept

Suddenly people seem to agree with us anthropologists; culture is everywhere. Immigrants have it, business corporations have it, young people have it, women have it, even ordinary middle-aged men may have it, all in their own versions. Where such versions meet, the talk is of "cultural collisions" (or, as we remember from the preceding chapter, of "culture shock"). We see advertising where products are extolled for "bed culture" and "ice cream culture," and something called "the cultural defense plea" is under debate in jurisprudence.[1]

And not least intriguingly to us, it is also a fairly widespread notion that "culture" is something on which anthropologists can speak with some authority.[2] For some time now, to take one instance, since culture became part of the project of the welfare state, Swedish policy-makers have habitually made the distinction, at least by way of preface, between "the anthropological culture concept" and that culture concept which refers mainly to the arts, which is after all what they mostly deal with. But now that somehow seems to worry them a bit.

One might have thought that this success story of what has so long been a favorite concept of theirs should make anthropologists very happy. Actually, at present it seems rather to make us nervous, for a variety of reasons. Despite a winning streak, and to a degree because of it, the culture concept seems perhaps more contested, or contestable, than ever. Here I want to identify some of the sources of unease, to map actual and possible debates over culture, and in the end to make a suggestion or two about what we may want to do with the culture concept from here on.

AGAINST CULTURE

To repeat, we seem in part to be the victims of success, and this is one reason why we may be having second thoughts, and getting cold feet. It is a trifle embarrassing when what is purportedly our culture concept is set up in opposition to that denoting esthetic excellence, in such a way that we come out looking like philistines and populists, unable or unwilling to discern any qualitative difference between experiencing great works of art and, as I think one cartoonist (with a sure feeling for Nordic life) had it, taking a sandwich into the forest to commune with

30

Nature. We may be more actually worried when the state places its weight, even *x Tp* with benign intentions, behind culture as an administrative category, using it perhaps rather clumsily to identify one target minority population or other for special measures.[3]

Then there is also perhaps some uncertainty about how strong our defenses really are when our most cherished beliefs come under attack. We are accustomed to making strong claims for the effects of culture on human behavior, for the almost infinite malleability of human nature. As the biosciences appear increasingly to make new, competing claims, these can be understood – by ourselves and by others – as attacks on the intellectual integrity of anthropology. Take the example of the Mead–Freeman controversy over Samoan culture. Writing in an important journal of opinion, one philosopher-turned-medical researcher suggests that Derek Freeman showed that "almost everything that Margaret Mead has claimed about Samoa was untrue"; and obviously he sees this as a typical example of the exaggerated claims of a range of environmental and cultural determinisms during much of the twentieth century (Hesslow 1992: 50).

If it is thus claimed that we do not really know how far culture extends, there are also strong hints that we have not understood all that much about how it works either. Such suggestions can come from inside the anthropological community as well. In introductory courses and in textbooks we drone on about how culture is "passed down from generation to generation," perhaps giving little further thought to it. Then along comes Maurice Bloch (1985: 33), who argues that "we shall have to rely on the work of psychologists and psycholinguists for our main theories of learning and we cannot carry on formulating theories of culture in such a way that they imply learning processes which cannot be genuine." And elsewhere, he goes on to argue that anthropologists have mostly worked from a "false theory of cognition," and that more recent work in cognitive science, of the kind referred to as connectionism, should make us "suspicious of overlinguistic, overlogic-sentential conceptualizations" of the kind we are actually accustomed to (Bloch 1992: 127–130).

I will come back to this. Meanwhile, one more strand in the current anthropological critique of received cultural thought must be identified. It is represented for example by Lila Abu-Lughod (1991), who describes culture as "the essential tool for making other." As anthropology accounts for and explains cultural difference, she suggests, it simultaneously helps construct, produce, and maintain it. And difference, whatever anthropologists may wish, often goes with distance and inequality. She also finds most conceptions of culture static and homogenizing, and thus dehumanizing; moreover, given to exaggerating coherence; and also strongly inclined toward depicting cultures as bounded and discrete.[4]

Abu-Lughod suggests three ways of countering this tendency. One is to draw on a vocabulary of practice and discourse, which would emphasize contradictions and misunderstandings, strategies, interests, and improvisations, and the play of shifting and competing statements with practical implications. Another is to emphasize connections, both those which in more general terms make cultures in the plural into something other than isolated units (historically, but surely also

31

in the present) and those particular circumstances which bring an ethnographer into a field. The third approach, she proposes, is to refuse to generalize, to tell stories instead about particular individuals in time and place. This is again to subvert connotations of homogeneity, coherence, and timelessness, and to bring out similarities in lives. As real people are portrayed agonizing over decisions, enduring tragedies and losses, trying to make themselves look good, suffering humiliations, or finding moments of happiness, a sense of recognition and familiarity can replace that of distance.

A somewhat similar line of reasoning is pursued by Unni Wikan (1992), as she contrasts culture with what she terms "resonance." Resonance is said to be a matter of the "thinking-feeling" which Wikan learned from her hosts in Bali; of empathy and compassion, of an appeal to shared experience, of charitable inter- pretation and reaching out for intelligibility, of going "beyond the words" in seeking an understanding of the concrete predicaments of people. The concept of culture, in Wikan's view, points in the opposite direction from all this. It turns "others" into "exotic breeds, propelled by a force."

Or for one more example, consider Tim Ingold (1993), scrutinizing the notion of "translation" between cultures. Taking his point of departure in two definitions of culture, one by Edward Tylor and the other by Robert Lowie, at first glance quite similar, Ingold still manages to discern a difference. To Tylor, culture is progress, the cultivation of reason and intellect, a "core curriculum for humanity." Lowie's cultures are "an almost haphazard diversity of habitual ways of living and thinking, each with its own internal criteria of judgement." And as it turns out, this has become the way the West has distinguished between itself and the rest. *We* are with Tylor, rational, modern, *they* are with Lowie, contained by arbitrary traditions. Under such circumstances, there can be no real translation, under conditions of equality and reciprocity. The West can look in at the others, the latter cannot look out.

Ingold's alternative is to "imagine the world in which people dwell as a contin- uous and unbounded landscape, endlessly varied in its features and contours, yet without seams or breaks." There are different places here, and different horizons, but as you move in the landscape you see different things, and when people arrive from different directions in the same place, they see the same thing. When he, the Cambridge academic, immersed himself in joint action with reindeer herdsmen in northern Finland, he learned to attend to the environment in the same way they did, and thus to see the world in their way.[5] There was, then, no need for trans- lation, and the notion of anthropology as a translation between cultures is the artificial consequence of a theory of culture which fragments the world.

Abu-Lughod, Wikan, and Ingold all draw similar conclusions. Abu-Lughod is "writing against culture," Wikan opposes culture to resonance and is obviously in greater sympathy with the latter. Ingold tells us that only by accepting the idea of the continuous world can we engage with others and reach mutual understanding; and if that is what we want, then "the concept of culture," as a key term of an alienating discourse, "will have to go."

32

SHIFTING EMPHASES:
CULTURAL DIFFERENCE AND HUMAN NATURE

So it seems that there are now quite a number of anthropologists who, when they hear the word "culture," will reach for their guns. Perhaps someone like Ingold, raised in British social anthropology with its long tradition of culture-bashing, should not be expected to have any serious qualms about burying it (although Ingold certainly also has an intellectual agenda of his own). But a great many people, anthropologists and non-anthropologists alike, may think of the union between anthropology and the culture concept as just about indissoluble. How much credibility will we have left if we now turn publicly "against culture," or pretend to have nothing to do with the concept? The alternative, presumably, would be to see what can be salvaged.

Pondering criticisms such as Abu-Lughod's, Wikan's, and Ingold's, it seemed to me that something Robert Redfield once wrote might have a bearing on the problem. So I looked up a lecture on "The universally human and the culturally variable" which he gave in 1957, the year he died, and which was later published in his collected papers (Redfield 1962: 439 ff.).

What I found, for one thing, were some comments on shifting emphases in anthropological thought during Redfield's own life and career. When he was in high school, he reminisced, he had often brought his noontime sandwiches into the library, and taken down from the shelf any one of the twelve volumes of Frazer's *The Golden Bough*: "what a parade I saw there of marvelous and exotic custom." Yet Frazer's point had in fact been to show not that peoples in the world are infinitely different, but that in many ways they are the same. Then as Redfield began to study anthropology, in the 1920s, particular cultures were everything, while his teachers mostly ignored or denied any resemblances. And as he wrote, in the 1950s, the emphasis was once more on what humanity held in common.[6] Indeed, the history of anthropological thought made him wonder if "whatever is thoroughly repudiated by one generation of anthropologists is not likely to reappear in the next generation."

Such musings apart, the lecture also offered a diagram, a two-by-three table, which I think we may still find a useful device, in mapping ways of thinking about culture as well as the kinds of debate over culture which may worry us now. I have changed it very slightly; the middle category between "Individual" and "Universal" Redfield labeled "Culture-group," whereas I think "enduring collectivities" (encompassing "communities," "societies," ethnic groups, etc.) is less likely to cause confusion. And I have added the numbers identifying the six resulting spaces:

Table 1 Human characteristics

	Inherent	*Developed*
Individual (idiosyncratic)	1	2
Enduring collectivities	3	4
Universal (panhuman)	5	6

Source: R. Redfield, *Human Nature and the Study of Society*, Chicago: University of Chicago Press (1962: 444)

Along one axis, then, we have the contrast between the modes of thought and action which are biologically inherited and those which are in one way or other acquired after birth. Along the other axis, we have three kinds of distribution. What can we do with this diagram? Let us follow Redfield a bit further, as he develops an argument about human nature.

We can think of human nature in several ways, Redfield points out. The term may refer to what all human beings have in common because it is part of the biology of *Homo sapiens*; human nature is then in box 5 in the diagram. In a more paradoxical way, one may emphasize how dependent all human beings are on learning the distinctive way of life of their particular group; and then human nature somehow ends up in box 4. Cultural difference *is* human nature. But what Redfield is especially concerned with is a notion of "developed human nature," the qualities people acquire everywhere, anytime, as they go through lives in which universally they have similar experiences and face similar problems.[7] This conception of human nature is in box 6.

Now where is the culture concept which Abu-Lughod, Wikan, and Ingold criticize, and where do they want to go? True, the diagram may not be able to take every subtle variation into account, but I think it is fair to say that they oppose a concept of culture which is fully contained within box 4. The heartlands of ethnography have indeed quite constantly been here. In Redfield's formulation, "anthropology has prospered largely on the exploration of the differences among human groups."[8] Yet there are these historical shifts, from Frazer onwards, and we can now identify them as shifts at least in relative emphasis between boxes 4 and 6. When Lila Abu-Lughod (1991: 158) argues that her ethnographic particulars "suggest that others live as we perceive ourselves living," or when Wikan (1992: 476) writes of "shared human experience, what people across place and time can have in common," or when Ingold concludes that the concept of culture which he opposes "fragments the experiential continuity of being-in-the-world," they, too, seem to move toward Redfield's "developed human nature," in box 6. Yet Abu-Lughod's strategy for writing against culture is more complicated, for her insistence on ethnographic particulars entails a simultaneous move into box 2. And this should not be understood as a contradiction: her insight is that the two moves imply one another.

The history of swings between boxes 4 and 6 may be described, then, for our purposes, to have begun in box 6, with Frazer, according to Redfield, and Tylor, according to Ingold; Redfield also asks us to remember Adolf Bastian. We move from there to box 4, where Ingold places Robert Lowie, and Redfield, without identifying particular individuals, his own teachers (but we know that these were mostly, like Lowie, students of Franz Boas). Then Redfield tells us that at the time of his writing, there is again that concern with what human beings share; box 6. And thereafter evidently one more swing to box 4, after which once more our contemporaries, Abu-Lughod and the others, seem to be on their way into box 6.

It is tempting to describe this as a pendulum swing, but it is probably not quite that. The terms of debate are not entirely recurrent. The ways boxes 4 and 6 are

defined may well have changed somewhat over time, and one would hope that succeeding generations have learned something from the repudiations of their predecessors, so that an upward spiral would be the more appropriate image. Ingold is not Tylor, Wikan not Bastian. We can hardly be sure, however, that history is not sometimes simply ignored.

What happened between Redfield's time and ours? The next-to-last swing has perhaps not yet been fully identified. I am not sure that each swing can be completely accounted for by naming names, but one of Clifford Geertz' relatively early essays, "The impact of the concept of culture on the concept of man" (1965), would seem to fill in the gap especially effectively.[9] Redfield mentions Clyde Kluckhohn – although rarely read now, a leading cultural theorist in anthropology in the mid-twentieth century – as a contemporary protagonist of a sense of shared human nature, and indeed Geertz describes Kluckhohn as "the most persuasive" of those whom he labels as "*consensus gentium* theorists." But Geertz dismisses these. He finds their arguments vague, or too frequently based on some kind of conceptual sleight of hand, such as a construction of universal culture patterns which turn out to consist of empty analytical categories.[10] When Kluckhohn describes the Zuni Indians as valuing restraint, and the Kwakiutl as encouraging exhibitionism, and then goes on to say that both "show their allegiance to a universal value; the prizing of the distinctive norms of one's culture," Geertz (1965: 102) comments ironically that "this is sheer evasion, but it is only more apparent, not more evasive, than discussions of cultural universals in general."

What Geertz proposes instead is, of course, part of the very recent history of anthropology. "There is no such thing as human nature independent of culture." Between what our genes tell us and what we have to know in order to live there is an information gap, and we fill that gap with culture. "Man's great capacity for learning, his plasticity, has often been remarked, but what is even more critical is his extreme dependence upon a certain kind of learning: the attainment of concepts, the apprehension and application of specific systems of symbolic meaning." But as we thus "finish ourselves through culture," it is not "through culture in general but through highly particular forms of it: Dobuan and Javanese, Hopi and Italian, upper-class and lower-class, academic and commercial" (Geertz 1965: 112–113).

Thus Geertz moves swiftly from box 5 to box 4, accepting perhaps two of Redfield's senses of "human nature," but not the third. He might make a passing bow of recognition in the direction of box 2, but he leaves box 6 just about empty. Here the next-to-last swing from box 6 to box 4 is succinctly defined.

But despite this, do we have to accept a confinement of the culture concept to box 4, as a concept emphasizing only the differences between particular cultures belonging to distinct enduring collectivities? Redfield, at least, did not think so. About his diagram, he commented that "everything to the right *is* cultural"; and "that which is cultural is not always difference" (Redfield 1962: 446).

Personally, I am inclined to go along with this view, although with one emphasis added. I am concerned with the way this unfinished, learning, human animal

fills her information gap by participating in social life, and thus with the way her acquired modes of thought and action become socially organized; regardless, that is, whether she shares them with nobody else, with the people in her group, or with every other human being.

Taking this view of culture, broadly inclusive along the distributive dimension, one can accept easily enough the idea of the continuous world, and whether one speaks of culture in the singular or cultures in the plural can be understood to be a matter of convenience. And one can unload more of that excess baggage which has accumulated over the years: assumptions not only of certain difference but also of the internal homogeneity, coherence, and timelessness of cultures. To be able to recognize contradiction and misunderstanding, one would not have to "write against culture," and one could have resonance and culture, too. There would seem to be no need to think that cultures are what "they" have, whereas we do not. (Yet one does not have to lend support, either, to breathless relativist exclamations such as the "All cultures are wonderful!," a recent slogan of one ethnographic museum. We are still entitled to finding some cultures distinctly less wonderful than others.)

THE UNIVERSAL, THE COLLECTIVE, AND THE UNIQUE

I did not want to introduce the Redfield diagram, however, only to become preoccupied largely with three of its six boxes – 4, 5, and 6. As I suggested above, it may be an aid in mapping more of our controversies over culture, and more of the issues we may have to face.

Historically the most fateful opposition is obviously that between boxes 3 and 4. To try to keep box 3 as empty as possible is to struggle against racism. The nearest place to go, when differences between collectivities are to be accounted for, is box 4, and to keep it well endowed may thus have seemed to be a sometimes heroic task. Yet box 3 tends to stand in tempestuous relationships to other boxes as well, in the column to the left as well as that to the right.

And debates seem to have a way of spreading and being transformed, probably especially when initially involving the left–right, "nature–nurture," divide in the diagram. Take Margaret Mead's Samoa study again. What Mead tried to do, as I understand it, primarily involved boxes 5 and 4. If box 4 could be enriched, if particular cultures could be seen to shape human beings in very different ways, so that Samoans would be very unlike Americans, then there would be little content in box 5. Inherent human nature would be largely a *tabula rasa*. If Samoans could be depicted as pretty much all alike, culturally constructed in box 4, on the other hand, there would not seem to be all that much in box 1 either. Inherited individual differences would seem negligible. Thus a study like Mead's draws critical scrutiny as well from those who otherwise appear primarily preoccupied with similarities and differences at the micro-level (identical-twin comparisons and the like).[11]

I do not have much more to say here about this left–right divide. Generally, it is probably true that concerned with culture (and thus with boxes 2, 4, and 6) as we may be, we are not now so inclined to seek border skirmishes with boxes 1 and 5. Box 3, however, remains another matter. We may have a renewed curiosity about how inherent human nature actually sets the limits of cultural variability, and we are more likely to accept, even with our anthropologists' hats on, that individuality also has something to do with genes. Most importantly, we allow for fuzzy boundaries, and complicated interactions between what is biologically given and what we learn.[12]

That is to say very little about some very intriguing matters, and no doubt to leave out a great deal altogether. I want to devote more attention, however, to the relationships on the right-hand side, between 2, 4, and 6.

Why is it that so much of human meanings and practices seems to belong in box 4; or why is it, at least, that anthropologists have been so strongly inclined to place them there?[13] In part, I would argue, it has to do with the characteristics of the classic field sites, where much of anthropological thinking about culture has remained rooted: little communities of enduring face-to-face relationships and a very limited division of labor. In such places a large proportion of knowledge and experiences may quite naturally come to be extensively shared – that is, uniformly distributed. Ongoing life is so redundant that much of the reproduction of culture occurs without much deliberate effort, more or less as a by-product of the daily round of activity and commentary. Field workers may well take their leave of such places, their task accomplished, with much ethnography, yet little specific concern with the nature of cultural process.

Yet there are also reasons why anthropologists have often not done justice to that actual diversity which exists in just about any community. Limited field periods and imperfect cultural and linguistic competence make it difficult to pin down differences. Theoretical or prototheoretical assumptions may also draw attention away from such matters, and as recent critiques of the making of anthropological texts have pointed out, we have had this established way of putting things: the Nuer believe this, the Balinese do that, and internal variations are glossed over.

And thus box 4 fills up.

That unfinished human animal can take various paths through social life, however, and so she can be constructed and reconstructed, eventually perhaps finished, in different ways as she goes along. Let us just enumerate, not entirely systematically, some of the things that may happen to her in the world we now inhabit. She will be fitted into a division of labor which makes her specialize in some particular kind of knowledge, and which assigns her to a particular kind of life situation, and life experience. The state may have its ways of making a citizen of her, which entails knowing and doing certain things, and in the market-place there are a great many agents, large and small, who will not only cater to her choices such as they are but will indeed try to develop and bend her tastes to match particular commodities. Bodily, at any one time, she will be in one place,

and in this setting she may learn things through face-to-face contacts and obser-
vations, just as does the inhabitant of that anthropological classic, the little
community. But over time, it may be that she moves between places, so that new
things can be learned, and so that some old things may even have to be – to a
degree, at least – unlearned. Furthermore, this contemporary unfinished animal
need not always have others physically present to pick up a thing or two from
them. She may read a book, look at a picture, listen to a record, watch television.

In this situation, the relationship between boxes 2, 4, and 6 – the distribution of
distributions, as it were – may shift. On the one hand, box 6, representing what is
culturally acquired but universal, may just possibly become more diverse in
content. Redfield, we have seen, had in mind the practically inevitable expe-
riences faced by people everywhere, through the recurrence of certain circum-
stances, even as these were not directly linked to another. Now we can perhaps
see, even more clearly than was possible a few decades ago, how box 6 can be
affected by long-distance interactions and large-scale cultural diffusion. In the
very unlikely event of a complete global homogenization of culture through such
mechanisms, of course, it would be box 4 that would be emptied, and box 6 would
have to hold a great deal. We would indeed have culture without cultural differ-
ence. (Yet the potential, and the circumstances, for a return of difference, or for
changes in what is universal, would certainly be other than were box 5 to be
similarly loaded.) Global diffusion, however, is surely more likely to work on a
more piecemeal basis. At least as things stand now, it may also be argued that
what will get into box 6 first is not a taste for Michael Jackson or Coca Cola, as
some rhetoric would have it, but rather such skills as basic literacy and numeracy,
and the mundane habits of using pencils, matches, and soap.

The debates over globalization, in all their varieties and nuances, we can see,
are again in considerable part a matter of the relationship between boxes 4 and 6.
These debates are clearly of a different kind than those involved in the historical
back-and-forth shifts in anthropological thought. Even so, it seems very possible
that the current shift back to an emphasis on box 6, in such writings as those of
Abu-Lughod, Wikan, and Ingold, is in no small part motivated by the intensi-
fication of global interactions, even as the arguments are mostly couched in terms
of a desire to identify human commonalities and the possibilities of empathy.
Such a desire may come more naturally now.

The relationship between boxes 4 and 2, however, would appear to be no less
affected by the current circumstances of culture. For example, it is obviously a
fact that the division of labor adds something to the enduring group cultures of
box 4. Again, in Geertz' phrasing above, they are not only those of Dobuan and
Javanese, but also "upper-class and lower-class, academic and commercial." The
insight that a range of other groups within today's society likewise have distinc-
tive clusters of meanings, symbols, and practices has indeed contributed to the
current popularity of the culture concept.

Nonetheless, the complicated interpenetrations of contemporary cultural
currents do not only involve more varied confluences at the level of collectivities.

It is at the same time perhaps more than ever before possible for individuals to become constructed in quite unique ways, through particular sets of involvements and experiences. As she changes jobs, moves between places, and makes her choices in cultural consumption, one human being may turn out to construct a cultural repertoire which in its entirety is like nobody else's. It may be that each of its varied components is shared with different sets of other people, yet to the extent that the repertoire is integrated – to the degree that it becomes a perspective, a self – it becomes an individual matter, a thing of box 2.

It is for such reasons that individuality can be seen not as something residual, something outside the domain of culture, but at least in part as a product of cultural organization; in one relationship or other with what comes out of box 1. We may remind ourselves that Abu-Lughod sees it as "writing against culture" to portray individuality as it stubbornly resists any generalizing analysis. I can see, and feel some sympathy with, the humanist motives underlying such a stance. Despite this, I would argue that it must be a reasonable ambition to try to understand in some disciplined way how individuality is generated in cultural process, and what part such individuality has in cultural organization. And I am not convinced that this analysis must necessarily be accompanied by some sort of disrespect.

In yet another way the relationship between boxes 2 and 4 can be said to be especially significant to contemporary arguments about culture. If box 4 is indeed the traditional home territory of that "anthropological culture concept," it may be that we can place that other culture concept which I referred to initially, that of the arts, mostly in box 2. We are talking here mostly about the overt cultural products of particular individuals. And if we are not just going to continue speaking of these as two different concepts, which merely, and somewhat confusingly, happen to share a label, it would seem that we can usefully think of it in terms of the combination of cultural influences into relative individuality, on the one hand, and the esthetic and intellectual resonance (perhaps not entirely in Wikan's sense of the latter word) of that individuality in collective culture on the other hand.

DIVERSITY IN CULTURAL ACQUISITION

A well-known sentence of Clyde Kluckhohn's (Kluckhohn and Murray 1948: 15) goes some way toward summarizing what has been said so far (and let us for the moment disregard the androcentrism toward which we may now be sensitive, but people almost a half-century ago mostly were not): "Every man is in certain respects like all other men; like some other men; like no other man." It seems preferable, in my view – and not least in consideration of contemporary tendencies in the social organization of meaning – to try to deal with all three instances within a single intellectual framework, rather than having a separate one for each, obscurely related to one another.

Finally, I want to come back to the question of how that incomplete human animal actually gets completed, as it were; the issue of cultural acquisition, which as I noted before has been raised again recently, for example by Maurice Bloch.

To repeat, Bloch has little faith in what have been conventional anthropological assumptions here. In contrast with the tendency to think of culture as "language-like" (and thus linear), the "connectionist" cognitive psychology he favors suggests that everyday thought depends on "clumped networks of signification," integrating information simultaneously in a multiplicity of ways and thereby making it more readily retrievable. And the information thus managed is only in part linguistic. It also includes "visual imagery, other sensory cognition, the cognitive aspects of learned practices, evaluations, memories of sensations, and memories of typical examples" (Bloch 1992: 130). We get a sense here of human beings completing themselves through their continuous immersion in an environment, learning from a wide range of experiences. Yet at the same time, the real role of direct symbolic, and particularly linguistic, communication from other human beings seems a bit more uncertain.

Bloch then goes on to argue the implications of all this for ethnography. It is a problem, he notes, that ethnography as we know it is still in the end linguistic, written, linear. Even so, we should try to get closer in ethnographic description to the way people actually acquire and manage culture. What he suggests here is that participant observation is of strategic importance to such an ambition. Anthropologists who have really immersed themselves into the round of life of a group of people and shared a large part of their experiences should be able to account for these in their great variety, even if they have to be given the clothing of words.

It may strike us that we seldom come across such a theoretically grounded argument for the value of prolonged fieldwork and participant observation in a strict sense; too often, there has only been "the fieldwork mystique." But apart from that, what I find remarkable is the convergence between Bloch's reasoning and some suggestions in those writings of Wikan and Ingold to which we have already paid some attention above.[14] Neither of them refers to the particular variety of cognitive psychology on which Bloch draws, yet both make a strong point of "being there," attending with the range of senses – indeed "beyond the words," as Wikan has it, or to "what goes without saying," to quote Bloch's own title.

I value the point of view toward cultural acquisition put forward here; perhaps not least because it reminds me of my own efforts, twenty-five years or so ago, in the context of the "culture of poverty" debate in the United States, to depict the ambiguous relationship between normative statements and lived experience. This was also a matter of going beyond the words (although not exactly disregarding them in the process; cf. Hannerz 1969: 178 ff.). What I also find interesting is the possible affinity between this view of cultural acquisition, and of ethnography, and the emphasis on box 6-type (or even box 5-type) "human nature."

I am reminded of Robin Horton's (1982: 228 ff.) exploration of a distinction between "primary" and "secondary" theory as aspects of human knowledge, where he suggests that primary theory does not differ much between cultures, and that for such reasons, "it provides the cross-cultural voyager with his intellectual bridgehead." The entities and processes of primary theory, in Horton's view,

appear to be directly "given" to the human observer, whereas those of secondary theory are somehow "hidden." In primary theory, as he delineates it, we find such notions as a push–pull conception of causality, with attention paid to spatial and temporal contiguity; such dichotomies as left/right, above/below, in-front-of/behind, and inside/outside; the sense of before/at the same time/after; and distinctions between human beings and other objects, and between other human beings and the self. Primary theory, Horton suggests, goes back to the dawn of history, as part of the equipment for the adaptive practices of the human species. In fact, he is not entirely sure whether it goes in our box 5 of innate human nature or in box 6 of what all human beings acquire (Horton 1982: 233–234). Secondary theory, in contrast, reveals a startling variability between cultures, depends in many ways on primary theory, but is in large part concerned with other conceptions of causality – whether these are ideas about gods and spirits or about particles, currents, and waves.

I would not claim that the match between Horton's ideas and those of the other commentators on culture referred to above is perfect. It hardly seems altogether unlikely, anyway, that it is something akin to his area of primary theory which relates more to the kind of largely non-linguistic learning to which Bloch draws our attention, which, being less variable between cultures, is where anthropologists can most readily practice empathy or "resonance," and from which they can then proceed to that less accessible area of greater cultural difference, in large part laid out in language. The latter, that is to say (and to repeat a line from Geertz quoted earlier), is the area of "extreme dependence upon a certain kind of learning: the attainment of concepts, the apprehension and application of specific systems of symbolic meaning."

What I am getting to here is a plea for pluralism, and a sense of complexity, in our conception of the acquisition of culture. Perhaps there is at present some risk that, as a part of the back-and-forth shift of anthropological thought, the more muscular, sensuous approach to culture seems just a little too attractive to the deprived denizens of the ivory tower. The evocative power of Bloch's (1992: 144–145) phrasing is striking: life in a society, he tells us, is learnt "as one learns as a baby to negotiate the material aspect of one's house, as one follows other children in looking for berries in the forest, as one watches the stiff gait of one's grandfather, as one enjoys the pleasure of working harmoniously with a spouse, as one cooks with the implements of the hearth ..." Surely we will recognize all that, and nod thoughtfully in agreement. But it is probably not entirely insignificant that Bloch takes us to a group of shifting cultivators in the Madagascar forest, and Ingold to northern reindeer herders, as the settings in which they argue persuasively for their views of learning, and for their ways of learning of other people's learning.

Bloch (1985: 33) has indeed also made the point that "it is the complexity and variety in the nature of knowledge which needs to be recognized first and its irreducibility to one process of acquisition which has first to be noted." I agree fully, and would add that we may find these various kinds of knowledge, and various modes of acquisition, differentially distributed between social contexts,

within societies and in that "continuous world." In local, face-to-face, everyday life, we may be allowed to use all our senses, and it is good that our thinking about culture now increasingly recognizes this. It helps us understand some of the real cultural strengths of the everyday; I had some related comments on the advantages of the local in Chapter 2.

When culture is everywhere, however, it is also in contexts where language, in its spoken as well as written forms, may after all be quite dominant. What is characteristic, for example, of the culture flowing through contemporary state machineries, in administration, and in formal education? Perhaps when we find the state turning "culture" into some sort of administrative category, our unease results at least in part from the way that it transforms experiences and interactions into words and rules. And we can argue among ourselves, and with the state, over that, but we must also be aware that (to adapt a well-known social science theorem) when bureaucrats define a thing as real, it has a way of becoming real in its consequences. They have their culture, too.

How, on the other hand, is culture acquired, and deployed, in the market-place of our time? Commodities can perhaps be seen, heard, touched, or tasted, when they are immediately at hand. If they are advertised in small print or on the radio, they may again be referred to only in words. Yet as media become more elaborated, there is at least the attempt in advertising to call forth, or to simulate, those sensuous experiences, and to connect commodities, often somewhat arbitrarily, to them. Watch that stiff gait of your grandfather, while enjoying a cup of coffee of the brand he likes best.

Where there is culture, there is cultural acquisition, I am arguing, and it is now in everyday life as well as in states and markets, and in media as cultural technologies. Shifting from the intimate scene of attentive, berry-picking children to the large-scale process of global cultural diffusion, we can view the latter simply as a rearrangement in space of contexts of cultural acquisition, and thereby realize that these are not matters altogether apart. But then we also sense that neither culture nor its acquisition necessarily take the same form everywhere, and that to reach toward a more general understanding of how human beings construct themselves and each other, we have to inquire into the range of variations. The development of an array of media, making use of different combinations of senses and symbolic modes, ought to be of special interest if we want to continue on, and expand, the kind of research program which Maurice Bloch seems to suggest. Had Marshall McLuhan (e.g. 1964) been alive, with his vision of the "retribalization of the world" and of the media as extensions of the senses, we might have liked to arrange a meeting between him and Bloch; I believe they would have had interests in common.

CONCLUSION: RETAINING CULTURE, REFORMED, CRITICIZED

Having identified some of the current criticisms of the culture concept, and of more or less well-established assumptions about culture, I asked before what we

should do now. And I think it was clear early on that I do not personally think that the culture concept "will have to go." We will only have to keep on criticizing it, and reforming it. I believe it is still the most useful key word we have to summarize that peculiar capacity of human beings for creating and maintaining their own lives together, and to suggest the usefulness of a fairly free-ranging kind of inquiry into the ways people assemble their lives.

To reiterate what I suggested before, I think the public credibility of anthropologists would suffer if we were now to reject the concept of culture, but I am not only concerned with intellectual respectability in a cold and competitive world (although that is perhaps not altogether unimportant). I think the concept can be kept genuinely useful, but we must then use whatever intellectual authority we are granted in this area to be watchdogs and whistle-blowers, to point out weak arguments and unwarranted assumptions among ourselves, and to speak out against misappropriations and misuses by others. We should not, on the other hand, throw out the baby with the bath-water.

It has been at least implied by what I have said that in pursuing this task, we may benefit from cultivating a sense of what has already been said about culture over the years, to be able to discern more precisely what is new in current critiques, and to remember the previous critiques of what is not so new in them.

Moreover, it may be wise not to take our expertise in the area of culture too much for granted. Many working anthropologists are specialists in cultures, rather than in culture. They deal in specific ethnography, more than in a broad understanding of recurrent issues of human capacity or social process. For quite some time they may have assumed that it would be safe for their purposes to stick piously to textbook homilies about wholeness, coherence, sharing, and continuity, and if they are currently not quite at ease with the culture concept, or with the debate over it, this may result from their never really having confronted it actively with more tricky case materials, never really having had to think it through. When culture is everywhere, and if we as anthropologists choose still to think that it is in a particular way ours, complacency will not do; and it may even be that we must sometimes call for a little help from friends in other disciplines to continue to build some kind of orderly understanding of how culture works, and of where, after all, it begins and ends.

4

THE GLOBAL ECUMENE AS A
LANDSCAPE OF MODERNITY

Modernization theory, in the versions available thirty or forty years ago, in the 1950s and 1960s, did not appeal very much to anthropologists, compared to many other social scientists. Neither its more or less ethnocentric assumption of a single path to progress, nor its tendency to make analytical abstractions either in structural or in psychological terms, would attract those who were inclined to value cultural diversity in its own right, and who specialized in describing it, analyzing it, and theorizing about it. Apart from all that, it is true that even now, when the modernity concept has returned to somewhere near the center of social thought, we may still find it rather unwieldy as a totality, and more than most concepts strained between analytical and rhetorical uses.

But now we are invited to see modernity – rather more than before, at least – in cultural terms, and some of the major commentators suggest that in its particular manifestations, modernity may involve continuity as well as change.

S.N. Eisenstadt, *doyen* of sociological theorists, is one of these. Eisenstadt has not only been able to witness the shifts occurring over time in thinking about modernity and modernization, but has also been an active participant in the history of these ideas. In recent writings (e.g. 1987, 1992), he has argued for a turn toward what might be described as a civilizational, historical, and diffusionist understanding of the spread of modernity. Originating in Europe, this civilization has expanded into the rest of the world, until in the period after World War II it encompassed just about all of it.

While the crystallization of this new civilization has something in common with earlier historical phenomena (the spread of the great religions, the expansions of early empires), it is nevertheless more complex, and the scope of its impact wider, as it combines ideological, economic, and political and perhaps other dimensions. The nature of its global spread, Eisenstadt emphasizes, is not to be understood as an uncomplicated matter either. As the civilization of modernity enters into contact with other cultures, changes and refractions result, so that one may see it alternatively as one increasingly internally diverse civilization or as multiple modernities.

We may appreciate the general approach (and see parallels, perhaps, in the work of those anthropologists a generation or so ago who were engaged in the

comparative study of civilizations and large-scale historical processes of cultural spread).[1] A theorist's work is never done, however; there is always more thinking, rethinking, and unthinking waiting around the next bend. For those anthropologists who have been pleased enough to remember diffusion as the laughing-stock of theory courses, something last heard of with the British Heliocentrists and Viennese *Kulturkreislehre*, let us say in the 1920s, it may be somewhat unsettling to find that globalization takes us back to the topic again, and even to learn that others have been working on it meanwhile.[2]

And there are even more central concepts which seem to require some scrutiny. As a Scandinavian, I may be inclined to feel fairly comfortable with Eisenstadt's view of modernity. Without doing justice to its details, I see it as one showing societies with effective citizen elites (and sometimes counter-elites) giving the ideals of modernity a working-over to merge with their own assumptions, and doing so with rather little self-consciousness about cultural difference; whatever there may have been of such consciousness has perhaps come in retrospectively. Which does not make cultural specificity any less real. Moreover, the elites in question control overarching organizational machineries strong enough to make the influence of their understandings of modernity permeate the everyday conditions of life of ordinary citizens. All that may remind us of the march into modernity of the Scandinavian countries, let us say in the first half of the twentieth century.[3]

Precisely this, however, may also make me think again about the conceptualization, as I suspect that all the world is not like Scandinavia, and as I have a native's experience of some of the juggling of terms involved. (In Sweden, the expression "strong society" has long referred to a strong state, and when "society must do something," it means that the state should be obliged to get involved.) Eisenstadt (1992: 414–415) points out that on the one hand, "the construction of the boundaries of collectivities and social and, above all, political systems is a basic component or aspect of human social life," on the other hand that these boundaries tend to be fragile, permeable, and relative to times and contexts. What I want to do here is to consider once more the question of the boundedness of societal and cultural entities, against the background of present-day global interconnections and their part in the spread of modernity.

Otherwise, I will be especially concerned with the general question of how modernity goes with cultural difference. In what way may core understandings of modernity, and the management of meaning which involves them, channel cultural flow through this ecumene? And what different understandings of cultural difference are there now? This is in part a matter of conceptual and theoretical scrutiny. Yet, as some theorists point out, reflexivity is a major feature of modernity, and in the continuous examination of practice and discourse, the social sciences may weave in and out of ordinary life, the scholar often only a step ahead of the layperson (see e.g. Giddens 1990: 36 ff.). Sometimes not even that. I believe this entanglement of reflexivities will also become evident here.

MODERNITY IN MALABO

Some borrowed ethnography will offer at least a part of the illustrative materials I need. It comes not from academic anthropology, but from a book named *Tropical Gangsters: One Man's Experience with Development and Decadence in Deepest Africa* (1990); an account by the American development economist Robert Klitgaard of his two-and-a-half years of work and life in the small African republic of Equatorial Guinea. The main title, I understand, comes from a tune by Kid Creole and the Coconuts, and the book deals in an engagingly personal manner with Klitgaard's interactions with the Equatoguinean administration, his participation in the night-life and popular culture of the capital, Malabo, and his search along the coastline, as an inveterate surfer, for the perfect wave.

I choose Klitgaard's book because it offers a view of a slice of the global ecumene, extending, not least through its author, from its center to one of its most distant peripheries. Klitgaard, a former faculty member of the Kennedy School of Government, Harvard University, and author of one book on choosing elites and another on controlling corruption, was in Equatorial Guinea working on a project funded by the World Bank, "to rehabilitate the country's crumbling infrastructure and to get the economy moving." Four-fifths of the population, Klitgaard tells us, depend on subsistence agriculture. Cocoa has been the only major export, but it has declined since the colonial period, so there may even be deglobalization going on.

The country had an extremely poor image in the outside world. Spanish colonialism had been followed by one of the most brutal and ruthless dictatorships in Africa, only less well-known than some of the others. This had been over-thrown, but the new regime was headed by the old tyrant's nephew, and its reputation was hardly spotless either. Equatorial Guinea would seem to be located at the outskirts of modernity. Theorists who see "trust in abstract systems" as one of the central features of modern life, and are fond of pointing to the banking system as an obvious example, might note Klitgaard's report on the situation in Malabo, as the local bank went broke:

> Honest people cannot retrieve their savings or take money from their checking accounts. Taxes cannot be paid. Consequently, business limps and government crawls. Now a French affiliate is open and for a predatory fee will change your travelers' checks or open an account for you that actually works. Too bad if you want foreign exchange, though ... when I sought some French Francs for a European trip, the bank said they simply did not have enough foreign exchange in stock to help me.
>
> (Klitgaard 1990: 2)

During the daytime, and sometimes in the evenings, Klitgaard worked with people in government offices, or simply tried (and tried, and tried) to get appoint-ments with them at all. Two of his collaborators were Don Bonifacio, Minister of Finance, with a Spanish economics degree, and Don Constantino, Minister of Planning, trained in heavy equipment repair in the Soviet Union. A third was Don

Milagroso, reputedly the youngest head of a central bank anywhere in the world, and a man with "mysterious sources of power," somehow relating to witchcraft. There were few professionally trained Equatoguineans in the offices, and not too many in the country as a whole; at any one time, however, some of these would more likely be found in Madrid than in Malabo.

On the other hand, there appeared to be a considerable and varied population of expatriate experts in town, many of them Latin Americans – somewhat predictably, in a Spanish-speaking country. The Equatoguineans had their doubts about these foreigners, and some of the experts were themselves similarly sceptical of at least others of their number: "They dream up a bunch of silly projects, the main effect of which is to keep themselves and others like them employed" (Klitgaard 1990: 77).

Later in the day, or for lunch, Klitgaard might go to the Beiruth restaurant, where chickens would roam freely among the tables under large umbrellas advertising Kronenbourg beer, and where a record player would alternate between African electric guitar, Lebanese laments, and an old album by Abba. Then on, perhaps, to a party, with more music. Klitgaard had taught Maele, Equatorial Guinea's leading rock star, an old song by Creedence Clearwater Revival, and it had now become a local tune – "Oh, Lord, I am stuck in Malabo again." Maele wanted two instrumental solos, the western-style one which Klitgaard had suggested and another Africanized one.

One of the civil servants working with Klitgaard temporarily disappeared. When he turned up again, it became clear that he had been imprisoned and tortured, according to a method known locally as "Ethiopia" – introduced, in the days of the past dictator, by instructors lent out by the fraternal revolutionary government of that country. There were indeed rumors of political unrest. Real power in the country, it appeared, was held by the Mongomo clan, of the Fang people, from an outlying part of the country.[4] Clan elders in the home town would make many of the big political decisions, favoring themselves, their clan, and their region. The president, as well as Don Constantino and Don Milagroso, were Mongomo. Sometimes other Equatoguineans would plot against the clan, but the greater nervousness in government circles in Malabo seemed to result from Mongomo internal discord. Tropical gangsters – predatory local politicians, costumed perhaps in imported ideologies? Or international business corporations? Or development agencies with their nomadic consultants? Klitgaard seems to leave it an open question.

"SOCIETY" AND "CULTURE"

To repeat, Equatorial Guinea appears to be at modernity's margin. Klitgaard's portrait of it, and not least of its involvement with international structures, however, offers a vantage point toward that wider, relatively open landscape through which modernity now makes its way, and allows us to think once more about some of the conceptual tools with which we try to map it.

The view of modernity as a civilizational complex, spreading globally, affecting the cultures of ever more societies, and at the same time being itself reshaped in those locations, especially through the agency of societal elites (and counter-elites) draws on a vocabulary which has long been conventional in the social sciences – but what can terms like "society" and "culture" stand for, in the current Equatoguinean context, and more generally these days?

I come back to some issues raised in Chapter 2. The idea that "societies" exist out there as relatively autonomous units, as systemic totalities exercising a powerful influence on their parts, and that these "societies" can be identified with nation-states, has itself been very much a modern notion, but one that is now increasingly seen as problematic.[5] It is not only that not all states are really nation-states in any strict sense (and Equatorial Guinea would seem to be one good example of that). The view of society as a system is also at least qualified by a reawakened concern with agency, and furthermore writers on globalization and the world system argue that, with increasing interconnectedness of many kinds, nation-states become less and less satisfactory as units of analysis.[6]

While avoiding the company of Thatcherite abolitionists with regard to the concept of "society," in its abstract singular form, I am for such reasons inclined to be more sceptical about the plural form. Much as one may agree with Eisenstadt that boundary construction is a basic ingredient in human life, and that political entities have a major part in this, the very idea of modernity as an expansive civilization seems to be in some conflict with that of distinctly bounded units. A clear sense of what penetrates, cuts across, or supersedes boundaries must be at least an important complement to the understanding of whatever may be the internal workings of such units. Obviously this is not to disregard or underestimate the part of states in organizing the global ecumene – a Scandinavian would not be likely to do so. Rather, the idea is to call a spade a spade. When state apparatuses (rather than "societies") and their particular relationships to territories and the people in these are at issue, we may be well served by saying just that.

What about conceptual alternatives? I referred in Chapter 2 to Zygmunt Bauman's (1992: 190–191) suggestion that the "habitat" in which agency operates may be taken as a key idea in a renovation of social theory. It may strike us that it resonates metaphorically with the notion of the global ecumene as an open landscape. The habitat offers both resources and constraints; it is defined with reference to particular agents, so that the habitats of different agents may overlap either more or less, within the landscape as a whole; and the habitat is emergent and transitory. It is not by definition linked to a particular territory. To what degree it actually turns out to be so depends on the conduct of the agents concerned. In more sociological terms, the habitat of an agent could be said to consist of a network of direct and indirect relationships, stretching out wherever they may, within or across national boundaries.[7]

The culture concept, we have seen in the preceding chapter, is also under reconsideration; and there are abolitionists here as well. What they criticize, in particular, is an emphasis on boundedness and difference. Alternatively, again, we may

think in terms of a pool of culture, held more or less in common within the global ecumene; and we may then regard it as an open question how individuals or different kinds of collectivities come to assemble their particular repertoires from this pool. Agents, that is to say (repeating a point from Chapter 2), also have their habitats of meanings and meaningful forms; their own working perspectives, with horizons perhaps drawn variously far away.

Look at Klitgaard's portrait of Equatorial Guinea again in these terms – or rather his portrait of himself, and expatriates more or less like him, in interactions with varied people of Equatoguinean citizenship. Klitgaard's own habitat is certainly not restricted to the territory of the Equatoguinean state, to people there, or to locally available meanings. Altogether he spends more than two years based in Malabo, but we learn that between two periods there, he was in Costa Rica, at the Central American management school, for a few months' writing, and then he "worked in Bolivia for a couple of months, consulted twice in Panama, made [his] second trip in two years to Nicaragua, and finished a book on elites in developing countries" (Klitgaard 1990: 52). More importantly, no doubt, his habitat consisted of the Washington offices of the World Bank, and academic connections in the United States, apart from family and friends at home.

In Malabo, on the other hand, conspicuously connected to the World Bank, Klitgaard was himself part of the habitat of people like Don Bonifacio and Don Constantino, the ministers; their habitats had at least at one time extended to include institutions and local settings in Spain and the Soviet Union, respectively, and presumably this had left a mark on their cultural repertoires. For Don Constantino, and Don Milagroso, the bank chief, membership of the Mongomo clan was surely also a significant part of their personal habitats. To Maele, the rock star, on the other hand, Klitgaard's World Bank connections probably mattered little. In his eyes, Klitgaard was a source of musical knowledge, and a help in transforming a Creedence Clearwater Revival tune into something with a local touch. Yet Maele was, of course, not entirely dependent for the renewal of his repertoire on personal encounters with knowledgeable expatriates. He could, for one thing, go down to the Beiruth restaurant and listen to that Abba album.

For the Mongomo clan collectively, the Equatoguinean state apparatus was surely a major resource in their emergent habitat – now expanding, in spatial terms, from their remote region to the capital Malabo, where they were strangers. It was a machinery they had somehow acquired from the departing Spanish colonial regime. To keep it serviceable, however, they needed both the World Bank and such techniques of violence as "Ethiopia." To other Equatoguineans, the same state apparatus may have been in large part a troublesome (although unpredictable, and only patchily present) part of their habitats, and at times the latter might thus have to be extended into exile in Spain.

We could go on teasing out the connections and overlaps between the habitats of people in Malabo, and trace the extensions of these habitats away from there, into the wider world. Yet the point I want to drive home is simply that on close inspection, these are the kinds of connections which taken together make the

contemporary global ecumene an open landscape, in terms of social relationships and in terms of the flow of culture. Thinking of some of them as "within a society" and of others as "between societies" may not be all that helpful, if such terms turn out to carry excess theoretical baggage.

MODERNITY AND DIFFERENCE

There is a story – I do not remember where I got it from, and I am not sure about the details – about a visitor traveling in Ireland, and asking a native standing by the roadside about how to get to a certain other village with one of these difficult Gaelic names. The native looks out over the land, thinks, scratches his head, and says, "You know, I don't think you can get from here to there."

The notion of culture, in the singular, as a global pool of meanings and meaningful forms, suggests that in principle, at least, anything cultural can indeed move from anywhere to anywhere, from anybody to anybody. Yet as the Irishman's reply suggests, such mobility of things cultural may in some instances be rare, impeded by various obstacles, and held not very desirable. One may look, then, for principles by way of which such an organization of diversity occurs that everything is not everywhere.

This seems to be in line with the sociologist Roland Robertson's (1992: 34, 41) recent argument for more attention to "metaculture." What the term suggests, as I understand it, is that people tend to draw on some more overarching conceptions according to which the materials of cultural minutiae tend to be interpreted and organized in human life. Such conceptions may be undetected, not directly available for reflection, or they may be reflected upon, by laypersons or specialists. These metacultural framing conceptions, it is understood, are not "above culture" but necessarily cultural themselves, in each of the senses identified in Chapter 1: they obviously have a bearing on any conception of culture "as a whole," they are developed and learned in social life, and they can vary.

Along such lines, I would suggest that two major metacultures coexist and play a part in shaping the present-day globalization of modernity, by encouraging or constraining cultural flow. Let me draw on a few recent commentators.

On the one hand, we have the sociologists David Strang and John W. Meyer (1993), who are concerned with a general understanding of the conditions for the diffusion of social practices. These two writers are somewhat dissatisfied with an approach which focuses solely on relational aspects, on the model of infectious diseases. No doubt, the existence and relative intensity of relationships have an important part in diffusion. (It is partly for such reasons that I have emphasized the notion of the global ecumene as an open, fairly densely networked landscape.) But Strang and Meyer find that the participants' understandings of themselves, each other, and the practices involved are also of major importance. In order to adopt a practice exhibited by someone else, people have to have some idea of how it would fit into their own life; and this may involve analyzing similarities and differences between their respective situations, and similarities and differences between themselves and the other.

Here, Strang and Meyer argue, theorization – obviously a form of reflexivity – has a major part in contemporary life. Through theorization, abstract categories and patterned relationships are formulated, rising above the welter of everyday diversity. Theorization tends to favor similarity over difference; not everything is entirely unique, but situations, practices and people tend rather to become instances of a class, variations linked to an ideal type. In so doing, theorization also encourages diffusion, as participants become to varying degrees homogenized.

Such theorization may occur on a small scale, at an interpersonal level; but what really matters is that it also occurs at the level of major institutions and organizations. And Strang and Meyer (1993: 500) point out that the outstanding instance "where theorization is central to the construction of both units and specific elements, where partial theorizations articulate with each other, and where a network of congruent theories forms a hegemonic cultural frame ... is modernity itself."

This, then, is one major contemporary metaculture; a metaculture emphasizing similarity. In so far as modern theories favor a universalistic moral order, a scientific and standardized analysis of means–ends relationships and of nature, and a largely ahistorical view of human nature and society, participants are constructed around such views to become more similar. In modernity, the right things, at least, can get from anywhere to anywhere (although that tends to mean from center to periphery). Once the basic premise establishes a foothold that social life is to be organized around notions of progress and justice, and that human beings are to be autonomous, rational, and purposive individual citizens, then a wide variety of other things appears to follow logically, and gain organizational support for further spread. Yet of course, it is not actually a simple two-step process of the general premise arriving first, in its fully developed form, and all its various specific instantiations later. Rather, as the latter accumulate, the general principle also feeds on them for its overall power.

Strang and Meyer conclude by drawing attention to an anomaly. Modernity celebrates the autonomous, competent actor. And yet it is precisely this autonomy and this competence that tend to be subjected to the modern forces of standardization by way of diffusion. Perhaps we could also say, somewhat paradoxically, that what we see here is the diffusion of an evolutionary idea: the metacultural conception of modernity portrayed by Strang and Meyer appears rather more like that of the modernization theory of a few decades ago than the present one of Eisenstadt's, which is the point of departure of this chapter.

On the other hand, let us observe how two Chicago anthropologists identify a different metaculture. Marshall Sahlins (1993), long concerned with the cultural formation of reason, draws on Terence Turner, as Turner (1993) draws on Sahlins.[8] If modernity theorists (such as Anthony Giddens) have often emphasized discontinuity, and someone like Eisenstadt has sought to combine continuity and discontinuity in one vision, Sahlins is perhaps after all most interested in cultural continuity, and diversity. It is only because Western culture is so obvious to us – to those of us who are ourselves Western – that we are inclined to

think of our "practical reason" as something beyond culture, he argues. Other people also have their practical reason; in their particular cultural dialects, as ours is. When new resources become available to them, for example as a consequence of new global connections, they are inclined to reason on the basis of their tradition about what is acceptable or desirable change.

Culture is thus continued, fitted to new circumstances. In the highlands of Papua New Guinea, this may mean more pig feasts, a new men's house. The impulse is "not to become just like us but more like themselves" (Sahlins 1993: 17). Looking back in history, away from the West, it was not the first coming of the White Man, but the establishment of colonial power, which entailed a rupture, because it involved a loss of control. Yet there was only dominance, not hegemony, as the colonial state was continuously compromising with local cultural particularism.

So there can be different cultural premises.[9] What we witness now, however, I understand Sahlins to say, is another step. People everywhere are showing a new level of self-consciousness about culture; which in this context means an emphatic underlining of difference. Some things should not get here, and some should definitely stay where they are. Sahlins notes Turner's (1991) observation that by the late 1980s, in the tropical rain forest of Brazil, even Kayapo Indians who were otherwise monolingual in their own mother tongue would use the Portuguese *cultura* to refer to traditional customs. Moreover, this self-consciousness was an integral part of a defiant attempt to maintain autonomy *vis-à-vis* the state and the world around them. So we see "the formation of a World System of cultures, a Culture of cultures" (Sahlins 1993: 19).

Turner (1993: 424), referring directly to this, discerns an important historical transformation here. Culture as a universal category, distinct from, but subsuming, specific cultures, has become precisely – the term is there again – a "metaculture." It is a "locus of collective rights to self-determination," "a source of values that can be converted into political assets, both internally as bases of group solidarity and mobilization, and externally as claims on the support of other social groups, governments, and public opinion all over the globe." Turner makes his point in the context of the growth of multiculturalism and identity politics in the United States, another setting for that metaculture where difference is itself a premise.[10]

THE LOCI OF METACULTURAL COMMITMENTS

The metacultures of difference and modernity (where modernity suggests similarity) are themselves differentially distributed among agents in social life, and in the landscape of the global ecumene. It is a major characteristic of the late twentieth century that the metaculture of similarity has a strong base in formal political organization. When European explorers started traveling in distant, foreign lands, they ran into a great many different political set-ups – foraging bands, divine kingdoms, gerontocratic republics, structured anarchies. Yet by way of colonialism, and then the coming of independence in a great many places after World

War II, more or less the same kind of state organization was replicated throughout the world. "Consider how much diffusion would be slowed if nation-states were wholly primordial, or if they occupied formally differentiated positions within a hierarchical global political structure," Strang and Meyer (1993: 491) reflect. The fact is that, despite enormous real disparities, states are acknowledged as possessing identical legal standing, and officially at least, they subscribe to similar goals of modernity. And this is a fundamental premise of all those proliferating late twentieth-century international organizations which link them, and which not least link center and periphery – as exemplified in the enduring or on-and-off presence in Malabo of AID, ILO, UDEAC, IMF, the World Bank, and UNESCO, in a veritable carnival of acronyms.

To a degree, at least, the metaculture of modernity may thus tend to work from the top down. It can also be argued that it has a strong academic base. Much of the theorization of modernity has been carried out by social scientists. Metacultures of difference may actually have occurred historically in some variety – I remember seeing the old structure of village India described as a "nonimitative order" (Marriott 1959: 67). In its present version, however, this metaculture tends to be oppositional, if not always literally bottom-up. By claiming cultural difference, one asserts special rights, at least the right to be excluded from the field of others' exercise of power. (I return to this topic in the next chapter.)

Yet to say this is hardly enough. Marshall Sahlins notes, as others have also done, that the leaders of cultural revival, the major celebrants of difference, are very often among those who lead very successful lives in habitats dominated by modernity, people who have obviously acquired important diffused skills. One might look at this, as Sahlins does, as an "indigenization of modernity" – appropriating of the imported material and ideational goods what is valuable from one's own point of view. Simultaneously, however, it would seem that there is a modernization of indigeneity, a domestication of difference; that is to say, the "Culture of cultures" also entails a tendency to assert difference along somewhat standardized lines. Since this metaculture is obviously itself an item of diffusion – those Kayapo Indians did not come up with the concept of *cultura* themselves – such a tendency is not surprising. Moreover, if – as Turner points out – the assertion of difference is intended to mobilize support among distant others, such as global public opinion, it probably helps if these can readily recognize one's distinctiveness by way of established criteria. Too alien an otherness may not do.

Again, how does the Malabo scene relate to all this? Klitgaard and his peers connected to various international organizations are obviously agents of modernity – working, that is to say, on the assumptions of its metaculture. Yet that clearly does not mean that they always find its theorization very helpful. "I was humbled daily by my ignorance of the local economy and of local politics," Klitgaard (1990: 197) writes; "I was frustrated to the point of despair by all the things that could go wrong. In Equatorial Guinea Murphy's Law would be a legal encyclopedia." Strang and Meyer (1993: 500), by no means convinced that abstract theorization is always a good thing, comment that "global theorization defocuses individual

variability, assuming equivalences that are perceptibly inaccurate given local information ... The unpersuaded observer will see in theorized diffusion only ritualized isomorphism." Internationally sponsored modernity perhaps grinds to a halt here, the clients in practice not quite consenting to being theorized.

One may suspect that the elders of the mysterious and powerful Mongomo clan, of the Fang people, are conducting their affairs, as Sahlins has it, to become "more like themselves," developing their own tradition in the new habitat. To repeat, having a state machinery at their disposal for this purpose would seem like a marvelous advantage. As far as the metaculture of difference is concerned, on the other hand, it seems that in the form most succinctly described by Turner, it has not really established itself in Malabo – at least not as far as we can tell from Klitgaard's reporting. (Look up "cultural differences" in the index of *Tropical Gangsters*, and you find one reference to a couple of paragraphs about relationships between Equatoguinean husbands and wives, and another to a few pages about local female competition for Klitgaard's attention.)

To repeat, the theorizing of modernity as similarity has been in no small part the work of social scientists (most often economists, sociologists, and political scientists). We may ask if the theorization of difference does not similarly have an academic base. Anthropologists must be prime suspects here, given their inclination to celebrate difference, and since after a fashion, they have provided a haven for cultural relativism.

In fact, the metaculture of difference is probably at least to some extent inspired by the extramural diffusion of one long-standing tendency in anthropology. Yet it seems worth noting that precisely as this metaculture is emerging as a more or less world-wide intellectual/ideological/political current, there is that debate over the culture concept going on in anthropology which I discussed in Chapter 3.

In the article to which I have already referred extensively, Marshall Sahlins actually exemplifies the emphasis on cultural difference ("box 4" in Chapter 3) in a sophisticated and unusually explicit manner. Yet other anthropologists, we have seen, are now more inclined to draw attention to continuities in intelligibility, built on shared human nature, the recurrent conditions of human life, or more specifically on negotiations or overlaps between individuals, with their biographically constituted cultural repertoires. Back to Malabo again. In terms of the social membership categories of clanship and ethnicity, Don Milagroso may always remain a Mongomo and a Fang, but as he goes through schools and then moves into the Malabo international set, does he remain forever fundamentally a vessel of Fang culture? Or is the US citizen Klitgaard always equally fundamentally a creature of American culture, regardless of his globe-trotting curriculum vitae? By now, it may be that Don Milagroso understands the Mongomo elders rather better than they understand him, and gradually he and Klitgaard perhaps make more sense to each other. In the landscape of the global ecumene, there may be partial common grounds of understanding, or series of bridges.

The controversy over the culture concept suggests that anthropology would now seem to provide only an uneasy, ambivalent academic base for the

contemporary metaculture of diversity, as defined above. Some practitioners, and theorists, have come closer to the idea that human beings are, after all, similar. It could even be suggested that there is nothing in principle that would prevent that culture concept which emphasizes acquisition in social life from coexisting even with a metaculture of modernity as similarity – if all of humankind in the end chooses the same software, as it were, so be it. But this is hardly where we are now. People may be similar in some ways and different in others, and what requires theorization in the global ecumene is rather openness and variation occurring together.

CONCLUSION: DIVERSITY WITHIN INTERCONNECTEDNESS

As modernity has once more become a current theoretical focus in the social sciences, there is often a tendency to discuss it in the abstract. Nonetheless, while globalization is identified as an important part of modernity, it is frequently obvious, although left implicit, that where theorists are really at home is still the West: western Europe, North America. Possibly Japan has by now been added, but on the whole theorists are still Occidentalists. It ought perhaps to be made an obligation on the part of those who discuss modernity in general – or such related abstract notions as "knowledge society" or "information society" – to try to give some real attention to the implications of what they are saying to people at the margins of the global ecumene: not just to see whether their claims hold, but also to ponder the consequences of emerging uneven distributions.

One of the great advantages of a conception of modernity as an expansive civilization is that it draws attention to global asymmetries, to center–periphery relations. Modernity was not originally everywhere, and if it has spread everywhere, or is at least making itself felt everywhere, it is present under quite variable conditions.

The journey to Malabo allows us to see some of the diversity of the civilization in question. In some places at the periphery there may be little of an indigenous elite committed to modernity, the nation-state as a community still mostly remains to be imagined, and the state machinery may swing back and forth between weakness and terror. In the interstitial spaces between what is modern and what is not, there may yet be those spontaneous attempts to grow from autochthonous cultural bases, with little regard for metropolitan models. Perhaps not in Malabo, but elsewhere, there may be self-conscious, variously accomplished efforts at striking a bargain between opposing metacultures, trying hard to be modern and different at the same time. And not least do we learn something, from Klitgaard and company, about the uneven distribution of organized, large-scale reflexivity in the world. In the periphery, systematic scrutiny and theorization, in their legitimated form, are often imported from the center, and still controlled by the center, with all the political and cultural consequences that this may have.

5

SEVEN ARGUMENTS
FOR DIVERSITY

What is cultural diversity actually good for? The value of diversity may have become so entrenched in contemporary rhetoric about culture that we rarely take time out to reflect on it. Yet let us try to look at it as a matter of global cultural policy, as it were. What, in reasonably unambiguous and down-to-earth terms, are the advantages or disadvantages of cultural diversity?

There are, we know, two major aspects to globalization. On the one hand, populations and social structures which have previously been rather more separate now increasingly impinge physically and materially on one another's living conditions. On the other hand, there is also the increasingly direct flow of culture, of meanings, and modes of expression. With regard to the first of these aspects, there has recently been a growing interest, at the interface of ecology and economics, in the notion of "transnational commons": resources which are somehow shared by humanity, not directly under the control of any one government. Because of unregulated access, it is held, such resources risk being destroyed, damaged, depleted. Global warming and polluted seas are conspicuous examples.

Biodiversity has also come to be seen as a part of the transnational commons. Species of animals and plants are disappearing as humans invade and destroy their habitats. How can the value of this diversity be calculated, in what terms can it be understood?

And then the parallel question of the value of cultural diversity comes up. With increasing interconnectedness in the world, it is assumed, there is also a threat to cultural diversity, or at least to certain cultural variations. In the words of Clifford Geertz (1986: 253), "we may be faced with a world in which there simply aren't any more headhunters, matrilinealists, or people who predict the weather from the entrails of a pig."

Facing the prospect of overall homogenization – if, for a moment anyway, we accept its credibility – we may ask whether we should try to put up some resistance. What arguments can be put forward for and against cultural diversity, and on what assumptions do such arguments rest? In what ways may arguments concerning cultural diversity parallel those concerned with biological diversity, and how would they differ? This is the conceptual terrain I will attempt to map in this chapter.

56

In one way at least, there might in fact be something rather practical about getting rid of diversity. We must not lose sight of the fact that culture is the medium by which human beings interact. They make themselves more or less well understood to one another through culture, and the more culture they share, the more effective is (at least in some ways) their coordination in interaction. They become more transparent to each other, as it were, and often render themselves understandable to others even by way of quite minimal overt signals. So much can be left implicit, to be taken for granted. The organizational formula, ideally, is that "I know, and I know that you know, and I know that you know that I know." We are so thoroughly habituated to this culturally based effortlessness of interaction that we hardly notice it except in its breach – but again, such breaches seem to become increasingly frequent.

This nuisance value of cultural diversity need not concern us further here, although we may at least remind ourselves when we listen to more high-minded praise of cultural diversity that it often conveniently disregards the minor and major irritants which come with not sharing a culture.

All the same, I will devote more attention to some arguments for cultural diversity. Whether mostly in passing or in some detail, I will identify seven types of arguments, and also try to indicate their respective limitations. They are certainly not entirely independent of one another, and at times they may get in each other's way.

One of them entails advocating cultural diversity for its own sake, as it were, as a sort of monument to the creativity of humankind. Another argument would be based on principles of equity and self-determination. Yet another way of looking at the matter is to suggest that cultural diversity is beneficial in the adaptation of humanity to the limited environmental resources of the world. Fourth, it may be argued that cultural diversity counteracts relations of political and economic dependency. One may alternatively, and fifth, take a largely esthetic stance toward the pleasures of cultural diversity; or, sixth, view it as a useful provocation to the intellect; or, seventh, draw on it as from a fund of tested knowledge about ways of going about things.

THE RIGHT TO ONE'S CULTURE

Let us begin with the notion that people have a right to their own culture. Here terms like "cultural heritage" and "cultural identity" often enter the discussion. Humanity is no *tabula rasa*, cultural diversity is already there, and this fact can hardly be neglected in any debate over it. The basic assumption is that people are attached to their own culture, but since this in fact means that they are attached to different cultures, one has to "agree to disagree," live and let live.

This, then, in its pure form is not really an argument for the superior value of any experience of diversity as such; not an argument for wider cultural access. Instead it rather takes us back to the metaphor of the global cultural mosaic, of separate bounded units. Each individual should have the right to live his or her life

encapsulated in a smaller world of the like-minded. The persistence of diversity is merely a logical consequence of the central principle.

It is hardly an unreasonable idea that given in some sense a cultural choice, people will choose the culture they already have. To a considerable degree, anthropologists would tend to argue, people do not only possess a culture, they are possessed by it; they have been constructed out of its materials of meaning and expression. The choice, if this premise is accepted, is not quite a real choice.

Yet the argument can be pushed too far. It should not be taken as self-evident that an overall agreement pertains within a group, or what we think of as a society, on the intrinsic worth of that collective structure of meanings which we describe as its culture, since it may be merely a working arrangement reflecting the more or less contestable balance of power among the members. Slaves, lower castes, or oppressed women or youths might actually want to raise their voices, or vote with their feet, but are quite possibly not in a position to do so. Or that working arrangement is simply the best that could be done together, with the resources at hand.

Presented with a choice, then, people may under some circumstances not opt for what may have seemed to be "their" culture. They were perhaps never wholeheartedly for it in the first place. Moreover, human beings also have some capacity for remaking themselves, their cultural repertoires may have some openings to new potentialities. In other words, presented with alternatives to the culture they have lived by, they might at times prefer to pursue these – whether or not they understand them in detail, and in their implications.

Here, then, is a profound difference between the cultures of *Homo sapiens* and the biograms of other species. One kind of animal cannot choose to become another kind of animal, its right of survival as an individual and as a population can only be safeguarded by allowing it to be what it already is. In contrast, cultures may die while people live on; and "dying" here only means that a complex of ideas and the practices based on it pass into disuse.

Watching out for people's right to choose must not be confused, then, with safeguarding a specific cultural heritage, or cultural diversity generally, for its own sake – the "monument to human creativity" idea. Such safeguarding may be based on a judgment of mostly esthetic and antiquarian nature, and is often based on vicarious pleasure: it often seems to be outsiders who reach such a conclusion, and grieve for the cultures others leave behind. To make sure that existing varieties of cultures are preserved as living entities, obviously, one would have to transform "the right to one's own culture" into a duty to that culture. And that would no doubt be a great deal more controversial.

CULTURE AND ECOLOGY

Cultural diversity could also be seen to have an ecological dimension. In so far as cultures entail different orientations to the limited environmental resources of the world, and not least different sets of knowledge about them, it could be advantageous to our long-term survival if the diversity of cultures would lead populations

to place themselves in different niches. If the Spaceship Earth is the home we share, it might yet be good not to have to share cabins.

Anthropologists' studies of the relationship between culture and ecology have often shown how a people has achieved an enduring balance with its habitat – whether it is a rain forest, a steppe, or an Arctic sea – by way of keen observations of nature, a set of social and ritual practices the beneficial environmental implications of which may not be wholly understood, and a modest technology; and these studies have frequently also pointed to the way different groups coexist more or less successfully in a limited territory by drawing on different environmental resources.[1]

On the large scale, approximately this argument is now heard as a warning that the peoples of the Third World especially must not acquire the resource-depleting, polluting habits of First World (and ex-Second World) peoples; this would be a global environmental disaster. If their cultures are to change at all, please, not in this direction.

We can hardly dismiss the point, and yet one discerns a weakness. If all people have the same right to choose culture, whether this entails keeping the one they have or moving on to another one, one can hardly claim that some people have a greater right to destroy the environment because they have been doing it longer, or have invented the means of destruction.

Whatever cultural diversity may contribute to the husbanding of the resources of our planet, we must by now certainly also be aware that cultural differences do not necessarily lead away from ecological competition. As things stand, we are more likely to argue the other way around, that the access of particular populations to their habitats needs to be safeguarded because it is only in this way they can be guaranteed the right to their own culture; the latter being intimately connected to a particular ecological adaptation, or actually consisting in large part of it.

This way of arguing, from principles of cultural equity to their ecological consequences, is of course necessary because First World industrial culture has a propensity for expanding into new niches, whether these are already occupied or not. Where mines, power plants, and forest companies enter, the hunters and gatherers and the horticulturalists are very often forced out, or marginalized. And this is obviously frequently not a matter of their choice, their attraction to new ideas or opportunities; not a way to upgrade their ecological know-how, but rather a way to render it useless. At present (as I noted in Chapter 2) we discern such environmental change in particular as a threat to what we term the Fourth World, aboriginal peoples whose adaptations to their habitats are so specific that major intrusions may lead to cultural loss rather than to mere cultural change, and where furthermore the intrusions are sometimes so violent as to amount to genocide; a situation about as analogous to a threat to a biological species as one gets in the universe of cultural diversity.[2]

Whichever way we argue about ecology and cultural diversity along the lines suggested, it once more entails seeing cultures as fundamentally separate. It is a matter of how populations of different cultures may relate to one another in varied

manners by way of their culturally constructed ecologies. On the other hand, it does not involve a view of access to variations in meaning systems as either beneficial or disadvantageous. In the next instance the argument for cultural diversity, as it is often implied or explicitly put forth, is more directly opposed to a certain kind of widened cultural access.

DIFFERENCE AS RESISTANCE

The flow of culture within the contemporary world is in large part asymmetrical, a stronger flow from center to periphery than vice versa; in cultural terms, this is what defines center and periphery. Yet center and periphery may not be defined only in terms of cultural flow, to the extent that the latter is correlated with economic and political power.

To what extent, then, does the flow of meaning and meaningful form contribute to political and economic dependence and subjugation? It is a well-known argument that it does, that this is an important part of a hegemonic process. The culturally mediated access of center to periphery is understood to constitute a sort of brainwashing, a way of tying the periphery even more closely, and on the face of it voluntarily, to the interests of the center. Culture here is ideology.[3]

Cultural diversity, then, may be cultural resistance. The point of view is familiar, for example from the world system theory of Immanuel Wallerstein (e.g. 1974, 1984), which, in its rather limited attention to culture, has emphasized the ideological facet. As Wallerstein has noted, it is a resistance often put up, not to say manipulated, by those elites of the periphery who thereby both draw the line *vis-à-vis* the center and try to win a following among those masses of the periphery who presumably remain more habitually committed to local tradition. It is such elites, for example, who tend to launch political campaigns of "authenticity." What they aim at is a counter-hegemony, opposed to that which has its anchorage in some distant center. It is likewise such elites who tend to regard as unreliable, and as possible adversaries, those of their compatriots who allow themselves to be "accessed" by alien cultural flows, and who even draw pleasure and stimulation from these; one of those kinds of people to whom the label "cosmopolitan" is frequently attached.

Yet resistance to imported culture as a manner of resisting political and economic domination is not always a matter of elite strategy, but can be more widely based. It is also a type of argument for the maintenance of bounded cultures which can readily and fairly unobtrusively be combined rhetorically with the claim of a right to one's own culture. What was said in Chapter 4 about "the metaculture of difference" obviously fits directly in here.

ENJOYING DIVERSITY

I turn now to arguments for cultural diversity which are of that other kind, emphasizing the value of access to diversity, and of the experience of diversity; arguments

which see the global ecumene as a promise rather more than as a threat. Here I wish to distinguish between three somewhat different views of the benefits involved.

The first of these I see as principally an esthetic attitude. "Other cultures" are valued as experiences in their own right, that is, regardless of any readily identifiable concrete use value. They become the materials for what I would regard as a major form of cosmopolitanism; I develop this view further in Chapter 9. A person rooted in one culture thus enters another with its meanings and practices, or perhaps many of them serially, but usually temporarily. The esthetic attitude entails being positively oriented toward such experiences, but also striving toward achieving some degree of competence in handling other cultures as ongoing arrangements of life. One masters them to a degree, and at the same time surrenders to them, trying for the moment to abide by their rules. And at the same time this kind of competence entails a particular kind of mastery of one's own culture, as one shows that one can establish a distance to it.

One might say that the attitude tends to be based on cultural boundaries remaining largely in place. Although some (preferably not too many) individuals cross them, these individuals keep their experiences on each side mostly apart. The esthetic attitude does not involve using those cultural experiences from somewhere else to effect change, except at some private level. From this perspective one may well mourn the passing of other cultures, even as these are quite voluntarily deserted by their erstwhile creators and bearers. The attitude may appear somewhat self-indulgent.

CREATIVE CONFRONTATIONS

It may be only a rather short step, however, from the above attitude to the second kind of experience of diversity I have in mind; one where the coming together of distinct flows of meaning results in a generative cultural process. There have been differing opinions on the value of such confluences. Claude Lévi-Strauss, one of the most eminent figures of anthropology, has argued that

> all true creation implies a certain deafness to the appeal of other values, even going so far as to reject them if not denying them altogether. For one cannot fully enjoy the other, identify with him, and yet at the same time remain different. When integral communication with the other is achieved completely, it sooner or later spells doom for both his and my creativity. The great creative eras were those in which communication had become adequate for mutual stimulation by remote partners, yet was not so frequent or so rapid as to endanger the indispensable obstacles between individuals and groups or to reduce them to the point where overly facile exchanges might equalize and nullify their diversity.
>
> (Lévi-Strauss 1985: 24)

Yet at the same time it has often been pointed out that many of the most creative individuals in the history of human consciousness have been "marginal men,"

61

people who have acutely experienced a contrast between ongoing cultural traditions and who have thereby been provoked into new understandings – bridging the cultures, synthesizing them, or scrutinizing them. Lévi-Strauss himself has indeed been offered as an instance of this; Marx and Freud are likewise mentioned as examples.[4]

This generativity may well depend on the more precise circumstances under which people have to manage the encounter between cultural currents. The late Alvin Gouldner (1985: 204 ff.), a sociologist who took some special interest in the heterogeneous intellectual bases of Marx' theoretical achievements, argued that the most advantageous situation is one where one has access to more than one line of thought and can thus escape the control of any one of them; where one can move between them in a way which deviates from any conventional division of labor between them; and where one yet orders them hierarchically, thus presumably avoiding confusion and retaining a sense of direction.

We should certainly be aware here that Marx, Freud, and Lévi-Strauss are all from an ethnic subculture which is not set very far apart from the surrounding mainstream. The question also arises, then, whether all kinds and degrees of contrast or affinity in the combinations of cultural difference can be expected to be equally productive. In response to Gouldner's formulation, too, one may wonder to what extent the intellectual fertility of an encounter between cultures necessarily entails drawing more directly on the resources of both cultures (or whatever number is involved). At times it might also be that the mere heightening of awareness stimulated by such a confrontation leads to a creative management of the resources available within one's own culture.

DRAWING ON OTHER CULTURES

Arguments about the esthetic appreciation of cultural diversity and about the experience of cultural diversity as a source of creativity both tend, I believe, to be couched in terms of micro-level, individual experience; what happens if such experiences are aggregated in a population is a question mostly left open or even unidentified. The third kind of use of an access to cultural diversity, in contrast, seems more often to involve actual or potential macro-level changes (of course, here as so often the contrast is relative and imprecise).

What I have in mind is the notion that cultural diversity within the global ecumene can be used as a kind of reserve of improvements and alternatives to what is at any one time immediately available in one's own culture, and of solutions to its problems.[5] One curious thing about the economics of culture, of course, is that this reserve, this particular kind of transnational common, does not risk becoming depleted merely because people borrow heavily from it, as people can keep giving meanings and their expressions away to others without losing them for themselves.

The economist Stephen Marglin, in his discussion of "cultural diversity as a global asset," emphasizes this perspective (although he also refers to the right to one's own culture):

> Cultural diversity may be the key to the survival of the human species. Just as biologists defend exotic species like the snail darter in order to maintain the diversity of the genetic pool ... so should we defend exotic cultures in order to maintain the diversity of forms of understanding, creating and coping that the human species has managed to generate.
>
> (Marglin 1990: 15–17)

As one extreme variation on this theme there is the premonition that humanity will need its remaining hunters and gatherers to show the way when catastrophies, self-inflicted or otherwise, have destroyed more complicated forms of life. Marglin touches on this possibility. It is a kind of scenario perhaps no longer as close at hand as it was at the height of the Cold War nuclear arms race. Alternatively, and certainly as a fairly common ingredient in recent cultural history, we may cast ideologically motivated glances across boundaries to find our Utopias most nearly approximated somewhere else. As the twentieth century has passed, we have seen several such imagined laboratories for humanity, mostly on the left: the young Soviet Union, China, Cuba, Tanzania. But rather more continuously, the United States has also served in a similar way as a source of alternatives and materialized ideas of the future for people elsewhere, perhaps in this case moving with time from left to right. These sources, then, may be reasonably familiar (whether realistically understood or not) and popular with a great many, or they may have their distant enthusiasts, sometime pilgrims perhaps, who act as middlemen advocates in arguing for large-scale change in accordance with the models thus identified.[6]

The argument for cultural diversity here, to repeat, is that it keeps alternatives alive; and not only in their existing state, it may be added, but also in their specific potential for further development. This is an appealing idea, although not without possible weaknesses. One of them is that it tends to assume that if the alternatives are not continuously kept going, they will be lost forever. Perhaps one takes an unnecessarily bleak view of human inventiveness here; would people not be able to construct the alternatives as they needed them, without seeing them continuously modeled?

One might also ask what kind of documentation, as it were, is needed to maintain access to this cultural reserve. What difference does it make whether cultures are really kept 100 per cent alive, with fully employed participants, so to speak, or are merely preserved in the archives, through texts, recordings, or whatever? Archives, it is true, can also be destroyed, as can the skills required to use them. But unless we all become non-literate hunters and gatherers again, and out-of-practice hunters and gatherers at that, it seems that it will be through the antiquarian efforts of specialists that access to much of the accumulated cultural diversity of the world can most likely be guaranteed.

Yet another problem with the idea of global cultural diversity as a shared reserve to draw upon is the difficulty of transporting items of culture from one context to another, to be readily redeployed there. For three quarters of a century

or so, much of the analytical effort of anthropologists has gone into showing how cultures hang together, how particular beliefs and practices make sense only as parts of cultural wholes. True, the discipline has lately seemed less committed to the idea of a culture as a tightly integrated entity, a "seamless web." Nonetheless it remains difficult to accept the idea that whatever seems to work in one culture can be predicted to be equally successful in some quite different context. (If that were the case, it might be that finally, as all the good ideas had been identified and brought together, all the bad ones could be assigned to the dustheap of history, and diversity would thus have finished its job; a sort of "end of history" vision.)

CONCLUSION: THE FUTURE OF DIVERSITY

I have sketched very summarily some different arguments in favor of cultural diversity. As I suggested before, not a single one of them may be entirely without hitches. Different audiences will no doubt also find them of varying appeal. On the other hand, none of them may have been proved entirely false. It might yet be sound policy for humanity to attach some value to cultural diversity.

We may also well ask, however, to what extent it needs to be actively defended; to what extent that scenario of global homogenization to which I referred before is realistic. I find it questionable. The prognosis for cultural diversity is not that bad. Again, some cultural forms vanish, and the spectrum of what is alive and well may become narrower. But at the same time as some of the human cultural record remains available only through archives, museums, and monographs, there is that continuous cultural reconstruction going on within the global ecumene.

If we look at the cultures around us now, I think we can discern that much of their diversity is not merely old diversity in decline, but new diversity that the global ecumene has bred. In this, cultural diversity differs from biological diversity. Zoological and botanical species now become extinct much more rapidly than new species can develop; the development of new culture, in contrast, is not necessarily such a slow process. I turn to that in the next chapter.

6

KOKOSCHKA'S RETURN
Or, the social organization of creolization

Trying to grasp the ways cultures change, we search for illuminating metaphors. Ernest Gellner, in *Nations and Nationalism*, contrasts two ethnographic maps; but the maps change quickly into other kinds of pictures. One of them, he says,

> resembles a painting by Kokoschka. The riot of diverse points of colour is such that no clear pattern can be discerned in any detail, though the picture as a whole does have one. A great diversity and plurality and complexity characterizes all distinct parts of the whole: the minute social groups, which are the atoms of which the picture is composed, have complex and ambiguous and multiple relations to many cultures; some through speech, others through their dominant faith, another still through a variant faith or set of practices, a fourth through administrative loyalty, and so forth.
>
> (Gellner 1983: 139)

Gellner's other map resembles Modigliani rather than Kokoschka: very little shading, neat flat surfaces clearly separated from one another, little ambiguity or overlap.

The first map, according to Gellner, is from before the age of nationalism, the other "after the principle of nationalism had done much of its work." The second map is one where state and culture coincide, where an industrial economy requires mobility and communication between individuals, and where the state, through one way or other of controlling formal education, makes sure that suitably modular individuals are made available.

What kind of ethnographic map of the world would we actually draw now – is it really Modigliani forever after, so to speak? And everywhere?[1] Let us hear from another immigrant intellectual on the British scene, Salman Rushdie, explicating his most famous novel:

> *The Satanic Verses* celebrates hybridity, impurity, intermingling, the transformation that comes of new and unexpected combinations of human beings, cultures, ideas, politics, movies, songs. It rejoices in mongrelization and fears the absolutism of the pure. *Mélange*, hotchpotch, a bit of this and a bit of that is *how newness enters the world*.
>
> (Rushdie 1991: 394)

Kokoschka's return? If the painting cannot be quite the same as before, at least there seems to be again, in Gellner's terms, "diversity and plurality and complexity," "ambiguous and multiple relations." Yet we realize also that Rushdie's metaphors are different – "a love-song to our mongrel selves," "I am a bastard child of history."

Long ago, a leading American anthropologist suggested that cultures were "things of shreds and patches" (Lowie 1920: 441), a sartorial metaphor perhaps. Since then, imageries have more often been artistic, "art-istic," as in Gellner's Kokoschka/Modigliani contrast, or in the recurrent idea of contemporary culture as a "pastiche" or "collage"; or unreflectively or, as in Rushdie's case, ironically biologistic ("hybrid" and "miscegenation" are yet other alternatives here).[2]

Concepts of "creole" and "creolization" offer us another set of images which have come to appear intellectually attractive, as a way of becoming sensitive to a number of features of the cultural history of the present. It used to be that there were only some handful of historically recognized creole cultures, mostly in the plantation areas of the New World, but now we sense that "creole cultures" may be turning into more of a generic term, of wider applicability.[3]

Some of the appeal of creolist concepts is no doubt rhetorical. In opposition to that broad and long-established current of cultural thought which emphasizes the purity, homogeneity, and boundedness of cultures, and in contrast with those biologistic metaphors which Rushdie struggles to turn on their heads, creolist concepts suggest that cultural mixture is not necessarily deviant, second-rate, unworthy of attention, matter out of place. To me, at least, "creole" has connotations of creativity and of richness of expression. Creolist concepts also intimate that there is hope yet for cultural variety. Globalization need not be a matter only of far-reaching or complete homogenization; the increasing interconnectedness of the world also results in some cultural gain.[4] Again, "a bit of this and a bit of that is how newness enters the world."

But I believe we can get beyond the merely rhetorical uses, to delineate what we call creole culture more precisely, and also to understand more clearly the processes by which such culture is made. In large part, of course, creolist ideas enter cultural studies from linguistics, and so we may see that language takes a place beside biology and art in offering at least metaphorical first aid in our attempts to grasp what is going on in culture today.

Here I would say on the one hand that it is plainly not always a good idea to model one's understanding of culture too closely on that of language, and that language hardly provides us with altogether unambiguous guidance anyway; on the other hand, more specifically, that creole linguistics, in all its internal variation and controversy, has rather more to offer than the occasional resonant image, even if we will also need to proceed beyond it.

In this chapter, what I want to do first, then, is to sketch the characteristic features of what I take to be creole culture. Secondly, I want to inquire further into the social organization of creolization. In scope, the resulting macro-anthropology of culture is perhaps not altogether unlike Gellner's; yet (to draw on his imagery again) the result may be rather more like the Kokoschka than the Modigliani.

CONFLUENCE AND CONTINUUM

What is at the core of the concept of creole culture, I think, is a combination of diversity, interconnectedness, and innovation, in the context of global center–periphery relationships.

The diversity in question involves a mostly rather recent confluence of separate and quite different traditions; set in the global context, this tends to mean that they have their historical roots in different continents. Perhaps it needs pointing out that this does not mean that these formerly separate cultural currents in themselves have been "pure," or "homogeneous," or "bounded."[5] We are not merely pushing an outdated understanding of cultures one step back. The point is simply that they are usefully identifiable as of different derivation in the moment, or the period, of creolization. To remind ourselves of the linguistic parallel again, there are a number of English-based creole languages in the world, yet hardly anybody would seriously argue that the English language is historically pure.

The interconnectedness typically takes the shape of a relatively continuous spectrum of interacting meanings and meaningful forms, along which the various contributing historical sources of the culture are differentially visible and active.[6] The context of center–periphery relationships suggests both the spatial dimension and the fact that the creole continuum has a built-in political economy of culture. Social power and material resources, as well as prestige, tend to be matched with the spectrum of cultural forms. At one end of this continuum there is thus the culture of the center, with greater although not always unambiguous prestige, as in creolist linguistics the "Standard," the "superstratum." At the other end are the cultural forms of the farthest periphery, often in greater parochial variety. In between are, to put it simply, a variety of mixtures.

A couple of additional points need to be made about this general conception of the cultural continuum. One is that the emphasis on the characteristic political and economic context of creole culture means that, despite what was suggested before about the worth and the vitality of creole culture, one should beware of taking an entirely celebratory attitude toward it. It is, after all, pervasively marked by the constraints of inequality.

The other is that the relative openness of the continuum as seen in cultural terms may be modified by social distinctions and the tendency to emblematize these through more sharply discontinuous cultural distributions. Where ethnicity channels interactions, for example, people may be more attuned to the creolizing constructions of others within their own group than to those of members of other groups, and engage in their own adoptions and adaptations of meaning and meaningful form with ethnic demarcations as an at least occasionally relevant criterion of acceptability. This may at times tend to create several coexisting continua, rather than a single, inclusive one. The idea of one creole cultural continuum must certainly often be understood as a rather oversimplified image, or a first approximative construct.[7]

In general, however, along the continuum, people are differentially and some-what complicatedly placed or on the move among different situations, mixing, observing each other, and commenting on each other. And to repeat: the cultural processes of creolization are not merely a matter of a constant pressure from the center toward the periphery, but a more creative interplay.

A creole complex such as this, I would suggest, can be seen as variably visible and pervasive in different places, and kinds of places. By the nature of things, it is less conspicuous in the center than in the periphery, although the furthest periph-ery may not be the most promising observation post either; look, rather, for a site a little closer to the center.

My own interest in creole culture was stimulated especially in connection with fieldwork in Nigeria, and certainly creolization, in culture as in language, is particularly typical of what were colonial, and are by now more likely post-colonial, situations (cf. Hannerz 1987). In Nigeria, I was in a country invented by European conquerors in the twentieth century, and where the visions and prac-ticalities of nation-building had since then been in the minds and hands of (among others) native-born contractors, academics, newsmen, taxi-drivers, and soldiers, in uncertain collaboration. I was in a town which, having begun as an alien artifact around a railway junction, went on creating and recreating itself through local comings and goings, enterprises, controversies, and hopes. Literacy and a world language had been brought to the country, not least by thousands of mission schools; now homegrown sects were doing Christianity their way, while Nigerian novelists and dramatists were winning international acclaim and metropolitan prizes. The popular culture scene was lively; its music had had some of its beginnings in guitar strumming in the palm wine bars of port cities, and some in old-style praise singing for chiefs and big men.

In an instance like this, creolist concepts may be useful in putting together a coherent understanding of a national culture; probably not the kind of homog-enizing, boundary-making, past-enhancing understanding that nationalists tend to prefer, but a more dispassionate mapping of the ordering of the cultural inventory. Yet we may also want to ask what are the possibilities of applying these concepts more expansively on the world scene, and examine moreover how creolization affects the center itself.

I can hardly more than hint at these possibilities here. Mostly, again, I am concerned with the overall social organization of contemporary creolization processes. I would argue that creole linguistics helps take us some of the way here, in so far as it has a built-in sociolinguistics which (perhaps with some poetic licence) I have just restated in cultural terms. In this sociological dimension creole linguistics has an advantage over the recurrent metaphors from art and biology, as well as over many other metaphors from the language domain, and it also seems to offer a more precise conception of the social ordering of cultural diversity and creativity than a term such as "syncretism." Even so, it may be that it helps us construct a type, rather than actually account for the making of creole culture.

THE PRODUCTION AND CIRCULATION OF CULTURE:
FOUR FRAMES

It is an understanding of that "making" I want to spell out here. My point of departure is that cultures are not themselves living beings; they are shaped and carried by people in varying social constellations, pursuing different aims. I take it as a useful approach to the complexity of cultural process to identify four organizational frames which entail different tendencies in the way that meanings and meaningful forms are produced and circulated in social relationships.[8]

These frames, I think, are easy to recognize, and allow us to account in at least a preliminary manner for a very large part of the flow of culture in the world today, whether in any more limited unit or in what we may refer to as the global ecumene. They are not to be seen in isolation from one another, however, but rather in their interplay, with varying respective strengths. What I propose to do here is to use them to map not least the spatial ordering of culture today, and in particular, the contexts of creolization.

The first of these frames, then, is that which I call *form of life*. My main point here is that cultural flow within this frame is just about always massively present, because we all contribute to it merely by going about our ordinary everyday lives. As we are around each other and observe each other, and listen to each other's running commentary on life, we take in the cultural flow of the form-of-life frame. It is the characteristic kind of circulation of meaning in households, work places, neighborhoods, and so forth; often routinized because it results from practical adaptations to enduring circumstances. This is not only the framework of relationships of great personal intimacy, however, but also that of more or less unregulated mingling with acquaintances and strangers, not necessarily much like oneself.

In many of the classical field sites of anthropology, the form-of-life frame encompasses more or less the entire cultural process. But even as in complex societies the latter becomes more differentiated, it would seem to remain the frame of most fundamental importance. It is characterized, again, by being the not very deliberate communicative by-product of living, decentered, largely symmetrically organized in the sense that we are all more or less equally at the producing and consuming, or sending and receiving, ends. It tends to involve great repetitiveness, and while our involvements with different frames may become more variously distributed as we get older, our earliest and perhaps in no small part formative experiences tend to be in this form-of-life frame.

I take the *state* to be another main frame of cultural organization, referring here to the flow of meaning between the state apparatus and the people defined as subjects/citizens. This is a much more deliberate and asymmetrically organized flow than that characteristic of the form-of-life frame, involving a number of institutions such as media, schools, museums, or civic ritual. The *market* as a frame of cultural process encompasses commoditized culture, that which passes from buyer to seller. Here again, cultural production and distribution seem to be mostly deliberate and asymmetrically organized. If the form-of-life frame is present

69

wherever human beings are together, the state and the market are also engaged in cultural management in most places in the contemporary world. As I noted in Chapter 2, state activity in this field increased with the coming of the ideal of the nation-state, and the Modigliani-like ethnographic map that Gellner suggests would be the ideal result of that activity. And to reiterate, the market is now both commoditizing more culture and making commodities more cultural.

The fourth frame of cultural management that I find it useful to identify is not as ubiquitous as the previous three, but it is one which has had a great impact on the cultural history of the present in a somewhat off-and-on fashion. I am speaking here of the *movement* frame, involving a highly deliberate although often rather decentered handling of meaning, a matter of persuasion and proselytizing, in relationships between those converted and those not yet converted. This is a frame which is perhaps not so central to an understanding of contemporary cultural creolization (although hardly irrelevant to it), and I will not discuss it further here.

Now imagining for ourselves a more or less overall accounting of cultural process in terms of these frames, I believe we can see how different agents are involved in the management of meaning and meaningful forms, but with different motives and with varying degrees of deliberateness; with some relatively few reaching out through asymmetrical relationships to a great many others, and a much greater number on the other hand reaching, through more symmetrical relationships, each to relatively few. There are spatial as well as temporal implications in this, and they are important to an understanding of creolization.

CREOLIZING THE PERIPHERY

Let us begin to work this out at the periphery. This is where center–periphery relationships are more intensely experienced and where we should consequently be able to assume that creolization processes ought to be most comprehensive; also, of course, what we may now term the periphery has the classic field sites of anthropologists.

In the terms of cultural flow, it is particularly the asymmetries of the market and state frames that create relatively unambiguous center–periphery relationships. It would seem natural to say something first about the market, widely assumed to be the prime mover in the twentieth-century globalization of culture. Commoditized meaning and meaningful form are what seem most readily to diffuse across national boundaries, asymmetrically from the North American/western European center to Africa, Asia, Oceania, or Latin America. The market is expansive not only in terms of its agents trying to commoditize as much as possible, but also in terms of their selling the same thing to as many as possible, regardless of where these customers are. From this point of view, unless it is constrained, the market will try to work over great distances, and transnationally. Transportation technology, and particularly the media as specifically cultural technology, are obviously of great assistance here.

But saying this much one does not take the consumers, their tastes, and their exercise of choice, much into account. Not least in order to get a sense of the construction of consumers, we may be better off giving some priority to an examination of cultural management within the state frame.

More successful states may "paint Modiglianis" together, through their cultural policies; but the view of the nation state as homogenizing on the inside and bounding toward the outside needs some scrutiny. In particular, the peripheral state has a rather more multifaceted part as an agent in cultural process.

The view of nations as "imagined communities" put forward by Benedict Anderson (1983) – and discussed from a somewhat different point of view in Chapter 2 – is similar to Gellner's, although there are some differences of emphasis. Language is taken to be the main marker of the distinctiveness of the nation, as that conception developed in European history. This, however, was specifically the written and printed language of the bourgeoisie, a dominant stratum who could draw on it to build and celebrate an identity beyond the local. Being written, this language became standardized. It was fixed in time, and while in spoken language a great many local or regional dialects could exist side by side with more or less equal authority, writing, and especially print, made one dialect dominant, subordinated others, and drew boundaries from its vantage point.

A language, it has been said, is a dialect with an army; the joke points to the interrelationship between state, nation, and language. This, it would appear, is also the linguistic metaphor for cultural organization which matches the Modigliani.

Creolist imagery seems to me to allow a more complete view of variation. It takes into account the fact that the language of writing and print becomes the standard, but it does not hide the continued presence of the entire range of interrelated dialects as well. If we return to Gellner's argument that education is an important component in nation-building, we can indeed see that through its control of education – and in one way or other, this is a prevalent arrangement – the state engages in the cultural construction of citizens, inculcating loyalty to that conception of the nation to which it publicly adheres, as well as an almost universally replicated set of basic skills, including literacy and numeracy.[9] On the other hand, education in the hands of, especially, the peripheral state also has some quite different, almost opposite implications for the ordering of culture. It is on such tendencies I want to focus attention here, with some recognizable linkage to both Bourdieu and other recent sociologists of education and culture.[10]

Education creates differences, as it sorts and prepares people for that division of knowledge which matches a contemporary division of labor. And this division of knowledge also entails a differentiation of more general cultural orientations which would appear to be important in organizing the creole continuum.

By making education a common cultural currency, of which people can have more or less, the state both creates hierarchy and makes people differentially located within it at least partially understandable to one another.[11] In the peripheral regions of the world, too, more formal education tends to be synonymous

71

with a greater involvement with metropolitan culture, as much of the knowledge involved is shared with, and at one time or other imported from, the center.

The state, that is to say, is a transnational cultural mediator. It is involved here on a large scale in ordering the population into categories with different cultural horizons, where those with a stronger orientation toward both global and national centers are also given more power and greater prestige; and usually superior material resources as well. While the state is hardly alone in shaping this pattern of cultural distribution, it is obvious that it contributes greatly to the formation of a cultural center–periphery continuum, in the national setting and with transnational extensions. Yet this center–periphery continuum of culture needs to be further contextualized, to pin down a little more precisely both the extent and the limitations of the state as an agent of creolization, where the diffusion suggested here is combined with innovation and synthesis. We should attend to the varied ways in which the organizational frames of cultural flow may interrelate.

Nobody, anywhere, is completely shaped as a cultural being within the formal educational apparatus. Rather, people are formed continuously through their experiences in all kinds of contexts; and a great many of these contexts can be seen to belong in what I have called the form-of-life frame.

Accepting that the educational apparatus has a significant impact in constructing and categorizing people in contemporary societies, then, we need to ask how this is also rather more indirectly apparent, especially in the form-of-life contexts where a greater part of the action is. It would seem that there is great variation in this respect. Some people, having spent more time undergoing education, are more likely to have been extensively shaped by it; as agents within the form-of-life frame, the most highly educated elites may thus tend to organize contexts around themselves, individually and in groups, in such a way that these contexts are fairly permeated by the competences, beliefs, and values acquired through formal training. These may well be the people most directly reached from the center, through their personal networks as well as through, for example, their media habits.

At the periphery, they represent one end of the cultural continuum. They and their life styles are often highly visible on the national arena, and are likely to be emulated by others, to one degree or other, directly or indirectly through a kind of downward cultural trickle. They are mediators and models. Literary fiction as well as social criticism from the colonial or postcolonial periphery have long been somewhat preoccupied with such groups and individuals, immersing themselves in metropolitanism; they are, or have been, the *evolués*, the *assimilados*, the "brown sahibs," the Afro-Saxons, in Anglophone West Africa the "beentos," so called because they have been to Britain. (In Malabo, the Equatoguinean capital as sketched in Chapter 4, they would surely have included Don Bonifacio and Don Constantino, with their overseas training.)

Yet these people's particular equation of cultural engagements, where meanings and symbols anchored in the state educational apparatus seem to reverberate through other frameworks of cultural organization as well, appears unusual. With its

organizational bias toward large scale in the handling of meanings and symbols, the state cannot directly regulate the minutiae of cultural management in a myriad of everyday events, even in parts of the range where its presence is more noticeable, and often does not do so even indirectly, through the agency of those most clearly under its influence. The fact that it offers less of the culture under its control to some people than to others, moreover, obviously does not mean that these latter will be in a more general way "uncultured," "culturally deprived"; it only means that the state has a smaller part (apart from what is involved in the homogenizing construction of the citizenry) in giving cultural content to situations along some range of that continuum the overall form of which it has taken a major part in defining.

Thus in the lives of a great many people, some situations tend to become the free zones of other cultural currents, less immediately affected by center–periphery relationships, often drawing from local or regional traditions. These are most likely the situations of domesticity and neighborhood life, or work situations where the part of formal education is limited or negligible.

Briefly put, it is through the part played by more indigenous elements such as these in the construction of ordinary practices and interactions not exhaustively defined by outside powers that much of the everyday life of the periphery is creolized. To take up a theme from Chapter 4 again, it is in large part in this way that the shift occurs from a mere diffusion of modernity to the emergence of new diversity. There is great variation here in the personal and situational equations which shape outcomes, and this – not merely the more or less officially defined hierarchy – generates the actual cultural continuum. It is by way of people's attentions to one another in situations within the form-of-life frame, perhaps more indirectly reflecting the currents within other frames, that meanings are most continuously and precisely constructed. Depending on patterns of social inclusion and exclusion which influence interactions and attention structures, individual cultural repertoires will furthermore include different degrees of acquaintance and familiarity with various parts of the entire cultural inventory, as stretched out along the continuum.

The main implication of the view I have sketched seems to be that the state comes in at an early point in the overall formation of the cultural continuum, but has a more limited role in actually filling out its entire space. In supplying people with different amounts of educational assets, in promoting an organization of the division of labor to no small extent around this distribution, and in thereby giving its support to one principle of cultural as well as social hierarchy, the state opens up that space to transnational influences at one end, and indicates a direction for internal processes. In the detailed working out of cultural confluences, on the other hand, its presence cannot be very strongly felt, and is less so in some situations and among some people than elsewhere.

Such a view should be directly relevant to an understanding of what actually goes on in the market frame. As the state is engaged in differentiating people through education, but constructs them more or less completely in doing so, it also

has its part in constructing different kinds of consumers, with different tastes in the cultural market-place. Those who we have observed as being most intensely shaped by formal schooling – taught to fix their gaze further away, trained to interpret and enjoy imported meanings and symbolic forms – are often the most metropolis-oriented consumers; usually they have the greatest spending-power as well.

The rhetoric of global homogenization by way of the market, I would suggest, draws many of its overly generalized examples from the highly visible consumption patterns of this market segment. These are the people frequenting major department stores, reading *Time* and *Newsweek* perhaps, preferring transplanted foreign fast-food chains to the local street stalls, and – in good years – even flying into London or Paris for shopping safaris.

They are, of course, visible to other local people at home as well, and again, one should not ignore their importance as cultural models to other people, when it comes to consumption either. Yet these other people hardly fit into the market the same way, in terms of either cultural or other capital. It is here we must make more explicit a cultural understanding of the segmentation of the market. If there is one tendency within the market frame to homogenize and reach as widely as possible with the same goods, there is also the alternative of limiting the competition by finding a particular niche for a more specialized product. In focusing on the market as the major force of global homogenization, we are too prone to ignore this alternative. And the major way in which such niches are found, as far as the cultural market place is concerned, is presumably in the production of commodities which show a closer fit with cultural flow within the form-of-life frame.

The market frame, that is to say, does not only present us with the spectre of global homogenization, but also striking instances of cultural innovation through creolization.[12] Popular culture tends to offer the most conspicuous and appealing examples. Nobody with any experience of West African urban life, for example, can fail to be impressed with the continuously changing variety of popular music – highlife, juju, Afrobeat, apala, fuji.[13]

Creolized music, art, literature, fashion, cuisine, often religion as well, come about through such processes. The cultural entrepreneurs of the periphery carve out their own niche, find their own market segment, by developing a product more specifically attuned to the characteristics of their local consumers. The culture businesses of the center may have much greater material resources, but these local entrepreneurs have the advantage of knowing their territory. Their particular asset is cultural competence, cultural sensibility. Through their roots in local forms of life, they sense which concerns and tastes can be translated into market shares. Quite possibly they may engage here in commoditizing culture hitherto available through the free flow within the form-of-life frame. Yet the meanings and symbolic forms which they draw upon tend also to be inserted into new and original combinations with organizational forms, technology, and culture drawn from more distant, transnational sources.

This, it might be inserted, is looking at the creolization of the market more from the point of view of the local cultural entrepreneur. As far as the consumers are concerned, their choices among the commodities of the cultural market are not necessarily confined within a single segment, but may sometimes reflect a familiarity with a wider range within the cultural continuum through a greater spread of consumption preferences. Their cultural tastes may be, as it were, more or less omnivorous rather than univorous (cf. Peterson 1992). This, too, makes the creole continuum more complex.

STATE AND FORM-OF-LIFE:
ADDITIONAL COMMENTS

I have tried to sketch roughly how I understand that the state and the market, by way of their interrelations with cultural process in the form-of-life frame, come to organize a creole continuum in the periphery of the contemporary global ecumene. A number of additional comments are no doubt called for.

To begin with, I may run the risk of granting too little to the power of national identity and nation-building. It is, of course, true that like the bourgeoisies of Benedict Anderson's imagined communities, peripheral elites today want to draw boundaries, want to turn their states into distinctive nations. Thus they may use culture for ideological purposes to distance themselves from the center and to assert their identification with the masses.[14] Placing such an understanding next to that of the cultural continuum relating to education and differing cultural horizons, however – and combining the two – I suspect creates the more acute sense of a Janus-faced life; the sense of a jet-set searching for roots, or at least proclaiming such a search, and at the same time seeking out the bright lights of the metropolis.

In any case, the involvement of the elite in nation-building entrepreneurship is one factor that contributes to making the creole continuum something other than a simple cultural trickle-down affair: there would also be a certain trickle-up of ideological appropriation from the further reaches of the periphery. It is yet another complication that, in so far as culture is differentially distributed so as to correspond to a distribution of power, it can be used not only transnationally, but internally as well, to represent conflict and resistance; and whatever tendency there may be for metropolitan culture to pass downward may then be opposed by the tendency from below to draw on more indigenous cultural currents, and to ridicule foreign imports. This is again part of the dynamic ambiguity of the creole cultural continuum.

Another aspect of the idea of national culture which one may want to keep in mind is that the idea of the nation-state is itself in part an item of global cultural diffusion. It encompasses a standardized inventory of forms, to be given local and contrastive, as well as culturally resonant, content.[15] This inventory may have been developed in nineteenth-century Europe, but in the twentieth century it is used almost everywhere. I take this to be in large part an expression in the cultural domain of the fact that the late-starting states of the periphery are

creations of the international system, built from the top down rather than from the bottom up, as it were.[16]

Pursuing this line of thought, one might go as far as to argue that a great many state apparatuses today, as they promote messages of nationhood, are themselves creolizing local cultures; they produce new culture by inserting selected indigenous meanings and symbols into an imported matrix, to which they must in some ways be adapted. Yet this is a creolization which the state can hardly itself celebrate, but must rather define away, in its pursuit of cultural integrity and authenticity.

It is perhaps especially important to clarify some assumptions about the form-of-life frame. I have suggested that the state, through its educational machinery, has a large part in arranging its subject population into the structure of a creole continuum, but that the form-of-life frame is more important in filling in its content, to put matters perhaps somewhat inexactly. And I have also argued that it is through its interrelation with the diversity included within the form-of-life frame that the cultural market becomes segmented, and thus likewise an integral part of the creole continuum. Clearly I attach great significance in both these ways to the form-of-life frame as a source of cultural resilience and innovation in the creolization of the periphery.

For such reasons, a few words of caution are also in order; some related comments were made in Chapter 2. The form-of-life frame may be just too convenient a receptacle for a number of timeworn and somewhat dubious anthropological ideas. There is the danger that we see it as timeless and unchanging, a bottomless well of cultural tradition, an unqualified guarantee that the exotic will always be with us.

Even if we accept that the sheer massiveness and redundancy of cultural flow within this frame inevitably make it a major factor in the overall cultural equation, something the cultural administrators and entrepreneurs of state and market cannot realistically avoid grappling with, we must not disregard the fact that it, too, can change. Already before globalization became as involved in changing the hearts and minds of people directly as it has been in recent times, it could do so more indirectly by changing the material contexts to which forms of life had to adapt, as in old-style, resource-extraction colonialism.

This, obviously, is a source of historical change which has already had an irreversible impact in many places, and continues to be important, appearing forever in new guises. Moreover, the relationships between market, state, and form-of-life are under continuous negotiation, and the influx of meanings and meaningful forms from the former two no doubt has a long-term influence on the latter as well.

So much for the relationship between the form-of-life frame and time. With regard to space, there is some risk that we identify the form-of-life frame too closely with the local, so that the state/form-of-life interface is routinely taken to involve a "nation and community" problematic, and the market/form-of-life interface what is now very popularly described as "the global and the local." It is obviously true that much of the cultural process of the form-of-life frame occurs

within a very limited territory; again, often the face-to-face relationships of family, work place, neighborhood. But we must take note that numerous current kinds of geographical mobility greatly increase the spaces within which some people directly, and a great many more people indirectly, are involved in the cultural processes of ordinary meeting and mingling. And such rather personally controlled, in principle symmetrically organized media as letters, telephones, faxes, photographs, and home-made videograms likewise contribute to the growth of that space. It may be that current social and cultural thought about globalization has been too preoccupied with the parts played by state and market really to observe and reflect on the proliferation of transnational linkages within the form-of-life frame, and their cumulative weight; a theme I will return to repeatedly in the next few chapters.

CREOLIZATION AT THE CENTER

This brings me to a few concluding comments on creolization at the center of the global ecumene, in western Europe and in North America; in places like London, Paris, and New York, the new homes of writers like Salman Rushdie and Ben Okri, or musicians like Youssou N'Dour or Manu Dibongo, not to speak of hundreds of thousands of more anonymous migrants.

The equation of cultural process, so to speak, is different here. The state frame is not, as in the periphery, involved in large-scale, systematic transnational cultural diffusion. Its major tradition as far as cultural management is concerned, is that of nation-building – contributing to the Modigliani picture. In some places, only in the last couple of decades, it may have assimilated ideas of cultural welfare to more general notions of the welfare state, but any cultural policy of such orientation seems to have a way of mostly merging with that of preserving and promoting nationhood. When the state is confronted with concepts of multiculturalism, there often seems to be acute intellectual and organizational embarrassment.

Here the market frame is apparently more flexible, but again by working through various and rather intricate interrelations with the form-of-life frame. The newcomers to the center may be seen, in part anyway, as local extensions of the periphery. Through the cultural processes there which I have already sketched, they are already creolized when they arrive, and they can be seen to be further creolized through their engagements within state, market, and form-of-life frames in their new surroundings. But the natives are also frequently, in some way, and to a lesser extent probably, creolized: the periphery is now speaking back. To some degree, perhaps, this happens to the natives through their encounters with new workmates, neighbors, even kinspeople, in the form-of-life frame; but in other ways fairly effectively (although not very comprehensively) in the market-place. (More on this in Chapters 11, 12, and 13.)

One way that competition in the market operates, of course, is through innovation, and this is true in the cultural market of the center as well. In recent times, one prominent source of novelties has been the periphery. This is very evident in

popular culture, for example in music and in cuisine, although recent lists of Nobel and Booker Prize winning writers tell us that high culture shows some of the same tendency. Yet note that the successful cultural commodities imported from the periphery to the center are hardly the "authentic," "pure" products of the most distant periphery, freshly commoditized out of the form-of-life free flow of any bush village. It is much more likely to be something already creolized, a mixed form out of the encounter between center and periphery, and thus already something with a rather greater cultural affinity to the center.

So what is then the final picture, or at least that of the present, the real ethnographic present (cf. Sanjek 1991)? Not, I would suggest, the Modigliani, unless we are willing to blind ourselves to many features of contemporary culture. It could be, of course, that we really should have had Modigliani and Kokoschka get to work on a canvas together, as there may be parts of the world where the neat surfaces really are even now more clearly separated, and others which have a great deal more of the multiple relationships, the complexity, the ambiguity. Yet Kokoschka is back, and it seems that he is taking over rather more of the canvas. He seems now to be an artist for both center and periphery, although not with quite the same pattern. The art metaphor, however, takes us only so far. We need other conceptual tools to understand how the pattern is generated; to understand that the multiple, the complex, the ambiguous, the diverse are also socially organized.

Part II

PEOPLE

7

THE WITHERING AWAY OF
THE NATION?

In the concluding pages of his *Nations and Nationalism since 1780*, Eric Hobsbawm asks whether the world history of the late twentieth and early twenty-first century will be written, as that of the nineteenth century could be, in terms of "nation-building." He does not think so. Nations and ethnic groups will rather be seen as perhaps offering some resistance to, but mostly retreating before, adapting to, or being absorbed or dislocated by a new supranational restructuring. One sign that the national phenomenon is past its peak is indeed the progress historians have recently made in studying it: "The owl of Minerva which brings wisdom, said Hegel, flies out at dusk. It is a good sign that it is now circling round nations and nationalism" (Hobsbawm 1990: 182–183).

Minerva's owl (here perhaps looking rather more like a vulture) might well be the historians' favorite bird, in so far as it can be relied on to lend its wings to their claims to superior understanding. And if we try to inquire into present or even future states of affairs, and more especially into what might be grounds for the retreat or decline of national ideas, we would seem to have both Hegel and Hobsbawm advising us against the undertaking.

Nonetheless, what I want to do here is to consider some of the present and emergent circumstances which could contribute, to one degree or other, and among some people but not necessarily all, to a weakening of the nation as imagined community and source of identity. I will proceed largely by arguing with or against some of the more prominent recent commentators on nations, national culture, and nationalism, letting their voices be heard as well; and also some other voices, in accord or discord, which may enrich our own imagination.

Before proceeding any further, however, I should probably say something about the title of this chapter. I distinguish between the nation and the state. In recent times we have indeed seen what might look a little like a withering away of states, in some places in the ex-Second and Third Worlds; but when I use the notion "withering away of the nation," I do not assume that such a process would necessarily entail a withering of the state as well.[1] It may be that "nation-ness is the most universally legitimate value in the political life of our time" (Anderson 1983: 12), but states, or whatever other agents use this value for purposes of legitimation, can conceivably find ways of continuing without nationhood, and might find other

ways of establishing their worth (if they in fact concern themselves with legitimacy).[2] Moreover, and very significantly, there is that question mark at the end of the title. I do not promise that it will be gone by the time I am through.

THE NATION AND CULTURAL RESONANCE

Hobsbawm, we just saw, had his doubts about the continued strength of nations in this era of globalization and transnational structures. We can juxtapose with him one of the most diligent writers on national phenomena in recent times, Anthony D. Smith (e.g. 1990, 1991), who looks with great skepticism at the power of contemporary transnational culture to impress itself upon people's more deeply held, enduring perspectives and sentiments. This transnational culture, Smith argues, consists of a number of discrete elements:

> effectively advertised mass commodities, a patchwork of folk or ethnic styles and motifs stripped of their context, some general ideological discourses concerned with "human rights and values" and a standardized quantitative and "scientific" language of communication and appraisal, all underpinned by the new information and telecommunications systems and their computerized technologies.
>
> (Smith 1991: 157)

It is "eclectic," "fundamentally artificial," and "indifferent to place and time," Smith goes on; its pastiche is "capricious and ironical," and its "effects are carefully calculated." It "lacks any emotional commitment to what is signified," and "is more interested in means and in reformulating dilemmas of value into technical problems with purely technological solutions." And then Smith reaches the big question: can such a culture "put down roots among the populations of the world?" (1991: 158).

By the time Smith gets to the question, one might note, the metaphors have been fairly well stacked against an affirmative reply. Transnational culture has been declared "fluid and shapeless," carries "surface decoration," is "shallow," and has a "veneer of streamlined modernism," we are also "deluged with a torrent of standardized mass commodities." Confronted with so much evidence of both superficialty and quite violent fluidity, and then asked if something like this can "put down roots," you would have to be an idiot to answer "yes" – or someone just a little provoked by rhetorical overkill.

If Smith is less than impressed with the depth and coherence of the transnational culture of the late twentieth century, he is the more so with national culture, and national identity. The idea of the nation is ubiquitous, itself globalized, as well as pervasive:

> Though there are some situations in which it is felt to be more important than others, it may also be said to pervade the life of individuals and communities in most spheres of activity. In the cultural sphere national

identity is revealed in a whole range of assumptions and myths, values and memories, as well as in language, law, institutions and ceremonies. Socially, the national bond provides the most inclusive community, the generally accepted boundary within which social intercourse normally takes place, and the limit for distinguishing the "outsider." The nation may also be seen as the basic unit of moral economy, in terms both of territory and of resources and skills.

(Smith 1991: 143–144)

Such pervasiveness, and not least the durability of such pervasiveness, sets the context for Smith's (1991: 160 ff.) argument concerning the continued viability of nations as imagined communities. The nation has a perceived collective past, and much as scholars (including, of course, Hobsbawm), with an ironical glint in the eye, have taken to celebrating the recent and ongoing manufacture of traditions, Smith believes such innovations would get nowhere unless they offered a sufficiently close fit with existing ideas and emotions.

This collective past, this "ethno-history," together with its promise of a future, he proposes, offer people above all three deep satisfactions. There is an answer to the problem of personal oblivion; your destiny is with the nation's future generations. There is also the sense of a national restoration of dignity. If there was a glorious past, there must be a glorious future, and a personal share in that coming renewal. Thirdly, the nation offers the possibility of fraternity. Those living are of one large family. Yet this is made clear, of course, through shared symbolic references to the past, to the ancestors held in common.

I am reminded, as I read Smith on the uses of the perceived collective past and its extension into the future, of Bennett Berger's (1971: 4–5) discussion of "cultural resonance." The power of culturally resonant images and events to evoke deep emotional response, according to Berger, is triggered not by economic self-interest, political expedience, or any other purely instrumental considerations, but by their direct appeal (or threat) to "expressive" or "consummatory" values which transcend such immediate interests. These images and events resonate far beyond the people most immediately and actively involved, they mobilize dispositions to affirm them or reject them, they "touch a people's sense of their past and anticipation of the future."

The national, obviously, has been something of great cultural resonance. Is it still? – to whom, and to whom perhaps not? Are there alternative, perhaps in some way competing sources of cultural resonance? How does the "new supranational restructuring" of which Hobsbawm speaks affect the generation and distribution of cultural resonance in the world?

VARIETIES OF TRANSNATIONAL EXPERIENCE

Let us consider some recurrent varieties of personal experience today; experiences which touch on issues of time, space, loyalty, and identity, and which relate somehow uneasily to national boundaries.

Increasingly in the current era, Robert Reich has argued in *The Work of Nations* (1991), work in advanced societies falls into three main categories; those he calls routine production services, in-person services, and symbolic–analytic services. The first of these entail the endlessly repetitive tasks of a great many blue-collar as well as white-collar workers. The major difference between these and the in-person services is that the latter must be provided, if not face-to-face with customers, at least in their immediate environment; in-person services include the jobs of retail sales people, waiters and waitresses, janitors, secretaries, hairdressers, taxi-drivers, and security guards. The third category is that with which Reich is most directly concerned: the symbolic–analytic services, including for example research scientists, various kinds of engineers, investment bankers, lawyers, any number of kinds of consultants, corporate headhunters, publishers and writers, musicians, television and film producers ... "even university professors."

What the symbolic analysts have in common, Reich suggests, is the non-standardized manipulation of symbols – data, words, oral and visual representations. They are problem-identifiers, problem-solvers, strategic brokers; highly skilled people whose continuously cumulative, varied experience is an asset which makes them relatively autonomous *vis-à-vis* particular places and organizations.

The symbolic analysts, in the contemporary picture which Reich draws, are linked to global webs of enterprise. They are no longer particularly dependent on the economic performance of other categories of people in their national contexts, such as people in routine production services. And in the American case, which is Reich's major concern, he finds that the "symbolic analysts have been seceding from the rest of the nation" (1991: 252). It has been a secession taking place gradually and without fanfare. The symbolic analysts may pledge allegiance to the flag with as much sincerity as ever, yet "the new global sources of their economic well-being have subtly altered how they understand their economic roles and responsibilities in society."

Among the tribes of symbolic analysts we seem to get the close-up view of the nation retreating, as suggested by Hobsbawm. They build their own monuments – the convention centers, the research parks, the international airports – and withdraw into their own private habitats, enclaves with security guards if need be. If they are less concerned with local routine production services, which are liable to be replaced more cheaply somewhere else in the world, they may on the other hand be more interested in the quality of the in-person services.

The tendency toward a withdrawal of the symbolic analysts is not only American, although Robert Reich sees some variations of degree in different places (1991: 202). It is not a tendency which pleases him. Symbolic analysts, he believes, are not likely to exchange an old commitment to the nation for a new global citizenship, with an even more extended sense of social responsibility. There are no strong attachments and loyalties here, but more likely a sense of resignation. "Even if the symbolic analyst is sensitive to the problems that plague the world, these dilemmas may seem so intractable and overpowering in their global dimension that any attempt to remedy them appears futile" (1991: 310).

What Reich argues for, then, is a revitalized commitment to the nation, more especially a shared investment in the productivity and competitiveness of all its citizens, within the framework of the globalized economy.

When Reich's book was published, he was a Harvard political economist. Since then, he has been Secretary of Labor in the Clinton Administration, and thus perhaps in a position to do something about all this. Yet it is hardly obvious how such a renewed political will, including the symbolic analysts in the alliance, is to come about. In any case, if we consider Reich's ethnography of recent trends rather than his enlightened nationalist call to action, we see that the symbolic analysts, in all their internal diversity, would appear to have distanced themselves from much of what Smith, as quoted above, sees as characteristic of the nation. The latter hardly "provides the most inclusive community, the generally accepted boundary within which social intercourse normally takes place," it is questionably "the basic unit of moral economy." The possibility of fraternity does not seem to be embraced. Yet there is no doubt room for some symbolic ambiguity even among symbolic analysts – national allegiance may be proclaimed even when not really practiced, and to the problem of personal oblivion, for example, one may not yet have come up with a better answer.

Again, the ideal-type symbolic analyst according to Reich is fairly autonomous in relation to organizations as well as places. This would seem to be not quite the kind of person, then, that another commentator on the contemporary restructuring of the world, Kenichi Ohmae, is most concerned with. Ohmae, author of *The Borderless World* (1990) and several other books, and a frequent contributor to *Wall Street Journal* as well as *Harvard Business Review*, is an international management consultant – "guru" is a term that comes to mind – with a particular interest in the workings of corporations in the global market place. What he has to say about the internal life of a corporation reaching the highest stage of globalism also reflects, I think, on our assumptions about the national.

The global corporation, in Ohmae's view, must loosen its ties to any particular country, "get rid of the headquarters mentality," "create a system of values shared by company managers around the globe to replace the glue a nation-based orientation once provided" (1990: 91). It needs an "amoebalike network organization." This organization depends on a shared unofficial culture which cannot be learned by reading the same manual or going to the same brief training program. It can only grow over time, Ohmae argues, as people develop a broad range of common references and experiences. They must meet face-to-face over the years, they must stay at each other's homes, their families must know each other; and at the same time formal structures – training programs, career planning, job rotation, evaluation systems – must also be the same wherever the corporation first finds you, and wherever it then places you. Only thus is the highest stage of corporate globalism reached:

> The customers you care about are the people who love your products every-
> where in the world. Your mission is to provide them with exceptional value.

When you think of your colleagues, you think of people who share that mission. Country of origin does not matter. Location of headquarters does not matter. The products for which you are responsible and the company you serve have become denationalized.

(Ohmae 1990: 94)

You really have to believe, deep down, that people may work "in" different national environments but are not "of" them. What they are "of" is the global corporation.

(Ohmae 1990: 96)

Ohmae admits that few if any corporations have quite reached this far, although "the signs of movement in this direction are numerous and unmistakable" (1990: 91). It is interesting, in any case, that the vision seems to go beyond that of Robert Reich, who sees among the symbolic analysts mostly an attenuation of national ties. Here the corporation apparently becomes an alternative, a transnational source of solidarity and collective identity, a basic unit of moral economy in Smith's terms again, while the nation at the same time becomes defined as little more than an environment, a local market (and moreover, not the only one).[3] In the shared life and personal ties of the corporation, it is implied, cultural resonance can again be found. The corporation may even have a history, a mythology of the past, and celebrate it. More certainly, it will offer some vision for the future.

Ohmae's transnational organization man and Reich's symbolic analyst are two recognizable social types of the present, fairly closely related. But listen now to another voice, the reggae fan Jo-Jo, as recorded by Simon Jones (and quoted by Dick Hebdige) in Birmingham's multi-ethnic Balsall Heath neighborhood:

there's no such thing as "England" any more … welcome to India brothers! This is the Caribbean! … Nigeria! … There is no England, man. This is what is coming. Balsall Heath is the centre of the melting pot, 'cos all I ever see when I go out is half-Arab, half-Pakistani, half-Jamaican, half-Scottish, half-Irish. I know 'cos I am (half Scottish/half Irish) … Who am I? Tell me who do I belong to? They criticise me, the good old England. Alright, where do I belong? You know I was brought up with blacks, Pakistanis, Africans, Asians, everything, you name it … who do I belong to? I'm just a broad person.

(Hebdige 1987: 158–159)

Jo-Jo, I take it, is a young man of the streets, not a self-conscious and well-read intellectual. Nonetheless, his point of view reminds me strikingly of some of Salman Rushdie's (1991: 394) formulations, as quoted in Chapter 6 – "hybridity, impurity, intermingling … a love-song to our mongrel selves." It seems to me that Jo-Jo and Rushdie are on to the same thing. But Rushdie, of course, gets both more reflective and more elaborate, and so we may record a little more of his comments.

Rushdie sees his writing as drawing on the migrant condition. In preparation for his earlier novel, *Midnight's Children*, he had spent months trying to recall as much as he could of his childhood Bombay. He was thrilled to see how much had

in fact been stored somewhere in his memory, and yet it was precisely the partial nature of his recollections that made them so evocative to him:

> The shards of memory acquired greater status, greater resonance, because they were *remains*; fragmentation made trivial things seem like symbols, and the mundane acquired numinous qualities ... It may be argued that the past is a country from which we have all emigrated, that its loss is part of our common humanity. Which seems to me self-evidently true; but it suggests that the writer who is out-of-country and even out-of-language may experience this loss in an intensified form. It is made more concrete for him by the physical fact of discontinuity, of his present being in a different place from his past, of his being "elsewere." This may enable him to speak properly and concretely on a subject of universal significance and appeal.
>
> (Rushdie 1991: 12)

The migrant looks here to a past which is spatially as well as temporally distant; it may be reflected in his present in different ways. For some, it may intensify the sense of nationhood and national identity, rooted back home. But Rushdie is also (as more obviously in *The Satanic Verses*) concerned with a more general human experience of migration and uprootedness. Moreover, he sees the possibility of a continuous reconstruction of the past of his adopted country as well. Others have become British before him – the Huguenots, the Irish, the Jews; Swift, Conrad, Marx. "America, a nation of immigrants, has created great literature out of the phenomenon of cultural transplantation," Rushdie (1991: 20) concludes, and suggests that the example can be followed elsewhere.

Indeed much of the most gripping in recent fiction and autobiography thematizes what Rushdie calls "hybridity, impurity, intermingling." Whether or not that great literature also becomes national literature may be another matter. It is one thing for the United States, more accustomed to defining itself as a nation of newcomers, to find its identity in a master narrative of migration and melting pot (yet even here we see the current problems of multiculturalism and the canon). In Britain, the dominance of other ideas of historical roots would seem much more difficult to contest. As Jo-Jo of Balsall Heath has it, "they criticise me, the good old England."

Being out-of-language, Rushdie also notes in the quote above, is an intense experience. Smith, on the other hand, points to language as one area where national identity is revealed. I will not dwell for long here on the argument about the connection between language and nation, and between cultural technologies and cultural boundaries, discussed fairly extensively especially in Chapter 2. Of the voices we have listened to here, however, Rushdie's is not alone in alluding to the possibility that, as globalization entails language shifts, multilingualism, or at least bilingualism, personal identification with one language may change character, together with the identification with the one imagined community attached to it. Kenichi Ohmae has another example:

Quite literally, global firms must share a common language, English, in addition to all the languages spoken locally. I know of two German companies that have recently changed their official language of business from German to English for just this reason. Talent must be accessible around the world ... mother-country identity must give way to corporate identity.

(Ohmae 1990: 94–95)

The fact that in one's ongoing life one is not always using the same language often stands as one very tangible sign of the fact that this life is not all carried on within the national framework. Speaking (or writing, or reading) one's "mother tongue" is no longer taken for granted; whether this increases one's identification with it, as one becomes aware of how naturally it flows compared to one's not altogether painless efforts to use other languages; or whether one's intellectual distance to it grows as certain things seem to be better said in the other languages, are questions with no single simple answer.

What, then, is my general point? From Reich to Rushdie, by way of Ohmae and Jo-Jo, I wish to suggest, we seem to see that there are now various kinds of people for whom the nation works less well as a source of cultural resonance. In the case of the symbolic analyst, and perhaps for some variety of others as well, it perhaps becomes less a richly imagined community than what Morris Janowitz (1967: 210 ff.), in an entirely different context, referred to as a "community of limited liability" – one has a largely transactional relationship to it, and one withdraws if it fails to serve one's needs. So the big question (a bit provocatively) would be, what can your nation do for you that a good credit card cannot do?

If the nation as an idea is culturally impoverished here, we cannot be quite certain whether it is replaced by anything else. Reich has little to say on this point. Ohmae, on the other hand, suggests that the global corporation should turn itself into something like a nation. We may disapprove of this, seeing it only as the business consultant's utopia, a manipulated product of corporate managerial ideology (but then some measure of manipulation has certainly gone into the building of other nations as well).

With Jo-Jo and Rushdie, however, it seems undeniable that much of the most deeply felt, highly resonant, personal experience is at odds with ordinary notions of the national. Perhaps this experience and the shared understandings which grow out of are "eclectic," as Smith has it in his portrayal of transnational culture, but it does not appear either "fundamentally artificial," "indifferent to place and time," or "carefully calculated," to say that it "lacks any emotional commitment" is hardly correct. Admittedly, we are looking here at something other than the commercial, bureaucratic, or technical transnationalism, of large-scale, impersonal organizational characteristics, which Smith has in mind. The argument, however, is that transnationality and globalization nowadays have more varied characteristics, and that sometimes, for some people (a growing number), they include precisely the kinds of sites where cultural resonance is generated.

It used to be, more often, that people's more real communities, those made up of people known personally to one another, primarily through enduring face-to-face relationships, were contained within the boundaries of those entities which could be made into nations and imagined communities. There was no great obstacle to a symbolic transformation of the concrete experience of the former into the imagery of the latter; hence, for example, "peasants into Frenchmen" (Weber 1976).

Now a great many real relationships to people and places may cross boundaries. Intimate circles and small networks can be involved here; the transnational is not always immense in scale. These relationships are sensed not to fit perfectly with established ideas of the nation, and in this way the latter becomes probably less pervasive, and even compromised. The feeling of deep historical rootedness may be replaced by an equally intense experience of discontinuity and rupture, as in the case of the transcontinental migrant; the fraternity of the present, as in Balsall Heath and innumerable places like it, is in opposition to the sedimented differences of history.

We should not take for granted, either, that such personal experiences come in only a few varieties. It seems, rather, that in the present phase of globalization, one characteristic is the proliferation of kinds of ties that can be transnational; ties to kin, friends, colleagues, business associates, and others.[4] In all that variety, such ties may entail a kind and a degree of tuning out, a weakened personal involvement with the nation and national culture, a shift from the disposition to take it for granted; possibly a critical distance to it. In such ways, the nation may have become more hollow than it was.

On the other hand, in their great diversity, these outside linkages tend not to coalesce into any single conspicuous alternative to the nation. The people involved are not all "cosmopolitans" in the same sense; most of them are probably not cosmopolitans in any precise sense at all. It is also in the nature of things that we are not always sure who is affected by these linkages. Some may be of a more dramatic and conspicuous kind, others apparently mundane and hardly noticeable to anyone not in the know, not intimately familiar with the other's network and biography. Globalization of this kind, diffused within social life, is opaque. Deep personal experiences and their distribution in the world can be in large part a private matter.

CONCLUSION:
NOT WITHERING, PERHAPS, BUT CHANGING

The particular sources of relative weakening of nations I have suggested here are surely most in evidence in those areas of western Europe and North America which have been most centrally involved in what Hobsbawm described as "the new supranational restructuring." This is where most recent academic commentators on things national reside, and where Minerva's owl is more likely in flight. It is not, on the other hand, where nationalists even now have grenades in their

hands, perform "cleansing operations" and storm palaces. At the very same time as globalization may lead us to rethink the notion of the nation in one array of instances, and perhaps look for signs of organizational or symbolic decay, in other cases nations and nationalism appear to be on an upswing. One would need to consider the circumstances in each instance.[5]

Even in the Occidental heartlands, no doubt, for a great many people, the idea of the nation is still largely in place, where it has been perhaps for some centuries. It still encompasses virtually all their social traffic, and offers the framework for thinking about past and future.

Yet interspersed among those most committed nationals, in patterns not always equally transparent, are a growing number of people of more varying experiences and connections. Some of them may wish to redefine the nation; place the emphasis, for example, more on the future and less on that past of which they happen not to have been a part. Of such desires, and their clash with established definitions, cultural debates may be made.

Others again are in the nation but not of it. They may be the real cosmopolitans, or they are people whose nations are actually elsewhere, objects of exile or diaspora nostalgia (and perhaps of other debates). Or they may indeed owe a stronger allegiance to some other kind of imagined transnational community – an occupational community, a community of believers in a new faith, of adherents to a youth style. There may be divided commitments, ambiguities, and conflicting resonances as well.

The nation and its culture, however, is not being replaced by any single "transnational culture." "It is not enough to imagine the global community; new and wider forms of political association and different types of cultural community will first have to emerge," our interlocutor Smith (1991: 160) argues, apparently in a polemic against those commentators whom he sees as too inclined toward vocabularies of invention, construction, and imagination; "it is likely to be a piecemeal movement, disjointed and largely unplanned." With the latter I agree. But I think it is a process of the piecemeal, the disjointed, and the frequently unplanned (but sometimes planned), on variously large and small scale, which we can already observe.

8

A POLISH POPE AMONG THE MAYA

On community and globality

I was in Mérida, capital of the Mexican state of Yucatán, mostly to see the Maya ruins at Chichen Itza and elsewhere, but as it happened, thousands and thousands of people were making their way there at the same time to see the Pope, His Holiness Juan Pablo Segundo, on the first visit of someone of his high office to Yucatán. Façades along what would be the path of the Papamobil were being spruced up during the days before the arrival of His Holiness (on the principle that the powerful of this world should not be confronted with its seamy sides), and headgear of the type *norteamericanos* would describe as baseball caps with his picture were sold in the Plaza Mayor, with Mickey Mouse caps as the only competition; the latter were clearly losing out by the time of his arrival.

After flying in from Jamaica to Mérida airport, *el Papa* immediately proceeded by helicopter to give his first sermon at the small town of Izamal, where centuries ago a Franciscan monastery had been built on top of the ruins of a Maya pyramid. I did not actually get to see the Pope. As he made his approach to Mérida itself, and as the crowds waited, I was trying to make my way out of the town, which under the circumstances meant finding a rather roundabout way to a back entrance of the airport.

Anthropologists, of course, may think of Mérida in another context. Yucatán was where Robert Redfield once elaborated his conception of a folk–urban continuum, and Mérida was at the urban end of that continuum. It was Mérida that represented heterogeneity, secularization, individualization, disorganization. Obviously the construct was mostly a Chicago anthropological version of a recurrent contrastive theme in social thought, and Redfield acknowledged the affinity with Tönnies' *Gemeinschaft* and *Gesellschaft* as well as with the various comparable formulations by Maine, Morgan, and Durkheim.

What struck me in Mérida, however, pondering the imminent arrival of the Pope, was that Redfield's continuum was contained within Mexico, even within the Yucatán peninsula, although he did provide a further opening as he noted that Mérida took the lead in "adopting new and modern ways from Euro-American civilization" (Redfield 1941: 21). As the Pope flew in and out, it now seemed as if the road from the tribal village of Tusik, by way of the peasant village of Chan

91

Kom, the town of Dzitas, and through Mérida continued on to Rome, eternal city and global city.

Yet at the same time, the master narrative of the folk–urban continuum, if you had been willing to accept it as it was, had now somehow gone astray.[1] When the Maya Indians flocked to the airport, the city streets, and the monastery grounds to acknowledge the Pole Karol Wojtyla as their father, was this not an encounter of the sacred, collectivistic nature we had expected back at the folk end of the continuum? Under conditions of globality, perhaps we should try sorting out *Gemeinschaft* and *Gesellschaft* once again.

Indeed, concepts of community and society recently have not been quite what they used to be, in social thought generally. As we saw in Chapter 4, the easy conflation of the more abstract "Society" with "societies" in the plural has come under critical scrutiny, and the suggestion is that the demarcation of the latter as distinctive universes has been an artifact of the dominant position of the nation-state. Perhaps, it is even asked, the concept of society is now obsolete? At the same time, while "communities" used to be thought of mostly as rather more tangible, small, face-to-face entities, unproblematically situated in space, they can now be "imagined," and we have seen that one major variety of "imagined community" is precisely the nation.

Some new kinds of relationships are being identified, and some qualities of relationships are being redistributed in space. In this chapter I want to consider some recent general formulations concerning the variable characteristics of present-day social relationships, from the perspective of what they suggest about the part of community in globality, and about the adaptation of anthropological work to transnational studies.

GEMEINSCHAFT AND *GESELLSCHAFT*: THE GLOBAL VARIETIES

So let me return to *Gemeinschaft* and *Gesellschaft*, by way of some recent sociology which can perhaps be identified, in this global context, as appropriately mid-Atlantic: work by Roland Robertson, a member of the British academic diaspora in the United States, and by Craig Calhoun, an American sociologist whose emphasis on "concrete social relationships," one may suspect, at least in part reflects an early sojourn among Manchester anthropologists.

Robertson is one of those who have labored most carefully to map the significance of globalization to social thought. The concept of globalization, Robertson (1992: 8) notes, refers "both to the compression of the world and the intensification of consciousness of the world as a whole." Globalization is not a new phenomenon, but it has accelerated in the twentieth century. And, citing Talcott Parsons' suggestion that modern social theory and ideology were in large part a response to that "great transformation" where the economy emerged as a relatively autonomous realm of life, Robertson (1992: 76) argues that "responses to

globality are very likely to frame the character of social theory, doctrine, ideology and political culture in the decades ahead."

Moreover, he already finds it possible to map many of these responses. There are now four main images of world order, he argues, and they can be described as *Global Gemeinschaft 1* and *2*, and *Global Gesellschaft 1* and *2*. But there are also subtypes.

Global Gemeinschaft 1 represents the world as consisting of relatively closed, unique communities; defined, it would seem, largely at the national level. These are either seen as of more or less equal worth, or some, usually one's own, may be seen as superior. If one holds *Global Gemeinschaft 1* to be ideal, the likely response to globalization is to define it as a threat, and resist it. Robertson sees this exemplified in a number of "fundamentalist" movements which try to restore a pristine condition and shut out alien influences.

Global Gemeinschaft 2 is the image of a fully globewide community. The notion of "the global village," taken more or less literally, fits in here. It is the human species as a whole that comes together in communal unity here to resolve the problems of globalization. But there are weaker and stronger versions, more or less tolerant of internal pluralism.

Global Gesellschaft 1 involves a view of a world order of open national societies, with considerable sociocultural exchange between them. The relationships between societies may be more equal or less so, but as the existence of national societies is a central feature of the contemporary global condition, regulating these relationships is a main problem to face.

Global Gesellschaft 2 entails a conception of formal, planned world organization. There may be more or less centralizing varieties of *Global Gesellschaft 2*, but they go beyond *Global Gesellschaft 1* in emphasizing the overarching importance of the world as a single system.

The first comment that needs to be made with reference to this rough delineation of Robertson's scheme is that we are hardly to be concerned here with a problem of whether one of these world images is more "correct" than the others. The point of it is rather that these are currently coexisting visions of the way the world is, or ought to be – different utopias are also involved. They may be shaped into competing ideologies, but to an extent they are likely to find their intellectual niches in different contexts of globalization. The peace movement and the environmental movement of recent decades, in Robertson's (1992: 81) view, thus represent decentralized versions of *Global Gemeinschaft 2*; and another image of *Global Gemeinschaft 2*, he suggests, is that of the Roman Catholic Church, which he describes as one "particularly effective globe-oriented and politically influential actor across most of the world, claiming mankind to be its major concern." So here, it would seem, is the quality of *Gemeinschaft* manifested during the Pope's visit to Yucatán.

It would also seem that different scholarly approaches to globalization are attached to different world images. Robertson suggests, for example, that Immanuel Wallerstein's world-system theory goes with *Global Gesellschaft 2*, in

its conception of a world of dynamic contradictions, moving toward a higher and better form of order. In this connection it may be interesting to ask what sort of world image is held, implicitly or occasionally explicitly, by anthropologists.

There is not, I believe, a single answer to this question, although one tendency would seem to have been dominant for some time. Robertson (1992: 80) notes that the more egalitarian variety of *Global Gemeinschaft 1* "has found twentieth-century expression in anthropological relativism," and it is no doubt true that the tradition of close-up study of local face-to-face relationships, and the emphasis on cultural difference, have their strongest affinities here. This is the view of the world as a "cultural mosaic." The current tendency in the discipline to think of globalization in terms of a relationship between "the global and the local," and to celebrate local vitality and resistance, is perhaps no more than a reformist version.

But there is also more direct, focused scrutiny of such assumptions in anthropology now than perhaps ever before.[2] While Robertson (1992: 78) notes that the ideal of *Global Gemeinschaft 1* entails a particular concern with the problem of "homelessness" of individuals confronting globalization, Arjun Appadurai (1988: 37–39) seems to turn things around; he comments that in much anthropology, "natives are not only persons who are from certain places, and belong to those places, but they are also those who are somehow *incarcerated*, or confined, in those places ... How have places turned into prisons containing natives?"

This has happened, Appadurai argues, largely through the exaggeration of differences, the characterization of places and their people by way of some single essential sociocultural quality. The alternative includes emphasizing thematic diversity in ethnography, and not least to try to compare places polythetically – the reference is to Needham (1975) – to look for family resemblances between places, to permit different dimensions of resemblance and contrast.

Such a program is perhaps not so immediately ready to be categorized in any of Robertson's four main world images. Yet one could note in this connection that Robertson (1992: 81) sees the more diversity-oriented version of *Global Gemeinschaft 2* as involving what one may term a "concultural" view, where cultural traditions are "a set of indigenous variations on the condition and predicaments of mankind." There would appear to be some affinity between such a view and Appadurai's program. And a growing interest among anthropologists in the unity of humankind, in recognizing variations on common themes, in the possibility of empathy, is evident in those recent critiques of a culture concept emphasizing boundedness and difference which were discussed in Chapter 3. It is clear, then, that *Global Gemeinschaft 2* also attracts its own anthropology.

With its tendency toward the small-scale and sometimes with a romantic streak, anthropology may have a strong leaning toward one *Gemeinschaft* version or other. While Wallersteinian world-system theory may have served as scaffolding for some ethnographic work, that work has not necessarily become committed to a *Global Gesellschaft 2* understanding of globality. On the other hand the *Global Gesellschaft 1* conception of a series of national societies, with considerable openness and sociocultural exchange between them, can stand as a very reasonable

background for much of the emergent transnational anthropology. (For one thing, this is more or less the point of view presented in Chapter 7.) It is precisely that openness and exchange we are mapping ethnographically, although hardly losing sight of its multiple national embeddedness.

Nonetheless some of this work deals with what we call "transnational communities," and so there is a certain preoccupation with finding something resembling *Gemeinschaft* nesting inside *Global Gesellschaft 1*, encapsulating itself even when that has to be done over great distance; to a degree turning its back to the outside after all.

DIRECT AND INDIRECT RELATIONSHIPS

At this point the delineation of transnational ethnography and its materials becomes a bit too complicated to fit neatly into Robertson's categories, and so it is here that Craig Calhoun's (1991, 1992) discussion of four categories of social relationships may help us get further. The main question is how to identify more clearly the kinds of relationships which go into the making of contemporary social structures, especially those covering great spatial distances and crossing national boundaries; and to discern how these kinds of relationships link up with one another.

One point of departure for Calhoun's reasoning is yet another, more recent version of the *Gemeinschaft/Gesellschaft* theme, Jürgen Habermas' distinction between "system" and "lifeworld." Calhoun notes that Habermas' conceptualizations of those two are quite different in kind. While the lifeworld is delineated in relational terms of direct communication, the system is represented in more abstract cybernetic terms which tend to conceal the fact that it, too, is the creation of human social action.

What Calhoun argues for is a more consistently relational viewpoint, a concern with how "the action of each person in a population implies, depends on, or predicts that of the others" (1992: 206). Yet he recognizes that such a conceptualization must take into account the fact that a great number of what he would still refer to as "concrete relationships" in the contemporary world are now very indirect, depending on large-scale markets, complex organizations, and not least on information technology. With regard to the latter, he makes the point that sociological and economic accounts of technological change have tended to focus disproportionately on production technologies and their effects on the labor force; such accounts need to be complemented with more analysis of the implications of what he calls the "infrastructural technologies" (Calhoun 1992: 208).

From what kinds of elements, then, could a more inclusive relational view of contemporary society be constructed? Calhoun starts out here from Charles Horton Cooley's classic contrast between primary and secondary relationships, which of course we recognize as yet another variation on the *Gemeinschaft/Gesellschaft* theme – primary relationships link whole persons, secondary relationships merely enactors of specific roles. This distinction remains significant enough, but still covers only the direct relationships of physical co-presence. And

such linkages now organize less and less of social life, they are "no longer consti-tutive of society at its widest reaches" (Calhoun 1992: 211–212).

Thus we need to distinguish two additional types of relationships; two types of indirect relationships. Tertiary relationships are those mediated entirely by tech-nology and/or large-scale organization. We are aware of them as relationships between people, Calhoun argues, and in principle it is possible to turn them into direct relationships, although in practice it is unlikely to happen. We write or call to a government office or to a bank, to make a complaint, for example, but mostly do not personalize the relationship. Our contacts with politicians are almost entirely through the media. We realize that a chain of actions and interactions links the workers producing consumer goods with the people who eventually buy them and use them, although that chain is shaped according to the impersonal pattern of the market.

In what Calhoun terms quaternary relationships, in contrast, at least one of the parties is not aware that a relationship exists. They are fundamentally surveillance relationships, of a more or less unobtrusive kind. (Orwell and Foucault are inevitable references here.) Wire-tapping would be an obvious example of a quaternary relationship, but more generally information technology now allows a great variety of records to be generated which allow one party to keep track of the characteristics and actions of others: census data, credit card records, etc. (cf. Lyon 1994).

In terms of these four types of relationships, then, we can perhaps achieve a more complete, and at the same time reasonably subtle, portrayal of the contemporary social landscape. Perhaps the notion of "concrete social relationships" might strike us as a little quaint – reminiscent even of early structural-functionalism. Relieved of some intellectual excess baggage, however, the systematic concern with social form could be an old-fashioned social anthropological virtue to which we may want to return, even though it has to be taken further as we face new tasks. It seems, for one thing, that we have been going on and on criticizing unrealistic *Gemeinschaft* notions, a minor scholarly industry in itself. Yet often we seem not to get very far in developing conceptions of *Gesellschaft*; probably in part because we are ill at ease with vocabularies such as that of Habermas.

We can now see that while notions of *Gemeinschaft* have characteristically dwelt on primary relationships and other conceptions of whole human beings, *Gesellschaft* with its emphasis on impersonality may with time have become increasingly a blurred composite of secondary, tertiary, and quaternary relation-ships. The more differentiated language of social form may be useful in pushing inquiries further into the varied ways in which *Gemeinschaft* and *Gesellschaft* actually coexist, and also get entangled with one another.

Let me exemplify this by suggesting some further understandings of how social life is arranged through these various kinds of relationships. They entail rather different structures of symmetry or asymmetry, in what I would think of as terms of scale and directionality. Primary relationships, obviously, tend toward symme-try in both respects – people interact more or less on a one-to-one basis, with

communication flowing probably equally effectively in both directions. Secondary relationships tend to show a greater asymmetry of scale. Here people interact in terms of more narrowly specified roles, and often the incumbent of one role deals with a great many others who pass through the matching role – teacher and pupils, bus conductor and passengers, etc. With tertiary and quaternary relationships, asymmetries increase greatly, as relatively few, usually corporate actors are connected to innumerable individual (or small group) actors, and usually exercise a rather high degree of control over these relationships.

But tertiary and quaternary relationships would appear to differ between themselves with respect to the direction of information flow. In the tertiary relationships, there is a dominant, continuous outward flow, from the controlling corporate actors toward their respective publics, not least by way of media technologies. In the quaternary relationships, on the other hand, the publics may be largely unaware of the inward passage of information from them to the dominant center. Of course, there may be some of what, with an old social anthropological term, we may call multiplex relationships here. Tertiary and quaternary relationships may effectively run parallel, as information from quaternary relationships is used to manage the tertiary linkages.

Even as we can distinguish these types of relationships, however, we can also discern that social life often involves a variety of real and imagined shifts between primary, secondary, tertiary, and quaternary relationships. It is a well-recognized fact that because primary and secondary relationships have the quality of physical co-presence in common, the boundary between them is a rather permeable one. A secondary relationship can be renegotiated, expanded into a primary relationship. In a complex and mobile society, this is how *Gemeinschaft* is often carved out of *Gesellschaft* (cf. Hannerz 1980: 231–241).

At least in a somewhat weaker sense, it may be argued that similar shifts or attempts at redefinition can involve the tertiary and quaternary relationships. Picking up the idea of nations as "imagined communities," Calhoun (like some other commentators) remarks that there can be a great many different kinds of such communities, and that they have a long and expansive history. Co-religionists – and we may again think of the Catholic Church here – may imagine themselves as a community by way of a concrete iconography and participation in ritual. Beginning with print, however (as in Benedict Anderson's perspective), media technologies may have had a special part in allowing people to imagine themselves as similar to (or different from) others, whether on the basis of gender, ethnicity, age, or even consumer tastes; quite apart from any direct relationships. Although this is not Calhoun's phrasing, we may see, then, that being engaged in parallel tertiary relationships is a basis for imagining something like primary relationships. Again, the extreme example is Robertson's *Global Gemeinschaft 2*.

Quaternary relationships have their part here as well. As information is gathered and managed at the central collection points, populations are organized there into what we may think of as "imagined clienteles," on the basis of profiles of shared characteristics. With the use of personalized junk mail, for example,

members of such clienteles can then be approached in an idiom of persuasion which at least attempts to imitate primary relationships. ("Dear Ulf, you are the kind of person who should subscribe to ...")

What all this suggests, I believe, is that primary, secondary, tertiary, and quaternary relationships now make up a single field. They do not only impinge on each other in practice but also cross-fertilize each other in the social imagination. As we continue to speak of "communities," we had better keep this complexity and interpenetration in mind.

MAKING TRANSNATIONAL CULTURE

Turning now more specifically to exploring the possibilities of transnational anthropology, we may recall first the conception of transnational culture set forth by Anthony D. Smith, as cited in Chapter 7. Smith draws attention, for example, to mass commodities moving across borders – the Mickey Mouse caps in Mérida's Plaza Mayor would be an example – and to information and telecommunication technologies. Relating his imagery to Calhoun's categories, it is clear that he identifies the transnational strongly with the indirect varieties of relationship, particularly the tertiary linkages but at times the quaternary relationships as well.

In the face of widespread conceptions of the transnational of this kind, it seems necessary to give a little thought to mapping the distribution of the transnational over the various types of relationships, and important to recognize that it is now in all of them. Indeed, as we look back on the twentieth century, we must be impressed not only with the growth of tertiary and quaternary relationships, but also with the greatly extended reach of the direct relationships.

"Transnational communities" is not a contradiction in terms. This is a matter of kinship and friendship, of leisure pursuits, and of occupational and corporate communities. What is personal, primary, small-scale, is not necessarily narrowly confined in space, and what spans continents need not be large-scale in any other way.

A main point here, obviously, is that what Calhoun calls "infrastructural technologies," such as those of transportation and communication, have not only been essential to the growth of indirect relationships. They have also greatly affected the conduct of primary and secondary relationships. Another Mérida scene: I was in one of the city churches one evening, and witnessed the wedding of two young people looking unmistakably Maya. Like weddings just about anywhere nowadays, the ceremony was being videofilmed.[3] In this case, I would not know where the reel ended up, and a record like this could of course be intended to bind time as well as space, to be a greeting to those far away but also a souvenir for those who were present. But video, along with photos, telephone, fax, and old-style personal letters, certainly forms part of an increasingly varied technology of community, connected to a range of old and new symbolic forms. No close personal links may ever be formed wholly through the use of this technology, but it can do a great deal to maintain them across great distances.[4] Jet flights may even

98

help turn indirect into direct relationships. Can we claim that when the Pope arrived among the Mayas, an imagined community became a bit more real?

In any case, we are now seeing a growing number of ethnographies of transnational communities, transnational networks, transnational kinship groupings.[5] In large part, they continue to bear witness to the anthropological preoccupation with primary relationships, with something approximating *Gemeinschaft*. But the story they tend to tell is one of people continuously involved in two localities, if not more. The time is gone when migration implied the attenuation and eventual loss of links to the place of origin, and instead we hear for example of "transnational migrant circuits," in a case of Mexicans in California (Rouse 1992: 45), or of "yo-yo migration," in the instance of Brazilians in New York (Margolis 1994: 263).

In large part, the consequences of such extension of community in space, across borders, are of a practical nature. A marginally viable family farm is kept alive through remittances or the savings of homecomers; new petty enterprises are set up by migrants, whether as returnees or absentees; as people migrate in chains, they encounter familiar faces in the new location and are helped in getting settled.

Such ethnographies are gradually finding their form, or forms, grappling with some of the problems of what George Marcus and Michael Fischer (1986: 91 ff.) have advocated as "multi-locale field work." Rather than arguing over what is already being accomplished with a fair amount of success, I would like to make a few remarks here about some further problems and possibilities.

No doubt it is natural for anthropologists to become somewhat preoccupied with matters of family and kinship, and with ethnicity, even as these are transferred to a transnational context. This means that we rather disregard some other kinds of even direct relationships; and not least the fact that much of the contemporary work of globalization involves the globalization of work. This, at least initially, may involve mostly secondary relationships, but again we must be aware that these often have the potential of turning into primary relationships. To the extent that there is an anthropology of work, it may well also go transnational. One instance is Garsten's (1994) ethnography of community life at Apple Computer, based on field studies at headquarters in Silicon Valley as well as the Paris and Stockholm offices.

What I also think deserves more ethnographic attention (exemplified in Garsten's study) is the fact that all kinds of transnational relationships, whether primary, secondary, tertiary, or quaternary, entail their own cultural forms. As far as the transnational communities are concerned, this suggests a closer scrutiny of the small-scale cultural process that goes on in them.

One of my favorite quotations is from Peter Berger and Hansfried Kellner (1964: 24), who argue that a sociology of knowledge must also be concerned with a microsociology of "the many little workshops in which living individuals keep hammering away" at the construction and maintenance of social reality. Transnational communities, and not least transnational families, are such "little workshops." I believe we may assume that there is some fairly continuous negotiation of meanings, values, and symbolic forms going on here; involving the

cultures of the old place and the new place, as well as the migrants' intense experience of discontinuity and rupture in itself. And that negotiation is affected by the implication of the microcultural locus that these meanings, values, and symbolic forms may become associated in the participants' minds with particular individuals, events, and settings.[6] It may be a negotiation between those who migrated and those who stayed, between veterans and newcomers, between husbands and wives, between parents and children. The instances where, as it were, a loved one turns out to be an "Other" may involve some particularly dramatic clashes; but it is also possible that through such mediation through primary relationships, what is alien can be more readily accepted and even celebrated, rather than refused.[7] Set in the face-to-face relationships of the transnational community, or even transmitted through telephone calls, cassettes, family videotapes, and gift parcels, some of the meanings and meaningful forms of transnational life, at least, may well strike deep into people's hearts and minds.

My final argument is for a sense of openness with regard to the analytical units we chose to work with. I hinted before at the bias of anthropologists toward finding the *Gemeinschaft* within the *Gesellschaft*, perhaps seeking out more or less encapsulated groups, or simply doing the ethnographies of whatever groups are involved in rather inward-turning ways. Yet we must not forget that the various kinds of relationships occur parallel to one another, and in heterogeneous chains, and influencing one another. I will give a couple of brief examples from recent writings.

One of them relates to a particular kind of mix of direct and indirect relationships which has a large part in the lives of many migrant populations, in that *Global Gesellschaft 1* situation of relatively open national societies. Openness is indeed relative. State apparatuses still regulate the passage across borders, and migrants are thus drawn into tertiary and quaternary relationships of critical importance here; relationships which are culturally constructed from both sides, and of course involving an "imagined clientele" as constructed by officials. The symbolic potency of the American "green card" is an example of what goes on in this interface.[8] A study by Garrison and Weiss (1987) of how transnational Dominican family networks maneuver in relation to United States immigration policy shows in some detail how the indirect relationships affect the conduct of primary relationships, in both localities as well as between them. And of course, success in this maneuvering means that the control of the state over the indirect relationships is in some sense, to some degree, neutralized.

One striking finding is that family members recognize at least nine ways, legal or illegal, of crossing the border. Seven of these are found reasonably acceptable, two are not; one of them apparently because of the risk involved, and the other because of its clash with interpersonal morality. And for each of these, there is a familiar shorthand description in the migrant vocabulary. In transnational anthropology, perhaps, this is a counterpart of the rich vocabulary Eskimos are supposed to have for varieties of snow.

My other example involves the role of media in transnational connections. Academically, media studies and migration studies tend to function as separate fields. Yet in real life migration and medialization run parallel, not to say that they are continuously intertwined. Take for instance Appadurai's (1991: 198 ff.) intriguing argument that through the globalizing uses of media technology, the balance between lived experience and imagination may have shifted. Everybody, almost everywhere, is more than ever before aware of many possible lives; fantasy has become a major social practice. Yet people may act on such fantasy in different ways. They may, for example, engage with the media, and then migrate to a possible life depicted there.[9] But once such a move has been made, that which one left has become another possible life. Appadurai (1991: 193) notes the entanglement of different kinds of relationships as he comments about migrants that "deterritorialization creates new markets for film companies, impressarios, and travel agencies, which thrive on the need of the relocated population for contact with its homeland." Again, transnational communities are shown to be surrounded and infiltrated by secondary as well as tertiary relationships.[10]

Classical anthropology, in its time, may have confined people in places. My final point here, then, would be that while the natives may be in a manner released in transnational anthropology, anthropologists should also beware of getting themselves entirely trapped inside communities.

9

COSMOPOLITANS AND LOCALS IN WORLD CULTURE

There is now a world culture, but we had better make sure we understand what this means: not a replication of uniformity but an organization of diversity, an increasing interconnectedness of varied local cultures, as well as a development of cultures without a clear anchorage in any one territory. And to this inter-connected diversity people can relate in different ways. For one thing, there are cosmopolitans, and there are locals.[1]

The cosmopolitan–local distinction has been a part of the sociological vocabulary since Robert Merton (1957: 387 ff.) developed it out of a study, during World War II, of "patterns of influence" in a small town on the eastern seaboard of the United States. At that time (and certainly in that place), the distinction could hardly be set in anything but a national context. The cosmopolitans of the town were those who thought and who lived their lives within the structure of the nation rather than purely within the structure of the locality. Since then, the scale of culture and social structure has grown, so that what was cosmopolitan in the early 1940s may be counted as a moderate form of localism by now. "Today it is international integration that determines universality, while national culture has an air of provincialism," the Hungarian author George Konrad writes in his *Antipolitics* (1984: 209).

I shall not concern myself here with patterns of influence, and not so very much with locals. What follows is rather an exploration of cosmopolitanism as a perspective, a state of mind, or – to take a more process-oriented view – a mode of managing meaning. The point of view of locals I will touch upon mostly for purposes of contrast. The point of the exercise is not so much to come up with a definition of the true cosmopolitan, although I may have an opinion on that as well, but to point to some of the issues involved.[2]

THE COSMOPOLITAN PERSPECTIVE: ORIENTATION AND COMPETENCE

We often use the term "cosmopolitan" rather loosely, to describe just about anybody who moves about in the world. But of such people, some would seem more cosmopolitan than others, and others again hardly cosmopolitan at all.

I have before me a cutting from the *International Herald Tribune*, 16 October 1985, about travel and trade (the latter fairly often illicit) between Lagos and London. The article quotes reports by flight attendants on the route, claiming that Lagos market-women board London-bound planes with loose-fitting gowns, which enable them to travel with dried fish tied to their thighs and upper arms. The dried fish is presumably sold to their countrymen in London; on the return trip, the women carry similarly concealed bundles of frozen fish sticks, dried milk, and baby clothes, all of which are in great demand in Lagos. London is a consumer's (or middleman's) paradise for Nigerians. About one per cent of the passengers on the London-bound flights have excess baggage, and about thirty per cent of those traveling in the opposite direction.

Is this cosmopolitanism? In my opinion, no; in a stricter sense cosmopolitanism would entail a greater involvement with a plurality of contrasting cultures to some degree on their own terms. And the more of them the better; cosmopolitans should ideally be foxes rather than hedgehogs.[3] The shopping trips of Lagosian traders and smugglers hardly go beyond the horizons of urban Nigerian culture, as it now is. The fish sticks and the baby clothes hardly alter structures of meaning more than marginally. And much of that involvement with a wider world which is characteristic of contemporary lives is of this kind, largely a matter of assimilating items of some distant provenance into a fundamentally local culture.

A more genuine cosmopolitanism is first of all an orientation, a willingness to engage with the Other. It entails an intellectual and esthetic openness toward divergent cultural experiences, a search for contrasts rather than uniformity. To become acquainted with more cultures is to turn into an *aficionado*, to view them as artworks. At the same time, however, cosmopolitanism can be a matter of competence, and competence of both a generalized and a more specialized kind. There is the aspect of a state of readiness, a personal ability to make one's way into other cultures, through listening, looking, intuiting, and reflecting. And there is cultural competence in the stricter sense of the term, a built-up skill in maneuvering more or less expertly with a particular system of meanings.

In its concern with the Other, cosmopolitanism thus becomes a matter of varieties and levels. Cosmopolitans can be dilettantes as well as connoisseurs, and are often both, at different times.[4] But the willingness to become involved with the Other, and the concern with achieving competence in cultures which are initially alien, relate to considerations of self as well. Cosmopolitanism often has a narcissistic streak; the self is constructed in the space where cultures mirror one another.

Competence with regard to alien cultures itself entails a sense of mastery, as an aspect of the self. One's understandings have expanded, a little more of the world is somehow under control. Yet there is a curious, apparently paradoxical interplay between mastery and surrender here. It may be one kind of cosmopolitanism where the individual picks from other cultures only those pieces which suit himself. In the long term, this is likely to be the way a cosmopolitan constructs his own unique personal perspective out of an idiosyncratic collection of experiences. And such selectivity can operate in the short term, situationally, as well. In

another mode, however, the cosmopolitan does not make invidious distinctions among the particular elements of the alien culture in order to admit some of them into his repertoire and refuse others; he does not negotiate with the other culture but accepts it as a package deal. Even this surrender, however, is a part of the sense of mastery. The cosmopolitan's surrender to the alien culture implies personal autonomy *vis-à-vis* the culture where he originated. He has his obvious competence with regard to it, but he can choose to disengage from it. He possesses it, it does not possess him.

Cosmopolitanism thus becomes proteanism. Some would eat cockroaches to prove the point, others need only eat *escargots*. Whichever is required, the principle is that the more clearly the alien culture contrasts with the culture of origin, the more at least parts of the former would even be seen with revulsion through the lense of the latter, the more conspicuously is surrender abroad a form of mastery at home.

Yet the surrender is of course only conditional. The cosmopolitan may embrace the alien culture, but he does not become committed to it. All the time he knows where the exit is.

VARIETIES OF MOBILITY

Cosmopolitans are usually somewhat footloose, on the move in the world. Among the several cultures with which they are engaged, at least one is presumably of the territorial kind, a culture encompassing the round of everyday life in a community. The perspective of the cosmopolitan may indeed be composed only from experiences of different cultures of this kind, as his biography includes periods of stays in different places. But he may also be involved with one culture, and possibly but not usually more, of that other kind which is carried by a transnational network rather than by a territory. It is really the growth and proliferation of such cultures and social networks in the present period that generates more cosmopolitans now than there have been at any other time.

But being on the move, I have already argued, is not enough to turn one into a cosmopolitan, and we must not confuse the latter with other kinds of travelers. Are tourists, exiles, and expatriates cosmopolitans, and when not, why not?

In her novel *The Accidental Tourist* (1985) – also made into a film – Anne Tyler has a main character who makes his living churning out travel books for anti-cosmopolitans, people (mostly business travelers) who would rather not have left home. These are travel guides for Americans who would want to know what restaurants in Tokyo offer Sweet'n'Low, which hotel in Madrid has King Size Beauty-rest mattresses, and whether there is a Taco Bell in Mexico City.

Another contemporary writer, Paul Theroux (1986: 133), continuously occupied with themes of journeys and the cosmopolitan experience, comments that many people travel for the purpose of "home plus" – Spain is home plus sunshine, India is home plus servants, Africa is home plus elephants and lions. And for some, of course, travel is ideally home plus more and better business. There is no

general openness here to a somewhat unpredictable variety of experiences; the benefits of mobility are strictly regulated. Such travel is not for cosmopolitans, and does little to create cosmopolitans.

Much present-day tourism is of this kind. People engage in it specifically to go to another place, so the cosmopolitanism that could be involved would characteristically be that of combinations of territorially based cultures. But the "plus" often has nothing to do with alien systems of meaning, and a lot to do with facts of nature, such as nice beaches. Yet this is not the only reason why cosmopolitans nowadays loathe tourists, and especially loathe being taken for tourists.

Cosmopolitans tend to want to immerse themselves in other cultures, or in any case be free to do so. They want to be participants, or at least do not want to be too readily identifiable within a crowd of participants, that is, of locals. They want to be able to sneak backstage rather than being confined to the frontstage areas. Tourists are not participants; tourism is largely a spectator sport. Even if they want to become involved and in this sense have a cosmopolitan orientation, tourists are assumed to be incompetent. They are too likely to make a nuisance of themselves. The local, and the cosmopolitan, can spot them from a mile away. Locals evolve particular ways of handling tourists, keeping a distance to them, not necessarily exploiting them but not admitting them into local reciprocities either. Not least because cosmopolitanism is an uncertain practice, again and again balancing at the edge of competence, the cosmopolitan keeps running the risk of being taken for a tourist by locals whose experience make them apply this label increasingly routinely. And this could ruin many of the pleasures of cosmopolitanism, as well as pose a threat to the cosmopolitan sense of self.

The exile, also shifted directly from one territorial culture to another, is often no real cosmopolitan in our sense either, for his involvement with a culture away from his homeland is something that has been forced on him. Life in another country may be home plus safety, or home plus freedom, but often it is just not home at all. He is surrounded by the foreign culture but does not often immerse himself in it. Sometimes his imperfections as a cosmopolitan may be the opposite of those of the tourist: he may reluctantly build up a competence, but he does not enjoy it. Exile, Edward Said has argued, is an unhealable rift, a discontinuous state of being, a jealous state:

> With very little to possess, you hold on to what you have with aggressive defensiveness. What you achieve in exile is precisely what you have no wish to share, and it is in the drawing of lines around you and your compatriots that the least attractive aspects of being an exile emerge: an exaggerated sense of group solidarity as well as a passionate hostility toward outsiders, even those who may in fact be in the same predicament as you.
>
> (Said 1984: 51)

The French intellectuals who escaped to New York during World War II, as portrayed by Rutkoff and Scott (1983), were mostly exiles of this sort. Their New York, with its own academy and its own *revue*, was a sanctuary where they

sustained the notion that France and civilization were just about interchangeable terms. Among them, nonetheless, were individuals who seized the opportunity to explore the city with all their senses. In a charming memoir, Claude Lévi-Strauss (1985: 258 ff.) has described his New York, of antique shops, department stores, ethnic villages, museums of everything from art to natural history, and a Chinese opera performing under the first arch of the Brooklyn Bridge.

So now and then exiles can be cosmopolitans; but most of them are not. Most ordinary labor migrants do not become cosmopolitans either. For them going away may be, ideally, home plus higher income; often the involvement with another culture is not a fringe benefit but a necessary cost, to be kept as low as possible. A surrogate home is again created with the help of compatriots, in whose circle one becomes encapsulated.

The concept of the expatriate may be that which we will most readily associate with cosmopolitanism. Expatriates (or ex-expatriates) are people who have chosen to live abroad for some period, and who know when they are there that they can go home when it suits them. Not that all expatriates are living models of cosmopolitanism; colonialists were also expatriates, and mostly they abhorred "going native." But these are people who can afford to experiment, who do not stand to lose a treasured but threatened, uprooted sense of self. We often think of them as people of independent (even if modest) means, for whom openness to new experiences is a vocation, or people who can take along their work more or less where it pleases them; writers and painters in Paris between the wars are perhaps the archetypes. Nevertheless, the contemporary expatriate is rather more likely to be an organization man; so here I come back to the transnational cultures, and the networks and institutions which provide their social frameworks.

TRANSNATIONAL CULTURES TODAY

The historian James Field (1971), surveying the development in question over a longer period, writes of "Transnationalism and the new tribe," but one may as well identify a number of different tribes, as the people involved form rather separate sets of social relationships, and as the specialized contents of these cultures are of many kinds. Transnational cultures today tend to be more or less clear-cut occupational cultures (and are often tied to transnational job markets). George Konrad emphasizes the transnational culture of intellectuals:

> The global flow of information proceeds on many different technical and institutional levels, but on all levels the intellectuals are the ones who know most about one another across the frontiers, who keep in touch with one another, and who feel that they are one another's allies ... We may describe as transnational those intellectuals who are at home in the cultures of other peoples as well as their own. They keep track of what is happening in various places. They have special ties to those countries where they have lived, they have friends all over the world, they hop across the sea to discuss

106

something with their colleagues; they fly to visit one another as easily as their counterparts two hundred years ago rode over to the next town to exchange ideas.

(Konrad 1984: 208–209)

Yet there are transnational cultures also of bureaucrats, politicians, and business people, and of journalists and diplomats, and probably others (see e.g. Sauvant 1976). Perhaps the only transnational culture in decline is that of hereditary royalty. These cultures become transnational both as the individuals involved make quick forays from a home base to many other places – for a few hours or days in a week, for a few weeks here and there in a year – and as they shift their bases for longer periods within their lives. Wherever they go, they find others who will interact with them in the terms of specialized but collectively held understandings.

Because of the transnational cultures, a large number of people are nowadays systematically and directly involved with more than one culture. In human history, the direct movement between territorial cultures has often been accidental, a freak occurrence in biographies; if not an expression of sheer personal idiosyncracy, then a result of war, political upheaval or repression, ecological disaster.

But the transnational and the territorial cultures of the world are entangled with one another in manifold ways. Some transnational cultures are more insulated from local practices than others; that of diplomacy as compared with that of commerce, for example. The transnational cultures are also as wholes usually more marked by some territorial culture than by others. Most of them are in different ways extensions or transformations of the cultures of western Europe and North America. If even the transnational cultures have to have physical centers somewhere, places in which, or from where, their particular meanings are produced and disseminated with particular intensity, or places to which people travel in order to interact in their terms, this is where such centers tend to be located. But even away from these centers, the institutions of the transnational cultures tend to be organized so as to make people from western Europe and North America feel as much at home as possible (by using their languages, for one thing). In both ways, the organization of world culture through center–periphery relationships is made evident.

It is a consequence of this that western Europeans and North Americans can encapsulate themselves culturally, and basically remain metropolitan locals instead of becoming cosmopolitans, not only by staying at home in their territorial cultures. Like Anne Tyler's "accidental tourists," they can also do so, to a fairly high degree if not completely, in many of the transnational cultures. For those who are not western Europeans or North Americans, or who do not spend their every-day lives elsewhere in occidental cultural enclaves, involvement with one of the transnational cultures is more likely in itself to be a distinctive cultural experience.

The real significance of the growth of the transnational cultures, however, is often not the new cultural experience that they themselves can offer people – for it is frequently rather restricted in scope – but their mediating possibilities. The

107

transnational cultures are bridgeheads for entry into other territorial cultures. Instead of remaining within them, one can use the mobility connected with them to make contact with the meanings of other rounds of life, and gradually incorporate this experience into one's personal perspective.

COSMOPOLITANISM AND CULTURES OF CRITICAL DISCOURSE

The readiness to seize such opportunities and cosmopolitanize is no doubt often a very personal character trait. On the other hand, different transnational cultures may also relate in different ways to these opportunities. Here and there, and probably especially where the occupational practices themselves are not well insulated from the cultures of varied local settings, the development of competences in alien cultures has appeared too important to be left to chance and to personal whim; in the last few decades, we have seen the rapid growth of a culture shock prevention industry. Cross-cultural training programs have been developed to inculcate sensitivity, basic *savoir-faire*, and perhaps an appreciation of those other cultures which are of special strategic importance to one's goals (from the occidental point of view, particularly those of Japan and the oil-rich Arab world). There is also a burgeoning do-it-yourself literature in this field.[5] Skeptics, of course, may dismiss these programs and this literature as a "quick cosmopolitan fix." They would be inclined to doubt that course-work for a couple of days or weeks, or a characteristically unsubtle handbook genre, can substitute for the personal journey of discovery. And they may be committed to the notion that cosmopolitans, as such, should be self-made.

Some transnational cultures, on the other hand, may have a kind of built-in relationship to that type of openness and striving toward mastery that I have referred to above. George Konrad, in the statement which I have already quoted, proposes that intellectuals have a particular predilection toward making themselves at home in other cultures. This is evidently more true in some instances than others; the French academia in its New York exile, we have seen, tended to keep to itself. Nonetheless, it may be worth considering the possibility that there is some kind of affinity between cosmopolitanism and the culture of intellectuals.

When locals were influential, Robert Merton (1957: 400) found in his classic study, their influence rested not so much on what they knew as on whom they knew. Cosmopolitans, in contrast, based whatever influence they had on a knowledge less tied to particular others, or to the unique community setting. They came equipped with special knowledge, and they could leave and take it with them without devaluing it.

Not surprisingly, there has been more attention given to such people recently.[6] They are "the new class," people with credentials, decontextualized cultural capital. Within this broad social category some would distinguish, as Alvin Gouldner (1979) has done, between intelligentsia and intellectuals. This is hardly necessary for my purposes here; in any case, according to Gouldner, they share a "culture of critical discourse."

Certainly these are a type of people who now stand a particularly good chance of becoming involved with the transnational cultures. Their decontextualized knowledge can be quickly and shiftingly recontextualized in a series of different settings. (Which is not to say that the transnational cultures consist of nothing but such knowledge – they may well evolve their own particularisms as well, of the kind which are elsewhere the special resource of locals: biographical knowledge of individuals, anecdotal knowledge of events and even of the constellations of locales which form the settings of these cultures.) What they carry, however, is not just special knowledge, but also that overall orientation toward structures of meaning to which the notion of the "culture of critical discourse" refers. This orientation, according to Gouldner's (1979: 28 ff.) description, is reflexive, problematizing, concerned with metacommunication; I would also describe it as generally expansionist in its management of meaning. It pushes on and on in its analysis of the order of ideas, striving toward explicitness where common sense, as a contrasting mode of meaning management, might come to rest comfortably with the tacit, the ambiguous, and the contradictory.[7] In the end, it strives toward mastery.

Obviously it cannot be argued that such an orientation to structures of meaning is in any way likely to show a particularly close fit with those alien cultures in themselves which the cosmopolitan desires to explore. These are probably as full of contradictions, ambiguities, and tendencies toward inertia as any other local culture, including that in which the cosmopolitan himself originates. Yet as a mode of approach, it seems to include much of that openness and drive toward greater competence which I have suggested are also characteristic of cosmopolitanism. It is not a way of becoming a local, but rather of simulating local knowledge.

The special relationship between intellectuals and cosmopolitanism, if there is one, could also be described in another way, hardly unrelated to what I have just said. Intellectuals in the narrower sense are involved in a particular way with what we might see as the center–periphery relationships of culture itself. Kadushin (1974: 6), in his study of American intellectuals, has suggested that each culture has certain central "value concepts" which give meaning to experience and action, and that most members of society manipulate these concepts easily enough because they tend to be defined mostly in their concrete applications rather than through abstract formulations. Intellectuals, however, have the special task of finding the relationship between value concepts, and tracing the application of these concepts over time. Such concepts, Kadushin notes, are for example "rights of man," "justice," or "freedom of speech."

In their inquiries, the intellectuals traffic between the core of culture and the peripheral, ephemeral facts of everyday life. If they are vocationally in the habit of doing so, they would appear to have an advantageous point of departure for explorations of other cultures as well, when the opportunity of cosmopolitanism presents itself. And this advantage is surely not lost when different cultures in fact turn out to have central value concepts in common; George Konrad's transnational intellectuals, forming alliances across frontiers, tend to get together precisely over such shared concerns.

THE COSMOPOLITAN AT HOME

This has mostly been a sketch of the cosmopolitan abroad. Much of the time, even cosmopolitans are actually at home. Yet what does that mean in their case?

Perhaps real cosmopolitans, after they have taken out membership in that category, are never quite at home again, in the way real locals can be. Home is taken-for-grantedness, but after their perspectives have been irreversibly affected by the experience of the alien and the distant, cosmopolitans may not view either the seasons of the year or the minor rituals of everyday life as absolutely natural, obvious, and necessary. There may be a feeling of detachment, perhaps irritation with those committed to the local common sense and unaware of its arbitrariness. Or perhaps the cosmopolitan makes "home" as well one of his several sources of personal meaning, not so different from the others which are further away; or he is pleased with his ability to both surrender to and master this one as well.

Or home is really home, but in a special way; a constant reminder of a pre-cosmopolitan past, a privileged site of nostalgia. This is where once things seemed fairly simple and straightforward. Or it is again really home, a comfortable place of familiar faces, where one's competence is undisputed and where one does not have to prove it to either oneself or others, but where for much the same reasons there is some risk of boredom.

At home, for most cosmopolitans, most others are locals. This is true in the great majority of territorially based cultures. Conversely, for most of these locals, the cosmopolitan is someone a little unusual, one of us and yet not quite one of us. Someone to be respected for his experiences, possibly, but equally possibly not somebody to be trusted as a matter of course. Trust tends to be a matter of shared perspectives, of "I know, and I know that you know, and I know that you know that I know." And this formula for the social organization of meaning does not necessarily apply to the relationship between local and cosmopolitan.

Some cosmopolitans are more adept at making it apply again. "*Wenn jemand eine Reise tut, dann kann er 'was erzählen*," the saying goes, and there are those who make a specialty out of letting others know what they have come across in distant places. So the cosmopolitan can to some extent be channeled into the local; and precisely because these are on the whole separate spheres the cosmopolitan can become a broker, an entrepreneur who makes a profit. Yet there is a danger that such attempts to make the alien easily accessible only succeeds in trivializing it, and thereby betraying its nature and the character of the real first-hand encounter. So in a way the more purely cosmopolitan attitude may be to let separate things be separate.[8]

Despite all this, home is not necessarily a place where cosmopolitanism is in exile. It is natural that in the contemporary world many local settings are increasingly characterized by cultural diversity. Those of cosmopolitan inclinations may make selective use of their habitats to maintain their expansive orientation toward the wider world. Other cosmopolitans may be there, whether they in their turn are at home or abroad, and strangers of other than cosmopolitan orientations. Apart

from the face-to-face encounters, there are the media – both those intended for local consumption, although they speak of what is distant, and those which are really part of other cultures, like foreign books and films. What McLuhan once described as the implosive power of the media may now make just about everybody a little more cosmopolitan. And one may in the end ask whether it is now even possible to become a cosmopolitan without going away at all.

CONCLUSION: THE DEPENDENCE OF COSMOPOLITANS ON LOCALS, AND THEIR SHARED INTERESTS

To repeat, there is now one world culture; all the variously distributed structures of meaning and expression are becoming interrelated, somehow, somewhere. And people like the cosmopolitans have a special part in bringing about a degree of coherence; if there were only locals, world culture would be no more than the sum of its separate parts.

As things are now, on the other hand, it is no longer so easy to conform to the ideal type of a local. Some people, like exiles or migrant workers, are indeed taken away from the territorial bases of their local culture, but may try to encapsulate themselves within some approximation of it. Yet it is a greater number who, even staying home, find their local cultures less pervasive, less to be taken for granted, less clearly bounded toward the outside. If, through a terminal process of global homogenization, that other kind of world culture were ever to come about, locals would become extinct; or, seen differently, through the involvement with the one existing culture, everyone would be the same kind of local, at the global level.

Here, however, today's cosmopolitans and locals have common interests in the survival of cultural diversity. For the latter, diversity itself, as a matter of personal access to varied cultures, may be of little intrinsic interest. It just so happens that it is the survival of diversity that allows all locals to stick to their respective cultures. For the cosmopolitans, in contrast, there is value in diversity as such, but they are not likely to get it, in anything like the present form, unless other people are allowed to carve out special niches for their cultures, and keep them. Which is to say that there can be no cosmopolitans without locals.

10

TROUBLE IN THE GLOBAL VILLAGE
The world according to foreign correspondents

"Anyone here been raped & speaks English?" This is the title of the veteran foreign correspondent Edward Behr's (1982) autobiography, and it seems to summarize the working perspective of newsmen – looking for trouble and the human interest story, in a pragmatic, instrumental, calculating way. The question was apparently shouted, by a British television reporter in the early 1960s, at a crowd of refugee European women and children, escaping from civil war in ex-Belgian Congo.

Again, the world is said to have become a global village. Indeed, representatives of humanity from elsewhere now seem more instantly available. Hardly a day passes without their somehow impinging, however fleetingly, on our awareness.

Yet in other ways, I have argued already, the metaphor is questionable. This village is no serene idyll. Moreover, humanity elsewhere may seem instantly, but is not literally immediately, available in the way that people should perhaps be in a real village. For there are intermediaries. The globalization of consciousness also has its special personnel – to borrow C. Wright Mills' (1963: 406) old term, its own cultural apparatus. In a division of labor, partly old, partly new, different agents produce and circulate different representations of distant places, people, and practices, for different purposes.[1]

Among the more important such agents, certainly, are Edward Behr and his colleagues. Of all the varieties of worldmaking, that is to say, the one which is most overwhelmingly present in our everyday lives, through continuous media offerings that hardly anybody can now refuse, is that of "foreign news." The news is with us in the morning and in the evening; in the newspaper, on the screen, in magazines. Through the news, if in no other way, just about every mind must get at least a little globalized. It describes elections and coups, earthquakes and floods, massacres and famines, summit meetings, plane crashes and political scandals, war and sometimes peace. Conspicuously or inconspicuously, too, somebody is there doing the description – and, in the process, asking questions like "Anyone here been raped and speaks English?"

Anthropologists, it has been said, usually study down, engaging with others who are less affluent and powerful; more occasionally we have studied up (cf. Nader 1972). Yet in the global village, we may take some special interest in

studying sideways: aiming our curiosity, that is, at others who are like ourselves vocationally involved in a management of meaning across spatial and cultural distances.[2] For of course, in our own way, we are also part of that worldmaking cultural apparatus.

On such grounds, I am intrigued by the practices and productions of foreign correspondents, and their part in the making of contemporary culture. What follows, then, are some preliminary reflections on one of the occupational cultures of the global village; but in the hall of mirrors, these reflections can soon reflect back on ourselves.

If the journalist's dateline is thus, as Daniel Hallin (1987: 111) has noted, a convention that "serves to establish the *authority* of the news report," anthropologists have their ways of dealing with time, place, and ethnographic authority. If the anthropologist deals with the Other, so in some fashion does the foreign correspondent. And if ever the anthropologist, reporting from the field, lays claim to being a hero, so certainly does the foreign correspondent from his beat.

One could inspect the work of foreign correspondent at the reception end, in our own living rooms, at our breakfast tables, or one could do fieldwork on their fieldwork, a close-up study of their production routines. Here I place myself somewhere in between the two – drawing on another parallel between anthropologists and foreign correspondents. Recently, anthropologists have been producing not only ethnographies, but also a literature of the practice of fieldwork. The corpus of writings by foreign correspondents I will draw on is of a similar kind; autobiographical, more or less reflexive. As there are *Reflections on Fieldwork in Morocco* by Rabinow (1977) or *In Sorcery's Shadow* by Stoller and Olkes (1987), then, there are Behr's *"Anyone here been raped & speaks English?,"* or Ryszard Kapuscinski's *The Soccer War* (1990), or Malcolm Browne's *Muddy Boots and Red Socks* (1993); and some number of others.

These latter writings differ, of course, from their authors' production of daily news flow. They take the reader backstage, to the lives of foreign correspondents. Yet they are themselves presentations of that backstage, designed to entertain or otherwise engage the reader, and to be desirable commodities in a market-place. This is how I, as reader, may find myself somewhere in between, not quite behind the scenes, but allowed perhaps a suitable glimpse.

Which foreign correspondents, one may ask, write such books? Mostly, it seems clear, men-of-words, writers of chunks of text, rather than the electronic soundbite people. Perhaps they are the inveterate raconteurs, perhaps sometimes the organic intellectuals of their vocation. Whoever they may be, these are my informants in what follows.

DATELINES: QUESTIONS OF TIME AND PLACE

One of them (Rosenblum 1993: 1) begins his book by quoting an old pro: "Whenever you find hundreds of thousands of sane people trying to get out of a place and a little bunch of madmen struggling to get in, you know the latter are

newspapermen." Where, you might ask, would the anthropologist be? Perhaps among those scrambling to get away. Hardly with the newspeople moving in. While foreign correspondents and anthropologists both derive authority from "being there," they configure time and place in unlike ways.

Anthropologists emphasize place. We are very specific about where we go, even in cases where in publishing we conceal particular locations – neighborhoods, villages. On the whole, all places are more or less equally good, but we would rather have our own. So we have gone for the "white spots," each to a separate turf. *Vis-à-vis* colleagues, as field workers, we tend to be loners. The result, in principle (although practical and other constraints will modify the pattern), is a relatively even, sparse distribution of anthropologists on the ground. One senses an element of competition, but as the possibilities of ethnography are just about infinite and spread throughout the inhabited world, that element is not so prominent.

On the other hand, our classic notion of "the ethnographic present" may occasionally have been tied to theoretical predilections, but has mostly been studiedly vague. The "when?" of our description has not been supposed to matter greatly. We do not make much of the circumstance that even though we have spent a fairly extended period in a place, its timing is mostly a matter of chance. Arrivals and departures are often determined mostly by the calendars of funding agencies and academic institutions. And some of us may be writing up and publishing fifteen-year-old data.

In the terms of Fernand Braudel (1980: 25 ff.), the *Annales* historian, anthropologists are generally people of the *longue durée*: drawn to what is stable, or cyclical, or only slowly changing. And to "everyday life," thought of along such lines.

It is true that recently, old anthropological conventions regarding the representation of time have increasingly come to worry us. Others, after all, do not really live in "cold societies," "without history"; we are scrutinizing and rethinking "the ethnographic present" (Fabian 1983, Hastrup 1990, Sanjek 1991), and admit that we depict slices and sequences within the passage of history (Moore 1987). Yet while it may have lost its theoretical and stylistic alibis, our practical management of time may not have changed as much.

What, in contrast, are the "when" and the "where" of the foreign correspondents? One part of the answer, the most celebrated part, is that they must get their datelines right: the right place at the right time – and in most places there are few right times, while at any one time, there are few right places. In Braudel's terms, again, this is indeed *l'histoire événementielle*, the opposite of the *longue durée*.

"Keep in mind that our news-gathering system is no public service," writes Mort Rosenblum (1993: 8), Paris-based special correspondent for the Associated Press, and a critic of what he sees as a decline in foreign news coverage in the American media. "Forget the rhetoric: The news business sells a product that is blended and packaged, and the competition is cutthroat. When the product doesn't sell, its marketers tinker with the mix."

This is obviously fundamental: news is a commodity, and it is not equally available everywhere at any time. And not everything can be thus marketed. "News is

the exceptional, something which threatens, benefits, outrages, enlightens, titil-lates or amuses," Rosenblum (1993: 9) continues. Yes, there is some variety. But in large part, news is the commodity form of trouble; which is why those thou-sands of sane people try to escape where the newsmongers are moving in.

In the extreme case, trouble is war. Many of the memoirs of foreign correspon-dents are about wars – Korea, Algeria, the Congo, Vietnam, Biafra, Afghanistan, Angola, Lebanon, Kapuscinski's "soccer war" between Honduras and El Salvador, the Gulf, Somalia, Bosnia. And the brief war between India and China, and the Hungarian uprising.

To the extent that this is an American literature, and the wars are such where the United States has been directly engaged, the martial preoccupations of the correspondents are not surprising. Edward Behr, Russian by parentage, English and French by upbringing, but writing from Vietnam for *Newsweek*, comments:

> Such was the turnover of correspondents in Vietnam that the inexperienced reporter who came into contact with fighting for the first time was a veteran six months later, and most reporters – there were, of course, exceptions – seldom stayed for more than two years. Several generations of correspon-dents succeeded themselves during my Vietnamese period. For most of the war, any ambitious journalist needed to put in a Vietnam stint simply to be able to say that he had done so.
>
> (Behr 1982: 242–243)

Yet it is not just the American journalist who lists wars and related forms of trouble on his resumé. Ulf Nilson (1976: 16), a long-time foreign correspondent of the largest Swedish evening paper, *Expressen*, begins his reminiscences with Budapest, 1956, his first mission abroad. Twenty-five years old, barely two years out of covering birthdays and funerals for his home-town newspaper, he returns home with a commitment: "Whatever its cost in pain, adversity and danger – I wanted to be one of those who try to show Swedes the world."[3] Later on, Nilson gets to Vietnam as well (ten trips). And Kapuscinski, the Pole, for an extended period his country's only foreign correspondent, claims to have attended twenty-seven revolutions.

If anthropologists look for white spots, foreign correspondents head for trouble spots. As a consequence, patterns of migration, competition, and collegiality are different. Much of the autobiographical writing of the correspondents involves tales of "getting there"; finding transportation, crossing borders, getting a roof over one's head. A paragraph from Kapuscinski (1990: 41–42), in southern Sudan, trying to get into the Congo (and thus apparently in classical anthro-pological territory), is typical:

> The next afternoon we reach the border, guarded by a half-naked policeman with a half-naked girl and a little boy. They don't give us any trouble and everything starts to look enjoyable and idyllic until, a dozen or so kilometres on, in the village of Aba, we are stopped by a patrol of Congolese

gendarmes. I forgot to add that back in Cairo the minister of Lumumba's government, Pierre Mulele (later the leader of the Simba uprising, murdered) had written out a visa to the Congo for us – by hand, on an ordinary sheet of paper. But who cares about that visa? The name Mulele means nothing to the *gendarmes*. Their grim, closed faces, half-hidden in the depths of their helmets, are unfriendly. They order us to return to the Sudan.[4]

Arriving at the trouble spots, the correspondents probably find others of their kind, a dense temporary concentration of Americans, Frenchmen, Swedes, Italians, Japanese; trouble hunters and gatherers, coming together by way of some more or less global consensus on the definition of the situation. Here is the quest for the scoop, the rivalry over scant communication facilities; and rapid shifts in rules and practices as media technologies and means of transmission change. In Bucharest, during the uprising against Ceaucescu, everybody is trying to book calls through two operators at the Hotel Intercontinental. A little over a year later, Peter Arnett in Baghdad, is refusing others access to CNN facilities (Rosenblum 1993: 97). Then back in time to Algeria, during the early 1960s period of OAS terrorist campaigns, and we are once more in the company of Edward Behr, for some light relief:

> I remember asking another Japanese reporter how he managed to file his stories. "I send many by post," he said. "Mine are not urgent news stories." As he talked, he pointed to a letterbox outside the Aletti Hotel, which, he told me, he always used. A sticker, in French, on the box, read: "Do not post letters here. Owing to the circumstances, collections have been discontinued since February 12." We were in May.
>
> (Behr 1982: 142)

But despite competition, there is also cooperation and sociability; *communitas*, it would appear. "It is a curious fact," writes the British veteran James Cameron (1969: 82), "that in all proper corners of the world there was always a bar that was, as far as the correspondent was concerned, the hub and centre of that place's activities."[5]

In the foreign correspondent's world, there is a turnover of places. Trouble comes to an end, or it goes on but is no longer newsworthy. Or a place is no longer *the* place to be, since there is a bigger story elsewhere. "New wars drive out old wars," writes Edward Behr (1982: 107), and identifies "the golden rule of journalism, never officially admitted but everywhere tacitly observed: a conflict or calamity in the 'developed' world has precedence over a similar event in the 'developing' world."[6]

Behr's example is from early 1958. Indonesia had a "nasty little civil war" going, mostly in Sumatra, and it had begun to attract the attention of the world. Then came the May events in Algeria and France, and the Lebanon crisis, and Sumatra was not heard of again.

In anthropological reporting, then, places may maintain a relatively steady if modest presence, in foreign news they come and go. And many anthropologists

116

are one-field people; few of us ever work in more than two or three. Compare this to Kapuscinski's twenty-seven revolutions, just about all of which presumably occurred in different places. We may be reminded again of the classic contrast between hedgehogs and foxes: the fox knows many things, and the hedgehog knows one big thing. Or with regard to rhythm and the element of competition, another strand of imagery: there is something Dionysian about the way foreign correspondents produce culture, and something Apollonian about the way ethnographers usually do it. We are the Zuni, they are the Kwakiutl.[7]

Yet something more may have to be added, after all, about the "when" and "where" of foreign correspondents. Trouble, we have said, defines their world. It is as they follow the trouble trail that they become foxes and Dionysians. We may suspect, however, that the picture easily becomes a bit overdrawn here. In their lives, too, there are certainly periods without trouble, or at least the sort of trouble which has them on the move.

In such undramatic periods – to which they tend not to give much attention in their books – some of them may simply be at home, attending to other stories. Others may provide more routine coverage from their territory, staying in one place (preferably one with good communications, a certain enduring concentration of news events, and convenient living conditions) or traveling more arbitrarily. At such times, to us hedgehogs at least, assignments may seem absurdly broad: "Africa correspondent," "Asia correspondent." Nonetheless these are periods when some local or regional expertise can be built up, by way of everyday experience and office drudgery. And some foreign correspondents remain considerably longer in one station than most anthropologists do in their fields.

Edward Behr was thus in Algeria throughout most of its struggle for independence. Malcolm Browne was in Indochina for nearly a decade, and then in Eastern Europe for several mostly rather quiet years in the 1970s. Ulf Nilson, the Swedish journalist, spent thirteen years based in New York, and writes forthrightly about his situation. A correspondent from even the largest paper of a small European country would never gain entry into the Oval Office, and few scoops of any magnitude were likely to come his way. When President Kennedy was shot, Nilson did not go to Dallas; as he figured it, the best he could do was to work around the clock in the little backroom office in his apartment. Certainly, he traveled a great deal during his American years, but much of the time he was in his office, furiously reading (newspapers, magazines, books, government print), making notes, scissoring and filing away. If as anthropologists, frequently too desk-bound for our own tastes, we ever feel that our lives ought to have been more like those of foreign correspondents, moving around out there between interesting places, this inside view perhaps offers some solace.

I will turn briefly here to a theme in recent social theory. Modernity, in Anthony Giddens' view, involves another distribution of risk and trust than that which has been obtained in the past. The question of trust will come up later; let us consider risk here.[8] In premodern times, says Giddens (1990: 106–110), risk was largely local, an aspect of the primacy of place. People "had little protection

against natural disasters such as floods, storms, excessive rainfall, or drought," and few "could feel safe for lengthy periods from violence or the threat of violence from invading armies, marauders, local warlords, brigands, robbers, or pirates." Modernity, in contrast, features ecological threats which "are the outcome of socially organised knowledge, mediated by the impact of industrialism upon the material environment"; while military violence in the risk profile of modernity involves "the industrialisation of war."

In these terms, the reporting of foreign correspondents strikingly often seems to be about premodern (and yet altogether contemporary) varieties of risk. Vietnam and the Gulf War, it is true, were clear-cut instances of industrialized war, but there is certainly no shortage of either floods, drought, invading armies or local warlords in the foreign news of our time. Trouble in the global village is sometimes global, but often only the trouble of other villages. Datelines allow us a small share in everybody's local sense of insecurity.

Perhaps much modern trouble does not fit with the news format; it lacks the episodic quality of news, here today, gone tomorrow. This worries some newspeople as well: "By swarming to events, we correspondents miss the developments which are the basic factors of change" (Rosenblum, 1993: 22). We may remind ourselves of the "anthropology of trouble," as delineated recently by Roy Rappaport (1993). Here the focus is on maladaptations generating trouble in a global system, processes operating over longer periods and great distances; not least the sort of ecological threats which Giddens identifies as risks of modernity. This is hardly a matter of datelines, and of reporters rushing in and out. It seems more like Fernand Braudel's middle notion of "conjunctural history." Possibly anthropologists are approaching it from one end. Foreign correspondents, it appears, would have to come from the other.

THE ACCESSIBLE WORLD

Foreign news is news from abroad. What about the foreign in the sense of alien, strange, marked by otherness? The accessibility of news, to the foreign correspondent, could be something more than getting on a plane or the back of a truck, making it through border controls and battlelines. What do correspondents make of difficulties of comprehension, of problems of cultural translation? Again, anthropologists are "merchants of astonishment," we have customarily dealt in remarkable cultural differences. Foreign correspondents are perhaps merchants of astonishment, too – remember, "news is the exceptional." But how do they attend to our particular line of merchandise?

Clearly there is some variation here. It is significant that as James Cameron (1969: 71) points out: "journalism is not and never has been a profession; it is a trade, or a calling, that can be practiced in many ways ... There are no minimum requirements of scholarship nor credentials before a man can call himself a journalist." Some may be ex-academics, area scholars, others pick up what they feel they need as they go along; and again, probably as foxes rather than hedgehogs.[9]

In part, also, attention to differences may be a matter of how the correspondents imagine their readers. Ulf Nilson (1976: 62–63, 212), writing for a wide Swedish audience, is explicit about accessibility. True, when Nilson published his book, he had spent a long time reporting from the United States, which is, he suggests, "everybody's second homeland," hardly even a foreign country – "it is as if every country on earth had built an electronic bridge to the USA and found the messages it carries so fascinating that one has decided to shut out those from more nearby."

This could make things easier. Yet you must not lose your contact with the readers. Nilson would return every year to Slöinge, his home village in southern Sweden, to hang out with old schoolmates and other acquaintances, factory workers, shop assistants. In the local idiom, they were "the boys at the kiosk" – that little commercial enterprise, probably in the center of this village as in most others in Sweden, where newspapers, tobacco, fruit, candy, and perhaps a hot dog could be purchased even after other businesses had closed, and in front of which people would consequently hang out, gossip, banter, and comment on passers-by and on the day's events:

> The questions they asked me about the United States I would try to remember so that I could answer them in my articles. It struck me often that they knew less than I thought – but were more interested. What is self-evident for the correspondent and that small part of the readership that is active and follows events closely, all that must be explained to the others, in a language which is as simple and clear as possible. The foreign correspondent must not strive to be a literary phenomenon, must not seek the admiration of the mandarins ... He is the emissary of the boys at the kiosk, and he must not think that he can do more than take understanding more than part of the way. Then others must take over.
>
> (Nilson 1976: 62–63)

Occasionally, one catches the newsman in a state of puzzlement. Cameron (1969: 111) again, on war-time Koreans: "You got the impression of a world peopled with remote minds, of sudden resentments and strange loyalties, of savagery and stupidity and great lasting qualities; a great bewilderment shot through with hate." Or Nilson (1976: 37), in Rio de Janeiro, on the people of the *favelas*, as they come down to sacrifice to the god of the sea: "They build castles in the sand and dig holes for tens of thousands of candles, dance, fall into ecstasy (and sometimes drown). I want to listen to their incomprehensible song and brood over their strange beliefs ..."

It seems that correspondents also sometimes fall back on what has been described as "gatekeeping concepts" (Appadurai 1986b: 357) – caste-ridden India, Nigeria with its three hundred tribes – to frame their accounts of the alien. John and Jean Comaroff (1992: 3), anthropologists, look at the front page of their *Chicago Tribune* one Sunday morning, and see the headline "Mystic Warriors Gaining Ground in Mozambique War." "Faced with such evidence," they conclude after glancing through a report where machine guns mix with magic

potions and supernatural spirits, "anthropologists might be forgiven for doubting that they have made any impact at all on Western consciousness."

But mostly, newspeople do not seem much given to deciphering foreign meanings at all. The working assumption, apparently, is that understanding is not a problem, things are what they seem to be. The attitude may be common sense, even in a way populist; fundamentally, people are more alike than different, and the world can be approached without esoteric knowledge.[10] This is hardly writing against culture, but rather without culture.

Occasionally, otherness seems to consist not so much in difference as in inferiority. The *New York Times* correspondent Malcolm Browne's (1993: 288–297) chapter "Beware the Third World" is an extreme instance. "I have seen the future and it doesn't work," writes Browne (travestying Lincoln Steffens); "It's the Third World, and it's coming our way, as inexorably as the Africanized killer bees from Brazil." And "since most sensible people would want to avoid personal contact with the Third World," Browne lists some of the "warning symptoms … that can tell us when the Third World is nigh": "People refuse to stand in line for anything – buses, bread, railroad tickets, economic recovery, lifeboats, anything". "The clan takes precedence over collective society in all matters, even while strolling the sidewalks"; "Unenforced laws and edicts proliferate as rapidly as worthless money"; "Locally made products break, and the busiest and most prosperous artisans are the handymen and fixers"; and "A pervasive religious hierarchy – priests, mullahs or witch doctors – dominates society and suppresses dissent." Yet the essence of Browne's Third World is overpopulation. The Third World thus "has something in common with bacterial cultures and cancerous tumors" – "organisms propagate exponentially and without limit, as long as they have food and room to dump their wastes." (Browne is a former chemist and now a science editor, which may be why he and we seem to have different culture concepts uppermost in our minds.)

Often, in journalism, there are obvious practical constraints on going into subtleties. You simply cannot do very much with two or three columns in the newspaper, or thirty seconds on television.[11] And it frequently matters here, again, that the correspondent may be on the trouble trail. People, especially ordinary people, appear in this context, rather one-dimensionally, as victims. They have been killed or wounded, they have lost their property, they are fleeing. Not much cultural expertise, and only a little compassion, may be needed in grasping this much.

But here is perhaps also an issue of some theoretical interest. Recently (as I noted in Chapter 3), in anthropology, a reaction has set in against an emphasis on cultural difference; and instead attention is once more drawn to continuities, a common human condition, and emergent understandings across boundaries.

Again, in a pluralistic and somewhat McLuhanesque vein, I would suggest that our senses and communicative capabilities entail somewhat different and contrasting tendencies here, furthermore interacting with the present variety of media technologies. Some are more on the side of difference, others on the side of a shared humanity. Along such lines, we may find that the "global village"

metaphor works better with regard to the kinds of representations we are now considering than in most other contexts.

In television news especially, the view of trouble may be not only instant, after all, but in a way immediate - transcending barriers to understanding. It allows the sense of a direct encounter with the faces and bodies of other human beings far away. As conflicts and catastrophes are relentlessly pressed upon us as news consumers, more or less willing, week after week, year after year, the result may just be a heightened feeling that the world is a dangerous place. Yet the sight of starving children in Ethiopia, or of victims of a grenade thrown into a Sarajevo market, also seems capable of provoking a kind of electronic empathy, a view of the other which has more to do with notions of shared human nature than with cultivated differences. Momentarily, at least, news turns the global village into another imagined community, wider than those which, according to Benedict Anderson (1983), the print media once made out of people writing and reading the same language.[12]

THE FOREIGN CORRESPONDENT AS HERO

Ulf Nilson, the Swedish correspondent, is on the front cover of his book, with a tennis racket and a copy of *Le Figaro* under his arm, and the board of flight announcements at some foreign airport in the background. On the cover of James Cameron's memoirs there is a simple drawing of the author's ageing face. Malcolm Browne is less conspicuously present on his cover, although as you look more closely he is in two photographs, in helmet and battle fatigues in one and in front of his typewriter on the other. Then there are also several ID cards on a desk, with his picture on them; and next to these, a portable typewriter, a camera, an old electric fan, a large cartridge, an ashtray, and a bush hat.[13]

As guided tours of the backstage, these books by foreign correspondents are only to a degree about foreign people and places, or about news as work. Rather more, they are about the authors themselves, and their peers.

In large part, openly or more indirectly, they present claims to trust. And so to throw some partial light on the genre, we turn to Anthony Giddens (1990: 22 ff.) again. Modernity, he argues, does not only have its particular types of risk, but also its characteristic forms of trust. People have to rely, for one thing, on "expert systems" of technical accomplishment or professional expertise, the workings of which, to most lay people, remain quite opaque.[14]

While foreign correspondents often feed us news of premodern trouble, they may seem more modern as members of expert systems. Undeniably they are organization men. True, they enjoy greater latitude in defining their tasks, and in deciding what stories to go after (at least during times of no conspicuous crisis), than do journalists working at home. There may be competition with colleagues from other organizations, but within their own organizations the local division of labor tends to be minimal. Like anthropologists in the field, they can be jacks-of-all-trades. The potential stories of the territory are theirs to choose from, and the

121

overall motto is simply to "be prepared." If news, again, can be anything that "threatens, benefits, outrages, enlightens, titillates or amuses," then the correspondent can choose whether to titillate or to outrage.

Yet between them and the ordinary viewers, listeners or readers are all those complexities of media industries which also, as media studies have been telling us, leave their mark on the processing of news.[15] Here stories may be checked, rewritten, domesticated, cannibalized, cut, rejected, ignored; they must compete for space with local and national news.

But it is also through this machinery of production and marketing, of course, that foreign correspondents reach out so effectively, considering their fairly small actual numbers, to shape the picture of the world. The *Chicago Tribune*, according to Mort Rosenblum (1993: 19), has thirteen correspondents in eleven overseas bureaus; there are certainly many more anthropologists in the city's universities.

Despite all the intermediaries and interventions, moreover, by way of some organizational mystique, at least some of the foreign correspondents become the public faces of those anonymous expert systems – positioned, critically, at what Giddens calls its "access points." They turn into celebrities and heroes. Indeed, news may be a commodity; but in the contemporary cultural market-place, some news correspondents also become commodities in their own right. Their reporting is imbued with their own personal authority, and in the end the places where they go, and the events they report on, may be marked as more important by their presence. They are the people you can trust to give you trouble.[16]

The genre of autobiographical writing we consider here, then, may be seen for one thing as a promotional literature, for the correspondents as commodities, and for the expert systems to which they belong. It entails a collective and individual presentation of self, in an everyday life which is extraordinary.

Indeed, Giddens (1990: 84–86) draws inspiration from Erving Goffman at this point, as he emphasizes the need for expert systems to manage senses of frontstage and backstage. There is a special place for displays of trustworthiness and integrity here, he suggests, and of unflappability and a sense of "business as usual" in confronting risk.

So there is Ulf Nilson, certainly always looking for news, yet finding time for tennis courts as well; and there is Malcolm Browne, explaining the title of his book:

> In Viet Nam it was said that there were two kinds of observers: those who heard about the war from others and those with muddy boots. I preferred the latter category.
>
> As a GI in the fifties I came to loathe olive drab, and when the 8th Army PX in Korea had a sale on red socks I bought the lot. I've worn red socks ever since, which assures me of a match even when one disappears. And I still like red.
>
> (Browne 1993: ix)

An appealing combination of ruggedness, nonconformism, and practicality.

A streak of machismo seems to go with the readiness to deal with the world as a dangerous place (again, at "whatever its cost in pain, adversity and danger," as Nilson has it). Women foreign correspondents, even war correspondents, are present, but on the whole this is depicted as a man's world. Malcolm Browne (1993: 194) writes about one female reporter "whose bronzed body often adorned the swimming pool at the Hotel Royale in Phnom Penh" that she "frequently attached herself to some male colleague, endlessly seeking a protective wing and a lasting personal relationship." Edward Behr (1982: 262, 279–280) notes of the Italian star reporter Oriana Fallaci that her writings never showed that she would arrive at battle sites only after the battles were over, except in the instance when "she had to be put back on the first convoy, with a bad case of nerves."[17]

An imagery of connoisseurship and cosmopolitanism, of knowing and mastering not only the world's trouble spots but also its far-flung treasures, could also be seen to belong with the sense of easy expertise. The "fox, rather than hedgehog" aspect of the foreign correspondent's life is again made clear. James Cameron, looking backward and forward:

> I would not wish to contemplate a future in which I should not again see the surf-boats go out in Ghana, nor drink at the Cockpit in Singapore nor the Crillon in Paris, nor see the lotus-lakes in Kashmir or the Tung Tan market in Peking or the Staten Island Ferry in New York, or the windmills of Mykonos or the Baie d'Along in Tonking.
>
> (Cameron 1969: 312)

And yet here we sense, perhaps, that this is not entirely to be understood as a promotional literature, for a type of modern organization and its product. After all, it also reveals some of the strains, the tragic element in the life of the hero. A nostalgia in which few can share, a sense of horizons which few have seen. At the distant margin of the organization, too, the concern with autonomy; we can see Nilson's tennis rackets and Browne's red socks in this light as well. "They cultivate the self-image of independence but spend their lives at the end of a yo-yo string," writes Rosenblum (1993: 43) about his colleagues.[18] Kapuscinski (1990: 83–84) comes back to Warsaw from his first sojourn in Central Africa, and is told by a disapproving comrade in the Ministry of Foreign Affairs that his reporting shows he does not understand "the Marxist–Leninist processes that are at work in the world." But in a few months, he is sent back to Africa again. James Cameron (1969: 83–84) reminisces that he was attached to his London paper "by tenuous cable-links and little else." His relationship with it "could be likened only to that of a very remote and insignificant curate to the Holy See: I accepted their authority and paid no attention at all to their doctrine." It gave the foreign editor pleasure "to devise for me abrupt and intricate changes of location all over the world involving logistical problems of great complexity and expense, and it gave me pleasure to accomplish them." Ulf Nilson (1976: 48) notes that he could arrange his day according to his own wishes – as long as he got his twelve hours of work in.

There are, however, ways of relieving such strains. Some people, at least, are likely to understand, to share one's concerns and horizons: those engaged in the same craft. These are James Cameron's reflections on the nature of the mobile bar-room *communitas* of the foreign correspondents: "the only male company in which I am content," he writes, "in which I can drop pretences and relax in the conversational shorthand of completely common understanding, is that of news-papermen." He lists a dozen colleagues, and adds: "a score more of their kind, at any moment liable to appear through the swing-doors of anywhere between Tuscaloosa and Tonkin and reduce chaos to the healing anodyne of a glass and the shared misfortune of existence."

Anthony Giddens would approve. Those most committed to the abstract, disembedded systems of modernity, he argues, often (in a way which is not in itself so entirely modern) seek out the face-to-face community of their colleagues to resolve their existential doubts and rekindle that commitment. Giddens quotes Deirdre Boden, a sociologist colleague:

> the academics who cross continents to read dense fifteen-minute papers in windowless air-conditioned rooms aren't concerned with tourist or culinary or scholarly activities. They need, like soldiers of old, to see the whites of the eyes of colleagues and enemies alike, to reaffirm and, more centrally, update the basis of trust.
>
> (Giddens 1990: 87)

And so in one more way, the global village appears more like a real village; and again, looking sideways, we glimpse a reflection of ourselves.

Part III

PLACES

11

THE CULTURAL ROLE OF
WORLD CITIES

Cities like London were to change. They were to cease being more or less national cities; they were to become cities of the world, modern-day Romes, establishing the pattern of what great cities should be, in the eyes of islanders like myself and people even more remote in language and culture. They were to be cities visited for learning and elegant goods and manners and freedom by all the barbarian peoples of the globe, people of forest and desert, Arabs, Africans, Malays.

(Naipaul 1987: 141–142)

In 1954 Robert Redfield and Milton Singer published their article "The cultural role of cities," in which they dwelt on the distinction between cities of orthogenetic and heterogenetic cultural transformation. The orthogenetic cities, well-represented in the early beginnings of urbanism in the world, engaged with a relatively homogeneous peasant cultural "little tradition" (presumably including local variations) and refined it into a more elaborate, sophisticated "great tradition." Cultural process in the heterogenetic cities entailed "the creating of original modes of thought that have authority beyond or in conflict with old cultures and civilizations." In Redfield's and Singer's view, these latter were cities in which one or both of two things were true. The prevailing understandings and relationships would have to do with the technical rather than the moral order, which is to say that administrative regulation, business and technical convenience would be dominant; and the cities in question were populated by inhabitants of diverse cultural origins, removed from the indigenous loci of their cultures.

Almost half a century later, some of Redfield's and Singer's assumptions, interests, and vocabulary may no longer be ours. Nevertheless, it is clear that cities nowadays, with few possible exceptions, tend to be heterogenetic rather than orthogenetic, and that some of them indeed appear to be prominently engaged in transformations and recombinations of meanings and meaningful forms which are changing the cultural map of the earth, and perhaps the way we think about the relationship between culture and territory. Now more than ever before, the strong sense of place in cultural thought must be complemented (complemented, certainly, rather than replaced) by one of cultural flows in space,

partly ordered by center–periphery relationships. And at the centers in question, we tend to find a handful of world cities.

Which are these cities? As one major category of cities of heterogenetic cultural transformation, in that historical era of Western expansion and of industrialization in which the present global ecumene emerged, Redfield and Singer identify "the cities of the world-wide managerial and entrepreneurial class," exemplified by London, New York, Osaka, Yokohama, Shanghai, Singapore, and Bombay. In a more recent, influential paper on present-day world city formation to which I will return, John Friedmann and Goetz Wolff (1982: 310) suggest that world cities now are the control centers of the global economy, and offer a list which in part overlaps with Redfield's and Singer's: Tokyo, Los Angeles, San Francisco, Miami, New York, London, Paris, Frankfurt, Zurich, Cairo, Bangkok, Singapore, Hong Kong, Mexico City, and Sao Paulo.[1]

But some of these may appear to be more world cities than others, and their economic and cultural roles, while interrelated, need not be of the same magnitude. As my concern here is with culture, I am primarily interested in those rather few centers to which people in different parts of the world look, even from considerable distance and often from one continent to another, as fairly durable sources of new culture.

Cities undergo shifting fortunes in this respect. In the last century or so, at various stages, Berlin or Vienna were examples of such places to which much of the world, or at any rate the Western world, paid attention as the sites from which a wide variety of ideas and cultural forms might spread. They are not equally significant now. At present, the cities I have in mind would at least include New York, London, and Paris. Perhaps it is time to include Los Angeles. Miami may not quite measure up, although it has a sort of world city status *vis-à-vis* Latin America and the Caribbean. Perhaps with some foresight one should include for example Tokyo, Sydney, and Madrid, but then we would be getting to instances to which what I have to say at least at present would apply less fully.

What I want to do here is to sketch a point of view toward such cities; to identify the range of things that one has to take into account in discerning where world cities fit into the cultural history of the present, and to try to bring these things together, with some reasonable degree of coherence. But here, too, I should emphasize a parallel with Redfield's and Singer's paper. Having said that the latter "has as its purpose to set forth a framework of ideas that may prove useful in research on the part played by cities in the development, decline or transformation of culture," the two authors noted that it "contains no report of research done" and that it merely "offers a scheme of constructs; it does not describe observed conditions or processes; references to particular cities are illustrative and tentative." All of which are qualifications which are valid in this instance as well.

FOUR TRANSNATIONAL CATEGORIES

World cities are places in themselves, and also nodes in networks; their cultural organization involves local as well as transnational relationships. We need to

combine the various kinds of understandings we have concerning the internal characteristics of urban life in the world cities with those which pertain to their external linkages.

As a first step I want to identify four social categories of people who play major parts in the making of contemporary world cities. If New York, London, or Paris are not merely localized manifestations of American, British, or French culture, or even peculiarly urban versions of them, but something qualitatively different, it is in very large part due to the presence of these four categories. What they have in common is the fact that they are in one way or other transnational; the people involved are physically present in the world cities for some larger or smaller parts of their lives, but they also have strong ties to some other place in the world. They do not together make up the entire urban populations, and need not even constitute majorities within them. Nor do they altogether exhaust the possible ways of being transnational in the cities in question. Without these people, in one constellation or other, however, these cities would hardly have their global character.

The first of the categories is that of transnational business. To borrow Redfield's and Singer's description again, these are the "cities of the world-wide managerial and entrepreneurial class," nerve-centers of the world economy.[2] Their main functions, as listed by Friedmann and Wolff (1982: 320), are those of management, banking and finance, legal services, accounting, technical consulting, telecommunications and computing, international transportation, research, and higher education.[3] Whatever part manufacturing may still have in the economies of world cities, for reasons which may now be passing into their history, it is not what most directly and dynamically involves them with a wider world.

Highly educated, highly professionally skilled, and highly mobile individuals engaged with these functions thus make up one of the more conspicuous populations of the cities we are dealing with here. (With them, of course, go considerable numbers of ancillary clerical personnel.) "For those who are tuned into the international communications circuits, cities have utility precisely because they are rich in information," notes Webber (1968: 1095–1096), in an article already a few decades old, and continues: "The way such men use the city reveals its essential character most clearly, for to them the city is essentially a massive communications switchboard through which human interaction takes place."[4] Naturally a fairly large proportion of these people in any world city are indigenes of the nation where it is located. Yet many of them are from elsewhere, people whose occupational career mobility is combined with geographical mobility, what sociologists some decades ago (if at the time only within a national framework) would describe as "spiralists" (cf. Watson 1960). Perhaps one catches a glimpse of the growth of their numbers in the fact, for example, that the number of foreign banks in New York grew from 47 in 1970 to 249 in 1981 (Sassen-Koob 1984: 150); there are parallel developments in other world cities.[5]

The makeup of this transnational managerial category obviously varies between cities – there are no doubt proportionately more western Europeans in New York, more Asians in Los Angeles.[6] The peculiarity of Miami, argues

Allman (1987: 294–295) in one of a recent spate of books on that city, is that at the very point in time, about 1960, when its locational advantages in linking North America, Latin America, and Europe were ready to be realized, it became the focal point of a Cuban business diaspora which, because of United States refugee policy, was not allowed to concentrate entirely in this one place but spread out over all three continents.[7] And so the city had "the right people, rightly placed, not just in Miami, but around the world, to animate its intercontinental possibilities."

The second obvious transnational category in the world cities is made up of various Third World populations (in what are, in the cases I have in mind, First World locations). It has been claimed that greater Los Angeles is "the largest Mexican metropolitan area outside Mexico, the second largest Chinese metro-politan area outside China ... the largest Korean metropolitan area outside Korea, the largest Philippine metropolitan area outside the Philippines, and the largest Vietnamese metropolitan area outside Vietnam" (Lockwood and Leinberger 1988: 41); Sutton (1987: 19) points out that "New York forms the largest Caribbean city in the world, ahead of Kingston, Jamaica, San Juan, Puerto Rico, and Port-of-Spain, Trinidad, combined."[8] We may note that this Third World component has long been missing in Tokyo (unless, historically, one counts the Koreans here), although it is now entering the picture, with growing numbers of labor migrants from the Philippines, Bangladesh, and elsewhere.[9]

The affluent Cuban managerial and entrepreneurial elite of Miami is surely one reminder that not all the people of Third World backgrounds in world cities are of the same kind, in identical economic circumstances. Yet mostly these are people in low-skilled, low-income occupations, at the opposite end of the scale from the category first mentioned. (The claim that New York, or London, or Paris, has become, despite a First World location, "a Third World city," can thus be intended either metonymically or metaphorically – "because of immigration, it has become part of the Third World," or "with its wide gaps between rich and poor, and its poor services for the latter, it is structurally like a Latin American, Asian, or African city.")

As a third category I would identify an undoubtedly considerably smaller number of people who yet tend to maintain a rather high profile in the world cities I am concerned with: people concerned with culture in a narrower sense, people somehow specializing in expressive activities. The Parisian art world with its long-standing international makeup is a classical instance. So is again the eminence of Paris in the domain of fashion. But the present range of activities is wider, including art, fashion, design, photography, film-making, writing, music, cuisine, and more, perhaps now more fully and diversely represented in New York than anywhere else. London may have rather less of a reputation in this regard, yet it is obvious that it attracts at least a significant part of the talent of various Commonwealth countries, people who seem to find more resonance for their work there than at home. Because of the Hollywood film industry, Los Angeles could make an early but rather limited claim to world city status, while other characteristic features followed later.

Often the expressive specialists come to the world cities when young, because of unique learning opportunities, but there are also less instrumental aspects of simply "being in the right place" here, a sense of pilgrimage. These migrants may remain for short periods, or forever, and it is often difficult to predict who will do what. If the managerial category is made up of organization men (or sometimes women), the expressive specialists are usually in the world cities much more on their own.

The fourth category, finally, consists of tourists – with their quick turnover not officially included in the populations of world cities at all, but always present in considerable numbers, and engaging with a remarkable intensity with the cities for as long as they are on the scene.

The people in these four categories are presumably actively engaged in the transnational flow of culture by being mobile themselves. Clearly their numbers have grown because of (and their forms of life in their transnational aspects have in no small part been shaped by) recent changes in the technology and economy of transportation. In the age of jet planes, people can move over great distances, back and forth almost in a shuttle fashion, in ways which our more timeworn understandings of migrants and migration hardly account for very satisfactorily.

Culture also moves without people moving, however, not least through the media. Having identified the four categories above, I must add that special relationships also tend to exist between media and world cities, in that the former are frequently both based in and somewhat preoccupied with the latter. There will be various opportunities to come back to the implications.

As far as the people in the four categories are concerned, one could perhaps assume that they just happen to share the overall environments of world cities. It is, of course, true that they are engaged in ties of varied kinds with people in other categories as well. To some degree, however, they would also appear to link up with one another reasonably directly; making up each other's habitats.[10] "Transnational elites are the dominant class in the world city, and the city is arranged to cater to their life styles and occupational necessities," write Friedmann and Wolff (1982: 322). For one thing, they tend to require a wide variety of services; and the unskilled, low-income Third World migrants supply a number of these, partly through the informal economy. Sassen-Koob (1984), for example, suggests a clear relationship between the growth of global management in New York and Los Angeles and the influx of low-paid immigrants, working under uncertain conditions, in these cities. The consumer habits of the same managerial elites likewise contribute to the bases of survival of the population of expressive specialists; Sassen (1991: 335), again, writes of "a new vision of the good life," characterized by "the importance not just of food but of *cuisine*, not just of clothes but of designer labels, not just of decoration but of authentic objets d'art." In so far as the niches of the expressive specialists tend to be insecure, however, especially for the young and aspiring, they may also at times have to make ends meet, in an uncommitted way, by escaping into the sector of unskilled or semi-skilled services.

Managerial elites need things like airports and hotels, too, and without that demand on their part, tourists might also be less well served. And tourists are also fairly large-scale consumers of services; through their momentary indulgences, at least some of them may even parallel the more regular consumption habits of the managerial elites. To a degree, the latter and the tourists may be engaged in a sort of symbiosis; were it not for the simultaneous presence of both categories, the supply of attractions in the world city might be less certain for either of them.[11]

But then not all tourists are big spenders. There are even those visitors to the world cities who, coming there and lingering mostly for the diffuse pleasure of being in the right place, rather than for the specific occupational purposes of managers or expressive specialists (but perhaps in part for some such general purpose as improving language skills), become a kind of hybrid category between tourists and low-income service sector migrants, in a temporary state of voluntary relative poverty. Their personal background, then, may be very different from that of the unskilled Third World migrants with whom in a way they may compete; au pair girls would be one example. (And an actual Third World group in a world city which seems to have, or have had, certain such characteristics is that of the Central African *sapeurs* in Paris, dandies who are there for the sake of being there – or later, at home, having been there – and to assemble a brand name wardrobe.)[12]

THE LOCAL SCENE AS SPECTACLE

In earlier chapters, and most fully in Chapter 6, I have argued that the flow of meaning and meaningful form through contemporary societies can be seen as organized mostly within a few major kinds of organizational frames, and in their interrelations. These frames each have their own principles which animate cultural flow within them, their particular temporal and spatial implications, their different relationships to power and to material life. I will here be concerned largely with two of them, those which I term "market" (where people relate to each other in the cultural flow as buyer and seller, and meaning and meaningful form have been commoditized) and "form-of-life" (where cultural flow occurs simply between fellow human beings in their mingling with one another, in a free and reciprocal flow). We can view a large part of world city cultural process, I will argue, in both its local and its transnational facets, in terms of an interplay of cultural currents within and between these organizational frames. Some of it, quite conspicuously, is in the streets.

A New York sociologist, Gerald Handel (1984), had his students interview visitors to the city about their impressions. These were some of their responses:

> Well, I've had so many interesting experiences, but I guess the most interesting was seeing 42nd Street and being propositioned by a Black transvestite in a blond wig.
>
> (Man, 30–39, health care investigator, Minneapolis)

132

I went to the Village two days ago and saw a guy on roller skates wearing a wedding gown and a helmet skating down Seventh Avenue. I was amazed but I was told this is not strange in New York City, especially in the Village.

(Woman, 20–29, accountant, Dominican Republic)

I seen a little old lady fighting off a mugger. It was fascinating because the old lady turned out to be a cop.

(Woman, 30–39, housewife, Quebec)

The variety of different people. I come from a monolithic society where everyone has the same ethnicity. For example, here there's a large number of homosexuals.

(Woman, under 20, student, Jamaica)

There is, in other words, what Georg Simmel (1964: 410) pointed to in his essay on mental life in the metropolis, "the rapid crowding of changing images, the sharp discontinuity in the grasp of a single glance, and the unexpectedness of onrushing impressions" – a sense of spectacle. Obviously, this is something one gets in large part for nothing, simply by being present, through the reciprocities of the form-of-life frame. And we should be aware of the reciprocities here. To one degree or other, the spectacle of the world city is something people constitute mutually. Everybody is not merely an observer, but a participant observer, and the prominent features of the spectacle may depend on one's perspective. For the First World – western European, North American – visitor to (or resident in) London, Paris, or New York, it is perhaps the presence of the Third World populations that is most striking; to the accountant from the Dominican Republic, the sheer idiosyncracy of an individual; to a Jamaican student, homosexuality being explicitly announced, or simply the diversity, in which from her point of view even the Quebec housewife or the Minneapolis health care inspector may count.

For the visitor from far away, people in a city may be all alike, and yet strikingly different from what he or she sees at home, and therefore still a spectacle. But in the world city this is hardly all there is to it; it is also a matter of internal diversity. One may argue that in at least two ways, such diversity finds a likely habitat in the world city, as in most large cities. On the one hand, in so far as conspicuously different styles of life are collective phenomena, subcultures carried by more or less cohesive groups, their members can together offer whatever moral, emotional, or intellectual support is needed to evolve and maintain them, whether they are rooted in the historical backgrounds, current circumstances, or simply the preferences of group members. And other things being equal, large cities simply have the critical masses for more such groups, creating diversity together, than do smaller places.[13] On the other hand, large cities tend to be places where social relationships and personal reputations have to be achieved, where people may work on being personally distinctive because they find the alternative of anonymity unattractive. So some of the diversity is generated at the

individual rather than at the group level. The fact that the world city population is of unusually varied origins naturally combines with both these more general tendencies in urban life to promote diversity yet more strongly.

Now people can certainly be quite varyingly appreciative of the spectacle of the world city local scene. To some, it is mostly a nuisance or a threat, an experience of symbolic violence. These are perhaps mostly people who are not in the world city because it is world city, who were even there before it became one in the current sense of the word; often indigenes who would prefer Paris, New York, or London to be just like any French, American, or British city, and for one thing certainly not a Third World frontier. Here is one of the paradoxes of world city cultural process: while those of us who are at the periphery or semi-periphery always sense the cultural influence of the center, that is the center-to-periphery flow, at the center itself, whatever passes for a native culture frequently seems to view itself as beleaguered or invaded by the local representations of the periphery.

The reaction to diversity on the part of these inhabitants of the world city may be to shield themselves from it as much as they can, by living in their very own neighborhoods, or if affluent enough, in a house with a doorman, and traveling by taxi rather than subway. These are the people of the center wanting the periphery to go away from their doorstep, or at least to show up there only discreetly, to perform essential services. "You've got to insulate, insulate, insulate," as someone says in Tom Wolfe's New York novel, *The Bonfire of the Vanities*. Yet as that book suggests, they are still vulnerable. The diversity of the city can impinge on their lives suddenly and dramatically. The local media, for one thing, tend again and again to suggest this to them. Moreover, they often have difficulties telling symbolic and other violence apart.

At the other end of the scale with regard to stances toward world city spectacle it may well be that we find many of the most temporary, most voluntary visitors, such as those quoted above. Writing on "the semiotics of tourism," Jonathan Culler (1988: 154) draws on Roland Barthes as he points out that a tourist is apt to make of everything a sign of itself. Other people are more likely to "refunctionalize" a practice, to make it a more or less pure instance of use, to claim that the fur coat one wears is simply something that protects one from the cold. But the tourist is unconcerned with such alibis. The pub becomes a "typical British pub," a restaurant in the Quartier Latin becomes a Quartier Latin restaurant, even a thruway is not just an efficient way of getting between places but a typical thruway.

Indeed tourists, arriving with their guidebooks and cameras in search of signs, may not get around to refunctionalizing anything, for before they do so, they are already on their way home. But if they enjoy the juxtapositions of ongoing life around them, they are hardly alone in the world city in doing so. It seems likely that at least some members of several of the other categories of inhabitants of the world city have something of the same attitude. If they claim functional alibis for many of their own practices, they can still take much of everything else to be spectacle. And in so far as they are in the world city voluntarily, for one reason or

other having to do with its world city character, they may hold that to be something of value.

One characteristic of the world city spectacle is its pervasiveness – if you are a tourist, you may trek from one more specific, authorized local sight/site (the Louvre, Buckingham Palace, Empire State Building) to another, while in between, the wonders of the street are continuous. But at the same time, the sense of spectacle is inseparable from the local setting. You cannot take it with you as such; only as memory and anecdote, or perhaps in piecemeal technical representation. And this inseparability of sense from place helps keep the world city a world city. People really have to make the journey to see, and hear, and smell it for themselves.

Probably it must be inserted here that the media need also be taken into account as contributing to the wealth of serendipitous experience in the world city. Because of their particularly high density and ubiquitous presence there (more television channels, more radio stations, more daily papers, more journals, newsstands everywhere), what is not really in its own streets may still impinge on one's consciousness almost as much as if it were.[14]

THE CULTURAL MARKET-PLACE

Yet here we are slipping out of the form-of-life framework of cultural flow, through a vaguely defined boundary zone, into the market framework.

World cities derive much of their importance from being cultural market-places. If all information is culture (and that is a matter of definitional taste), then the managerial elites are also in these market-places, even during business hours, since information is what they are primarily dealing in: minute, ephemeral units and their aggregates. The question is there, in any case, of what kind of more durable, broadly patterned metalearning goes on in a form-of-life where there is such intense attention to information and its small shifts and differences. In Brint's (1991: 161) phrasing, theirs is a "culture of quick-witted discourse."[15] Quite possibly such everyday practices help form the intellectual and esthetic consumer habits and thus the relationships of this group to the cultural market in a narrower sense.

In any case, we understand world cities to be cultural market-places primarily because of the presence, in large numbers, of the expressive specialists. On the one hand, that presence is constant. The expressive specialists remain there – but not least, move there – because of the availability of mentors and peers, to learn from with or without acknowledgment, in institutionalized or uninstitutionalized ways; of a highly elaborated structure of gatekeeping institutions; and of a mass of more or less affluent consumers.

On the other hand, the particular cultural commodities are just as continuously changing. It is from the world cities we tend to get the *dernier cri*, the latest in a wide spectrum of fashions, -isms, avant-gardes and "movements" (which in this case are not much like what we otherwise think of as movements, but rather more stylistically and temporally marked clusters of cultural commodities and

producers). Because of this durable generative capacity, attention to the world cities as cultural market-places cannot be allowed to slacken, at least among those concerned to be *au courant*.

What are the sources of this creativity? In part, the inherent tendency within the market framework to try to gain competitive advantage through innovation. In part also, no doubt, intentionality and will-power – the expressive specialists know well enough that they are in the world cities to produce new culture. In part, again, a concentration of ability – the world cities draw, surely not all, but presumably a greater than average proportion of, "the best and the brightest."

There is also, however, the fact of diversity. Cultural creativity seems to feed on it (see the argument on this point in Chapters 5 and 6). Raymond Williams (1981: 83–84), for example, surveying avant-gardes in the decades around 1900, found that they usually grew in metropolitan settings (in which context he emphasized both the relative cultural autonomy and the internationalization of the metropolis), and that a high proportion of the contributors were immigrants, often from what were regarded as more provincial national cultures. It was in the encounter between modes of expression of different derivation, each now of doubtful relevance in its original form, that new kinds of consciousness and practice emerged which had a significance beyond the nation-state.

Probably Williams' analysis of the implications of diversity is in large part valid with regard to world city cultural process around the coming turn of century as well, only with a wider transnational scope yet. I would like to draw attention here, however, a little more specifically to the particular local potentialities of world city interrelations between the form-of-life and market frames of cultural flow.

The expressive specialists are most likely often among those who find intellectual and esthetic stimulation in spectacle as a part of the general urban ambience. This is one kind of form-of-life/market connection, although one that tends to be rather vaguely defined. Yet there are more specific interrelations as well, involving a shift of items, or clusters of items, of meaning or meaningful form from one frame to the other.

I will sketch a rough sequential model.[16] It applies, I believe, to such cultural careers as those of some ethnic music and some ethnic cuisines, but the same kind of process may be more widely recurrent. In a first phase, as it were, the items of meaning and meaningful form at issue flow fairly freely within some subcultural community, as long as the latter is large and cohesive enough to offer sufficient moral and other basically non-material support. People eat their home cooking and make music together. Whatever slight degree of specialization is involved among the members of the community with regard to the production of the items involved, these have not become commodities. They move largely within the internal matrix of personal relationships of the community, in its array of private settings.

In phase two, a higher degree of division of cultural labor is introduced within the community. Apparently the latter has also reached another kind of critical mass here, where it is profitable enough to commoditize subculturally distinctive items for consumption by community members, as an alternative to the free flow of the

form-of-life framework. And the market, of course, tends always to be looking out for such opportunities for expansion. At this point, members of the subcultural community may or may not make "signs" of these commodities, in line with what was said before – that is, they may see them as taken-for-granted items of their everyday routines, or they may be more acutely aware of, and appreciative of, their subcultural distinctiveness. In any case, the commodities tend to move here into more public arenas. Subcultural cuisines are on display in area food stores, carry-outs or restaurants; music is performed on stage in the ethnic quarter (by local talent or, if the subcultural community is the diasporic extension of a society which is mostly somewhere else, by the celebrities of the periphery, flying into the world city from home), or it is broadcast on the local ethnic radio station.

And so we reach stage three in the career of cultural commodities (where, of course, they were not yet commodities in stage one): having become more public, they are also more available to the constant scanning for novelties in the wider cultural market-place. The ethnic cuisine is discovered by people on an outing of gastronomic slumming; the music (Caribbean reggae in London in the 1970s, North African raï – not quite so successfully – in Paris in the 1980s) becomes ethnopop. And yet another New York visitor savors diversity:

> Walking through Greenwich Village was the best because it is unusual. I had a slice of pizza, a taco, a falafel, and a capuccino. (Woman, 20–29, radio station assistant program director, Nebraska.)
>
> (Handel 1984: 298)

The sequential model must certainly be allowed to encompass a number of variations. As a subcultural, transnational community is established in the world city, it may already be into the second stage, and sharing it with the country of origin. Sometimes, on the other hand, stage two is skipped; items from the subcultural free flow economy pass directly into commoditization in the wider cultural market.[17] In stage three, the appeal may not be quite so much to the wider cultural market, but rather, through some kind of elective affinity, with another subcultural community – the way the reggae music of Caribbean immigrants, for instance, appealed at first particularly to the adherents to certain British youth styles. Sometimes stages two and three coexist, as both the subcultural community and the wider cultural market are able to accept the cultural commodity in a single form; but sometimes the third stage involves further change, to render that commodity in a version more agreeable to existing tastes in the wider market. In music, a split may appear between "fusion music" and "roots music," but in so far as they remain in contact, and perhaps in a dialectical relationship, this may keep leading to more innovation, and more market crossovers.[18]

FROM CENTER TO PERIPHERY

The model of how cultural items move, from within the internally varied form-of-life frameworks, by way of commoditization in segmented local cultural markets,

into yet wider markets, is not necessarily relevant only with respect to ethnic items with some kind of Third World connection. In the American context, it has clearly long been applicable to the influence of Afro-American culture on American culture more generally; in part, but not only, in the world cities. In the British case, one could fit various youth cultures into the first stage of the sequential model and see what follows from there on. But the special point, in the world city context, of considering the cultures of transnational groups of Third World background in this light is that we can see how the center–periphery relationships in culture now, because of the makeup of world city populations and the structure of world city cultural markets, fairly often become, as we view them more completely, periphery–center–periphery relationships. The world cities are no doubt still frequently the points of origin of global cultural flow, but they also function as points of global cultural brokerage. Third World music, to return to perhaps the most obvious source of examples, may become world city music, and then world music.

Here, however, we are moving out from the local scene, and on to the field of transnational relationships between the world cities and their variously distant hinterlands. What are the channels through which culture flows here?

The actual physical mobility of the members of the four transnational social categories identified above must certainly be taken into account. Unless they are complete cultural chameleons, changing color depending on context, they presumably carry something from the world city back to wherever else they belong.

Yet we cannot now claim to know much about this in any ethnographic detail. Let me quote at some length from Sutton:

New York is a Caribbean cross-roads ... one that involves the transposition and production of cultural forms and ideology. Both Hispanics and Afro-Caribbeans reconstitute their lives in New York City by means of a "cross roads" process created by the mutual interaction of happenings in New York and the Caribbean. In general contrast with the situation of European immigrants, New York's Caribbean population is exposed to a more continuous and intense bi-directional flow of peoples, ideas, practices and ideologies between the Caribbean region and New York City. These bi-directional exchanges and interactions have generated what can be called a transnational socio-cultural system, a distinctly unitary though not unified transmission belt that reworks and further creolizes Caribbean culture and identities, both in New York and the Caribbean.

(Sutton 1987: 19–20)

This suggests a genuine awareness of the nature of the late twentieth-century situation in one world city, and a region affected by strong links to it, but even so it seems fair to say that there has so far been little research on the various transnational categories which really takes precisely their transnational nature fully into account. True to their traditions, anthropologists have no doubt had more to say about the Third World populations in world cities than about managerial elites,

138

expressive specialists, or tourists, but they still tend to see them mostly one-sidedly, as immigrants.[19] Friedmann and Wolff (1982: 318) comment on the managerial elites that "they are a highly mobile, polyglot group capable of working under pressure in fluid situations. We know as yet little about them."[20]

Not least at this point, it seems, any attempt to sketch a view of the cultural role of world cities necessarily becomes a matter of identifying – as researchers are inclined to do – the need for more research. At the same time, one might at least hint at some reasonably strong possibilities. The managerial elites, as people in strong organizations, may stand a better chance than others to extend their habitats from the world cities into their other locations; corporate cultures are exported, to become more or less conspicuous, prestigious and influential in the periphery as well. The expressive specialists, when and if they return to their places of origin, are likely to become noticeable proponents of new styles in cultural commodities. Even if they go back to operating mostly in the respective local cultural market-places of the periphery, it is quite possible that their sojourns in world cities play a part, directly or indirectly, in enhancing their reputations. Those denizens of the Third World who return from one world city or other may acquire the aura of sophisticates, they have become what have been known in Anglophone West Africa as "beentos." Together, all these, and returned tourists as well, may turn out to be conduits for the continued cultural flow from the world city, with their attention habitually turned its way, and with some investment perhaps at least emotionally in maintaining open channels.

It is true, of course, that the center–periphery flow of cultural commodities is not altogether dependent on the personal contacts and experiences of transnational groups. The market also has its entirely impersonal relationships, through which the commodities of meaning produced or transformed in the world city can reach people elsewhere whether or not the latter are even altogether aware of, or interested in, their world city connections. Yet the double vision I have suggested here, of the world city as both a place in itself and as a source of culture flowing out from it, which in its combination is most directly represented by the members of the various transnational groups, seems necessary to understand fully the contemporary cultural role of the world cities. We should understand that for those who do not go there themselves, the media again play a part in offering substitute world city spectacles. As the transnationally effective media are in large part at home in the world cities, and often preoccupied with portraying them to the world, hardly anybody can remain quite ignorant and unconcerned with them as places. Through a series like *Miami Vice*, for example, the mythicized local form of life becomes itself an exportable commodity, as sign of itself; as in a way it is also in tourism. And thus, every time we at the periphery come across one of those cultural commodities which can more readily be removed from the source, we remember the sense of spectacle, and note that "there is more where this came from."

12

AMSTERDAM: WINDOWS ON THE WORLD

IN BIJLMERMEER

Take a seat by the window in a café on one of the squares in the Amsterdamse Poort shopping center on a Saturday afternoon. Enjoy the pancake of your choice; and as you watch the ever-changing scene outside, you may marvel at the way the public spaces of larger cities in western Europe and North America have become transnational commons, where white, black, brown, and yellow people mingle.[1]

And this mingling continues in the Shopperhal block next door. Much of its merchandise is of the kind you can get anywhere in Amsterdam. But at the more distant, I believe northern, end of the Shopperhal, the scene begins to become a little different. One of the stalls sells beauty aids for non-European women, and across the aisle a food stall carries tropical specialties; there are *Surinaamse bollen* as well as *Berliner bollen*. You continue past the Razaq Islamic butchery and leave the Shopperhal through a nearby exit.

Then, in the square outside, and in the housing area beyond it, you see almost only black people. This is Bijlmermeer, sometimes described as the second largest city of Surinam – after Paramaribo, the capital – nestling inside the largest city of the Netherlands. In the 1970s, when the Netherlands gave independence to its sparsely populated colony on the northern coast of South America, the inhabitants (mostly of African descent, but some Asians as well) were offered a choice between becoming Surinamese or Dutch. Something like a third of them opted for the latter alternative, and newly built Bijlmermeer was where many of them ended up.

In the landscaped grounds between the rather rundown ten-storey apartment buildings, some boys are throwing fire crackers, which echo loudly between the walls; from an open window high up in one building you hear an old Bob Marley tune. A little further up in the air, a large jet plane is just coming in from the east to land at Schiphol airport.[2]

On your way back, you come upon a smaller, modest shopping area where the most prominent establishment is the Hi-Lo Supermarkt. Here you can get frozen fish straight from Surinam, frozen cassava, also dried fish, fresh okra from Kenya, plantains, and printed-in-Bombay greeting cards with a picture of Ganesh, the elephant god, on the cover and the text "We wish you that festive Deepawali bring

you and your family all round prosperity" inside. A small stall next to the Hi-Lo sells the same kinds of printed cloths which have always tempted me in the market-places of West Africa, and exhibits a male mannequin in a flowing, richly embroidered gown. The record and cassette store across the hall has Indian and Caribbean music, next to it a stall sells roti, and a few steps away the Pacific Travel Centre announces that it is the agent for Surinam Airways, while the Chez Polly hairdressing salon proclaims its expertise in handling Afro, Euro, and Asiatic hair.

Back in the main area of the Amsterdamse Poort again, you may rest in a reasonably credible likeness of that Dutch institution, the brown café; fringed lamp shades, carpeted tables, pool tables and all. Here again you see almost only white people, and only men. But a little dark-skinned girl in bright clothes dashes in through the door, looks among those standing at the bar, and leaves with her burly, blond father.

CITY OF WINDOWS

One of the first things to strike any visitor to Amsterdam – any foreign visitor, I should perhaps say, as an indigenous Netherlander will be less surprised – is the windows. A very large proportion of the façade of just about any building in the city seems to be taken up by windows, from the lowest floor to the highest. There may be good practical reasons for this. Houses are often deep, and want to draw in all the daylight they can get.

Yet they also offer the sensation of great openness: culture flows through these windows, as it were, from private to public spaces and vice versa. It may be a conspicuous claim that "I have something to trade," made by a scantily dressed young woman in a window framed by red neon lights; or, simply and piously, that "we have nothing to hide," in the instance of the elderly couple glimpsed through the next window, with their backs turned, lace curtains not drawn. Through the window the market displays its goods, and forms of life other than one's own can be inspected, at least surreptitiously, in passing. And this is a two-way flow, for windows also allow you to keep an eye on the street scene.

There has been some interest among anthropologists in the meaning of mirrors – what you see when you see yourself.[3] In the village, your neighbors may be like mirrors – they more or less resemble you. In Amsterdam, in some mirrors, you do not see yourself at all. There seem to be more than in any other big city of those little mirrors which, placed sideways from the façade, serve rather as window amplifiers, and again allow you to look at other people (particularly whoever is at your front door).

It is also obvious that Amsterdam has a great many "other people," not only of the kind that looks like you, but of many kinds. It has drawn them from the outside for centuries, and whether people have come from far away or not, they have been there in sufficient numbers to maintain a great many viable subcultures. Diversity within the form-of-life framework, then. But the market also seems to offer a

noteworthy variety of merchandise. This probably has something to do with the scale of the built environment. Some cities have been built, at least as far as their central business districts are concerned, to give preferential accommodation to large enterprises, and car traffic. In Amsterdam it seems as if there is a hole in the wall, with a window in front, for just about every business idea, with easy access for anyone who happens to pass by, on foot or bicycle.

Nonetheless, I am surprised by some of these ideas. Amsterdam is known throughout the world for some of its museums, and museums are great devices for importing diversity from the outside, or for maintaining it by preserving the past alongside a different present. What I had not really expected, however, was a cannabis museum, or a museum of torture.

Again, the street scene itself can also be a spectacle, a place for scanning diversity, a source for the life of imagination. In Amsterdam, as in many cities, people seem noticeably aware of this. It can be seen in the variety of entertainers – musicians, dancers, jugglers, or whatever – who seek out places almost any day on the Dam (the central square in front of the royal palace), in Kalverstraat, or in front of the Centraal Station. Also, I have been told, the number of sidewalk cafés is increasing. This is hardly just because of the drink and food they offer, or because of fresh air and sunlight, but not least because they are street observatories. If the view of human traffic usually makes up much of the cultural flow in the form-of-life framework, here we note that in choice locations, it, too, can be commoditized.

THE WORLD ON VIEW

In Amsterdam, the notion comes readily to one's mind that cities can be seen as windows on the world. In Bijlmermeer, and its Hi-Lo Supermarkt, you encounter the Caribbean: sights, sounds, smells, tastes. In Kalverstraat, the major pedestrian artery, Europe goes shopping, while a block or so away, you can browse in newspapers and magazines from almost everywhere in the Athenaeum Nieuws Centrum (and thus remind yourself that media also concentrate in major cities). The Jewish History Museum tells the story of people who came to the Netherlands and to Amsterdam, lived there for generations and had a part in shaping it, and then were taken away. At the Tropenmuseum, formerly a colonial museum, you get a sense of where the Dutch went in earlier years, and what they found there.

If cities are windows on the world, you see different things through different windows. I can only hope to have caught a glimpse through the window that is Amsterdam, but I will try to fit whatever impressionistic understandings I may have gained into the view which I began to sketch in Chapter 11 of the part played by cities in organizing the global ecumene.

All cities do not operate over the same distances, nor do they do the same things in organizing culture and social relationships. Each of them fits into the various frameworks which organize cultural process in its own way, has its own place in a partly hierarchically ordered, partly competitive network of urban places, and is a product of its own evolving history. Somehow certain of them seem to resonate better than others with the idea of a global ecumene. Where, in such terms, is Amsterdam?

While I am primarily concerned with the present, I think in this case there is no way of ignoring the past. Despite perhaps unpromising beginnings as a fishing village, threatened by the destructive powers of wind and water, Amsterdam in time grew quickly in size as well as importance, and did so on the basis of the long-distance relationships reaching out from its port. And thus, in the terminology of Redfield and Singer (1954), it evolved very obviously into a heterogenetic city.

It seems, moreover, that the ethos it thus established shows remarkable continuity and distinctiveness. Some comments by the urban historian Donald Olsen (1993: 184) are interesting in this regard. First of all, there is his characterization of Amsterdam in its seventeenth-century golden age – "capitalistic, individualistic, tolerant, republican, cosmopolitan, pragmatic, rationalistic, and scientific." Many of these terms seem equally true of the city three hundred years later. Yet Olsen goes on to note that even if Amsterdam in its golden age seems to anticipate the twentieth century, it was really rather "the last great medieval city," a successor to city states like Venice and Florence. As the nation-states of Europe came into being, such independent cities were generally brought into submission.

And so, something perhaps a little reminiscent of what Redfield and Singer called orthogenetic cities became a dominant urban model. In their pure form, best exemplified by the earliest urban centers of human history, orthogenetic cities are surely not around any more, but the centers to which the nation-states gave shape seem to have borrowed something from them. These states are not really, or only partly, theater states, yet their capital cities may have been conspicuously engaged in defining, refining, and celebrating national culture, and somewhat jealously watching the integrity of its own bounded domain.[4] In that sense, there is a greater affinity between them and the mosaic model of world culture.

Again, Amsterdam seems to show little of this; continuing, it seems, proudly heterogenetic, carrying that heritage of medieval urbanism and at the same time becoming very much a city of the contemporary global ecumene. If this is in any way enigmatic, the explanation for it may be found to some extent in the division of labor between Amsterdam and The Hague, as well as in the somewhat peculiar nature of the Dutch nation-state, historically itself to such an extent created by its cities, for its cities.[5]

And now, the time for something resembling the medieval city may be here once more. The cities which in the late twentieth century we call world cities are beginning to lead lives rather distinct from those of their territorial states again, and entities such as Singapore and Hong Kong may even suggest that city states can at least in some ways be viable social forms.

COMMERCE, MIGRANTS, TOURISTS

But does then Amsterdam at this point count as a world city? This is apparently something one can hold different opinions about. Various lists of such cities are in circulation. New York, London, and Paris are no doubt on all of them, but Amsterdam, alone or as part of a Randstad conurbation, is on some and not on others.[6]

143

Of course, it is not a very big city. New York is the Big Apple; Amsterdam, arranged by the canals into layer upon layer until you get to the core around the Dam, is more like a medium-sized onion. To get back to the metaphor of cities as windows on the world again, perhaps you expect to see more through big windows. That may be true to a degree, but what matters more is certainly how the window is placed relative to what is to be seen.

In other words, I think it is more important to consider what number and variety of linkages a city has beyond the boundaries of its nation. I will want to say something here summarily about Amsterdam and transnational commerce, about migrants to Amsterdam from other continents, and about Amsterdam and tourists. These, I think, have much to do with giving Amsterdam its place in the global ecumene; a place with some features shared with other more or less central places, and others quite distinctively its own.

To reiterate, what are nowadays thought of as world cities are, above all, nerve centers of the global economy, headquarters of managers and entrepreneurs. I am reminded again of Amsterdam in its golden age. In his widely praised cultural history of that period, *The Embarrassment of Riches*, Simon Schama describes the conduct of business in the city:

> News was of the utmost importance in these floating transactions, and the regular publication of the courants supplied political and military intelligence to help investors make informed decisions. Strategically placed relatives or correspondents in ports across the globe helped pass on relevant information, but professional punters on the bourse regularly used couriers, eavesdroppers and spies in the coffeehouses of the Kalverstraat to glean tidbits about an enterprise's prospects, or indeed to propagate optimism or pessimism as their stance required.
>
> (Schama 1987: 347)

In this era, it seems, Amsterdam was indeed a world city with respect to global business. It has not descended so very far from the heights of that business now either. If the port is no longer so important for communications, one can see Schiphol as its heir, not the world's largest airport but often said to be its finest (as I heard again and again some years ago in Singapore, whose Changi airport tended to come in second place and thus had to try harder). Yet in business terms, by now, Amsterdam is not at the level of New York, London, or Tokyo, and also has regional alternatives like Frankfurt, Zürich, and Brussels to compete with.[7]

World cities, we have also been told already, must cater to the interests and tastes of the transnational elites. Let us use this understanding to bridge the gap between global managers and global retail business. As windows on the world, for the rich and for those of modest means, for natives and visitors, cities are not least shop windows.

It is one of the theoretical tenets of the globalization of the market-place that a superior product finds its niche, its segment of the local market, anywhere in the world (cf. Levitt 1983). To modify this a little, I would suggest rather that the

market segments for some commodities are now just about everywhere, some are recurrent in a great many places, and others again are highly local. And as far as consumer goods are concerned, they are present to the extent that they match locally represented forms of life, with their characteristic resource bases, values, and everyday practices.

It is of course often those commodities which are everywhere, and those which are recurrent, that provide much of the support for the notion that globalization equals a global homogenization of culture. As there is a branch of Sotheby's on Rokin, we can assume that Amsterdam's elite is not doing too badly, and has tastes not altogether dissimilar from elites in at least a handful of other cities; yet P.C. Hooftstraat, sophisticated as its shops may be, is not really the last word in opulence. With regard to commodities at various points further downmarket, Amsterdam also has Benetton, Marks & Spencer, IKEA, Kentucky Fried Chicken, and McDonalds, all of which may or may not also be found in Singapore. In a way, of course, all these transnational retail enterprises serve to make Amsterdam a window on the world, not least for the Dutch.

Nonetheless, commerce in Amsterdam also makes it a cultural crossroads by way of things found in few other places; sometimes perhaps nowhere else. No visitor walking through Amsterdam can fail to notice its unusual mixture of fast foods, junk foods, "out-of-the-wall foods"; it is not all McDonalds, and not all herring, eels, little pancakoid *poffertjes* or croquettes either, but also *loempia* rolls and *saté*. In other words, Amsterdam's market-place also offers the traditions of immigrants from far away in readily accessible commodity form. And immigrants have for centuries contributed to the heterogenetic qualities of Amsterdam, in the form-of-life framework as well as in the market.

This has been an unusually open city, to Sephardic Jews departing in the seventeenth century from persecution in Spain and Portugal, and to Ashkenazic Jews coming later from the east; to Huguenots from France in the eighteenth century, and to a great many others arriving at one time or other through the port or the Centraal Station, in recent years not least to Turks and Moroccans in search of a livelihood. But the walk through Bijlmermeer, and the *loempia* in the street stand and the *saté* sticks in a brown café, remind us that not least, it has been an openness to a lingering empire.

One can perhaps more readily take the Pakistanis and the Jamaicans in London and the Senegalese in Paris for granted, since London and Paris are undisputedly world cities of the first rank. But the Surinamers and the Javanese in Amsterdam, whether first, second, or third generation, are more like the Angolans and the Goans in Lisbon. They demonstrate that the global ecumene, however its coherence may have increased in later years, is still a creation of a turning and twisting history, and derives some of its enduring polycentricity from this fact. Colonial and postcolonial memories are probably never unambiguously happy, on one side or the other, but in different ways old metropoles, even in what have become small countries, remain centers to which scholars, tourists, and sometimes exiles from old dependencies continue to be drawn. Sometimes these are merely brief

visits. In the Dutch case, however, decolonization has also entailed some noteworthy waves of permanent migration. That of the 1970s, when so many Surinamese chose to move to the Netherlands, is the last but perhaps most striking example.

As far as foreign tourists in Amsterdam are concerned (and the first thing to observe here is that Amsterdam is both energetic and successful in presenting itself as a tourist city), they may not mind the McDonalds restaurants and the Benetton stores so much. In a paradoxical way, in the global ecumene it may be such sights that in an alien environment remind them comfortably of home. What positively attracts them more, presumably, is whatever is not everywhere, for tourism must always feed on difference (if only a managed, balanced difference). These things, in Amsterdam, are partly things typically Dutch, for from the tourist perspective, these also make Amsterdam a window on the world: the houses and the canals, the museums, the brown cafés. Yet the tourists, taking in Amsterdam with all their senses, are also likely to be struck by the particular diversity of origins of people and things, in Kalverstraat, or in the less fashionable Albert Cuypstraat street market, or – if they ever get there – in Amsterdamse Poort. And the official tourist brochures are certain to make a point of recommending the exotic *Rijsttaafel*, even as they are mostly silent about the native pea soup.

MAKING CULTURE FROM DIVERSITY

What, then, do Amsterdamers do with the diversity of their city, as they manage meaning and meaningful form in their daily lives? Cities can handle diversity in different ways. Some are very heterogeneous as wholes, but make the least of it in their parts, by constructing something rather more like a spatial mosaic of its more or less homogeneous, segregated entities. Amsterdam has some of this as well. Yet partly due to the nature of the built environment, and partly to the way the powers that be have handled this resource, much of Amsterdam also exhibits unusual diversity at the micro-level of street and neighborhood.[8]

This may result in excitement as well as unease, and Amsterdam has some of both.[9] But the overarching metacultural stance which the people of Amsterdam have evolved toward diversity, it is frequently said, is one of tolerance, of cultural *laissez-faire*. I am reminded of a little book on San Francisco, where Howard Becker and Irving Louis Horowitz (1971) describe its "culture of civility." San Francisco, they say, has long had a tolerance of deviance, even a readiness to take difference to be a civic asset. Its history as a seaport, its tradition of radical unions, the fact that it has in large part been a city of single people or couples rather than families has contributed to such a climate. It would seem that very similar things can be said about Amsterdam, and given yet greater historical depth. This, of course, is one of its attractions to many natives; but also, as I will note again, to many strangers.

Perhaps this tolerance came early, as the Dutch passed through, and learned from their own historical crises and clashes over differences in belief and practice;

it was already on the list of traits which Donald Olsen enumerated with regard to the golden age. Just how it has been shiftingly influenced over the years by a range of quite different experiences – "pillarization," *verzuiling*, and its crumbling; the countercultural upheavals of the late 1960s and early 1970s, with their testing of established assumptions (commemorated at the Nieuwmarkt underground station); the rowdiness normally to be expected in a port city where sailors seek release from the harsh constraints of life on board; the influx of groups of aliens – would be difficult for anybody to work out, and impossibly so for a visitor.[10]

Anyway, one may suspect that as far as newcomer groups are concerned, it has probably helped Amsterdamers take a rather relaxed view of their incorporation into the social fabric that these have in several instances not shown very high-profile differences. The Sephardim did not seem so unlike other prosperous burghers. The people from the East Indies, and the Surinamers, had been through an anticipatory socialization for Dutch life by growing up in Dutch colonies. Possibly there is now a little more worry about the Moroccans and the Turks, who do not necessarily fit in quite so readily.[11]

Diversity and tolerance of diversity, however, do not only pertain to matters of ethnicity and religion. Amsterdam also has its reputation for allowing, in its easy-going manner, various other kinds of conduct, and the commerce catering to them, for which greater obstacles tend to be created in many other cities: of such phenomena the red-light district has obviously been around the longest, depending in history no doubt on the demands of a major port. Such acceptance is necessarily in some part a fact of local life, at the levels of official and unofficial native reactions. At the same time, at present, it also has its part in the attractiveness of Amsterdam to what one may term international subcultural tourism. Jansen (1991), in his study of the geography of cannabis in Amsterdam, notes that many of the visitors to the coffee houses of the central city are young foreigners who know little of the city except the names of some famous outlets for soft drugs. Perhaps Jansen's English-language monograph itself attracts readers as a guide to such facilities.

Generally, I suppose, in Amsterdam or anywhere else, tolerance is very often more of a passive and distracted rather than an active stance. As people go about their own affairs, others can conduct theirs in their own way, as long as they cause no significant disruption. Tolerance as an accomplished fact may likewise have something to do with the microecology of the Amsterdam built environment. Dense, unpredictable, unsurveillable, uncontrollable, it allows some activities to go on unseen, or at least allows the excuse that they are not seen, whenever one prefers not to see. It is a part of the history of the city that for minorities during times of difficulty or persecution, this environment has provided at least temporary sanctuaries: a Catholic church in an attic in the seventeenth century, a Jewish family behind a hidden door in the early 1940s.

Tolerance, however, is not all that has come out of the Amsterdam experience of diversity. Its handling in cultural process has also included the passage of

cultural forms between groups and contexts, along with reinterpretation and inno-
vation. There are the Yiddish loan words characteristic of the Amsterdam dialect,
and the somewhat bland *nasi goreng* served for lunch in a Dutch old people's
home.[12] The cuisine of the East Indies was no doubt introduced to the Netherlands
by immigrants from there, and by returning colonialists; then as it was gaining
popularity, I have been told, the resulting niche for small restaurants was taken
over and expanded by Chinese seamen on Dutch ships, coming ashore in a period
of economic depression. Thus almost every small town in the Netherlands seems
with time to have been colonized in its turn by that special culinary institution
which is part Chinese, part Southeast Asian, and certainly part Dutch. And as a
late twist, but not necessarily the last, the Amsterdam street trade in *loempia* rolls
now provides an opening for the Vietnamese.

The cultural careers of young black Surinamese, settled in Bijlmermeer or else-
where, can be no less interesting.[13] The Surinamese who came to the Netherlands
were mostly people of fairly limited education, and not very much cosmopolitan
sophistication. As they encountered the faster pace and rather bewildering hetero-
geneity and strangeness of Amsterdam and other cities, some found it a bit
threatening, and turned inward to their kin and friendship networks and to the
Moravian church they had brought from home. The younger people, as usual,
were quicker to explore the new habitat. Boys, predictably, tended to be in the
streets and other public places, and at least some of them made contacts with
their Dutch counterparts there. Surinamese and Dutch girls likewise sometimes
became friends, but more often they went to each other's homes. Thus it was the
Surinamese girls who often became more familiar with the domestic aspects of
Dutch life.

When the young Surinamese came to Amsterdam, however, they also found
transnational youth culture waiting for them, among their peers and in the market-
place. Some became "disco freaks," with whatever this implied in terms of cloth-
ing fashions and musical taste. In their case, as elsewhere in Europe, it turned out
that in one particular context at least, being black was no handicap; among the
devotees of popular culture inspired from the United States and the Caribbean,
belonging to an ethnic minority was rather a social asset, and Surinamers could
find themselves as stylistic leaders on the dance floor. If there was a disadvantage
to this, it might rather be that they were tempted to devote the larger part of their
energies to the night shift.

On the other hand, there were the Rastas. There had been no Rastafarianism in
Paramaribo, or anywhere else in their old homeland. In Amsterdam this movement,
or style, was apparently largely unknown until Bob Marley and his Wailers came for
a concert in 1976, but then it caught on. Groups of the new Surinamese Rastas from
Amsterdam might go over to London, European capital of Rastafarianism, and trade
Dutch marijuana for Rasta hats, badges, and records. They could find inspiration, as
well, in movies playing in a couple of ethnic-oriented theaters in Amsterdam.

Like Rastas elsewhere, they looked for authenticity in their African roots, only
with the special Surinamese twist that to the consternation or even horror of their

elders, they began to identify with the Bush Negroes of the Surinamese hinterland, treated back in Paramaribo rather as exemplars of the idiocy of rural life. Yet Amsterdam Rastafarianism was also a cultural *mélange* of varied ingredients. From elsewhere in the countercultural landscape of Amsterdam, it drew on the romantic environmentalism of "being in touch with nature." Meanwhile, if in a manner and to a degree Amsterdam Rastas thus became Greens, when Amsterdam coffee shops could no longer be quite so straightforward about being cannabis outlets, they adopted the red, yellow, and green emblematic colors of Rastafarianism, and the national flag of Jamaica, to advertise their merchandise in a slightly more roundabout way.

And so cultural mingling and recombination goes on and on, weaving its way between contexts and organizational frameworks. Ideas and symbols make their passage from Kingston, Jamaica, to Amsterdam by way of London, and inspire a wistful look back to the bush beyond Paramaribo; not quite the shortest route from one Caribbean place to another. But then that is the way center–periphery relationships work, and again, it means that the centers are often centers not because they are the origins of all things, but rather because they are places of exchange, the switchboards of culture.

13

STOCKHOLM:
DOUBLY CREOLIZING

Anthropologists and natives – usually different people, in a complicated encounter. But anthropologists are also natives somewhere. I have never held a research grant, or been on research leave, to carry out local studies in Stockholm. But as I move about the city where I have lived for the greater part of my life, I can be an observer–participant, and always available as my own informant. And I can use it, too, as a place to think with, in relation to wider processes.

If Amsterdam is at present just barely a world city, but shows the conspicuous traces of having been one, the same cannot be said for Stockholm. It looks toward the centers of the global ecumene from a certain distance, and has always done so, even as the centers have shifted. Yet in some ways Amsterdam and Stockholm are not now so different – both are in small, reasonably prosperous countries, with welfare state structures developed over considerable periods. And in both, recent decades have brought an influx of newcomers creating new transnational connections.

In this chapter, I will suggest, for one thing, that while in some ways one may use Stockholm to think about the world, one can also use the world to think about Stockholm; the people in the city often use the global metropoles as materials for the imagination as they consider the changing character of their home town. Yet it is also true that the welfare state has its own way of dealing with a new diversity.

FACES OF TRANSNATIONAL STOCKHOLM

For a glance at some of the easily accessible signs of that diversity, come along on an early Sunday afternoon walk through a couple of Botkyrka neighborhoods. Botkyrka, one could argue, is to Stockholm more or less what Bijlmermeer is to Amsterdam: an outlying suburb (also to the south of the city center) of high-rise apartment complexes and shopping areas, populated in large part by immigrants. Somewhat run-down, it is by Stockholm standards certainly not a prestige address. Rhetorically it is sometimes labeled a ghetto, but it would be difficult to think of it as a slum.

In the indoor shopping area at Hallunda, one of the main neighborhoods, the customers in the café and pizzeria in the middle of the central open space are almost all men, probably none of them of Swedish origin, engaged in conversations or

reading newspapers, many of them wearing suits and ties, as few ethnic Swedes would now do on a day off. The *Pressbyrå* shop (a sort of Swedish W.H. Smith, a British visitor might say) next door has much of the same merchandise as other members of the same chain would have anywhere in Sweden, mostly newspapers, magazines, and sweets. But there are rather more video films, and on the newspaper shelf are *Hürriyet* and *Günaydin*, which are Turkish newspapers, and the Finnish *Iltalehti*; no other foreign newspapers. The *Konsum* (cooperative) supermarket carries signs concerning "action against shoplifting" in about ten languages, one of which is Swedish, and none of which is English or French. There is one sign in French elsewhere in the shopping complex, in the window of a small fashion store. (And in the corresponding area in the nearby Fittja neighborhood, there are clothing stores named *Vanessa Fashion* as well as *Jet Set Kläder*.)

Walking away from the shopping complex at Hallunda through the nearby residential areas, one perhaps passes the large Syrian Orthodox church complex which is under construction, and reaches the more modest shopping area at Norsborg, with a small food store selling a variety of fresh, canned, and packaged goods from southern Europe, the Middle East, and Latin America: the modest counterpart of Bijlmermeer's Hi-Lo Supermarkt. Another store carries several hundred video cassettes for rental; mostly Turkish, Middle Eastern, and Indian, an assortment not available at the *Pressbyrå* store. There are music tapes for sale as well, of similar origins. Continuing toward the subway station, one may catch a glimpse of the fading posters of one or two Turkish communist parties, complete with hammer and sickle, and others announcing an Argentinian play.

Among the people one passes, the indigenous Swedes make up no large proportion. Three young mothers walk side by side, pushing their prams in front of them. One may be Swedish or perhaps Finnish, one is Middle Eastern, the third probably Vietnamese. As far as the ethnic mix is concerned, it would almost seem as if this is the world in a not quite fully representative microcosm. Actually it may mostly be the ubiquitous institutions of the welfare state that mark the Swedish presence. But these, too, reflect diversity. The public library at Botkyrka carries books (not least children's books) and newspapers in a wide range of languages – at the same time as a couple of the meeting halls in the *Folkets Hus* (People's House), where the library is located, are named after Odin and Frigg, ancient Swedish pagan gods.

As the subway trains from Hallunda and Norsborg reach central Stockholm and the passengers step out of them, it could sometimes indeed seem as if they had been express trains from southern Europe, or even further away. These passengers then climb the stairs and hurry into the streets, mixing with a larger proportion of natives, and they may at least fleetingly note the shop names and the neon signs of the central business district: *Uptown Mauritz, Step In, McDonalds, Bozzini, Joy, Konfekt House, Tie Rack, Yamaha Sound of Music*. These signs are all in Sergelgången, a main pedestrian shopping passage between two large squares, Sergels Torg and Hötorget; about one quarter of the commercial signs along this street, by my count, are wholly or partly in a foreign language, mostly English.

151

And thus the message of the storefronts is that the city center of Stockholm is involved in globalization as well. But its outward turn is to a great extent different from that of the Botkyrka suburbs. The language of the signs in part reflects the presence of transnational enterprises, transnational franchise operations. In part, however, it involves sheer image-making, some local enterprise trying to capitalize on a touch of New York, London, or Paris. Central Stockholm faces the dominant world cities rather more than it pays attention to wherever the Hallunda immigrants have their origins. Perhaps one can buy Finnish and Turkish newspapers from the news-stands here as well, but also the *International Herald Tribune*, the *Financial Times*, or *Le Monde*, not available in Botkyrka.

CENTER–PERIPHERY RELATIONSHIPS AND CREOLIZATION

Cities combine the local and the long-distance. One aspect of this is that transnational migration, at the receiving end, is in quite large part an urban matter. And the more so, it would seem, the greater the distance over which migration takes place. Observing the local scene in Hallunda, this is the impression one gets, but some figures give us more of a bird's-eye view.[1]

While in Sweden as a whole, some 9 per cent of the population are now foreign born, the people born outside Sweden are not evenly distributed over the country. In Botkyrka, they are some 27 per cent (but the municipality has semi-rural, non-immigrant areas as well, and on the other hand in the Fittja neighborhood, some 65 per cent are of foreign origin). In Stockholm and its fringe of suburban municipalities, they are mostly around 12 to 15 per cent, as in Göteborg and Malmö, the second and third largest cities. In the municipalities centering on smaller and mid-sized towns, on the other hand, the proportion of foreign-born is more often 5–10 per cent, and in many rural municipalities, it is down to 1–3 per cent.

Moreover, some immigrant groups concentrate more than others. People from the other Nordic countries, of whom the Finns are the greater number, end up in a wide range of Swedish localities, while the migrants from other continents gather to a greater extent in the major cities. Stockholm, with some of its fringe municipalities (Botkyrka, Haninge, Huddinge, and Nacka to the south, and Solna, Sundbyberg, and Järfälla to the north) and together with Göteborg and Malmö, have some 20 per cent of the total population of Sweden. But they have some 37 per cent of the Asian immigrants, some 46 per cent of the South Americans, and about 50 per cent of the Africans.[2] By some standards, an approximately 2 per cent proportion of intercontinental immigrants in the total population of Sweden does not seem very much. Yet we see that a rather large proportion of this fairly small proportion is in a few urban areas – despite what has clearly been the preference of the Swedish government for a more even distribution of immigrants throughout the country.[3]

But then Stockholm faces in different directions in its transnational linkages; while the resident immigrant populations often reasonably retain some ties and

give some attention to the societies from which they came, and serve locally to some extent as embodiments of these, we can see that the Swedish indigenes have a tendency to fix their gaze elsewhere. Certainly one should beware of exaggerating the degree of concentration here, but I think it is fair to say that by way of media, business travel, consumerism, and tourism, as well as in other ways, the major metropoles of western Europe and North America, and especially what we think of as the world cities, command much of the attention.

My argument, consequently, is that an understanding of where a place like Stockholm fits into world cultural process today can revolve around a conception of a set of center–periphery relationships, where centers and peripheries engage in a spatial pattern for the socially ordered production and flow of meaning and meaningful form.

New York–Stockholm is one major example of a transnational link between cities within this set; I would argue that the link between the center of Stockholm and a suburb such as Hallunda might be seen as a center–periphery relationship at the local level; and then we have the somewhat ambiguous relationship between the Stockholm immigrants and their home communities to take into account as well.

Now centers and peripheries are of course not merely spatial phenomena. They become centers and peripheries by being differentially influential with respect to one another. In the important formulations on center and periphery by Shils (e.g. 1975, 1988), the spatial aspect of this terminology is even turned into something largely metaphorical. Culture is ordered "as if" spatially, because a "center" – a value system, an institutional complex – dominates, exercises a measure of control, expands toward the "periphery." My reasoning certainly includes a strong sense of this social organization of culture; of the power bases of cultural process, whatever they may be in each particular relationship. Yet it so happens that in the case we deal with here, the center–periphery relationships do involve space not just as a metaphor, but also quite literally.

Is the imagery of creolization out of place in Stockholm, and in the relationships linking Stockholm to the world outside? True, the historical difference between cultural currents coming together here may not be of the magnitude of that present in a postcolonial town in Africa. Yet the center–periphery relationships are there, as is a degree of hierarchy. And at the same time there is some give and take, and some creativity involved in working out cultural mergers.[4]

A SINGLE FIELD OF INTERCONNECTEDNESS

Speaking, on such a conceptual basis, of Stockholm as "doubly creolizing" could be a matter of discerning two quite separate creolization processes. And often this is indeed the way we tend to see things (even when we are not using this vocabulary for what we see). On the one hand, there is the creolization of Swedish national culture, from the top down as it were, by way of that involvement with the world metropoles which is particularly intensive and noticeable in Stockholm. Frequently enough, this is described as "Americanization," and one may have to

look twice for the culturally creative aspects of it, not to accept that it is in large part direct import, and mere imitation.

On the other hand, there is that multifaceted creolization process which involves the greater majority of immigrants, coming in as labor migrants and refugees, and mostly having to adapt to Swedish circumstances. The creolization that occurs here is marked by the dominance of a Swedish institutional system, even as this struggles to be responsive to diversity. Swedish culture is at the center, and immigrant culture at the periphery.

What I want to propose, however, is that something can be gained by not seeing these as two separate fields of cultural change, but by looking at the double creolization as occurring within a single field of interconnectedness. Let me bring in one minor piece of textual evidence, in the form of the May 1990 issue of *CliC*, a glossy monthly specializing in fashion, interior design, food, travel, and other life style reporting.

This issue is devoted in large part to an "Ethnic Wave" theme. "*CliC* has always kept an eye on what happens abroad," the editorial notes; "often out of sheer curiosity, sometimes in the absence of inspiration here at home" (Österberg 1990). The sources used to be *Vogue, Vanity Fair*, and *Interview*, but now, with communication satellites and cable, they include MTV and other foreign television channels as well. However, as the editorial says, when the issue in question deals with the "new internationalism," it is not just a matter of what comes in by way of television, but also of what is "actually a part of Sweden." The editorial writer emphasizes that she does not believe this is a "trend" (a term which, when borrowed into Swedish, appears to have acquired the connotation of arbitrary "fashion"). On the contrary, it is held to be a "logical development with parallels in New York, Paris, and London."

An article by the reporter Per Andersson in the same *CliC* issue is particularly illuminating in its treatment of the topic. Out there in the world an ethnic revolution is on, the reporter suggests, and Sweden, as it is touched by the spirit of the times, begins to see itself in a new light. Sweden has never really been monocultural, a fiction maintained, he argues, only by Swedish state television, the Stockholm newspapers, and the Social Democratic party. In fact, we are already in a multicultural society. What's new is that we are beginning to realize it.

Not unexpectedly, Andersson finds the evidence not least in popular culture. Referring to three young Swedish performers of immigrant origins (Titiyo, Papa Dee, and Leila K), he points out that their music has its roots in hiphop, "which in its tactic of radical cultural mixing has been the natural musical choice of the Swedish second generations since it all began in the early 1980s in break dancing and electrofunk."

"If hiphop has succeeded in creating a functioning whole out of the cultural wreckage of South Bronx, it must also be able to succeed in Tensta and Rosengård." (The latter are again suburbs characterized by well-known immigrant concentrations, in Stockholm and Malmö respectively.) Yet this music does not stay in the suburbs. The new culture of the immigrants is eagerly picked up by

young elite Swedes, the reporter argues, as they go dancing at their favorite hangouts in central Stockholm, a "desegregated world – and perhaps a glimpse of the future – where foreign origins count as a plus in the balance sheet of social status."

I would not have referred so extensively to this issue of *CliC* if I did not think it is merely an especially eloquent example of a much more general tendency in Sweden generally, and in the larger cities especially, to think of immigration, ethnicity, and multiculturalism on the local scene in terms of imported ideas and expectations.

This entanglement of cultural processes between several center–periphery relationships works in several ways. The immigrants participate shoulder to shoulder with other Stockholmers in the relationship of their city to the world centers. Stockholm, then, is the place where some Turks, Ethiopians, and Vietnamese are exposed for example to some of the products of the transnational culture industries. They creolize not only with a dominant Swedish national culture, on a more massive scale, but with a range of cultural currents of other derivations as well. As one center's periphery is another periphery's center, some cultural leapfrogging becomes possible. Yet it is possible that they relate to some of these currents in another way than do the Swedish indigenes. They may hold their own perspectives toward them; or these currents may suggest particular adaptive niches for their lives in Sweden.

At the same time, as the recent *CliC* issue indicates, the stances adopted by the indigenous Swedes as a host population are not entirely local products, but are in part predicated on personal experiences or mediated understandings of the forms taken by diversity elsewhere. As the world centers are made into models, many Swedes expect to see Stockholm, as it is reached by "the ethnic wave," fashioning itself in the image of such cities, also as a pattern of parts and wholes: Tensta becomes South Bronx, a site of social problems as well as cultural innovation.

FRAMEWORKS OF CULTURAL FLOW

To elaborate a little further on this conception of the interconnectedness of cultural processes, I will argue here, as in previous chapters, that contemporary culture can be seen as flowing mostly within a few major kinds of organizational frames, and in their interrelations. Here I will be concerned mostly with three of these: form-of-life, state, and market.

In the form-of-life frame, as people observe one another and listen to one another mostly in everyday situations, they engage in a free and reciprocal flow of meaning which is a by-product of going about life. Some of the people we mix with in the form-of-life frame are more like ourselves, while others are less so. It is in the nature of city life, however, that as compared to what one would find in other localities, there are proportionately fewer people like oneself, and more of those which are in some way or other different; and this will frequently make urbanites rather more acutely aware of the flow of meaning within this frame than people would be in those communities where the round of everyday activities is mostly a matter of trafficking with other people of one's own kind.

155

The figures offered above give some indication of the part immigration plays in creating diversity within the form-of-life framework in greater Stockholm. For an immigrant in a place like Hallunda, obviously, it is a matter of rubbing shoulders not only with people of one's own group, and with ethnic Swedes, but also with people from a great many other immigrant groups. Some mixing and new combinations may result from these interactions, yet the management of meaning in such contexts also tends to become a matter of a practical mapping of the cultural differences among the people with whom one shares a habitat.[5]

Much of the cultural flow in this form-of-life frame is obviously local; as people are mostly sedentary, they see and hear mostly others anchored in the same territory. Increasingly, however, people lead lives in which work and leisure move them over great distances, so that they come to witness ongoing life, and participate in it, in several places. The migrants who have made their new homes in Stockholm suburbs are examples of this. And similarly, part of that center–periphery flow of culture which has places like New York at the center and Stockholm at the periphery involves Swedish natives going to other places, including world cities, and building up ideas there – indeed drawing on the ideas readily available there – concerning the organization of diversity. These Swedes are not least people engaged in transnational occupational or corporate cultures, ranging from businessmen and academics to artists and au pair girls. Together, in a place like Stockholm, they make up a considerable number.

Between the form-of-life and market frames there are close connections. The values, tastes, skills, or whatever people pick up from one another within the form-of-life frame tend to shape them as consumers, as buyers within the market frame, where culture is commoditized and made available by sellers – producers, middlemen. Those people who, having been to the world cities and having acquired new consumer tastes there, return to Stockholm, tend to form one part of the local market for the same type of cultural commodities as they have encountered at the centers.

The market as a frame for the flow of culture operates, however, not only by way of socializing people into particular consumption patterns in one place and then picking them up as customers again in another. It also does so, for example, by offering the cultural commodities imported from the center more directly in the peripheral locality, and often then by making their metropolitan derivation a significant part of their value to the consumer. It can do so with regard to quite specific goods, such as particular brand names in fashion or fast food, but also with regard to more diffuse complexes; and thus we should take note of the kinds of phenomena nowadays frequently packaged as "life styles."

Here we see another variation of the expansiveness of the market framework for cultural flow. Entire forms of life acquire some kind of news value (as "trends" in the *CliC* sense, it would seem), and information about them can be sold. At the same time, there is the tendency to make such stylistic delineations focus precisely around the interpenetration of form of life and market cultural flows. And indeed, fashionable "life styles" are often imports from the center – in Stockholm

recently, for example, there have been "yuppies," as well as a range of youth styles by way of which – not least – questions of ethnicity can be approached.

Looking at the cultural geography of Stockholm, now, while some of the transnational corporate cultures might strike roots in the Stockholm periphery, in a local "Silicon Valley" such as Kista, on the whole the standing of Stockholm as peripheral to New York or London or Paris is most clearly manifested in the central business district. This, as we realize when we read the shop signs, is where English (with French in second position) is most entrenched as the language of commodity esthetics – although *Vanessa Fashion* and *Jet Set Kläder* in Fittja show that it reaches into the immigrant suburbs as well. But this is also where we can most clearly see the examples of how the cultural diversity brought by immigrants is made to fit into a market framework inspired by the world cities. In a matter of years, *Hötorgshallen*, the large indoor food market, was transformed from a fairly traditional Swedish institution into a place where one might go for Turkish fast food, Indian spices, and varieties of butchery. The city center is also where we have seen the number of ethnic restaurants, or restaurants with at least some ethnic overtones, increase greatly over the last twenty years; where those Swedes who have acquired a taste for Arab, Chinese, or Indian food (so far, at least, more likely in London, New York, or Paris than in Beirut, Hong Kong, or Delhi) might find what they seek. And lastly, as the *CliC* reporter tells us, this is where ethnic diversity is commoditized in the fashions of popular culture, where the talented second generation out of Tensta and Hallunda can sometimes make it as artists.

In Stockholm as in Amsterdam, and in the world cities, a sort of cultural demography plays a part in organizing the diversity of the market-place. Items of immigrant cultures can be commoditized to the extent that there are sufficiently sizeable groups available whose members demand them; and all other things being equal, of course, it is likely that larger places offer such possibilities for more items than smaller places. But beyond this, by way of its greater direct involvements with the world, Stockholm has a greater than average proportion of its population which may be disposed toward making more diverse demands. Ethnic niches are thus developed, and these include cuisines as well as those expressive and esthetic occupational activities – music, perhaps sports as well – which seem to draw on a certain degree of exotic typecasting.

I turn now to the state as an organizational frame for cultural flow, to suggest again that we see in Stockholm some double and yet integrated creolization. As far as cultural management is concerned, clearly, basic facts about Sweden are that it is a nation-state and a welfare state. The state thus draws some of its legitimacy from its guardianship of a shared heritage ultimately anchored within the form-of-life framework. Providing for the welfare of its people, the state also has another source of legitimacy; and in more recent decades, the Swedish state has gone on from offering material and social welfare to developing an explicit conception of cultural welfare as well, according to which it is the responsibility of the good state to make available meanings and meaningful forms of high quality to its citizens.

Now both national and welfare cultural commitments are simplified when one is really dealing with a largely homogeneous population. Sweden may never have been entirely monocultural, as the writers at *CliC* point out, but perhaps nearly enough, and for some centuries, its slowly expanding state cultural apparatus – church, schools, and media – has mostly worked on that assumption. The mostly social democratic concept of *folkhemmet*, "the home of the people," precisely combines the ideas of nation-state and welfare state.

The growing cultural diversity since the 1960s, however, has brought about some rethinking of cultural management within the state framework. And I would suggest here as well that the rapid shift in Swedish official understandings of the cultural implications of large-scale immigration was not entirely home-made, but importantly influenced by understandings of goings-on elsewhere. To put it concretely, the revitalization of ethnicity which became global news, beginning with the emergence of Black Power in the United States in the 1960s, and continuing from then on in ever new shapes, was also to a significant extent a part of the center–periphery cultural flow. The media made it so; researchers, not least involved in the center–periphery structure of transnational Academia, helped make it so; not that the local conditions for such an importation of ideas were unsuitable.

Yet the recognition of cultural diversity was also refracted through the prism of the welfare state.[6] A quite highly centralized and cohesive state apparatus could make the shift from the old assumptions of homogeneity and assimilation to those of durable and accepted diversity remarkably quickly, at least in principle. Within a few years, the notion of a cultural "freedom of choice" had been institution-alized. Moreover, the new understandings of culture and ethnicity which were becoming rooted in the state apparatus also involved the typical creative give and take of the creolization process. Proceeding further than merely allowing people of a different cultural background to be themselves, cultural welfare as an indige-nous notion was transformed into multicultural welfare, as the state took upon itself to support immigrant cultures as well. And thus there were, and are, assis-tance to immigrant associational life, the home language classes in the schools, and that conspicuously multilingual public library which we have already come across in Hallunda.[7] Immigrant groups became, to use the term coined in Chapter 8, officialdom's imagined clienteles.

As a matter of principle, of course, the state as an organizational frame for the flow of culture operates within state territory as a whole; not in particular local-ities, not just in Stockholm. Yet in this instance, we have seen, the populations to which the particular cultural welfare measures in question apply are indeed some-what concentrated in cities, and in neighborhoods of these cities. As the market tends to organize diversity in the central business district, the state does so more significantly in the suburbs; in Hallunda, in Rinkeby.[8] And the state/form-of-life nexus also becomes the locus of another set of creolization processes, as people's everyday relationships within households and ethnic groups begin to take the material provisions of the state apparatus into account.

AFTERTHOUGHT:
STOCKHOLM AND ITS DISTANT PERIPHERIES

I have sketched a point of view toward Stockholm in the matrices of transnational cultural flow in extremely general terms, without working out the details. It remains to say something, even more briefly, about the implications of this perspective with respect to the relationship between the Stockholm immigrants and their distant home communities. There is obviously, in some cases, a fair amount of coming and going between Stockholm and these places. On the whole, this entails once more a cultural flow within the form-of-life framework, shaped to one degree or other by the fact that some of the people involved go about their lives in more than one place.

It is sometimes suggested that return migrants, homecomers, exercise a considerable influence as they come back temporarily or permanently to their places of origin. They may have acquired new skills, they may be among the more affluent members of the community. In such ways, Stockholm may be a center to some faraway periphery, in its own right and also as a conduit for currents from elsewhere. And this advantageous command of resources can perhaps leave its mark on the way local culture creolizes. Even so, there may be competing definitions of what is center and what is periphery, spatially, institutionally, and symbolically. The migrants are part of a diaspora, and diasporas tend by definition to be peripheries.[9] The question here, no doubt, is what capacity that whatever is then the center has to exercise its power to be a center. Local circumstances affecting especially the form-of-life framework are likely to be important here. So is again the management of meaning within the state framework: are the homecomers welcomed as contributors to the pool of collective cultural wealth, or are they perhaps branded as culturally polluted? Both these outcomes, and others, are possible.

14

SOPHIATOWN: THE VIEW FROM AFAR

When I first encountered Sophiatown, that legendary Johannesburg suburb, the real thing was already distant in time as well as space. At the Princes' Theatre in London's West End (and it must have been in the early 1960s), I saw the export version of *King Kong*, the musical, which, it has been said, "represented at once an ultimate achievement and final flowering of Sophiatown culture" (Coplan 1985: 175). And by then, Sophiatown itself was already gone, its people removed, its buildings erased, to make place for a different kind of neighborhood.

The idea of Sophiatown, however, thus entered my personal repertoire of images; indeed a symbol of change, if one accepts that change is not always linear, that it has its ups and downs, that the times of hope may alternate with those of frustration and despair. As time passed, I came upon Sophiatown again and again, at first stumbling on it in the writings of a generation of South African writers – Can Themba, Bloke Modisane, Ezekiel (Es'kia) Mphahlele, and others, all at one time or other journalists at *Drum* magazine – then looking for it a little more systematically, in places from Nadine Gordimer's novels to Miriam Makeba's ghostwritten autobiography and Father Trevor Huddleston's *Naught for your Comfort*.[1] Indeed, a polyphony of voices keeps at least the mythical community alive, even if naturally the great majority of ordinary Sophiatowners left no comparable documents.

Still, mine is "a view from afar"; I borrow this part of my title from the third volume of Claude Lévi-Strauss' (1985) collected papers. As I understand Lévi-Strauss, he takes this to sum up what anthropology is about. It involves field workers coming from distant places, and also examining the human condition against the background of exotic materials.[2] Not having even been "in the field" in Sophiatown, I must in this case identify rather more with the latter part of the view. Sophiatowners, I believe, have a great deal to tell us about how culture is made in the contemporary world, certainly as much as anthropology's classics: the Balinese, the Nuer, or the Nambikwara. Take what follows, then, as an essay in cultural interpretation – and appreciation – rather than as anything like an attempt to contribute to the detailed documentation of South African urban history.

But then again my interest in culture seems very different from that most often voiced by Lévi-Strauss. For in *The View from Afar*, he also recurrently comes

back to the idea of cultures as essentially separate from another, or most likely to prosper in that condition: "cultures are like trains moving each on its own track, at its own speed, and in its own direction" (1985: 10).[3] Now that, I think, is hardly the sort of traffic which makes Sophiatown worth thinking about.

WHERE THE ACTION IS

Anthropology, I have suggested before in these pages, has long been drawn to the view of the global mosaic, as exemplified by Lévi-Strauss. Yet it is worth noting in this context that in an extreme version, it comes uncomfortably close to the cultural policy of *apartheid*. The view taken in this book, of continuous cultural exchange and blending within a global ecumene, and of heterogenetic cities as focal points for the emergence of new culture, has a great deal more to do with cities like Johannesburg, and particularly urban quarters of Sophiatown's kind.[4]

Far from being an isolate, Sophiatown was not even a separate urban community. Rather, I understand it to have been the kind of part of a larger urban conglomerate "where the action is," where cultural process is somehow intensified – the Soho, the Greenwich Village, the Quartier Latin, the Kreuzberg, the North Beach of Johannesburg; or perhaps what Harlem was to New York in the days (and nights) of the 1920s Harlem Renaissance.[5] There is a great deal going on, in such a place, in terms of the local shaping and handling of ideas and symbolic forms. But it also brings in culture from the outside, as working materials, and then perhaps also exports something of its own to the surrounding world: regionally, nationally, globally.

King Kong, the musical I saw in London some thirty years ago, suggests some of this. It is the story, with a fairly strong basis in actual events, of a tragical hero, the heavyweight champion Ezekiel Dhlamini (taking his public alias from the movie posters); a star of the boxing ring who became involved with gangsters, found his woman friend involved with another man, killed her, was sentenced to jail, and committed suicide there.[6] And *King Kong* the musical had the street life, those illicit drinking spots called shebeens, the violence, and something at least approximating the music of the township: jazz, penny whistles, the work songs of black miners.

As a story of the township, however, it was already on the road leading away from it, and changing as it went. It was a story put into writing by one white South African, and produced on stage by yet others. The score was by Todd Matshikiza, composer as well as writer, certainly someone who knew the alleys of Sophiatown well. But soon enough Matshikiza was on his way into exile. When *King Kong* premiered in Johannesburg, the female lead role was played by the vocalist of a leading township group, the Manhattan Brothers: Miriam Makeba. By the time I saw it in London, however, she had left the cast, to pursue her own international career. And in the West End orchestra pit, some critics argued, the music was losing some of its flavor.

161

THE PHYSICAL MAKING OF THE MYTHICAL PLACE

From beginning to bitter end, Sophiatown lasted some fifty years.[7] A speculator named Tobiansky acquired the land, 237 acres, four miles or so west of the center of Johannesburg, just before the turn of the century, and after various other schemes had failed, he started to sell plots to whomever would buy, whether white or black. To begin with, consequently, Sophiatown (named after Tobiansky's wife) got a racially mixed population. Yet in those early days, the distance from the city center was seen as disadvantageous, and after the city built a sewage plant nearby the area seemed even less attractive, so that most of the white inhabitants left.[8]

For its black and its colored settlers, on the other hand, Sophiatown had its particular attractions. Soon enough, after land ownership had been severely restricted through the 1923 Urban Areas Act, it was one of few places where they could own their plots and houses. Even if the larger part of the Sophiatown population would be working class or lumpenproletariat, it was thus also a desirable area for the African middle class. Moreover, there were some Indian and Chinese residents, and Indian, Chinese as well as Jewish shopkeepers. All this contributed to the diversity of the local scenery.

Was Sophiatown a slum? This essay would not be the place to try to enumerate what kinds of social problems Sophiatown had, or what physical facilities it lacked. For our purposes, it may suffice to say that some inhabitants and observers would concede that it was, and others assert that it was not. Father Huddleston has suggested the counter-image of an Italian hill town, perhaps somewhere in Umbria:

> in the evening light, across the blue-grey haze of smoke from braziers and chimneys, against a saffron sky, you see close-packed, red-roofed little houses. You see, on the furthest skyline, the tall and shapely blue-gum trees … You see, moving up and down the hilly street, people in groups: people with colourful clothes: people who, when you come up to them, are children playing, dancing and standing around the braziers.
>
> (Huddleston 1956: 121–122)

It was certainly a place which with time became increasingly overcrowded. By midcentury some 40,000 people lived there. As newer black townships were built much further out, there was hardly anywhere else that Africans could live so conveniently close to the center of Johannesburg, in such relative freedom of control. Houses, then, had more and more occupants – owners, tenants, and subtenants; sometimes forty to a dwelling, and fifteen to a room – and new shacks were squeezed into the existing plots. The city provided fewer amenities than it would in areas more directly under its domination. And there was forever a danger of violence; while some would argue that the township gangsters, the *tsotsis*, would seldom bother ordinary people, in large part preoccupied with their own internecine battles (and otherwise engaging in a sort of Robin Hood-like social banditry, stealing from white businesses and selling at favorable prices in the townships), it can hardly be denied that their presence was often felt to be quite menacing.[9]

As the land on which Sophiatown stood became increasingly valuable, and the presence of a large black suburb so near the center of Johannesburg more irritating to the bodies of government, "slum clearance" lent itself as a motive for doing something about the township; indeed, doing away with it. (In its place came a white suburb, named Triomf.) But while it lasted, the particular physical conditions of Sophiatown could certainly as well be seen to contribute importantly to the special combination of diversity with intimacy in its social life. Classes and life styles mingled. People had to sort each other out and find ways of coexisting. "Double-storey mansions and quaint cottages, with attractive, well-tended gardens, stood side by side with rusty wood-and-iron shacks, locked in a fraternal embrace of filth and felony" writes Don Mattera (1989: 74), gang leader turned writer, and the grandson of an Italian immigrant who became a prosperous transporter. "The communal water taps, toilets and showerhouses of Sophiatown, though insanitary and inadequate, are remembered today as casual meeting places where the better-off and educated mixed with their humbler neighbors," David Coplan (1985: 152) notes. And somewhere there, among all those modest, fairly run-down dwellings, could stand the "palatial home of Dr. A.B. Xuma with two garages" – the reminiscence is the writer Bloke Modisane's (1965: 27). Alfred Bitini Xuma, medical doctor, trained in America, Scotland, and England, sometime president of the African National Congress, was perhaps *the* local celebrity, and his house a Sophiatown landmark.[10] Modisane goes on to remember how he himself, and his widowed mother who ran a shebeen to support her family, had looked to Dr Xuma and his house for a model of the good life – "separate bedrooms, a room for sitting, another for eating, and a room to be alone, for reading or thinking, to shut out South Africa and not be black" (Modisane 1965: 36). A place of escape in the mind; yet there it was, as real as anything, with the teeming life of the township surrounding it.

INSTITUTIONS OF AN URBAN CULTURE

I have cited Georg Simmel on city life before (in Chapter 11): "the rapid crowding of changing images." Even in the city, no doubt, much of the cultural process is massively repetitive and slow-moving. The making and maintenance of meanings are also, anywhere, in part fairly private, and dispersed into a variety of settings; probably not so often reflected and reported upon. But then on the other hand, there are those special places, contexts, and institutions where the pace is somehow quicker, where things come together in dramatic ways, calling perhaps for immediate response, but also serving as food for thought. Cities may have more of these, and at least some of them seem recurrent in their general form, even as they vary in detail.

Imagining Sophiatown from far away in time and space, I can think of particular sites where I would especially have liked to be present, observing the action, listening to the conversation. Probably those communal water taps, and other shared facilities at the fringes of mundane domestic life, should be among them, as well as that street life which made Father Huddleston think of Italy.

PLACES

I would also have wanted the doors of the shebeens to open for me; not so much to try my luck with skokiaan or barberton, those dangerous home brews which reformers like Dr Xuma would warn against, but rather because they – places like the *Back of the Moon*, the *Thirty-nine Steps*, the *Cabin in the Sky*, or the *Battleship* – seem to have been the kind of places where, in endless and probably noisy debates, reality as well as alternatives to it are continuously constructed, destroyed, and reconstructed again:

> In such places one could sit until the following day just as long as one bought liquor. The shebeens were one of the main forms of social entertainment. In old Sophiatown the shebeens were not simply made up of a gathering of drunkards. People came to the shebeens to discuss matters, to talk about things, their daily worries, their political ideas, their fears, and their hopes. There were various kinds of people who frequented the shebeens. But probably the most interesting and the most dangerous types were the politicians. Such people have always tried to influence others and get them to conform to their way of thinking, and if one disagreed he immediately became suspect and classed as an informer ... Such were the Sophiatown shebeens, dirty dark little rooms, hidden away in some back alley, or smart posh joints furnished with contemporary Swedish furniture.
>
> (de Ridder 1961: 41)[11]

Perhaps the classic shebeens were to black township culture what the *Vesuvio Bar* and the *Caffe Trieste* were to the Beats in San Francisco at much the same time, or what the *Griensteidl* and the *Café Central* were to turn-of-the-century Vienna?[12]

No doubt I would also have slipped in, once in a while, at the *Odin*, the larger of the two cinemas in Sophiatown; the largest in all of Africa, it has in fact been claimed (and one rather enigmatically named, it appears to me, although perhaps it simply approximated *Odeon*). It was to the *Odin* people would go to see "blood and thunder tuppenny horrors," as Bloke Modisane (1965: 8) described them: *Two Guns West, The Fastest Gun Alive, Guns Over the Prairie*. But it was also the site of a series of "Jazz at the *Odin*" jam sessions, featuring white as well as black musicians, which attracted township sophisticates, and some *tsotsis*, even though this kind of music was still a little alien to the taste of most Sophiatowners (Coplan 1985: 172). And it was at a meeting at the *Odin* that the ultimately unsuccessful resistance to the destruction of Sophiatown began to coalesce (Gready 1990: 157).

Then there would be the compound of the Anglican mission, with its highly regarded St Peter's School, and a very popular swimming pool, the only one in Sophiatown. For more than a decade, as long as he was in South Africa, the mission was the home base of Father Huddleston, the tireless churchman, educator, social worker, and political activist; he was one of the participants in that meeting at the *Odin* on Sophiatown's future. When one of the boys at the school told Huddleston of his discovery of the music of Louis Armstrong, Huddleston found a trumpet for

him, and as the interest in making music caught on among other the other boys, the
Huddleston Jazz Band was formed. Some time later came the Bantu Education Act,
and Huddleston closed St Peter's rather than submitting to its political destruction.
He left South Africa not so long after, and was given a farewell concert by some
two hundred performers. The young man who had been given that first trumpet,
Hugh Masekela, did not stay very long in Sophiatown either. He was in the orches-
tra of *King Kong*, and then made his own international reputation.

Outside of Sophiatown physically, but a part of it spiritually, there was, finally,
Drum, the popular monthly magazine.[13] While the editorial offices were else-
where, some of its black journalists lived there, and others would hunt stories
there, or just hang out in its shebeens. At least a couple of them had been pupils at
St Peter's School, and another had taught there.

Drum was owned by the scion of a prominent white South African business
family, who hired a series of white expatriate editors to take charge over the local
black writing talent. Probably inevitably, there were skirmishes, between editors
and journalists, and between the proprietor and everybody else. But meanwhile,
Drum revolutionized South African writing. When the magazine had begun, the
first editor was inclined toward a sort of "noble savagery" angle: stories on chiefs,
tribal music, tribal customs; acquainting the readership with its own traditions.
Just the kind of uplifting reading matter literate Africans ought to appreciate, in the
view of his enlightened white acquaintances. The only trouble was that the people
of the townships did not seem to agree, so few of them could be bothered with
Drum. The second editor, Anthony Sampson, turned things around, and the maga-
zine became a mirror of the facts and fantasies of urban life: popular music, crime,
exposés of social ills, sports, young ladies in bathing suits ... lots of pictures. The
senior black journalist, Henry Nxumalo, would turn himself anonymously into a
contract farm laborer, or a prison inmate, and return from these experiences to
report on what he had been through; the kind of investigative journalism which
in Europe, in more recent years, has been the specialty of Günther Wallraff,
the German writer. Moreover, *Drum* began a new style of writing. Of Todd
Matshikiza, who went on to do the music for *King Kong*, one of his editors said
that he handled his typewriter "as if it were a cross between a saxophone and a
machine gun" (Hopkinson 1962: 87).

VOICES OF CREOLIZATION

It is through the voices of the *Drum* writers that we learn most fully of
Sophiatown as an exemplar of heterogenetic urbanism (and we may be struck by
the fact that they were writing at about the same time as Redfield and Singer on
that latter topic). Their monthly journalism may have been in large part concrete,
vibrant, of the moment, but from some of them – Bloke Modisane, Can Themba,
Es'kia Mphahlele, Nat Nakasa – there are also (mostly from later periods in exile)
more analytical, interpretive, in large part autobiographical writings.

They had a view of the kind of people they were, and the kind of culture they were engaging with. Can Themba:

I think the rest of African society looked upon us as an excrescence. We were not the calm dignified Africans that the Church so admires (and fights for); not the unspoiled rural African the Government so admires, for they tell no lies, they do not steal, and above all, they do not try to measure up to the white man. Neither were we *tsotsis* in the classical sense of the term, though the *tsotsis* saw us as cousins. I swear, however, that not one of the gentlemen who associated with me in that period was guilty (caught or not) of murder, rape, assault, robbery, theft, or anything like that. True, we spent nights at police stations, but it was invariably for possession of illicit liquor or, its corollary, drunkenness. We were not "cats", either; that sophisticated group of urban Africans who play jazz, live jazz, and speak the township transmigrations of American slang.

We were those sensitive might-have-beens who had knocked on the door of white civilization (at the highest levels that South Africa could offer) and had heard a gruff "No"or a "Yes" so shaky and insincere that we withdrew our snail horns at once.

(Themba 1972: 110)

Or Es'kia Mphahlele:

in a dance hall a jazz combo is creating music; music taken from American Negro jazz and hammered out on the anvil of the South African experience: slum living, thuggery, police raids, job-hunting, shifting ghettos, and so on. The penny whistle takes the key melody, with bass and drums keeping the rhythm. On and off the sax weaves its way through the penny-whistle notes. The musicians grope their way through the notes, expressing by this improvisation the uncertainty and restlessness of urban life ... And so an urban culture has evolved. It is an escape route for a people on the run; but it is the only virile culture in South Africa.

(Mphahlele 1972: 154)

Or Mphahlele again, issuing

a warning to those Africans who think of a culture as an anthropological thing that belongs in the past and must be reconstructed as a mere landmark or a monument; the here and now of its struggle to come to terms with modern technology, with the confrontation of other ways of life, must give as valid a definition to our culture as its historical past.

(Mphahlele 1972: 158)

Or Bloke Modisane:

I was encouraged ... to develop and cultivate an appreciation for my own culture of the shield and the assegai, of ancestral gods, drums, mud huts and

half-naked women with breasts as hard as green mangoes ... But I am a freak, I do presume an appreciation for Western music, art, drama and philosophy; I can rationalize as well as they, and using their own system of assumption, I presume myself civilized and then set about to prove it by writing a book with the title, *Blame Me on History*.

(Modisane 1965: 183–184)

There is indeed a sense of the global ecumene here, of the simultaneous presence within one's field of experience of ancestral gods, Western philosophy, and the jazz of black America; and it is all being worked on right there, in the township. Distinctive cultural currents are coming together, having been separated by oceans and continents, working their way into one another over time, developing new ways of shaping human beings. The Sophiatown writers, demanding head-strongly to be "blamed on history," seem to be forerunners of a kind of cultural understanding, and of cultural critique, which has become much more prominent a third of a century later; the preoccupation with cultural mixture, "mongre-lization," "hybridity." Theirs, to put it in one more way, are voices of creolization.

Sophiatown, of course, was not at the extreme periphery of what I described, in Chapter 6, as a characteristic creole continuum. Mphahlele (1962: 192), after portraying township culture – "a fugitive culture: borrowing here, incorporating there, retaining this, rejecting that" – goes on to argue the importance of migrant labor to extending this continuum into the rural areas. The migrants would bring back to their country homes new gadgets: gramophones, radio sets, concertinas, mouth organs. They would bring cloth and styles of dress, and stories of industrial life. In such ways, the township was a center with its own periphery. Yet in Sophiatown, it would be rather the connections with the outside world, and particularly with metropolitan ways of life, that would draw one's attention and capture one's imagination. Can Themba about "the magic of Sophiatown" again:

You don't just find your place here, you make it and you find yourself. There is a tang about it. You might now and then have to give way to others making their ways of life by methods which aren't in the book, but you can't be bored. You have the right to listen to the latest jazz records at Ah Sing's over the road. You can walk a Coloured girl of an evening down to the Odin cinema, and no questions asked. You can try out Rhugubar's curry with your bare fingers without embarrassment. All this with no sense of heresy. Indeed, I've shown quite a few white people "the little Paris of the Transvaal" – but only a few were Afrikaners.

(Themba 1972: 107)

Parenthetically, I am reminded here of the essayist Jonathan Raban's (1974) idea of the "soft city" – translated into the vocabulary of social theory, the role of agency in creating one's personal urban environment.[14] And beyond that, I also come to think of Zygmunt Bauman's (1992: 190–191) more recent conception of agency and habitat.[15] These are notions which go well with an emphasis on creolization as an active process.

Anyway, Sophiatown certainly did see more white people than most black townships. It was not so far away, and its entrance was not controlled as some others (cf. Nicol 1991: 96). To the more adventurous, it was an attractive place. Yet the interface between black and white Johannesburg remained limited. In her novel *A World of Strangers*, Nadine Gordimer (1962: 168) has a young visiting Englishman conclude that "in the few houses in Johannesburg where people of different colours met, you were likely to meet the same people time after time."

It is so much more striking, then, to find the great variety of ways in which different kinds of Sophiatowners would cherish their own views from afar. It seemed that one would leapfrog over white South Africa, and involve oneself more directly with what one thought of as interesting, attractive, or superior in more distant places. To someone like Bloke Modisane, it could be literally an appetite:

> I remember that once I confronted a shop assistant with a list of items that I wanted: a jar of stuffed olives, a tin of asparagus, a quarter of smoked salmon, a half-pound of chopped chicken liver, a piece of Estrom cheese; and with every item I called out she reacted with jerky motions of looking at me in bewilderment, and throughout all this I was faintly amused.
>
> (Modisane 1965: 99)

Among Sophiatown literati, Nat Nakasa (1985: 188) would reminisce along similar lines, you would be more likely to "walk into a conversation centered around James Joyce or John Osborne or Langston Hughes" than around any white South African writer; and this was "because with us, virtually everything South African was always synonymous with mediocrity."[16] In the same vein again, Mphahlele (1962: 28) could argue that the evolving black music entails a merging of cultures, and that "is why our music will always be more vital, vibrant and meaningful than *boere-musiek* (Afrikaans music), which is a monument to a dead past, full of false posturing, hemmed in as it is by a frontier laager." And in fashion, once more the gaze fixed elsewhere:

> The well-dressed man about Sophiatown was exclusively styled with American and English labels unobtainable around the shops of Johannesburg; the boys were expensively dressed in a stunning ensemble of colour: "Jewished" in their phraseology; in dress items described as "can't gets"; clothes sent for from New York or London. Shoes from America – Florsheims, Winthrops, Bostonians, Saxone and Mansfield from London; BVD's, Van Heusen, Arrow shirts; suits from Simpsons, Hector Powe, Robert Hall; Dobbs, Woodrow, Borsolino hats. The label was the thing.
>
> (Modisane 1965: 52)

The township gangsters were likewise engaged in this game of cosmopolitanism and distant horizons. Their gangs were "the Americans," "the Russians," "the Koreans," or "the Berliners"; the very word *tsotsis* was a corruption of "zoot suits," as worn by American delinquent youths in a slightly earlier period, and the

urban dialect associated with these criminals, *tsotsitaal,* was a variety of Afrikaans with an unusually large proportion of American slang.[17] Not least were the *tsotsis* deeply taken in by the typical fare shown at the *Odin* cinema. Miriam Makeba remembers them from the times when she sang in township clubs with the Manhattan Brothers, and they were out there in the audience:

> there is a movie in the cinemas now in which Richard Widmark plays the hoodlum. They call him Styles, and he dresses up in a hat, a belted jacket, and those Florsheim shoes. The black gangsters go out and dress just like him. In the movie, Richard Widmark eats an apple after each of his crimes. So, all the African hoodlums have gone out and gotten apples, too! I see them right there on the tables between the bottles and the guns.
>
> (Makeba 1987: 50)

LOCAL RESISTANCE, TRANSNATIONAL RESPONSE

How are we to interpret Modisane with his asparagus and smoked salmon, Nakasa and his friends discussing Joyce, the tsotsi with his apple next to his gun? Presumably one could, routinely and with some distaste, dismiss them as more sad examples of the overwhelming cultural power of the center over the periphery, of the way that autonomy and diversity are lost in the world.

Yet we can perhaps also see all this in another way. The Sophiatowners were confronted with an adversary – the government and all those supporting it – who was intent on inserting barriers of discontinuity into the cultural continuum of creolization, who wanted to redefine the situation as one of the global mosaic rather than the global ecumene. To the people of the township, a cosmopolitan esthetic thus became a form of local resistance. Accepting New York could be a way of rejecting Pretoria, to refuse the cultural entailments of any sort of "separate development." We are inclined to think of local cultural resistance as something that draws its symbolic resources from local roots, and undoubtedly, Sophiatowners could use such resources as well. As things stood, however, it seems to have been in the logic of the situation rather to reaffirm the links between Sophiatown and the world.

Here, too, it seems apposite to draw attention to the diversity of the cultural flow between at least some centers and some peripheries. This seems considerably to have enriched the kinds of adversary stands that were available to Sophiatown. To Nakasa and friends, it could involve using the yardstick of the best in world literature to measure the mediocrity of "virtually everything South African." Appreciating American jazz, again, could involve a display of sophistication, a sense of receptive mastery of a subtle art form. But then there is also the racial component. While a celebration of American culture could perhaps more generally affirm cosmopolitanism and a sense of freedom, the special connection to black American culture could offer particular cultural resources for the adversary relationship with white South Africa. Obviously this special connection has

taken many forms in the history of black South African society, from popular music to church life; and of course, Nakasa suggests that those bookish towns-people were discussing not only Joyce but Langston Hughes as well. The Westerns and gangster movies at the *Odin* also fit in here, carrying templates of freedom and of conflict with authority.

So much for the local uses of the global; the ways in which Sophiatowners could employ imported means for making their statements, to other South Africans and to themselves, about who they were or wanted to be. The everyday context is important here, for understanding the peculiarities of creolization and creativity in the black township. One is reminded of Lévi-Strauss again, as he describes, in one chapter in *The View from Afar*, his life in exile in New York during World War II:

> This may be the reason so many aspects of life in New York enthralled us: it set before our eyes a list of recipes thanks to which, in a society becoming each day more oppressive and inhuman, the people who find it decidedly intolerable can learn the thousand and one tricks offered, for a few brief moments, by the illusion that one has the power to escape.
>
> (Lévi-Strauss 1985)

Sophiatown, with its thousand and one tricks, captures one's imagination simi-larly, although one may worry about the note on which Lévi-Strauss ends; are such escapes necessarily only illusions?

Then there is also, however, the global use of the local – not what the world meant to Sophiatowners, but what Sophiatown has meant to the world.

Perhaps one point it can be taken to exemplify concerns the way culture flows in center–periphery relationships in the contemporary world. To repeat, Sophiatown cannot be said to have represented the extreme periphery. It seems to be rather somewhere midway, where cross-currents are strongest, and where the interactive processes of creolization bring the most strikingly new results. But the cultural forms coming out from such midway points are often not only original, being neither wholly of the center nor entirely of the periphery. Being midway, as I have pointed out before, they are also in a way more accessible from either end.

Thus Sophiatowners did not only interact with the world by imitating the center; which I have argued they may also have done for reasons of their own. They also put together things in new ways, in their writings in *Drum*, in *King Kong*, in the music with which Miriam Makeba and Hugh Masekela have toured the world. As Mphahlele had it, "borrowing here, incorporating there, retaining this, rejecting that." And again, it seems now often to be through such culture that the periphery, possibly a little indirectly, responds to the center. If, that is to say, cultural traffic is now less of a one-way thing, it is from places like Sophiatown, the focal points of creolization, that the centers of the global ecumene (with their own switchboard functions) are most easily reached. True, it may not be "authentic," and the further from the periphery and the closer to the center that it gets, the less authentic it is likely to become, perhaps like that West End *King*

Kong. But then notions of authenticity belong rather more in the global mosaic than in the global ecumene.

Sophiatown is gone, and the *Drum* writers mostly went into exile. Disoriented, and continuing the drinking they had begun in the shebeens, many of them died there.[18] Only a few ever returned to South Africa. Meanwhile, their writings were for a long time banned in their home country. Nat Nakasa (1985: 172) listens to Hugh Masekela blowing Pondo and Swazi tunes in Greenwich Village, and wishing he could go home to hear more of that music; Nakasa himself commits suicide by jumping from a seventh-floor window in New York.[19]

But the mythical community is still there, claiming its place, it would seem, in the useful past of the South African future; and in the view from afar, Sophiatown belongs not only to South Africa but to the world.

NOTES

1 INTRODUCTION

1 I have discussed some aspects of the past and present of Kafanchan in other publications (Hannerz 1979, 1982, 1983b, 1985, 1987, 1993).

2 One should realize, however, that the term is not entirely unambiguous; see Verdery (1994) for an illuminating discussion.

3 As I have put it elsewhere, "there is a cumulative microstructuring of ... a fairly sizeable part of the new social landscape of the global ecumene" (Hannerz 1992a: 48). In political science, Rosenau (1990) has suggested the term "postinternational" in developing a related point of view.

4 Cf. Restivo (1991: 177 ff.), Hodgson (1993: 247 ff.), Wax (1993) and Patterson (1994). In the context of African cultural history, Kopytoff (1987: 10) has succinctly defined an ecumene as "a region of persistent cultural interaction and exchange," and this seems like a useful formulation on the global scale as well. I might perhaps add here that while I began thinking, speaking, and writing about this kind of issues in terms of the "world system," I found that term too definitively linked to theoretical assumptions made widely familiar through the work of Immanuel Wallerstein (e.g. 1974, 1991) – which, I should acknowledge, has obviously been immensely influential in stimulating my interest, like that of many others, in a global turn in the social sciences. There seemed also to be some risk that using that term, one could get trapped in rather unproductive debates over the "systemness" of the world. Once again, this may be a time when a sensitizing concept which carries less extra baggage serves us well as we try to get on with things.

5 That perspective is elaborated most fully in a previous book, *Cultural Complexity* (Hannerz 1992b).

6 For other contributions to that conversation see for example Appadurai (1990, 1991, 1993), Friedman (1994), and several articles in two thematic issues of the journal *Cultural Anthropology*, edited by Ferguson and Gupta (1992) and Harding and Myers (1994) respectively.

7 Archer (1988: 2 ff.) relates what she calls "the myth of cultural integration" to "the anthropological heritage," but does not seem very familiar with more recent anthropological trends.

8 One might argue that even this notion now needs some close watching, in so far as genetic engineering could come to place what is biologically given under increasingly precise cultural control; see Chapter 3, note 13.

9 See e.g. Hannerz (1969, 1980).

2 THE LOCAL AND THE GLOBAL

1 The classic parody of our normal lack of awareness of the geographical origins of things is Linton's (1936: 326–327) "100 % American."

2 For a macrosociological view of Second World globalization see Arnason (1995).

3 Raymond Williams (1975: 9 ff.) has a particularly lucid discussion of the historical relationship between technology and society.

4 See Handler's (1985) discussion of this point.

5 See e.g. Calhoun (1991) and Bauman (1992: xviii ff.).

6 On the emerging global language system see the illuminating work by de Swaan (e.g. 1991, 1993). See also some additional comments on language switching in Chapter 7.

7 See e.g. Bauman (1992: 190).

8 See e.g. Ortner (1984: 144 ff.), Keesing (1987), and Obeyesekere (1990: 285 ff.).

9 This notion of habitats of meaning is related to my discussion of perspectives and horizons in *Cultural Complexity* (Hannerz 1992b: 64 ff.).

10 There is an argument along related lines especially in Chapter 5 of *Cultural Complexity* (Hannerz 1992b: 126 ff.).

11 As Appadurai (1986a: 56) has it: "The images of sociality (belonging, sex appeal, power, distinction, health, togetherness, camaraderie) that underly much advertising focus on the transformation of the consumer to the point where the particular commodity being sold is almost an afterthought." See also e.g. Schudson (1984: 129 ff.), McCracken (1988: 77 ff.), Tomlinson 1990: 6 ff.) and Wernick (1991: 27 ff.).

12 I have considered this briefly in the context of a Swedish conference on the management of cultural heritage (Hannerz 1988).

13 I have discussed this extensively elsewhere (Hannerz 1989a, 1989b, 1991, 1992b: 223 ff.).

14 Heller's (1995) comments on conceptions of "home" are in some ways parallel to what follows.

15 Undoubtedly the characterization of everyday life here will be recognized to have an affinity with Bourdieu's (1977) conception of habitus.

16 For some relevant work see e.g. Bloch (1992), Howes (1991), Shilling (1993), Stoller (1989), and Synnott (1993).

17 For one extensive discussion of this theme see Meyrowitz (1985).

18 The formulation here is inspired by Sahlins (1985: ix).

19 Raban (1974) takes a similar view of contemporary urban life – I will refer to it in Chapter 14 – and it may well be true that it is especially in cities that culture is increasingly a matter of choice. It may involve a class factor as well, but I do not think this type of relationship between agency and habitat is now entirely confined to more prosperous categories of people, at least in the First World.

20 See for example Rosander's (1991: 255 ff.) comments on the difference between Muslim men and women in Ceuta, the Spanish enclave on the coast of North Africa.

21 On various aspects of transnational tendencies in the culture of young people, see Jourdan (1995), Liechty (1995), Sansone (1995), Schade-Poulsen (1995), and Wulff (1992, 1995: 10 ff.)

22 I have also discussed the proliferation of transnational ties at the personal level elsewhere (Hannerz 1992a, 1992c).

3 WHEN CULTURE IS EVERYWHERE

1 I will not be able to touch on all the notions of culture implied in these uses. "Bed culture" and "ice cream culture" may have a somewhat Bourdieuesque connotation of distinction, presumably relating to tradition and craftsmanship; it is suggested that there are uncultured beds and ice creams as well. For a brief discussion of "the cultural defense plea" in the context of cultural theory by an anthropologist of law, see Rosen (1991: 603 ff.).

2 Perhaps we are better situated in this respect in Sweden than for example American anthropologists are, judging from the complaints that few seem to ask for anthropological expertise in arguments over "multiculturalism."

3 See for example Ålund and Schierup (1991: 15 ff.).

4 I have previously discussed several of these difficulties in terms of degrees of "culturality" (Hannerz 1983a).

5 I am referring here to early Ingold, the field working graduate student; not to the later Ingold, Manchester theorist.

6 Eric Wolf (1964: 20) makes the same judgment: "where the anthropologists of the 1930's emphasized the free play of the human disposition, the anthropologists of the postwar period have returned to the question of cultural universals."

7 On "developed human nature" see also Singer (1961: 21 ff.).

8 See also Narroll and Narroll (1963).

9 The essay is reprinted in Geertz (1973), where it may now be more accessible.

10 Indeed, Redfield (1962) seems to agree that formulations on behalf of box 6 are imprecise, and yet finds them valid. One may also feel that his own view shows some affinity with those more recently invoking humanism, empathy, or charitable interpretation: "To talk about universally or frequently developed human nature is to speak of a reality. It is not a reality that is easily amenable to investigation by precise method and subject to dependable proof ... With respect to the universal developed nature of humanity, the crude apprehensions that we have of this reality are behind science in that they are vague and in detail no doubt incorrect, but they are ahead of science in that, as compared with what few formal propositions science can offer about it, the crude apprehensions seem to go to the very nature of the thing; it is through the crude apprehensions, rather than through the propositions about patrilateral cross-cousin marriage, that we feel we have met our human kind face to face. It is a dim face, but it looms convincingly" (1962: 448).

11 The comments by Hesslow (1992) cited above would appear to be one example.

12 Relations across the left–right divide obviously acquire a complicating twist when, through techniques of genetic manipulation, the right acquires an increasing influence over the left. We can imagine a range of scenarios, with control over such techniques lodged in boxes 2, 4, or 6, and the techniques exercised in boxes 1, 3, or 5.

13 The next few paragraphs are elaborated in Hannerz (1992b: 10–12, 41 ff.).

14 Bloch also acknowledges the parallels with Bourdieu's theory of practice.

4 A LANDSCAPE OF MODERNITY

1 Primarily, again, I have in mind the work of Kroeber and Redfield.

2 But then some of the diffusionist old-timers may not be quite as irrelevant to contemporary ideas as we have been accustomed to thinking. Cf. Vincent (1990: 125): "What was distinctive about diffusionists such as Rivers, Hocart, Wheeler, Perry, and Elliot Smith was their uncompromising insistence that anthropology study not only primitive or savage peoples but the whole world, ancient and modern, in its historical complexity." Marilyn Strathern (1995: 24), in her inaugural lecture at the University of Cambridge, notes that with a returning interest in technology and material culture, and with diffusion finding new vigor through the interest in globalization, it sometimes feels as if, in anthropology, "we are closer to the beginning of the century than to the middle of it." Yet she points out that those early interests must be routed to the end of the century through the mid-century interests in social relations.

3 See on this for example Hannerz and Löfgren (1994: 205): "Ever more frequently, the citizens found messages, claims, and gifts from the state in their mail, learned to fill in tax forms and to apply for home building loans, memorized the highway code to get a

driver's license, had their health tested, answered questionnaires from the school about their children, and so forth. People found themselves sharing new identities and routines, experiencing similar settings, whether as senior citizens in an old people's home or as children going to the local day care center. During the last half century the state has thus provided a large part of the new framework for everyday life ... The process has produced more of a national habitus than a national rhetoric." In the terms used below, this is the state apparatus constructing important features of a modern habitat.

4 Even by postcolonial African standards, Equatorial Guinea is a notably artificial state construct, comprising primarily a slice of territory on the coast of Central Africa and an island (formerly Fernando Poo, now Bioko) in the Atlantic, closer to Nigeria and Cameroun. Malabo is on the island, while the Fang originate on the mainland.

5 See for example Giddens (1987: 32 ff.), Wallerstein (1991: 64 ff.) and Bauman (1992: 56 ff.).

6 Smelser's (1992) discussion of internationalization is enlightening here.

7 For the conception of relationships used here, see Calhoun (1991, 1992), as discussed further in Chapter 8.

8 Robertson (1992: 34), in his discussion of metaculture, also refers to Sahlins (1985).

9 For some discussion of such matters see Dahl and Rabo (1992).

10 Similarly, Robertson (1992: 83) notes that the growth of the field of cultural studies seems completely in line with Wallerstein's (1990) view of culture as an ideological battleground of the world system.

5 SEVEN ARGUMENTS FOR DIVERSITY

1 See for example Barth's (1956) pioneering study of ecology and group relations in northern Pakistan, or Rappaport's (1984) interpretation of the ecological significance of ritual life among a New Guinea people. For a related, polemical statement on cultural viability in terms of ecological adaptation, see the radical Nigerian cultural critic Chinweizu (1982).

2 Organizations such as the International Work Group on Indigenous Affairs (IWGIA) and Cultural Survival are among those who strive to mobilize public opinion on such matters.

3 Things become a bit more complicated when it turns out that the periphery also imports the cultural autocritique of the center.

4 See for instance the rather controversial interpretation by Cuddihy (1974) along such lines.

5 Salzman (1981) has a related argument about the way a rather less than fully integrated culture can maintain its cultural alternatives within itself.

6 Caute (1973) and Hollander (1981) have discussed the phenomenon of political pilgrims at some length.

6 KOKOSCHKA'S RETURN

1 See for example Moore's (1989) critique of Gellner's view.

2 For one treatment of "globalization as hybridization," see Nederveen Pieterse (1994).

3 See for example Fabian (1978: 317), Drummond (1980), Graburn (1984: 402 ff.), Gupta (1994: 180), Hannerz (1987, 1992a: 261 ff.), Jackson (1989), Jourdan (1995), and Miller (1994).

4 Parkin (1993: 85), in a perceptive comment on recent conceptions of culture in creolization, seems still to think of the latter rather too much in terms of homogenization. In his version, the inequality built into the political economy of creole culture (see below) means that the local cultures of the periphery are losing the struggle with the center, or "at least are having to compromise." My point, suggested also in Chapter 2, is that local

culture, on its home ground, is strong enough (in these adversarial terms) to force the expansive culture of the center into a compromise, and in this lies the creolization.

I am also somewhat puzzled by Parkin's suggestion that I want "our intensive ethnographies" to address "the surface, organizational mix of macro and micro and centre and periphery." I have no particular preference for surface phenomena, and I do not think creole cultural phenomena are necessarily superficial. My understanding of matters of depth and surface in cultural process is spelled out in Chapter 2. I suspect that Parkin has allowed himself to be somewhat influenced by the notion of the superficiality of the transnational exemplified by Anthony D. Smith and discussed in Chapter 7.

In the same vein, as I understand it, is Cohen's (1993: 4 ff.) view of creolization. Cohen discusses this in some relation to my analysis of "the cultural role of world cities" (Chapter 11 in this book) – somewhat mysteriously, as the concept of creolization is not involved there. As far as I can see, Cohen altogether misunderstands (and misrepresents) my position.

5 Friedman (1991: 104, 1994: 208–210) is mistaken on this point.

6 I realize that this is not the only social arrangement in which creole languages occur; however, it seems to be the situation in which the ideas of creolist linguistics take on the greatest appeal to those of us concerned with culture as a collective, socially distributed phenomenon.

7 Van Wetering (1994: 107) comes to the conclusion, entirely surprising to me, that in earlier writings, I "dismiss ethnicity and embrace creolization." Coming to creolist concepts from research experience in Nigeria as I do, my supposed dismissal of the importance of ethnicity would indeed be anomalous. However, in the main article cited by van Wetering, I do write that "an analysis of Nigeria which leaves out ethnicity and ethnic cultures cannot make much sense" (1987: 550); and also that "the emphasis on ethnicity in analysing Nigerian national society contains no more than half the story" (1987: 553). This is hardly a dismissal. My argument is that cultures marked as belonging to ethnic groups are involved in the creolization process in countries like Nigeria, but that ethnicity in my analysis is primarily a fact of social organization which may or may not intrude into creolization as a general cultural process. On the view of the relationship between ethnicity and culture which I assume, see Barth's (1969) classic statement.

8 The conceptualization is developed more extensively in Hannerz (1992b).

9 See for example Boli, Ramirez, and Meyer (1986). It is true that state apparatuses do not always have a monopoly on education. Indigenous as well as imported (or at least externally inspired) religious agencies, for one thing, have frequently also operated in this field, with somewhat different implications for ordering the center–periphery relationships of culture. Undeniably, however, the tendency for states to reach for a greater measure of control over education, at least relative to other agencies, has been pronounced in the postcolonial period.

10 See for example Bourdieu and Passeron (1977) and Collins (1979).

11 For further relevant arguments here see for example Collins (1979: 58 ff.) and Gellner (1983: 26–29).

12 One may bear in mind here Bauman's (1992: 18) argument that "the market seems to thrive on cultural diversity ... It is plausible that in the new domination of market forces culture has recovered a mechanism of the reproduction of diversity once located in autonomous communities." See also Hannerz (1991: 119 ff.).

13 The formulation here parallels that in Hannerz (1991: 119–120), where some aspects of the argument are further developed and exemplified. Waterman's (1990) study of jùjú, for several decades a leading popular music form especially among the Yoruba of southwestern Nigeria, provides one of the most illuminating examples of the creative interplay of Western and indigenous culture.

14 See also Chapter 5, under "Difference as resistance."

15 Löfgren (1989: 7 ff.; 1993) has discussed several aspects of this in his work on the making of national cultures.

16 There is some comment on this in Chapter 4 as well. See also for example Jackson and Rosberg (1982).

7 THE WITHERING AWAY OF THE NATION?

1 For an enlightening discussion of the withering away of the state, see Navari (1991).

2 Conversely, it is obviously possible for nations to survive state apparatuses.

3 Cf. Ohmae (1990: 89): "A global company must be prepared to pull out of a region where its core values cannot be implemented."

4 I have argued this point elsewhere (Hannerz 1992a).

5 See for example Verdery's (1991: 433) point that the revival of ethnicity and nationalism in postcommunist Eastern Europe is reinforced by the "shortage economies" of socialism, favoring any social device which draws clear boundaries between insiders and outsiders, thus reducing competition for scarce resources.

8 A POLISH POPE AMONG THE MAYA

1 The story, of course, has been criticized as a whole; see for example the relatively recent comment by Roseberry (1988: 426–427).

2 See for example Thornton (1988), Clifford (1992), Gupta and Ferguson (1992), and Paine (1992).

3 By chance, I found ethnographic examples of video weddings in Sweden as well as Kenya in contributions to a book on cultures and media which I edited a few years ago (Fornäs 1990, Fuglesang 1990); see also Fuglesang (1994: 150 ff.) and Glick Schiller *et al.* (1992: 11).

4 Note, for example, Margolis (1994: 193) on the telephone habits of Brazilians in New York: "95 percent of the immigrants in my sample call Brazil on a regular basis. In fact, they spend sizable sums on long distance calls; most spend between $85 to $150 a month, while quite a few (sheepishly) admit that their bills regularly come to $200 a month or more."

5 For one important overview of this trend, see Basch *et al.* (1994).

6 On the notion of microcultures see Wulff (1988: 21 ff.) and Hannerz (1992b: 76 ff.).

7 For an early discussion suggesting such possibilities see Plotnicov (1962).

8 For one relevant anthropological study here see Colen (1990); note also Margolis' (1994: 21 ff.) extensive discussion of Brazilians' varieties of entry into the United States.

9 See for example Wulff (1992) on how, through the media, young Swedes go through an anticipatory socialization to life in New York before they go there.

10 In her study of Brazilians in New York, again, Margolis (1994: 93) notes that Governador Valadares, a town with a lengthy history of emigration, is "saturated with information about traveling to the United States, about what it is like to live there, and what opportunities exist for immigrants there"; moreover that the town is "awash with travel agencies."

9 COSMOPOLITANS AND LOCALS

1 This chapter was first published in a volume (Featherstone 1990) which has been more widely available than most of the publications where some of the other chapters first appeared, and therefore I had at first planned not to include it here. It seems, however,

that some readers who may have come across this article in isolation have somehow assumed that it stands for a comprehensive view toward globalization, which it certainly does not (or at least not the view which they may think they see in it); and for that reason it may be useful to place it in the context of the other chapters.

To take one example, Buell (1994: 291 ff.) uses it to contrast generalized theories which depict "the global" as a separate layer on top of prior local formations with another, "more sophisticated line of inquiry," where globalization is seen as at work within older social and cultural formations. In Buell's view, I, together with Anthony D. Smith, represent the former type. I would hope that the difference between my view and Smith's is made sufficiently clear in Chapter 7 of this book, also published in its first version well before Buell's book. I might note that Buell refers elsewhere to another book (King 1991), in which I have a contribution discussing creolization and related matters in terms similar to those in Chapter 6 (Hannerz 1991). This would suggest that he should be aware of at least one of my publications where I formulate quite a different view than that which he is so quick to ascribe to me. But I recognize that the literature is large, and that it may be difficult to keep track of everything. (Elsewhere in his book, Buell refers repeatedly to one Anthony Tambiah, which may suggest that he has some difficulty keeping his Appiahs and Tambiahs apart.)

2 Robbins (1993: 188 ff.), who wants to capture the term "cosmopolitan" for other uses, suggests (in reacting to this chapter in its first publication) that "the cosmopolitan's privileges are most grossly accepted" in my argument here, which he describes as a "shameless use of the new 'global culture' to re-invent or re-legitimate Mannheim's 'free-floating' intellectuals." It is true that the cosmopolitanism I describe centers on an esthetic stance. I also point out that such a stance is a bit of a luxury, in which one can most readily indulge from a fairly privileged position; see also Chapter 5, under "Enjoying diversity." On the other hand, I am hardly concerned with "accepting" (grossly or otherwise) or "legitimating" the privilege in political terms. Robbins' objectives in writing about cosmopolitanism are other than mine, and it may be unfair to attack him in that context for being humorless, but it seems to me that he has failed to notice a tone of irony and playfulness in my portrayal of the cosmopolitan which I would think has little to do with legitimation. Robbins' own preferred conception of cosmopolitanism is "the provocatively impure but irreducible combination of a certain privilege at home, as part of a real belonging in institutional places, with a no less real but much less common (and therefore highly desirable) extension of democratic, anti-imperial principles abroad." I realize that "cosmopolitan" and "cosmopolitanism" are among those words which will be drawn variously far in different directions for different purposes, but at least it seems to me that I stay closer to ordinary usage, and to dictionary definitions such as "marked by interest in, familiarity with, or knowledge and appreciation of many parts of the world," or "marked by sophistication and savoir faire arising from urban life and wide travel," or "a climate of opinion distinguished by the absence of narrow national loyalties or parochial prejudices and by a readiness to borrow from other lands or regions in the formation of cultural or artistic patterns" (*Webster's Third New International Dictionary of the English Language*, unabridged, 1981). As far as Mannheim's free-floating intellectuals are concerned, I have discussed them elsewhere (Hannerz 1992: 145–146).

3 On hedgehogs and foxes, see Berlin (1978), and Chapter 10 of this book.

4 The dilettante, remember, is "one who delights"; someone whose curiosity takes him a bit beyond ordinary knowledge, although in a gentlemanly way he refrains from becoming a specialist (cf. Lynes 1966).

5 See for example the volume *Do's and Taboos Around the World*, issued by the Parker Pen Company (Axtell 1985), which describes its goals in the foreword: "Ideally, this book will help each world traveler grow little invisible antennae that will sense

incoming messages about cultural differences and nuances. An appreciation and understanding of these differences will prevent embarrassment, unhappiness, and failure. In fact, learning through travel about these cultural differences can be both challenging and fun."

6 Randall Collins' (1979: 60 ff.) contrast between "indigenous" and "formal" production of culture is a related conception.

7 On common sense, see for example Geertz (1975), and Bourdieu's (1977: 164 ff.) discussion of the "doxic mode."

8 The cosmopolitan, that is to say, would tend not to be an active agent of creolization (cf. Chapter 6).

10 TROUBLE IN THE GLOBAL VILLAGE

1 See further discussion of the concept of cultural apparatus in Hannerz (1992b: 81 ff.).

2 I have some earlier comments on this in another paper (Hannerz 1993). Work such as that by Lutz and Collins on *Reading National Geographic* (1993) obviously exemplifies such an interest, and there is at least loosely comparable work elsewhere, such as Said's (1981) critique of media coverage of Islam. And since this chapter was written, a full-length ethnography of foreign correspondents has appeared, Pedelty's (1995) study of Salvador war journalism.

3 Ulf Nilson's book is in Swedish; the translations of this and other passages from it are mine.

4 Or for another example, Rosenblum (1993: 99) on Bill Drozdiak: "He was touring Asian cities in 1989, as the *Post*'s foreign editor, when he got a 1 a.m. phone call in Bangkok. The Berlin Wall had fallen, and the paper's correspondent was ill. At 4 a.m., he and several hundred wiped-out Germans were aboard a sex adventure tour charter heading back to Frankfurt. Before the evening deadline, he had two Berlin stories for the front page."

5 Cf. Rosenblum (1993: 102): "throughout the tumult of Lebanon, the Commodore in Beirut was a time-out zone. It provided drivers, telex lines, visas, banking facilities and edible meals when the city around was ablaze in battle. Bar bills were laundered, as laundry charges. Various militias and the Palestine Liberation Organization were paid to lay off the place. Its well-stocked bar featured a parrot which whistled a flawless imitation of incoming artillery. Sometimes, the noise wasn't the parrot."

6 Cf. Rosenblum (1993: 9), quoting a memo tacked up by a British press lord in his newsroom: "One Englishman is a story. Ten Frenchmen is a story. One hundred Germans is a story. And nothing ever happens in Chile." (This, obviously, was before 1973.)

7 The fox–hedgehog contrast comes to us from Archilochus by way of Sir Isaiah Berlin (1978). Anthropologists have been taught by Ruth Benedict (1934) to think of the Zuni Indians of the American Southwest as prototypically Apollonian, and of the Kwakiutl of the Northwest Coast of America as Dionysian.

8 On the theme of risk in current theoretical conceptions of modernity, see also Beck (1992).

9 Language clearly has a part here – remember the title of Behr's book. Returning from the United States to cover Europe for his paper, Ulf Nilson (1976: 211) at first found himself a language invalid: "why cannot the whole world learn English so that at least one doesn't have to starve?" Rosenblum (1993: 11) notes that "correspondents usually speak several languages, but these are not necessarily understood by anyone they need to interview." And "interpreters, never quite good enough, can be awful." Edward Behr (1982: 142), reports on meeting a Japanese TV team in the Central African break-away state Katanga:

"'How are you doing?" I asked.

"'Very good. Today we had an interview with President Tshombe."
"'Excellent. What did he tell you?"
The Japanese TV reporter burst into spasmodic, near-hysterical laughter. "'We no unnerstand," he said.

10 On this point see Geertz (1975) and Hannerz (1992b: 129).

11 Yet it is true that there seems to be little inclination to do so in the books described here either.

12 Roland Robertson's (1992: 78–79) conception, discussed in Chapter 8, of "global *Gemeinschaft 2*" as a species-wide community is relevant here; the foreign correspondent may become a moral entrepreneur. One may also consider in this context the formulation by Appadurai (1991: 198), where he discusses how cinema, VCR and television allow people in the emergent global cultural order a more intense understanding of "possible lives": "What is implied is that even the meanest and most hopeless of lives, the most brutal and dehumanizing of circumstances, the harshest of lived inequalities is now open to the play of imagination. Prisoners of conscience, child laborers, women who toil in the fields and factories, and others whose lot is harsh no longer see their lives as mere outcomes of the givenness of things, but often as the ironic compromise between what they could imagine and what social life will permit." While Appadurai seems primarily to have in mind the support they can provide for fantasies of a better life, my point here would be that the same media can conversely offer materials for the imagination of a worse life as well, on the part of those more fortunate. For further discussion of such issues see Benthall (1993).

13 Which, incidentally, looks much like that lying next to Stephen Tyler on the cover of *Writing Culture* (Clifford and Marcus 1986).

14 The typical example of such expert systems, we noted in Chapter 4, is that of banking.

15 See for example Tuchman (1978), Gans (1980: 31–38), Turow (1984) and Manoff and Schudson (1986).

16 "If something happens in France big enough to attract a Sam Donaldson, for example, viewers have a comforting sense of the familiar," Mort Rosenblum (1993: 54) notes; but goes on to comment that stardom does not guarantee the quality of reporting. "ABC's Jim Bitterman has smaller eyebrows and earns less, but he lives in France; he is more likely to know what's lurking beyond the range of the camera." It is likely that as the real and electronic mobility of familiar faces increases, the value of local knowledge decreases.

17 Behr (1982: 273–274) is more impressed, on the other hand, by a "diminutive French photographer whose battle fatigues could have come from a stylish Paris store specializing in children's uniforms." She got so close to the Hue battle front that the North Vietnamese took her prisoner, yet "with her inimitable charm and through a complete absence of fear, she not only talked the North Vietnamese into allowing her to take pictures but also got them to release her immediately afterward." For a biography of a famous woman war correspondent of a slightly earlier period, Marguerite Higgins of the *New York Herald Tribune*, see May (1985).

18 While there may have been some exaggeration in claims to autonomy earlier as well, interviews I have conducted since this chapter was written suggest that recent changes in communication technology have tended to increase significantly the control of the editors at home over the work of the correspondents.

11 THE CULTURAL ROLE OF WORLD CITIES

1 Heenan (1977) again identifies a somewhat different set of cities with global economic functions; giving some special attention to Paris and Miami (to be more exact, Coral Gables), his article is of some direct relevance to our concerns here.

2 Most of the recent writings on world cities focus on their place in the world economy; apart from the Friedmann and Wolff (1982) article referred to in the text and Heenan's (1977) article mentioned in note 1, see for example Friedmann (1986), Rimmer (1986), Korff (1987), Masai (1989), King (1990), and Sassen (1991).

3 Obviously the list is very similar to what Reich, as cited in Chapter 7, calls "symbolic analysts."

4 Castells (1989) has more recently emphasized the informational aspect of contemporary urbanism.

5 Sassen (1991: 7) emphasizes that after 1982, much of the growth has actually been in other financial institutions than banks.

6 Yet such differences are only relative; see for example Webb (1989) on the Japanese in London.

7 On Miami, apart from Allman, see especially Portes and Stepick (1993).

8 Lockwood and Leinberger also include in their listing "the second largest Japanese metropolitan area outside Japan."

9 For comments on this development see, for example, Haruo (1990), Toshio (1990) and Sassen (1991: 307 ff.).

10 Wulff (1992), discussing young Swedes in New York, describes the connections which occur especially in leisure life among banking and business people, artists, and au pairs.

11 See for instance the comments on this by Heenan (1977: 88).

12 For an extensive study of the *sapeurs* see Gandoulou (1989), and for further comments Friedman (1994: 105–109, 157–166). See also Devisch (1995: 619 ff.) for a glimpse of the *sapeur* in Kinshasa, Zaire.

13 The point has been elaborated by Fischer (1975); see also Hannerz (1992b: 201 ff.).

14 As I have suggested, in the introductory chapter, with regard to the Rushdie affair in its New York version.

15 The allusion is to Gouldner's (1979) conception of a "culture of critical discourse"; see Chapter 9.

16 With inspiration from Appadurai (1986a) and Kopytoff (1986).

17 This seems to be what Palmer (1984: 98 ff.) suggests with respect to Italian restauranteurs in London's Soho; on the other hand, James Watson's (1977: 196) comments on the Chinese restaurants in Gerrard Street in the same city indicate a progression between stages two and three.

18 On such matters, see for example Clarke's (1980: 172) and Hebdige's (1987: 128) comments on changes in reggae, and Schade-Poulsen's (1995) on raï.

19 For an emphasis on the transnational (mostly in a New York context), however, see Glick Schiller, Basch, and Blanc-Szanton (1992) and Basch, Glick Schiller, and Szanton Blanc (1994).

20 But see, for example, Brint (1991).

12 AMSTERDAM: WINDOWS ON THE WORLD

1 I realize that I will return again and again to exemplifying the cultural diversity of Amsterdam by way of its foods; not only, I suppose, because they are among the cultural forms of which a temporary visitor like myself most readily becomes aware, but also because food has a significant place in the definition of ethnic identities and cultural changes.

2 About a year after my stay in Amsterdam, a large Israeli freight plane actually crashed into the housing project described here.

3 See e.g. Fernandez (1980) and Hannerz (1983b).

4 They are prominent sites, that is, for the cultural flow of the state framework.

5 See de Vries (1988: 35): "the Revolt of the Netherlands could be described as the creation of a state controlled by the cities, to avoid their being subjugated by a territorial state."

6 The Randstad includes, apart from Amsterdam, Rotterdam, The Hague, Utrecht, Leiden, Delft, Dordrecht, and Hilversum.

7 Note here the discussion by Lambooy (1988) of the world economic system, the rivalry of global cities within it, and the position of Amsterdam in such rivalry, as well as the related comments by Soja (1993: 83 ff.).

8 See e.g. Anderiesen and Reijndorp (1990), and the comments by Soja (1993: 71 ff.).

9 For further discussion of this see Lofland (1993).

10 For a brief statement on *verzuiling*, the vertical division of Dutch society and its institutions by religion and ideology, see Goudsblom (1967: 120 ff.).

11 One gets some sense of this in Brunt's (1989) study of Turks and Moroccans in Utrecht.

12 On the relationship of the Dutch to exotic cuisines, see van Otterloo (1987).

13 Here again I rely on the research of local colleagues. See van Wetering (1987), van Niekerk and Vermeulen (1989), and especially the published and unpublished work of Livio Sansone (1991a, 1991b, 1995).

13 STOCKHOLM: DOUBLY CREOLIZING

1 All statistics are directly from, or computed from, Statistiska Centralbyrån (Central Bureau of Statistics) 1989.

2 Among Asian countries, the three contributing the largest numbers of foreign-born inhabitants of Sweden were by 1988 Iran, Turkey, and Lebanon; the corresponding three South American countries, Chile, Colombia, and Uruguay; and the three African countries, Ethiopia, Morocco, and Tunisia; in these respective numerical orders.

3 We should keep in mind the Swedish habit of counting (with a fair amount of realism as far as social and cultural conditions are concerned) the Swedish-born children of foreign-born parents as part of the immigrant population; a practice which would add substantially to several of the figures just offered. In total, the "second generation," with one or two foreign-born parents, forms close to 3 per cent of the national population; but its size relative to the "first generation" varies greatly between different immigrant groups.

4 I note also that in 1994, a new glossy magazine named *Creole* appeared in Sweden, with a focus on immigrant cultures and their contribution to Swedish life.

5 Billy Ehn (1992: 69–73), a Swedish ethnologist who has carried out research in Botkyrka, has an illuminating discussion of young people's perceptions of ethnic differences.

6 Wallman's (1981) incisive use of the metaphor of refraction has made a lasting impression on me, and I wish to acknowledge its influence on my formulation here.

7 Ehn (1992: 67) notes that out of some 400 voluntary associations in the Botkyrka municipality, some 60 are explicitly immigrant associations: the Aramaic–Syrian Culture and Sports Association, the Botkyrka Bangladesh Muslim-Democratic Socialist Union, and so forth. He also points to the paradox that these associations "support the cultural identification with other countries and national groups at the same time as they are strictly regulated by Swedish laws and organizational traditions."

8 This should be slightly qualified; we have seen that there are enterprises in Hallunda and Norsborg which find their niches in purveying the commodities of immigrant cultures. On the other hand, I would suggest that the market framework has a smaller part in handling diversity within immigrant/indigene relationships in the suburbs.

9 See, however, Ghosh's (1989) and Clifford's (1994: 304–306) comments on this assumption.

14 SOPHIATOWN: THE VIEW FROM AFAR

1 There is also a growing scholarly literature on Sophiatown, or relating to it; e.g. Coplan (1979, 1985), Lodge (1981) and Gready (1990). I make no claim to having a complete view of the literature, being aware that in particular many South African publications (and unpublished sources) have not been accessible to me while writing this paper. Nixon's (1994) book, taking the story of South African culture and its global connections further into the present, appeared after this chapter was written.

2 Note in this context Geertz' (1988: 46 ff.) comments on Lévi-Strauss' remoteness.

3 Remember, in this context, Lévi-Strauss' comment on the importance of separateness, quoted in Chapter 5.

4 What Redfield and Singer (1954) termed orthogenetic cities, I suggested in Chapter 12, may have a rather better fit with a world organized more like a global mosaic. Did Pretoria under *apartheid* possibly have some of this? I note Nakasa's (1985: 49) comment that "the Afrikaner people of Pretoria seem to be more at home than anywhere else in the country. They seem to walk with a particular kind of dignity, confidence and sense of pride on the pavements of Pretoria."

5 The comparisons are not entirely original. Hopkinson (1962: 90), the British expatriate editor of *Drum*, refers to Sophiatown as the African " Latin Quarter," while Nakasa (1985: 188) argues that "Sophiatown had a heart like Greenwich Village or Harlem."

6 See e.g. Nakasa (1985: 119 ff.) on *King Kong*, and Matshikiza (1961: 110 ff.) on his experience of the trial and his involvement in the musical.

7 On the beginnings of Sophiatown, see e.g. Lodge (1981: 109 ff.) and Coplan (1985: 143 ff.).

8 Among those remaining was Francesco Paulo Mattera, Italian sailor and the writer Don Mattera's grandfather; see below.

9 See e.g. Lodge (1981: 119 ff.) and Themba (1972: 68 ff.) on *tsotsis*. Makeba (1987: 50–51) and Modisane (1965: 182–183) both describe an occasion when *tsotsis* intimidate Makeba into singing the same tune several times in a row in a performance (although Modisane places the performance at the *Odin* cinema, and Makeba in another township).

10 See Nakasa (1985: 141 ff.) on Dr Xuma.

11 From an account of Sophiatown by "an African who was born and brought up there."

12 See Hannerz (1992b: 206 ff.) on Viennese cafés and San Francisco coffee houses.

13 Because it has drawn so much commentary, and because several of its writers became well-known, there is some risk that the relative importance of *Drum* to black South African urban life, compared to some other contemporary publications, tends to become somewhat exaggerated. Anyway, for accounts of life at *Drum*, see the accounts by two British editors, Sampson (1956) and Hopkinson (1962), as well as the recent volume by Nicol (1991). Mphahlele's novel *The Wanderers* (1971) is a fictionalized portrait.

14 For a comment on Raban's book as an example of emergent postmodernism, see Harvey (1989: 3ff.).

15 See also Chapters 2 and 4.

16 Mphahlele actually corresponded with Langston Hughes, who had gotten in touch with him after someone had brought Mphahlele's *Drum* stories to Hughes' attention (Manganyi 1983: 141).

17 The gang names serve as a useful reminder of the time in history at which Sophiatown culture flowered; the Cold War and the Korean war, and the promise of independence elsewhere in Africa, starting with what became Ghana. Certainly all this had its impact on the imagination of Sophiatowners.

18 Mphahlele, who in the end returned to South Africa after a long period in other parts of Africa as well as in the United States, describes the fate of several of them in his autobiographical *Afrika My Music* (1984); on Mphahlele's own life, see also Manganyi (1983).

19 Masekela, on the other hand, did in fact return to South Africa.

REFERENCES

Abu-Lughod, J. (1991) "Going beyond global babble," in A.D. King (ed.) *Culture, Globalization and the World-System*, London: Macmillan.

Abu-Lughod, L. (1991) "Writing against culture," in R.G. Fox (ed.) *Recapturing Anthropology*, Santa Fe, NM: School of American Research Press.

Allman, T.D. (1987) *Miami*, New York: Atlantic Monthly Press.

Ålund, A., and Schierup, C.-U. (1991) *Paradoxes of Multiculturalism*, Aldershot: Avebury.

Anderiesen, G., and Reindorp, A. (1990) "The stabilization of heterogeneity – urban renewal areas in Amsterdam and Rotterdam," in L. Deben, W. Heinemeijer, and D. van der Vaart (eds) *Residential Differentiation*, Amsterdam: Centrum voor Grootstedelijk Onderzoek.

Anderson, B. (1983) *Imagined Communities*, London: Verso.

Andersson, P. (1990) "Det nya Sverige," *CliC* no. 3, May: 56–60.

Appadurai, A. (1986a) "Introduction: commodities and the politics of value," in A. Appadurai (ed.) *The Social Life of Things*, Cambridge: Cambridge University Press.

—— (1986b) "Theory in anthropology: center and periphery," *Comparative Studies in Society and History* 28: 356–361.

—— (1988) "Putting hierarchy in its place," *Cultural Anthropology* 3: 36–49.

—— (1990) "Disjuncture and difference in the global cultural economy," *Public Culture* 2, 2: 1–24.

—— (1991) "Global ethnoscapes: notes and queries for a transnational anthropology," in R.G. Fox (ed.) *Recapturing Anthropology*, Santa Fe, NM: School of American Research Press.

—— (1993), "Patriotism and its futures," *Public Culture* 5: 411–429.

Archer, M. (1988) *Culture and Agency*, Cambridge: Cambridge University Press.

Arnason, J.P. (1995) "The Soviet model as a mode of globalization," *Thesis Eleven* 41: 36–53.

Axtell, R.E. (1985) *Do's and Taboos Around the World*, New York: Wiley.

Barth, F. (1956), "Ecologic relationships of ethnic groups in Swat, North Pakistan," *American Anthropologist* 58: 1079–1089.

—— (1966) *Models of Social Organization*, Occasional paper no. 23, London: Royal Anthropological Institute.

—— (1969) "Introduction," in F. Barth (ed.) *Ethnic Groups and Boundaries*, Oslo: Universitetsforlaget.

Basch, L., Glick Schiller, N., and Szanton Blanc, C. (1994) *Nations Unbound*, Langhorne, PA: Gordon & Breach.

Bauman, Z. (1992) *Intimations of Postmodernity*, London: Routledge.

Beck, U. (1992), *Risk Society*, London: Sage.

Becker, H.S., and Horowitz, I.L. (1971) "The culture of civility," in H.S. Becker (ed.) *Culture and Civility in San Francisco*, Chicago: Transaction/Aldine.

184

REFERENCES

Behr, E. (1982) *"Anyone here been raped & speaks English?,"* London: New English Library. (First published in 1978 by Viking Press.)

Benedict, R. (1934) *Patterns of Culture*, Boston: Houghton Mifflin.

Benthall, J. (1993) *Disasters, Relief and the Media*, London: I.B. Tauris.

Berger, B.M. (1971), *Looking for America*, Englewood Cliffs, NJ: Prentice-Hall.

Berger, P., and Kellner, H. (1964), "Marriage and the construction of reality: an exercise in the microsociology of knowledge," *Diogenes* 46: 1–24.

Berlin, I. (1978), *Russian Thinkers*, New York: Viking.

Bloch, M. (1985), "From cognition to ideology," in R. Fardon (ed.) *Power and Knowledge*, Edinburgh: Scottish Academic Press.

—— (1992) "What goes without saying: the conceptualization of Zafimaniry society," in A. Kuper (ed.) *Conceptualizing Society*, London: Routledge.

Boli, J., Ramirez, F.O., and Meyer, J.W. (1986) "Explaining the origins and expansion of mass education," in P.G. Altbach and G.P. Kelly (eds) *New Approaches to Comparative Education*, Chicago: University of Chicago Press.

Bourdieu, P. (1977) *Outline of a Theory of Practice*, Cambridge: Cambridge University Press.

—— and Passeron, J.-C. (1977) *Reproduction in Education, Society and Culture*, London: Sage.

Braudel, F. (1980) *On History*, Chicago: University of Chicago Press.

Brint, S. (1991) "Upper professionals: a high command of commerce, culture, and civic regulation," in J.H. Mollenkopf and M. Castells (eds) *Dual City*, New York: Russell Sage Foundation.

Browne, M.C. (1993) *Muddy Boots and Red Socks*, New York: Random House.

Brunt, L. (1989) "Foreigners in the neighbourhood: ethnic groups and institutions in Utrecht," in J. Boissevain and J. Verrips (eds) *Dutch Dilemmas*, Assen/Maastricht: Van Gorcum.

Buell, F. (1994) *National Culture and the New Global System*, Baltimore, MD: Johns Hopkins University Press.

Calhoun, C. (1991) "Indirect relationships and imagined communities: large-scale social integration and the transformation of everyday life," in P. Bourdieu and J.S. Coleman (eds) *Social Theory for a Changing Society*, Boulder, CO: Westview Press/Russell Sage Foundation.

—— (1992) "The infrastructure of modernity: indirect social relationships, information technology, and social integration," in H. Haferkamp and N.J. Smelser (eds) *Social Change and Modernity*, Berkeley: University of California Press.

Cameron, J. (1969) *Point of Departure*, London: Panther. (First published in 1967 by Arthur Barker.)

Castells, M. (1989) *The Informational City*, Oxford: Blackwell.

Caute, D. (1973) *The Fellow-Travellers*, New York: Macmillan.

Chinweizu (1982) "On the ecological viability of cultures," *Alternatives* 8: 225–241.

Clarke, S. (1980) *Jah Music*, London: Heinemann.

Clifford, J. (1988) *The Predicament of Culture*, Cambridge, MA: Harvard University Press.

—— (1992) "Traveling cultures," in L. Grossberg, C. Nelson and P. Treichler (eds) *Cultural Studies*, New York and London: Routledge.

—— (1994) "Diasporas," *Cultural Anthropology* 9: 302–338.

—— and Marcus, G.E. (eds)(1986) *Writing Culture*, Berkeley: University of California Press.

Cohen, A.P. (1993) "Introduction," in A.P. Cohen and K. Fukui (eds) *Humanising the City?*, Edinburgh: Edinburgh University Press.

Colen, S. (1990) "'Housekeeping' for the green card: West Indian household workers, the state, and stratified reproduction in New York," in R. Sanjek and S. Colen (eds) *At Work*

in Homes: Household Workers in World Perspective, Washington, DC: American Anthropological Association.

Collins, R. (1979) *The Credential Society*, New York: Academic Press.

Comaroff, J. and J. (1992) *Ethnography and the Historical Imagination*, Boulder, CO: Westview.

Coplan, D.B. (1979) "The African musician and the development of the Johannesburg entertainment industry, 1900–1960," *Journal of Southern African Studies* 5: 135–164.

—— (1985) *In Township Tonight!* London: Longman.

Cuddihy, J.M. (1974) *The Ordeal of Civility*, New York: Basic Books.

Culler, J. (1988) *Framing the Sign*, Norman: University of Oklahoma Press.

Dahl, G. and Rabo, A. (eds) (1992) *Kam-ap or Take-off*, Stockholm Studies in Social Anthropology 29, Stockholm: Almquist & Wiksell International.

Devisch, R. (1995) "Frenzy, violence and ethical renewal in Kinshasa," *Public Culture* 7: 593–629.

Drummond, L. (1980) "The cultural continuum: a theory of intersystems," *Man* 5: 352–374.

Ehn, B. (1992) "The organization of diversity: youth experience in multi-ethnic Sweden," in Å. Daun, B. Ehn, and B. Klein (eds) *To Make the World Safe for Diversity*, Botkyrka: The Swedish Immigration Institute and Museum.

Eisenstadt, S.N. (1987) "Introduction: historical traditions, modernization and development," in S.N. Eisenstadt (ed.) *Patterns of Modernity*, vol. 1: *The West*, New York: New York University Press.

—— (1992) "A reappraisal of theories of social change and modernization," in H. Haferkamp and N.J. Smelser (eds) *Social Change and Modernity*, Berkeley: University of California Press.

Fabian, J. (1978) "Popular culture in Africa: findings and conjectures," *Africa* 48: 315–334.

—— (1983), *Time and the Other*, New York: Columbia University Press.

Featherstone, M. (ed.) (1990) *Global Culture*, London: Sage.

Ferguson, J., and Gupta, A. (eds)(1992) "Space, identity, and the politics of difference," *Cultural Anthropology* 7,1.

Fernandez, J. (1980) "Reflections on looking into mirrors," *Semiotica* 30: 27–39.

Field, J.A., Jr (1971) "Transnationalism and the new tribe," *International Organization* 25: 353–362.

Fischer, C.S. (1975) "Toward a subcultural theory of urbanism," *American Journal of Sociology* 80: 1319–1341.

Fornäs, J. (1990) "Speglingar: om ungas mediebruk i senmoderniteten," in U. Hannerz (ed.) *Medier och kulturer*, Stockholm: Carlssons.

Friedman, J. (1991) "Further notes on the adventures of Phallus in Blunderland," in L. Nencel and P. Pels (eds) *Constructing Knowledge*, London: Sage.

—— (1994) *Cultural Identity and Global Process*, London: Sage.

Friedmann, J. (1986) "The world city hypothesis," *Development and Change* 17: 69–83.

—— and Wolff, G. (1982) "World city formation: an agenda for research and action," *International Journal of Urban and Regional Research* 6: 309–344.

Fuglesang, M. (1990) "Film som romantikens verktyg: om medialisering i staden Lamu, Kenya," in U. Hannerz (ed.) *Medier och kulturer*, Stockholm: Carlssons.

—— (1994) *Veils and Videos*, Stockholm Studies in Social Anthropology 32, Stockholm: Almqvist & Wiksell International.

Gandoulou, J.-D. (1989) *Dandies à Bacongo*, Paris: Editions L'Harmattan.

Gans, H.J. (1980) *Deciding What's News*, New York: Random House/Vintage Books. (First published in 1979 by Pantheon Books.)

Garrison, V., and Weiss, C.I. (1987) "Dominican family networks and United States immigration policy: a case study," in C.R. Sutton and E.M. Chaney (eds) *Caribbean Life in New York City*, New York: Center for Migration Studies.

Garsten, C. (1994) *Apple World*, Stockholm Studies in Social Anthropology 33, Stockholm: Almqvist & Wiksell International.

Geertz, C. (1965) "The impact of the concept of culture on the concept of man," in J.R. Platt (ed.) *New Views of the Nature of Man*, Chicago: University of Chicago Press.

—— (1973) *The Interpretation of Cultures*, New York: Basic Books.

—— (1975) "Common sense as a cultural system," *Antioch Review* 33: 5–26.

—— (1984) "Distinguished lecture: anti anti-relativism," *American Anthropologist* 86: 263–278.

—— (1986) "The uses of diversity," in S.M. McMurrin (ed.) *The Tanner Lectures on Human Values* 7, Cambridge: Cambridge University Press.

—— (1988) *Works and Lives*, Stanford: Stanford University Press.

Gellner, E. (1983) *Nations and Nationalism*, Oxford: Blackwell.

Ghosh, A. (1989) "The diaspora in Indian culture," *Public Culture* 2,1: 73–78.

Giddens, A. (1987) *Social Theory and Modern Sociology*, Cambridge: Polity Press.

—— (1990) *The Consequences of Modernity*, Cambridge: Polity Press.

Glick Schiller, N., Basch, L., and Blanc-Szanton, C. (1992) "Transnationalism: a new analytic framework for understanding migration," in N. Glick Schiller, L. Basch, and C. Blanc-Szanton (eds) *Towards a Transnational Perspective on Migration*, Annals of the New York Academy of Sciences, vol. 645.

Gordimer, N. (1962) *A World of Strangers*, London: Penguin. (First published 1958.)

Goudsblom, J. (1967) *Dutch Society*, New York: Random House.

Gouldner, A.W. (1979) *The Future of the Intellectuals and the Rise of the New Class*, London: Macmillan.

—— (1985) *Against Fragmentation*, New York: Oxford University Press.

Graburn, N.H.H. (1984) "The evolution of tourist arts," *Annals of Tourism Research* 11: 393–419.

Gready, P. (1990) "The Sophiatown writers of the fifties: the unreal reality of their world," *Journal of Southern African Studies* 16: 139–164.

Gupta, A. (1994) "The reincarnation of souls and the rebirth of commodities: representations of time in 'east' and 'west'," in J. Boyarin (ed.) *Remapping Memory*, Minneapolis: University of Minnesota Press.

—— and Ferguson, J. (1992) "Beyond 'culture': space, identity, and the politics of difference," *Cultural Anthropology* 7: 6–23.

Hallin, D.C. (1987) "Cartography, community, and the cold war," in R.K. Manoff and M. Schudson (eds) *Reading the News*, New York: Pantheon.

Handel, G. (1984) "Visiting New York," in V. Boggs, G. Handel and S.F. Fava (eds) *The Apple Sliced*, South Hadley, MA: Bergin & Garvey.

Handler, R. (1985) "On dialogue and destructive analysis: problems in narrating nationalism and ethnicity," *Journal of Anthropological Research* 41: 171–182.

Hannerz, U. (1969) *Soulside*, New York: Columbia University Press.

—— (1979) "Town and country in Southern Zaria: a view from Kafanchan," in A. Southall (ed.) *Small Urban Centers in Rural Development in Africa*, Madison: African Studies Program, University of Wisconsin.

—— (1980) *Exploring the City*, New York: Columbia University Press.

—— (1982) "Washington and Kafanchan: a view of urban anthropology," *L'Homme* 22,4: 25–36.

—— (1983a) *Över gränser*, Lund: Liber.

—— (1983b) "Tools of identity and imagination," in A. Jacobson-Widding (ed.) *Identity: Personal and Socio-Cultural*, Stockholm: Almqvist & Wiksell International.

—— (1985) "Structures for strangers: ethnicity and institutions in a colonial Nigerian town," in A. Southall, P.J.M. Nas, and G. Ansari (eds) *City and Society*, Leiden: Institute of Cultural and Social Studies.

—— (1987) "The world in creolisation," *Africa* 57: 546–559.

—— (1988) "Kriterier för att identifiera ett kulturarv," in P. Sörbom (ed.) *Kulturen vi ärvde*, Stockholm: Swedish Board of Research Councils (FRN).

—— (1989a) "Culture between center and periphery: toward a macroanthropology," *Ethnos* 54: 200–216.

—— (1989b) "Notes on the global ecumene," *Public Culture* 1,2: 66–75.

—— (1991) "Scenarios for peripheral cultures," in A.D. King (ed.) *Culture, Globalization and the World-System*, London: Macmillan.

—— (1992a) "The global ecumene as a network of networks," in A. Kuper (ed.) *Conceptualizing Society*, London: Routledge.

—— (1992b) *Cultural Complexity*, New York: Columbia University Press.

—— (1992c) "Networks of Americanization," in R. Lundén and E. Åsard (eds) *Networks of Americanization*, Stockholm: Almqvist & Wiksell International.

—— (1993) "Mediations in the global ecumene," in Gísli Pálsson (ed.) *Beyond Boundaries*, London: Berg.

—— and Löfgren, O. (1994) "The nation in the global village," *Cultural Studies* 8: 198–207.

Harding, S., and Myers, F. (eds)(1994) "Further inflections: toward ethnographies of the future," *Cultural Anthropology* 9,3.

Haruo, S. (1990) "The labor shortage and workers from abroad," *Japan Echo* 17,1: 57–62.

Harvey, D. (1989) *The Condition of Postmodernity*, Oxford: Blackwell.

Hastrup, K. (1990) "The ethnographic present: a reinvention," *Cultural Anthropology* 5: 45–61.

Hebdige, D. (1987) *Cut'n'Mix*, London: Comedia/Methuen.

Heenan, D.A. (1977) "Global cities of tomorrow," *Harvard Business Review* 55,3: 79–92.

Heller, A. (1995) "Where are we at home?," *Thesis Eleven* 41: 1–18.

Hesslow, G. (1992) "Individens allt tyngre arv," *Moderna Tider* 3,23: 50–52.

Hobsbawm, E.J. (1990) *Nations and Nationalism since 1780*, Cambridge: Cambridge University Press.

Hodgson, M.G.S. (1993) *Rethinking World History*, Cambridge: Cambridge University Press.

Hollander, P. (1981) *Political Pilgrims*, New York: Oxford University Press.

Hopkinson, T. (1962) *In the Fiery Continent*, London: Gollancz.

Horton, R. (1982) "Tradition and modernity revisited," in M. Hollis and S. Lukes (eds) *Rationality and Relativism*, Oxford: Blackwell.

Howes, D. (ed.)(1991) *The Varieties of Sensory Experience*, Toronto: University of Toronto Press.

Huddleston, T. (1956) *Naught for your Comfort*, London: Collins.

Ingold, T. (1993) "The art of translation in a continuous world," in G. Pálsson (ed.) *Beyond Boundaries*, London: Berg.

Jackson, J. (1989) "Is there a way to talk about culture without making enemies?," *Dialectical Anthropology* 14: 127–143.

Jackson, R.H., and Rosberg, C.G. (1982) "Why Africa's weak states persist: the empirical and the juridical in statehood," *World Politics* 35: 1–24.

Janowitz, M. (1967) *The Community Press in an Urban Setting*, Chicago: University of Chicago Press. (First published 1952.)

Jansen, A.C.M. (1991) *Cannabis in Amsterdam*, Muiderberg: Coutinho.

Jourdan, C. (1995) "Masta Liu," in V. Amit-Talai and H. Wulff (eds) *Youth Cultures*, London: Routledge.

REFERENCES

Kadushin, C. (1974) *The American Intellectual Elite*, Boston: Little, Brown.

Kapuscinski, R. (1990) *The Soccer War*, London: Granta Books.

Keesing, R.M. (1987) "Anthropology as interpretive quest," *Current Anthropology* 28: 161–176.

King, A.D. (1990) *Global Cities*, London: Routledge.

—— (ed.)(1991) *Culture, Globalization and the World-System*, London: Macmillan.

Klitgaard, R. (1990) *Tropical Gangsters*, New York: Basic Books.

Kluckhohn, C., and Murray, H.A. (eds)(1948) *Personality in Nature, Society, and Culture*, New York: Knopf.

Konrad, G. (1984) *Antipolitics*, San Diego and New York: Harcourt Brace Jovanovich.

Kopytoff, I. (1986) "The cultural biography of things: commoditization as process," in A. Appadurai (ed.) *The Social Life of Things*, Cambridge: Cambridge University Press.

—— (1987) "The internal African frontier: the making of African political culture," in I. Kopytoff (ed.) *The African Frontier*, Bloomington: Indiana University Press.

Korff, R. (1987) "The world city hypothesis: a critique," *Development and Change* 18: 483–493.

Kroeber, A.L. (1945) "The ancient *Oikoumenê* as an historic culture aggregate," *Journal of the Royal Anthropological Institute* 75: 9–20.

Lambooy, J.G. (1988) "Global cities and the world economic system: rivalry and decision-making," in L. Deben, W. Heinemeijer, and D. van der Vaart (eds) *Capital Cities as Achievement*, Amsterdam: Centrum voor Grootstedelijk Onderzoek.

Lash, S., and Urry, J. (1994) *Economies of Signs and Space*, London: Sage.

Leach, E.R. (1961) *Rethinking Anthropology*, London: Athlone Press.

Lévi-Strauss, C. (1985) *The View from Afar*, New York: Basic Books.

Levitt, T. (1983) "The globalization of markets," *Harvard Business Review* 61,3: 92–102.

Liechty, M. (1995) "Media, markets and modernization: youth identities and the experience of modernity in Kathmandu, Nepal," in V. Amit-Talai and H. Wulff (eds) *Youth Cultures*, London: Routledge.

Linton, R. (1936) *The Study of Man*, New York: Appleton-Century-Crofts.

Lockwood, C., and Leinberger, C.B. (1988) "Los Angeles comes of age," *Atlantic Monthly* 261,1: 31–56.

Lodge, T. (1981) "The destruction of Sophiatown," *Journal of Modern African Studies* 19: 107–132.

Löfgren, O. (1989) "The nationalization of culture," *Ethnologia Europaea* 19: 5–24.

—— (1993) "Materializing the nation in Sweden and America," *Ethnos* 58: 161–196.

Lofland, L.H (1993) "Urbanity, tolerance and public space: the creation of cosmopolitans," in L. Deben, W. Heinemeijer, and D. van der Vaart (eds) *Understanding Amsterdam*, Amsterdam: Het Spinhuis.

Lowie, R. (1920) *Primitive Society*, New York: Liveright.

Lutz, C.A., and Collins, J.L. (1993) *Reading National Geographic*, Chicago: University of Chicago Press.

Lynes, R. (1966) *Confessions of a Dilettante*, New York: Harper & Row.

Lyon, D. (1994) *The Electronic Eye*, Minneapolis: University of Minnesota Press.

McCracken, G. (1988) *Culture and Consumption*, Bloomington: Indiana University Press.

McLuhan, M. (1964) *Understanding Media*, New York: McGraw-Hill.

Makeba, M. (with J. Hall) (1987) *Makeba: My Story*, New York: New American Library.

Manganyi, N.C. (1983) *Exiles and Homecomings*, Johannesburg: Ravan Press.

Manoff, R.K., and Schudson, M. (eds)(1986) *Reading the News*, New York: Pantheon.

Marcus, G.E. and Fischer, M.M.J. (1986) *Anthropology as Cultural Critique*, Chicago: University of Chicago Press.

Marglin, S.A. (1990) "Towards the decolonization of the mind," in F.A. Marglin and S.A. Marglin (eds) *Dominating Knowledge*, Oxford: Clarendon Press.

REFERENCES

Margolis, M.L. (1994) *Little Brazil*, Princeton, NJ: Princeton University Press.

Marriott, M. (1959) "Changing channels of cultural transmission in Indian civilization," in V.F. Ray (ed.) *Intermediate Societies, Social Mobility, and Communication*, Proceedings of the 1959 Annual Spring Meeting of the American Ethnological Society, Seattle: American Ethnological Society/University of Washington Press.

Masai, Y. (1989) "Greater Tokyo as a global city," in R.V. Knight and G. Gappert (eds) *Cities in a Global Society*, Urban Affairs Annual Reviews 35, Newbury Park and London: Sage.

Matshikiza, T. (1961) *Chocolates for My Wife*, London: Hodder & Stoughton.

Mattera, D (1989) *Sophiatown*, Boston: Beacon Press.

May, A. (1985) *Witness to War*, New York: Viking Penguin.

Merton, R.K. (1957) *Social Theory and Social Structure*, Glencoe, IL: Free Press.

Meyrowitz, J. (1985) *No Sense of Place*, New York: Oxford University Press.

Miller, I. (1994) "Creolizing for survival in the city," *Cultural Critique* 27: 153–188.

Mills, C.W. (1963) *Power, Politics, and People*, New York: Ballantine.

Modisane, B. (1965) *Blame Me on History*, London: Panther. (First published 1963.)

Moore, S.F. (1987) "Explaining the present: theoretical dilemmas in processual ethnography," *American Ethnologist* 14: 727–736.

—— (1989) "The production of cultural pluralism as a process," *Public Culture* 1,2: 26–48.

Mphahlele, E. (1962) *The African Image*, London: Faber.

—— (1971) *The Wanderers*, New York: Macmillan.

—— (1972) *Voices in the Whirlwind*, New York: Hill & Wang.

—— (1984) *Afrika My Music*, Johannesburg: Ravan Press.

Nader, L. (1972) "Up the anthropologist – perspectives gained from studying up," in D. Hymes (ed.) *Reinventing Anthropology*, New York: Pantheon.

Naipaul, V.S. (1987) *The Enigma of Arrival*, New York: Knopf.

Nakasa, N. (1985) *The World of Nat Nakasa*, E. Patel (ed.), Johannesburg: Ravan Press. Second impression.

Narroll, R. and F. (1963) "On bias of exotic data," *Man* 63: 24–26.

Navari, C. (1991) "On the withering away of the state," in C. Navari (ed.) *The Condition of States*, Buckingham: Open University Press.

Nederveen Pieterse, J. (1994) "Globalisation as hybridisation," *International Sociology* 9: 161–184.

Needham, R. (1975) "Polythetic classification: convergence and consequences," *Man*, 10: 349, 369.

Nicol, M. (1991) *A Good-looking Corpse*, London: Secker & Warburg.

van Niekerk, M., and Vermeulen, H. (1989) "Ethnicity and leisure time: Surinamese girls in Amsterdam," in J. Boissevain and J. Verrips (eds) *Dutch Dilemmas*, Assen/Maastricht: Van Gorcum.

Nilson, U. (1976) *Ulf Nilson, Utrikeskorrespondent*, Höganäs: Bra Böcker.

Nixon, R. (1994) *Homelands, Harlem and Hollywood*, New York and London: Routledge.

Obeyesekere, G. (1990) *The Work of Culture*, Chicago: University of Chicago Press.

Ohmae, K. (1990) *The Borderless World*, New York: Harper Business.

Olsen, D. (1993) "Urbanity, modernity, and liberty: Amsterdam in the seventeenth century," in L. Deben, W. Heinemeijer, and D. van der Vaart (eds) *Understanding Amsterdam*, Amsterdam: Het Spinhuis.

Ortner, S.B. (1984) "Theory in anthropology since the sixties," *Comparative Studies in Society and History* 26: 126–166.

Österberg, M. (1990) "Etnisk våg," *CliC* no. 3, May: 17.

van Otterloo, A.H. (1987) "Foreign immigrants and the Dutch at table, 1945–1985: bridging or widening the gap?," *Netherlands' Journal of Sociology* 23: 126–143.

190

Paine, R. (1992) "The Marabar Caves, 1920–2020," in S. Wallman (ed.) *Contemporary Futures*, London: Routledge.

Palmer, R. (1984) "The rise of the Britalian culture entrepreneur," in R. Ward and R. Jenkins (eds) *Ethnic Communities in Business*, Cambridge: Cambridge University Press.

Parkin, D. (1993) "Nemi in the modern world: return of the exotic?," *Man* 28: 79–99.

Patterson, O. (1994) "Ecumenical America: global culture and the American cosmos," *World Policy Journal* 11,2: 103–117.

Pedelty, M. (1995) *War Stories*, New York: Routledge.

Peterson, R.A. (1992) "Understanding audience segmentation: from elite and mass to omnivore and univore," *Poetics* 21: 243–258.

Plotnicov, L. (1962) "Fixed membership groups: the locus of culture processes," *American Anthropologist* 64: 97–103.

Portes, A., and Stepick, A. (1993) *City on the Edge*, Berkeley: University of California Press.

Poster, M. (1990) *The Mode of Information*, Cambridge: Polity.

Raban, J. (1974) *Soft City*, London: Hamish Hamilton.

Rabinow, P. (1977) *Reflections on Fieldwork in Morocco*, Berkeley: University of California Press.

Rappaport, R.A. (1984) *Pigs for the Ancestors*, New Haven: Yale University Press. Second edition.

—— (1993) "Distinguished lecture in general anthropology: the anthropology of trouble," *American Anthropologist* 95: 295–303.

Redfield, R. (1941) *The Folk Culture of Yucatan*, Chicago: University of Chicago Press.

—— (1962) *Human Nature and the Study of Society*, Chicago: University of Chicago Press.

—— and Singer, M. (1954) "The cultural role of cities," *Economic Development and Cultural Change* 3: 53–73.

Reich, R.B. (1991) *The Work of Nations*, New York: Knopf.

Restivo, S. (1991) *The Sociological Worldview*, Cambridge, MA, and Oxford: Blackwell.

de Ridder, J.C. (1961) *The Personality of the Urban African in South Africa*, London: Routledge & Kegan Paul.

Rimmer, P.J. (1986) "Japan's world cities: Tokyo, Osaka, Nagoya or Tokaido megalopolis?," *Development and Change* 17: 121–157.

Robbins, B. (1993) *Secular Vocations*, London: Verso.

Robertson, R. (1992) *Globalization*, London and Newbury Park: Sage.

Rosander, E.E. (1991) *Women in a Borderland*, Stockholm Studies in Social Anthropology 26, Stockholm: Almqvist & Wiksell International.

Roseberry, W. (1988) "Domestic modes, domesticated models," *Journal of Historical Sociology* 1: 423–430.

Rosen, L. (1991) "The integrity of cultures," *American Behavioral Scientist* 34: 594–617.

Rosenau, J.N. (1990) *Turbulence in World Politics*, Princeton, NJ: Princeton University Press.

Rosenblum, M. (1993) *Who Stole the News?*, New York: Wiley.

Rouse, R. (1992) "Making sense of settlement: class transformation, cultural struggle, and transnationalism among Mexican migrants in the United States," in N. Glick Schiller, L. Basch, and C. Blanc-Szanton (eds) *Towards a Transnational Perspective on Migration*, Annals of the New York Academy of Sciences, vol. 645.

Rushdie, S. (1991) *Imaginary Homelands*, London: Granta.

Rutkoff, P.M., and Scott, W.B. (1983) "The French in New York: resistance and structure," *Social Research* 50: 185–214.

Sahlins, M. (1985) *Islands of History*, Chicago: University of Chicago Press.

—— (1993) "Goodbye to *tristes tropes*: ethnography in the context of modern world history," *Journal of Modern History* 65: 1–25.

Said, E.W. (1981) *Covering Islam*, New York: Pantheon.

—— (1984) "The mind of winter: reflections on life in exile," *Harper's Magazine*, September: 49–55.

Salzman, P.C. (1981) "Culture as enhabilmentis," in L. Holy and M. Stuchlik (eds) *The Structure of Folk Models*, London: Academic Press.

Sampson, A. (1956) *Drum*, London: Collins.

Sanjek, R. (1991) "The ethnographic present," *Man* 26: 609–628.

Sansone, L. (1991a) "From Creole to Black: leisure time, style and the new ethnicity of lower-class young Blacks of Surinamese origin in Amsterdam: 1975–1991," unpublished MS.

—— (1991b) "Marginalisation and survival strategies among young lower-class Blacks of Surinamese origin in Amsterdam," unpublished MS.

—— (1995) "The making of a black youth culture: lower-class young men of Surinamese origin in Amsterdam," in V. Amit-Talai and H. Wulff (eds) *Youth Cultures*, London: Routledge.

Sassen, S. (1991) *The Global City*, Princeton, NJ: Princeton University Press.

Sassen-Koob, S. (1984) "The new labor demand in global cities," in M.P. Smith (ed) *Cities in Transformation*, Urban Affairs Annual Reviews 26, Beverly Hills, CA: Sage.

Sauvant, K.P. (1976) "The potential of multinational enterprises as vehicles for the transmission of business culture," in K.P. Sauvant and F.G. Lavipour (eds) *Controlling Multinational Enterprises*, Boulder, CO: Westview.

Schade-Poulsen, M. (1995) "The power of love: raï music and youth in Algeria," in V. Amit-Talai and H. Wulff (eds) *Youth Cultures*, London: Routledge.

Schama, S. (1987) *The Embarrassment of Riches*, London: Collins.

Schudson, M. (1984) *Advertising, The Uneasy Persuasion*, New York: Basic Books.

Shilling, C. (1993) *The Body and Social Theory*, London: Sage.

Shils, E. (1975) *Center and Periphery*, Chicago: University of Chicago Press.

—— (1988) "Center and periphery: an idea and its career," in L. Greenfeld and M. Martin (eds) *Center: Ideas and Institutions*, Chicago: University of Chicago Press.

Simmel, G. (1964) *The Sociology of Georg Simmel*, New York: Free Press.

Singer, M. (1961) "A survey of culture and personality theory and research," in B. Kaplan (ed.) *Studying Personality Cross-Culturally*, Evanston, IL: Row, Peterson.

Siverson, L. (1992) "Äventyr i Borneos djungel," *Nordvästra Skånes Tidningar*, July 12.

Smelser, N.J. (1992) "External and internal factors in theories of social change," in Hans Haferkamp and Neil J. Smelser (eds) *Social Change and Modernity*, Berkeley: University of California Press.

Smith, A.D. (1990) "Towards a global culture?," in M. Featherstone (ed.) *Global Culture*, London and Newbury Park: Sage.

—— (1991) *National Identity*, London: Penguin.

Soja, E. (1993) "The stimulus of a little confusion: a contemporary comparison of Amsterdam and Los Angeles," in L. Deben, W. Heinemeijer and D. van der Vaart (eds) *Understanding Amsterdam*, Amsterdam: Het Spinhuis.

Sperber, D. (1985) "Anthropology and psychology: towards an epidemiology of representations," *Man* 20: 73–89.

Statistiska Centralbyrån (1989) *Folkmängd 31 dec 1988, Del III: Fördelning efter kön, ålder, civilstånd och medborgarskap i kommuner m m.*, Stockholm: SCB.

Stoller, P. (1989) *The Taste of Ethnographic Things*, Philadelphia: University of Pennsylvania Press.

—— and Olkes, C. (1987) *In Sorcery's Shadow*, Chicago: University of Chicago Press.

REFERENCES

Strang, D., and Meyer, J.W. (1993) "Institutional conditions for diffusion," *Theory and Society* 22: 487–511.

Strathern, M. (1995) *The Relation*, Cambridge: Prickly Pear Press.

Sutton, C.R. (1987) "The caribbeanization of New York City and the emergence of a transnational socio-cultural system," in C.R. Sutton and E.M. Chaney (eds) *Caribbean Life in New York City*, New York: Center for Migration Studies.

de Swaan, A. (1991) "Notes on the emerging global language system: regional, national and supranational," *Media, Culture and Society* 13: 309–323.

—— (1993) "The emergent world language system: an introduction," *International Political Science Review* 14: 219–226.

Synnott, A. (1993) *The Body Social*, London: Routledge.

Themba, C. (1972) *The Will to Die*, London: Heinemann.

Theroux, P. (1986) *Sunrise with Seamonsters*, Harmondsworth: Penguin.

Thornton, R. (1988) "The rhetoric of ethnographic holism," *Cultural Anthropology* 3: 285–303.

Tomlinson, A. (1990) "Introduction: consumer culture and the aura of the commodity," in A. Tomlinson (ed.) *Consumption, Identity, and Style*, London: Routledge.

Toshio, W. (1990) "A flawed approach to foreign labor," *Japan Echo* 17,1: 45–50.

Tuchman, G. (1978) *Making News*, New York: Free Press.

Turner, T. (1991) "Representing, resisting, rethinking: historical transformations of Kayapo culture and anthropological consciousness," in G.W. Stocking (ed.) *Colonial Situations*, Madison: University of Wisconsin Press.

—— (1993) "Anthropology and multiculturalism: what is anthropology that multiculturalists should be mindful of it?," *Cultural Anthropology* 8: 411–429.

Turner, V. (1977) "Process, system and symbol: a new anthropological synthesis," *Daedalus* 106,3: 61–80.

Turow, J. (1984) *Media Industries*, New York and London: Longman.

Tyler, A. (1985) *The Accidental Tourist*, New York: Knopf.

Verdery, K. (1991) "Theorizing socialism: a prologue to the 'transition'," *American Ethnologist* 18: 419–439.

—— (1994) "Beyond the nation in Eastern Europe," *Social Text* 38: 1–19.

Vincent, J. (1990) *Anthropology and Politics*, Tucson: University of Arizona Press.

de Vries, J. (1988) "Power and the capital city," in L. Deben, W. Heinmeijer, and D. van der Vaart (eds) *Capital Cities as Achievement*, Amsterdam: Centrum voor Grootstedelijk Onderzoek.

Wallerstein, I. (1974) *The Modern World-System*, New York: Academic Press.

—— (1984) *The Politics of the World-Economy*, Cambridge: Cambridge University Press.

—— (1990) "Culture as the ideological battleground of the modern world-system," in M. Featherstone (ed.) *Global Culture*, London and Newbury Park: Sage.

—— (1991) *Unthinking Social Science*, Cambridge: Polity Press.

Wallman, S. (1981) "Refractions of rhetoric: evidence for the meaning of 'race' in England," in R. Paine (ed.) *Politically Speaking*, Philadelphia: ISHI.

Waterman, C.A. (1990) *Jùjú*, Chicago: University of Chicago Press.

Watson, J.L. (1977) "The Chinese: Hong Kong villagers in the British catering trade," in J.L. Watson (ed.) *Between Two Cultures*, Oxford: Blackwell.

Watson, W. (1960) "The managerial spiralist," *Twentieth Century* 7: 413–418.

Wax, M.L. (1993) "How culture misdirects multiculturalism," *Anthropology and Education Quarterly* 24,2: 99–115.

Webb, G. (1989) "The new wave: Japan in London," *Encounter* 72,5: 3–7.

Webber, M.M. (1968) "The post-city age," *Daedalus* 97: 1091–1110.

Weber, E. (1976) *Peasants into Frenchmen*, Stanford: Stanford University Press.

Wernick, A. (1991) *Promotional Culture*, London: Sage.

van Wetering, I. (1994) "Popular culture and anthropological debate: a case study in globalization and ethnicity," in J. Verrips (ed.) *Transactions*, Amsterdam: Het Spinhuis.

van Wetering, W. (1987) "Informal supportive networks: quasi-kin groups, religion and social order among Surinam Creoles in the Netherlands," *Netherlands' Journal of Sociology* 23: 92–101.

Wikan, U. (1992) "Beyond the words: the power of resonance," *American Ethnologist* 19: 460–482.

Williams, R. (1975) *Television: Technology and Cultural Form*, New York: Schocken.

—— (1981) *Culture*, London: Fontana.

Wolf, E.R. (1964) *Anthropology*, Englewood Cliffs, NJ: Prentice-Hall.

Wulff, H. (1988) *Twenty Girls*, Stockholm Studies in Social Anthropology 21, Stockholm: Almqvist & Wiksell International.

—— (1992) "Young Swedes in New York: workplace and playground," in R. Lundén and E. Åsard (eds) *Networks of Americanization*, Stockholm: Almqvist & Wiksell International.

—— (1995) "Introducing youth culture in its own right: the state of the art and new possibilities," in V. Amit-Talai and H. Wulff (eds) *Youth Cultures*, London: Routledge.

INDEX

folk–urban continuum 91–92
folkhem 3, 158
food 74, 78, 130, 131, 136–137, 145, 148, 157, 168, 181
foreign correspondents 10, 112–124
form-of-life 10, 69, 73–78, 132, 133, 135–136, 141–142, 145, 155–156, 159
Fortes, Meyer 11
Foucault, Michel 96
Fourth World 18, 59
foxes 117, 118, 123
France, French 89, 105–106, 108, 116
Frankfurt 128, 144
Frazer, James 33
Freeman, Derek 31
Freud, Sigmund 62
Friedmann, John 128, 129, 131, 139

Gaelic 17, 24, 50
Garrison, Vivian 100
Garsten, Christina 99
gatekeeping concepts 119
Geertz, Clifford 4, 8, 35, 38, 56
Gellner, Ernest 65, 66, 70
Gemeinschaft and *Gesellschaft* 91–97, 99, 100
gender 29, 123, 132, 133, 148
Germany 4
Giddens, Anthony 26, 45, 117–118, 121, 122, 124
global corporations 85–86, 88
global ecumene 7, 11, 13, 18, 21, 23, 29, 44, 45, 48, 50, 52, 54, 55, 62, 64, 142, 143, 145, 161, 167, 169–171, 172
global homogenization 24–25, 38, 56, 64, 66, 74, 111
global mosaic 4, 6, 18, 57, 94, 143, 161, 169, 171
global village 6, 93, 112, 113, 120, 124
globalization 5–6, 9, 17, 18, 19, 24, 25, 38, 45, 50, 66, 76, 82, 87–90, 92–95, 112, 152
Goa, Goans 145
Goffman, Erving 122
Gordimer, Nadine 160, 168
Göteborg 152
Gouldner, Alvin 62, 108–109
Gready, Paul 164
Greeks 7, 18
green card 100
Gulf War 115, 118

Habermas, Jürgen 95, 96
habitat 22–23, 25, 29, 48, 49, 59, 131, 148
Hague, The 143
Hallin, Daniel 113
Handel, Gerald 132–133, 137
Hannerz, Ulf 97
Harlem Renaissance 161
Hastrup, Kirsten 114
hedgehogs 3, 117, 118, 123
heliocentrists 45
Hesslow, Germund 31
heterogenetic cities 127–128, 143, 165
Hobsbawm, Eric 81–84, 89
homelessness 94, 110–111
Hong Kong 128, 143, 157
Hopkinson, Tom 165
Horowitz, Irving Louis 146
Horton, Robin 40–41
hotels 1–2, 5, 12, 104, 132
Huddleston, Trevor 160, 162–165
Hughes, Langston 168–169
human nature 34–35, 40, 41, 54, 121, 174
hybridity 10, 65, 66, 86, 87, 167

ideology 54, 60, 75
imagined clienteles 97–98, 100, 158
imagined communities 20–21, 71, 75, 81, 83, 88, 89, 92, 97, 99, 121
India, Indian 7, 115, 151, 157, 162
individuality 39
Indonesia 116
information society 55
Ingold, Tim 32–35, 38, 40, 41
intellectuals 65, 86, 105–109, 113
intelligibility 21, 22, 32
intercultural communication 9, 108
international organizations 53
Ireland 17, 19, 24, 25, 50
Italy 11–12

Jamaica, Jamaicans 130, 133, 145, 149
Jansen, A.C.M. 147
Japan, Japanese 55, 108, 116
Jews 142, 145, 147–148, 162
Johannesburg 160–171
journalism 5, 25–26, 107, 112–124, 165
Joyce, James 168

Kadushin, Charles 109
Kafanchan 1–2, 5, 7, 11, 12
Kapuscinski, Ryszard 113, 115, 117
Kayapo Indians 52, 53